Photographer's Guide to the Panasonic Lumix DC-LX100 II

Photographer's Guide to the Panasonic Lumix DC-LX100 II

Getting the Most from Panasonic's Advanced Compact Camera

Alexander S. White

WHITE KNIGHT PRESS HENRICO, VIRGINIA Copyright © 2019 by Alexander S. White.

All rights reserved.

No part of this publication may be reproduced, stored in a retrieval system or transmitted in any form or by any means, electronic, mechanical, photocopying, recording or otherwise, without the prior written permission of the copyright holder, except for brief quotations used in a review.

The publisher does not assume responsibility for any damage or injury to property or person that results from the use of any of the advice, information, or suggestions contained in this book. Although the information in this book has been checked carefully for errors, the information is not guaranteed. Corrections and updates will be posted as needed at whiteknightpress.com.

Product names, brand names, and company names mentioned in this book are protected by trademarks, which are acknowledged.

Published by White Knight Press 9704 Old Club Trace Henrico, Virginia 23238 www.whiteknightpress.com contact@whiteknightpress.com

ISBN: 978-1-937986-78-0 (paperback) 978-1-937986-79-7 (ebook

Contents

-
3
1 2
24 · 24 · 26 · 27 · 29 · 30 · 32

Firing Mode		3
	4	
Flash Synchro		-5
Flash Adjustment	4	6
	4	
Red-eye Removal		
ISO Auto Upper Limit (Photo)		
Minimum Shutter Speed		
Long Shutter Noise Reduction		
Diffraction Compensation		
Stabilizer		
Intelligent Zoom		
	50	
	5	
	5	
Multiple Exposure		0
Quick Menu		1
Chapter 5: Physical Controls	63	3
Aspect Ratio Switch	1 1 1 1 1 1 1 1 1 1 1 1 1 1 1 1 1 1 1	3
Aperture Ring		4
Control Ring		4
Step Zoom		5
Focus Switch		5
Shutter Button		5
Zoom Lever '		5
On/Off Switch		5
Shutter Speed Dial		7
Exposure Compensation Dial		7
iA (Intelligent Auto) Button		3
Fn1 Button		3
Viewfinder, Eye Sensor, and Diopter Adjustment Dial		3
Control Dial and its Buttons		
Control Dial		
Direction Buttons		
)
Up Button: ISO		
Up Button: ISO		1

Use of Left Button in Autofocus Mode		
Face/Eye Detection		73
AF Tracking		74
49-Area		74
Custom Multi		75
1-Area		-
Pinpoint		150
Moving the Focus Frame or Focus Area		
Use of Left Button in Manual Focus Mode		
Down Button: Drive Mode		
Burst Shooting		
4K Photo		
4K Burst		81
4K Burst S/S		81
4K Pre-burst		81
Extracting a 4K Photo Still Image		81
Post Focus		83
Focus Stacking		
Self-timer		
Panorama		
Center Button: Menu/Set		
Movie Button		89
AF/AE Lock Button		89
Playback Button		89
Display Button		89
Charging/Wireless Connection Lamp		90
Function Buttons		90
Fn1/4K Photo Button		90
Fn2/Q.Menu Button		91
Fn3/Delete/Cancel Button		
Fn4/Post Focus Button		
Fn5/LVF Button		
Assigning Functions to Function Buttons		
Preview		-
Focus Area Set		
Touch AE		-
Operation Lock		
AF Mode/MF		
Record/Playback Switch		95
Restore to Default		95
Assigning Options to Function Buttons for Playback Mode		95
LCD Monitor		96
Using the Touch Screen		96
AF Assist/Self-timer Lamp		98
hapter 6: Playback		9
HAPTEN O. I LAIDACK	9	19
Index View and Enlarging Images		99
The Playback Menu		100
Slide Show		100
[Play] All		100
[Play] Picture Only/Video Only		
		101
Playback Mode		101
Protect		101
Rating		102
Title Edit		102
Face Recognition Edit		103

Printing Directly from the Camera	
C	
Chapter 7: The Custom Menu ai	ND THE SETUP MENU 113
ISO Increments	113
Exposure Compensation Reset	
Loop Movement Focus Frame	
, ,	
Constant Fleview	

Live View Boost	 . 126
Peaking	 . 126
Histogram	 . 127
Guide Line	 . 128
Center Marker	 . 129
Highlight	
Zebra Pattern	
Exposure Meter	
MF Guide	
LVF/Monitor Display Settings	
LVF Display Setting	
Monitor Display Setting	
Monitor Information Display	
Recording Area	
Remaining Display	
Lens Position Resume	
Lens Retraction	
Self Timer Auto Off	
Face Recognition	
Profile Setup	
The Setup Menu	
Online Manual	
Utilize Custom Set Feature/Custom Set Memory	
Clock Set	
World Time	
Travel Date	
Wi-Fi	
Bluetooth	
Wireless Connection Lamp	
Beep	 . 137
Economy	 . 137
Sleep Mode	 . 137
Sleep Mode (Wi-Fi)	 . 137
Auto LVF/Monitor Off	 . 138
Monitor Display Speed	
LVF Display Speed	
Monitor Display/Viewfinder	
Monitor Luminance.	
m/ft	_
Eye Sensor	
USB Mode	
TV Connection	
Language	
Version Display	
Folder/File Settings	-
Select Folder	
Create a New Folder	
File Name Setting	
Number Reset	-
Reset	
Reset Network Settings	
Level Gauge Adjustment	
Demo Mode	
Format	
My Menu	 . 142

Chapter 8: Motion Pictures	144
Basics of LX100 II Videography	 144
Quick Start for Motion Picture Recording	 144
General Settings for Motion Picture Recording	 145
Exposure	
Focus	 146
Other Settings	 147
The Motion Picture Menu	 147
Recording Format	 147
Recording Quality	 148
AFS/AFF/AFC	 149
Continuous AF	 149
Photo Style	 149
Filter Settings	 149
Metering Mode	 149
Highlight Shadow	 149
Intelligent Dynamic	 150
Intelligent Resolution	 150
ISO Auto Upper Limit (Video)	 150
Diffraction Compensation	
Stabilizer	
Intelligent Zoom	
Digital Zoom	
Picture Mode in Recording	
Sound Recording Level Display	
Sound Recording Level Adjustment	
Wind Noise Canceller	
Using External Microphones	
Physical Controls	
Using the Touch Screen During Video Recording	
Silent Operation	
Recommendations for Recording Video	
Motion Picture Playback and Editing	
Editing with a Computer	
	 50
Chapter 9: Wi-Fi and Other Topics	157
Using Wi-Fi and Bluetooth Features	
Controlling the Camera with a Smartphone or Tablet	
Sending Images and Videos to a Smartphone or Tablet	
Adding Location Data to Images	
Photo Collage	
Turning the Camera On or Off Using Bluetooth	
Controlling the Camera's Shutter Button Using a Bluetooth Connection Only	
Uploading Images by Wi-Fi to Social Networks	
Connecting to a Computer to Transfer Images Wirelessly	
Sending Images to Other Devices	
Viewing Images Wirelessly on TV	
Other Menu Options for Wi-Fi and Bluetooth	
Wi-Fi Function	 167
Wi-Fi Setup	 167
Priority of Remote Device	 167
Wi-Fi Password	 167
Lumix Club	 168
PC Connection	 168
Device Name	 168

Wi-Fi Function Lock		
Network Address		
Approved Regulations		
Bluetooth		
Bluetooth		
Remote Wakeup		
Returning from Sleep Mode		168
Auto Transfer		
Location Logging		169
Auto Clock Set		169
Wi-Fi Network Settings		169
Wireless Connection Lamp		169
Macro (Closeup) Shooting		170
Infrared Photography		170
Digiscoping and Astrophotography		171
Street Photography		172
Portraits		173
Appendix A: Accessories	-	174
Cases		174
Batteries and Chargers		175
AC Adapter		176
Viewfinders		176
Add-on Filters and Lenses		177
External Flash Units		177
Automatic Lens Cap		179
External Microphones		
Appendix B: Quick Tips	1	80
Appendix C: Resources for Further Information	1	82
Photography Books		182
Websites		182
Digital Photography Review		182
Official Panasonic and Related Sites		
Reviews of the LX100 II		
Index		184

Introduction

his book is a guide to the operation, features, and capabilities of the Panasonic Lumix DC-LX100 II. I chose this camera to write about partly because of my experience with its predecessor, the LX100, and also because of the excellent features of this newer model.

The LX100 II, like the LX100, uses a "four thirds" image sensor, the same size used in many "system" cameras that take interchangeable lenses, such as the Panasonic Lumix DMC-GH5 and the Olympus OM-D E-M1X. This sensor is much larger than those of many compact cameras, and lets the LX100 II provide great image quality and beautifully blurred backgrounds.

The camera also has advanced features such as Raw image quality; manual control of exposure and focus; burst capability for continuous shooting; a large, 3-inch (7.6 cm) diagonal and sharp (1,240,000 pixels) LCD screen; a high-quality Leica-branded lens with a wide 24mm equivalent focal length and a much brighter than ordinary f/1.7-f/2.8 maximum aperture; as well as HD (high-definition) and 4K (sometimes called ultra-HD) motion picture recording. It also has a strong set of Wi-Fi and Bluetooth features, enabling remote control from a smartphone and transfer of images from the camera to other devices over a wireless network.

The camera is equipped with a hot shoe that accepts external flash units, and it has a built-in high-resolution electronic viewfinder. The LX100 II includes a self-timer, macro (closeup) focusing, a wide range of shutter speeds (1/16000 second to 60 seconds plus longer time exposures), many "filter effects" settings (such as miniature effect, soft focus, sepia, monochrome, and others), and several options for capturing images with broad dynamic range, including a built-in HDR feature.

Is anything lacking in the LX100 II? Some people would prefer a lens that goes beyond the 75mm equivalent of its maximum optical zoom; others would

like the camera to be smaller, so it could fit easily into a pocket. Some users would like the camera to have a built-in flash unit, rather than the small, add-on flash that Panasonic provides. The camera could use better audio recording features, such as a jack for an external microphone, to support its excellent video capability. It also lacks the ability to output an HDMI video signal while in recording mode.

This camera's quality and features make it a winner by many measures. However, the documentation that comes with it does not always do justice to its capabilities. In addition, the documentation is split between a brief printed pamphlet and a much longer, but less convenient document that is provided via download only. I find it's a lot easier to learn about a camera's features from a single book, with illustrations, that takes the time to explain the features clearly. That is the purpose of this book.

My goal is to provide a solid introduction to the LX100 II's controls and operation along with advice as to when and how to use various features. This book does not provide advanced technical information. If you already understand how to use every feature of the camera and when to use it and are looking for new insights, I have included some references in the Appendices that can provide more detailed information. This book is geared to the beginning to intermediate user who is not satisfied with the documentation provided with the camera, and who is looking for a reference guide that provides some additional help in mastering the camera's features.

One final note: As I write this in early 2019, Leica has released the D-Lux 7 camera, that company's version of the Lumix LX100 II. I may later publish a book that is similar to this one, covering the D-Lux 7. However, because that camera is similar in features and operation to the LX100 II, the information in this book about the LX100 II should be useful to D-Lux 7 owners as well.

3				
		r		
i.				

Chapter 1: Preliminary Setup

The LX100 II does not ship with a DVD that contains the Panasonic users guide and software. Instead, the brief users guide supplied with the camera provides links to sites from which you can download software for processing images and videos. For PHOTOfunSTUDIO software, which is used for managing and editing of images and movies, and which is available for Windows computers only, go to http:// panasonic.jp/support/global/cs/soft/download/d_ pfs10ae.html. For Silkypix software, which is used for processing images captured with the Raw format, http://www.isl.co.jp/SILKYPIX/english/p/. That software is available for both Windows-based and Macintosh computers. For a 30-day free trial of LoiLoScope software, for editing movies with Windows computers, go to http://loilo.tv/product/20.

To download the full Panasonic users manual for the LX100 II, go to http://av.jpn.support.panasonic.com/support/dsc/oi/index.html?model=DC-LX100M2&dest=P, or scan the QR code at page 81 of the brief users guide that is included with the camera. You also can get access to the Panasonic users manual from the camera, by going to the Online Manual item on the Setup menu.

One of the first things you should do with your new camera is attach the lens cap string, a small loop supplied in a plastic envelope that is easy to overlook. Thread it through the small opening on the lens cap and then through the neck-strap bracket closest to the lens, Now your lens cap will be attached to the camera and can't be misplaced. You might want to consider getting an "automatic" lens cap that stays attached to the camera and opens and closes as the lens extends. That item is discussed in Appendix A. You also may want to attach the supplied neck strap to the two brackets at the sides of the camera.

Charging and Inserting the Battery

The LX100 II ships with a single rechargeable lithiumion battery, model number DMW-BLG10PP. Unlike the situation with the original LX100, the battery can be charged inside the LX100 II. To do this, line up the battery with the camera as so its contacts will connect to those inside the camera, shown in Figure 1-1, insert the battery into the camera, then close and latch the battery compartment door.

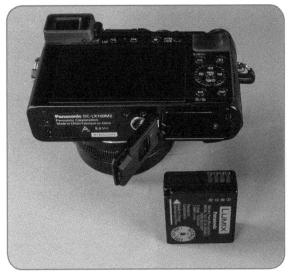

Figure 1-1. Battery Lined Up to Go into Camera

With the battery inserted, plug the small end of the supplied USB cable into the micro-USB slot on the right side of the camera, as shown in Figure 1-2. Plug the other end of the cable into the supplied charger, and plug the charger into any standard AC outlet or surge protector. A red light will illuminate at the top center of the camera's back to indicate that the battery is charging. When the red light turns off, after about 3 hours (190 minutes), the battery is fully charged and ready to use.

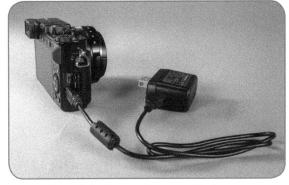

Figure 1-2. Charger Connected to Camera

You can operate the camera with the USB cable plugged into a power source (if a charged battery is in the camera), but the battery will not be charged until you turn the camera off.

You also can charge the battery outside of the camera using an external charger, as discussed in Appendix A.

Inserting the Memory Card

The LX100 II does not ship with a memory card. If you turn the camera on with no card inserted, you will see the message "No memory card" in the center of the screen. If you try to take pictures or movies with no card in the camera, they will not be saved and cannot be retrieved. So, you need to use a memory card.

The LX100 II can use any of the standard varieties of SD memory cards, which are about the size of a postage stamp. The standard card, SD, comes in capacities from 8 MB (megabytes) to 2 GB (gigabytes). The higher-capacity card, SDHC, comes in sizes from 4 GB to 32 GB. The newest type, SDXC, at this writing is available in a 48 GB, 64 GB, 128 GB, 256 GB, or 512 GB size, though its maximum capacity theoretically is 2 terabytes, or about 2,000 GB. Currently the 512 GB card is selling for about \$200.00, so it is rather expensive, but I have used a SanDisk Extreme PRO 512 GB card in the LX100 II with good results.

When choosing a memory card, there is one important point to bear in mind: If you want to use the excellent 4K motion picture recording capability of the LX100 II, you have to use a card in UHS speed class 3, for ultrahigh speed class 3. An example of one such card is shown in Figure 1-3. Look for the number 3 inside a U shape on the card.

Figure 1-3. Memory Card in UHS Speed Class 3

I recommend you purchase a card of that speed class, because it will help with burst shooting as well as with 4K video. If you don't need 4K features, you should get a card rated in speed class 6 or higher if you're going to record video.

Once you have the card, open the door on the bottom of the camera that covers the battery compartment and slide the card in until it catches. The card goes in with its label facing the front of the camera, as shown in Figure 1-4.

Figure 1-4. Memory Card Going into Camera

Once the card has been pushed down until it catches, close the compartment door and push the latch back to the locking position. To remove the card, push down on it until it releases and springs up so you can grab it.

Introduction to Main Controls

Before I discuss options for setting up the camera using the menu system and controls, I will introduce the main controls so you'll have a better idea of which button or dial is which. I won't discuss all of the controls here; they will be covered in some detail in Chapter 5. For now, I'm including a series of images that show the major items. You may want to refer back to these images for a reminder about each control.

Figure 1-5 shows the controls on top of the camera.

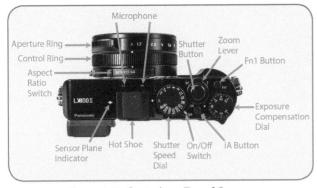

Figure 1-5. Controls on Top of Camera

TOP OF CAMERA

The shutter speed dial is used to set the shutter speed when you are using Shutter Priority mode or Manual exposure mode. If you set it to the red A mark, the camera will choose the shutter speed, in Aperture Priority or Program mode. Press the shutter button all the way down to take a picture; press it halfway to cause the camera to evaluate focus and exposure. The zoom lever, surrounding the shutter button, is used to zoom the lens from the wide-angle (W) setting to the telephoto (T) setting. The exposure compensation dial is used to adjust exposure compensation. The on/off switch is used to turn the camera on and off. The iA button is used to switch the camera into and out of Intelligent Auto mode. The Fn1 button can be programmed to call up any one of numerous options, such as 4K Photo, ISO, white balance, and many others, as discussed in Chapter 5.

The hot shoe is where you attach the small flash unit supplied with the camera, or another external flash unit, as well as certain other accessories. The two microphone openings receive sounds to be recorded with videos. The aspect ratio switch is used to select the aspect ratio for your images. The control ring is used for focus and other operations, depending on current settings. The aperture ring is used to set the aperture when you are using Aperture Priority or Manual exposure mode. If you set the ring to its red A mark, the camera will select the aperture, in Shutter Priority or Program mode. The image sensor plane marker indicates the location of the image sensor inside the camera, in case you need to measure the distance from the subject to the sensor precisely for a macro shot.

Figure 1-6 shows the major controls on the camera's back.

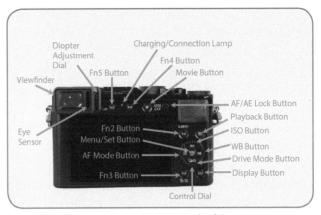

Figure 1-6. Controls on Back of Camera

BACK OF CAMERA

The viewfinder window is where you look to see the view through the camera's electronic viewfinder, or live viewfinder (LVF). The slit to its right is the eye sensor, which senses the presence of your head and switches between the LVF and the LCD screen display. The diopter adjustment dial lets you adjust the view in the LVF for your vision. The LVF button lets you set the LVF so it is automatically switched by the eye sensor, or so either the LVF or the LCD screen is active. This button also serves as the Fn5 button, and can be assigned to carry out another operation instead of LVF switching using the menu system.

The Fn4 button can be assigned one operation through the menu system. The red movie button is used to start and stop the recording of a movie sequence. The charging/wireless connection lamp lights up red when the battery is being charged inside the camera, or blue when a wireless function is turned on. It blinks blue when the camera is sending data. The AF/AE Lock button is used to lock exposure and/or focus, depending on settings you make through the menu system. The Q.Menu button is used to activate the Quick Menu system, which gives you instant access to several important menu settings. It also is labeled Fn2, meaning it is a programmable function button also. The Playback button puts the camera into playback mode so you can review your recorded images and videos.

The ridged control dial acts as a rotary wheel for moving through menu items and through options on various screens of settings, as well as for other purposes, such as moving through recorded images and videos. In addition, the four edges of this dial act as buttons (sometimes called the Up, Down, Left, and Right

buttons in this book) when you press in on them. These buttons control the settings of ISO, white balance, drive mode, and autofocus mode. The button in the center of the dial, called the Menu/Set button, is used to get access to the menu system and to select or confirm various menu options. The Fn3 button is another function button that can be assigned to an operation through the menu system. It also is permanently assigned as the Cancel/Delete button, for canceling out of menu screens and deleting images in playback mode. The Display button is used to switch among the various displays of information in the LVF and on the LCD screen in both shooting and playback modes, and to display help screens when menu items are highlighted.

FRONT OF CAMERA

There are only a few items to point out on the camera's front, shown in Figure 1-7. The AF Assist/Self-timer Lamp lights up to indicate the operation of the self-timer and also turns on in dim light to assist the camera's autofocus system, unless you disable it for that purpose through the menu system.

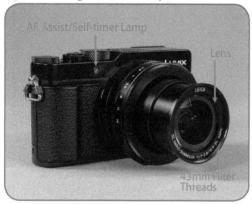

Figure 1-7. Items on Front of Camera

The lens is a high-quality zoom lens with a maximum aperture of f/1.7 at the wide-angle setting, changing to a maximum of f/2.8 at the telephoto end of its range. The focal length of the lens varies from 10.9mm at the wide-angle range to 34mm at the telephoto setting. Ordinarily, though, these focal lengths are stated using "35mm-equivalent" figures, meaning the values that these figures would correspond to for a camera using a full-frame, 35mm image sensor. Therefore, the focal length range of the lens is ordinarily stated as from 24mm to 75mm. The front of the lens is threaded to accept filters with a diameter of 43mm.

RIGHT SIDE OF CAMERA

Inside the door on the right side of the camera are the micro-HDMI port and the micro-USB port, as shown in Figure 1-8. The HDMI port is where you plug in an optional HDMI cable to display images and videos from the camera on an HDTV set. The USB port is where you plug in the camera's USB cable to charge the battery or transfer images and videos to a computer or other device. You also can use the micro-USB port to connect to a PictBridge-compliant printer to print images directly from the camera, as discussed in Chapter 6.

LEFT SIDE OF CAMERA

As shown in Figure 1-9, on the left side of the lens is the focus switch, which slides to select autofocus, autofocus macro, or manual focus for the focus mode.

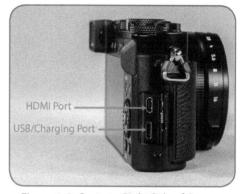

Figure 1-8. Ports on Right Side of Camera

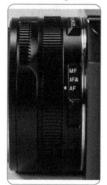

Figure 1-9. Focus Switch

BOTTOM OF CAMERA

Finally, as shown in Figure 1-10, on the bottom of the camera are the speaker, the tripod socket, the door for the battery and memory card compartment, and the small flap that is used to accommodate the cord for the AC adapter when it is connected to the camera, as discussed in Appendix A.

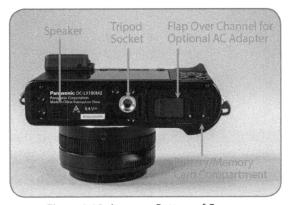

Figure 1-10. Items on Bottom of Camera

Setting the Date, Time, and Language

It's important to make sure the date and time are set correctly before you start taking pictures, because the camera records that information invisibly with each image, and displays it later if you want. Someday you may be very glad to have the date (and even the time of day) correctly recorded with your archives of digital images.

To get these basic items set, move the camera's power switch, on the top of the camera, to the On position. Then press the Menu/Set button (in the center of the control dial on the camera's back). Push the Left button to move the selection into the column for choosing the menu type (Recording, Motion Picture, Custom, Setup, My Menu, or Playback). The line at the left side of the display will turn yellow to indicate that the column of menu icons is now active, as shown in Figure 1-11.

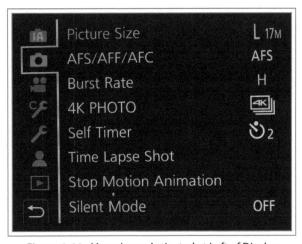

Figure 1-11. Menu Icons Activated at Left of Display

Press the Down button to highlight the wrench icon that represents the Setup menu, then press the Right button to place the yellow selection rectangle in the list of Setup menu items.

By turning the control dial or pressing the Up and Down buttons, move the yellow rectangle until it highlights Clock Set, the fourth item down on the first screen of the Setup menu, as shown in Figure 1-12. Then press the Right button to get access to the clock and date settings, as shown in Figure 1-13.

Navigate by pressing the Left and Right buttons or by turning the control dial, and select values with the Up and Down buttons. When you're done, press the Menu/Set button to save the settings. Then, using a similar procedure, navigate to the Language option on the third screen of the Setup menu, if necessary, and change the language the camera uses for menus and messages.

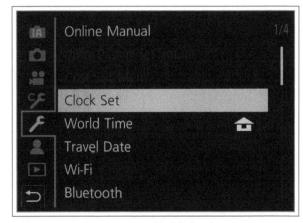

Figure 1-12. Clock Set Item Highlighted on Setup Menu

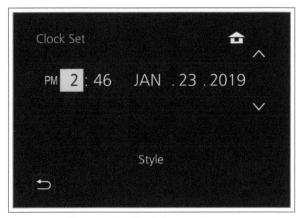

Figure 1-13. Clock Settings Screen

With the LX100 II, you can also use the touch screen to navigate through menus and select menu options. Just touch the item you want to select with your finger. I will discuss the use of the touch screen in general in Chapter 5.

CHAPTER 2: BASIC OPERATIONS

Taking Pictures in Intelligent Auto Mode

Here's a set of steps to follow if you want to set the camera to its most automatic mode and let it make most of the decisions for you. This is a good way to grab a quick shot without fiddling with many settings.

1. Look on the top of the lens barrel for the slide switch that selects among the four possible aspect ratios: 3:2, 16:9, 1:1, and 4:3, shown in Figure 2-1. Unless you know you want one of the other three aspect ratios, slide the switch over to the first position on the right to select the 4:3 aspect ratio for now. That aspect ratio uses more of the sensor's pixels than any other setting.

Figure 2-1. Aspect Ratio Switch

- Remove the lens cap and let it dangle by its string (or cup it in your hand to keep it from flapping around).
- 3. Move the power switch on the camera's top to the On position. The camera makes a whirring sound, the lens extends outward to its open position, and the LCD screen lights up.
- 4. Press the iA button, on top of the camera to the right of the on/off switch. This sets the camera to the Intelligent Auto mode of shooting. You should see a red icon with iA in white letters in the upper left corner of the display, as in Figure 2-2. (If you don't see this icon, press the Display button at the

lower right of the camera's back one or more times until the icon appears.)

Figure 2-2. iA Icon for Intelligent Auto Mode

5. If the iA icon on the screen has a plus sign to its right, that means the camera is in Intelligent Auto Plus mode. You can leave that setting in place, or, if you want to follow these steps exactly, touch the iA icon with your finger, bringing up a screen with the iA icon and the iA+ icon. Then touch the iA icon followed by the Set icon in the lower right corner of the screen, to set the mode to basic Intelligent Auto, rather than Intelligent Auto Plus.

Figure 2-3. L 17M Highlighted for Picture Size

6. Press the Menu/Set button to enter the menu system, and press the Left button to move to the

- list of menu icons at the left of the display. Navigate to the camera icon for the Recording menu, then press the Right button to move the highlight into the menu screen. Navigate to the Picture Size item, press the Right button to move to the list of choices, as shown in Figure 2-3, highlight L 17M, and select it by pressing the Menu/Set button.
- 7. Find the focus switch on the left side of the lens barrel and notice it has three settings, reading from bottom to top: AF, AF macro (with image of flower), and MF. Slide the switch to its uppermost position, selecting AF, for autofocus. With this setting, the camera will do its best to focus the lens to take a sharp picture within the normal (non-macro) focus range, which is from 1.6 feet (50 centimeters) to infinity. (Actually, in Intelligent Auto mode, the camera will use the AF macro setting even when this switch is set to the AF position, but I recommend you use the AF position for the switch, so it will be set there for use with other shooting modes.)
- 8. If you're taking a picture indoors, or it's dark enough that you think you might need the camera's flash, take the supplied flash unit out of its pouch, remove the hot shoe cover from the camera's hot shoe, and slide the flash into the shoe. Turn on the flash, and a flash icon should appear in the upper left corner of the display. (When you're done with the flash, turn it off and press the release lever on its left side to release it before pulling it out of the shoe. Then replace the hot shoe cover.)
- 9. Aim the camera at the subject and look at the screen (or into the viewfinder window) to compose the picture as you want it. Locate the zoom lever on the ring that surrounds the shutter button on the top right of the camera. Push that lever to the left, toward the W, to get a wider-angle shot (including more of the scene in the picture), or to the right, toward the T, to get a telephoto, zoomed-in shot.
- 10. Once the picture looks good on the display, press the shutter button halfway down. You should hear a beep and see a steady (not blinking) green dot in the upper right corner of the screen, indicating that the picture will be in focus. You also may see some green focus frames. (If you hear a series of four quick beeps and see a blinking green dot, that means the picture is not in focus. Try moving to a

- slightly different angle and then test the focus again by pressing the shutter button halfway down.)
- 11. Press the shutter button all the way down to take the picture.

Motion Picture Recording

Once the camera is turned on, press the iA button (if necessary) to set the shooting mode to Intelligent Auto, press the Menu/Set button to enter the menu system, and then press the Left button followed by the Up or Down button, to highlight the Motion Picture menu, symbolized by the icon of a movie camera, as shown in Figure 2-4.

Figure 2-4. Motion Picture Menu Icon Highlighted at Left

Press the Right button to go to the list of menu options. At the top of the screen, highlight Rec Format and press the Right button, giving the choices of AVCHD and MP4, as shown in Figure 2-5. (AVCHD stands for Advanced Video Coding High Definition; it and MP4 are video encoding formats.)

Figure 2-5. Rec Format Menu Options Screen

Highlight MP4 and press the Menu/Set button to select it. Then, on the menu screen, highlight the next option down, Rec Quality, and select FHD/20M/30p, for Full High Definition, the next-to-last option. Then press the Fn3 button to exit the menu system. Be sure the slide switch on the left of the lens barrel is set to AF for autofocus, unless you want to use manual focus. Now compose the shot the way you want it, and when you're ready, press the red button at the top of the camera's back, just above the LCD display.

You don't need to hold the button down; just press and release it. The LCD screen will show a blinking red dot as a recording indicator along with a countdown of recording time remaining, and the camera will keep recording until it runs out of storage space or reaches a recording limit, or until you press the Motion Picture button again to stop the recording.

The LX100 II should do a nice job of changing its focus and exposure automatically as necessary, and you are free to zoom in and out as the movie is recording. (The sound of the zooming mechanism may be audible on the sound track, though, so you may want to keep the zooming to a minimum.)

There are several other options and considerations for motion picture recording, which I will discuss in Chapter 8.

Basic Playback Procedures

Playback of images or videos is activated by pressing the Playback button, located near the top right on the back of the camera, with a triangle icon. When you press that button, if there are pictures or videos on the memory card, you will see whatever image or video was last displayed; the camera remembers which item was most recently viewed even after being turned off and back on.

To move to the next picture or video, press the Right button; to move back one item, use the Left button. You can hold either of those buttons down to move quickly through images and videos. If you prefer, you can move through the items with left or right turns of the control dial or by scrolling the touch screen with your finger. The display on the screen will tell you the number of the picture being displayed. (If it doesn't, press the Display button until it does.) This number will have a three-digit prefix, followed by a dash and then a sequence number.

For example, the card in my camera right now is showing picture number 103-1899; the next one is 103-1900.

To see an index view of multiple pictures, use the zoom lever on the top of the camera. Move it to the left, toward the W, one time, and the display changes to show 12 images in three rows of four, as shown in Figure 2-6.

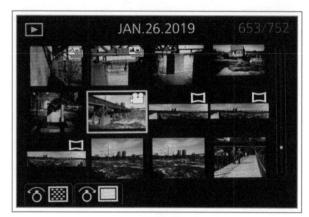

Figure 2-6. Index Screen with 12 Images

Move it to the left one more time, and it shows 30 pictures at a time. Give it one final leftward push and the screen shows a calendar from which you can select a date to view all images taken on that date.

You can also move the zoom lever to the right to retrace your steps through the options for multi-image viewing and back to viewing single images.

For now, move the zoom lever once to the left to see the 12-picture screen. Note that the Right and Left buttons now move through the pictures on this screen one at a time, while the Up and Down buttons move you up and down through the rows. If you move to the last row or the last image, the proper button will move you to the next screen of images. Once you've moved the selector to the image you want to view, press the Menu/Set button, and that image is chosen for individual viewing.

Once you have the single image you want displayed on the screen, you have more options. Press the zoom lever once to the right, toward the T, to zoom the image to twice its normal size, as shown in Figure 2-7. You also can tap twice on the screen to enlarge an image; tap twice again to reduce it to normal size.

Press the lever repeatedly to zoom up to 16 times normal size. Press the zoom lever to the left to reduce the enlargement in the same increments. Or, you can press the Menu/Set button to return the image

Chapter 2: Basic Operations

immediately to normal size. You can pinch and pull on the touch screen with your fingers to change the enlargement of the image, also.

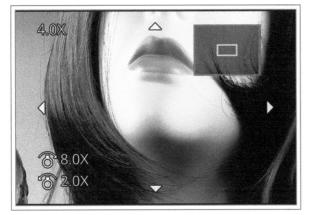

Figure 2-7. Enlarged Image in Playback Mode

While the zoomed picture is displayed, you can scroll it in any direction with the direction buttons or with a finger on the screen. You can review other images at the same zoom level by turning the control dial to navigate to the next or prior image, while the image is still zoomed.

PLAYING MOVIES

To play movies, navigate through the images by the methods described above until you find one that has a movie-camera icon with an upward-pointing triangle at the upper left and a playback triangle icon in the center, as in Figure 2-8. (If you don't see these icons, press the Display button until the screen that shows them appears.)

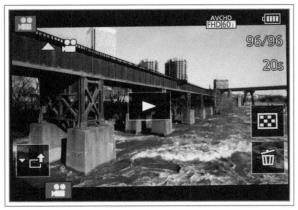

Figure 2-8. Movie Ready to Play in Camera

The upward-pointing triangle icon indicates that you press the Up button to start the movie playing. With the first frame of the motion picture displayed on the screen, press the Up button to start playback. After the movie starts to play, you can use the four direction buttons as a set of DVR controls; the camera will briefly display icons

that show the arrangement of those controls, as seen in Figure 2-9. The Up button is Play/Pause; the Right button is Fast Forward (or frame advance when paused); the Down button is Stop; the Left button is Rewind (or frame reverse when paused).

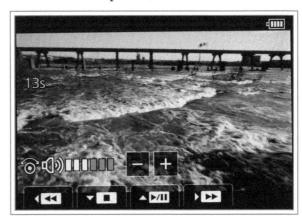

Figure 2-9. Initial Movie Playback Control Icons

You can raise or lower the volume of the audio by turning the control dial to the right or left. You will see a volume display when you activate this control. (This volume control will not appear when the camera is connected to a TV set, because the volume is adjusted by the TV's controls in that situation.)

MP4 movies will import nicely into software such as iMovie for the Macintosh, or into any other Mac or Windows program that can deal with video files with the extension .mp4. You can edit these files on a Windowsbased computer using Windows Movies & TV, Adobe Premiere Elements, or any one of a number of other programs. You also can edit AVCHD videos with most current video editing programs.

To save a frame from a movie as a single image, play the movie close to the frame you want, then press the Up button, which acts as the Play/Pause button in this context. Then press the Left and Right buttons to maneuver to the exact frame you want to save. While you are viewing this frame, press the Menu/Set button to select it, then, when prompted, highlight Yes and press Menu/Set to confirm, and you will have a new still image at the end of the current group of recorded images.

Press the Down button (Stop) to exit motion picture playback mode. Any still image saved from Full HD or HD video will be a JPEG with Quality set to Fine and no larger than 2 MP in size. If you need higher-resolution stills from movie files, save them from 4K videos or use the 4K Photo option, discussed in Chapter 5.

Chapter 3: The Recording Modes

Choosing a Recording Mode

Thenever you set out to capture still images or videos, an important first step is to select a recording mode, sometimes called a shooting mode. This "mode" is a general setting that controls the camera's behavior for adjusting exposure. As with most advanced cameras, the LX100 II provides a standard set of modes: Intelligent Auto, Program AE (also known

as Program), Aperture Priority, Shutter Priority, and Manual exposure. These last four are often known as the PASM modes, for the first letter of each mode.

The major distinguishing factors for the various modes are the degree of automation the camera uses for evaluating exposure and the settings that you, the user, make as opposed to those that the camera makes automatically. Table 3-1 gives a brief introduction to the modes and when you might want to choose each one.

Table 3-1. Recording Modes of the Panasonic Lumix LX100 II Camera

Mode	Exposure Setting(s) by Camera	Exposure Setting(s) by User	Situations for Using	How to Set
Intelligent Auto	Shutter Speed, Aperture	None	Quick shots without time to change settings	Press iA Button on top of camera
Program	Shutter Speed, Aperture	None	General shots when you want to control many settings	Set shutter speed dial and aperture ring to red A marks
Aperture Priority	Shutter Speed	Aperture	Blurred background to reduce distractions or large depth of field to keep various subjects in focus	Set shutter speed dial to the red A mark and set aperture ring to desired value
Shutter Priority	Aperture	Shutter Speed	For fast shutter speed to stop action or a slow shutter speed to blur action	Set aperture ring to the red A mark and set shutte speed dial to desired value
Manual Exposure	None	Shutter Speed, Aperture	To control motion blur and depth of field or for unusual exposure effects	Set aperture ring and shutter speed dial to desired values

Some cameras have a mode dial with an array of options labeled P, A, S, M, and the like for selecting recording modes, but the LX100 II uses a different approach. As you can see from Table 3-1, to select one of the advanced recording modes (Program, Aperture Priority, Shutter Priority, or Manual exposure), you set the shutter speed dial and aperture ring to different positions. To select Intelligent Auto mode, you simply press the iA button on top of the camera. When you do

that, the automatic mode will take effect, regardless of the settings of the shutter speed dial and aperture ring. When you have finished using Intelligent Auto mode, press the iA button again, and the mode that was previously active will take effect again.

With that introduction to the recording modes, I will provide more detailed explanations of the modes in this chapter. First, though, I will include a brief reminder

of the preliminary steps to take before shooting still images, no matter what recording mode you use. The steps don't have to be taken in this exact order, but this sequence is a useful one to remember in general terms.

Preliminary Steps Before Shooting Pictures

- 1. Check to be sure you have selected the aspect ratio you want—3:2, 16:9, 1:1, or 4:3—with the slide switch on top of the lens barrel. I generally use 3:2 or 4:3 for everyday shooting, but you may prefer one of the others. If you intend to use software to edit and tweak your photos later, you can always change the aspect ratio then.
- Check to be sure you have selected the focus method you want: AF for autofocus, AF macro for autofocus with close-ups, or MF for manual focus. Use the sliding focus switch on the left side of the lens barrel.
- 3. Remove the lens cap (unless you are using the automatic lens cap, discussed in Appendix A).
- 4. Turn on the camera.

Now you're ready to select a recording mode. I'll discuss them all below.

Intelligent Auto Mode

This is a good mode to use when you don't want to take time to adjust several controls or menu options. To make this setting, you don't have to worry about the position of the shutter speed dial or the aperture ring. Just press the iA button, located on top of the camera directly behind the shutter button. (You may have to hold the button down for a second or two, depending on the iA Button Switch setting on screen 3 of the Custom menu.) The camera will now be set to Intelligent Auto mode. You will see the iA icon in the upper left corner of the display, as shown in Figure 3-1. (You may instead see the iA+ icon for Intelligent Auto Plus mode, or an icon showing what sort of scene the camera detected, such as portrait, closeup, infant, etc., as discussed later in this section.)

In this mode, the camera limits the settings you can make, in order to simplify things. For example, you cannot fully adjust items such as white balance, ISO, Photo Style, Metering Mode, Filter Settings, Autofocus mode (setting the area for autofocus) and several others. In addition, as I discussed in Chapter 2, even if you select AF with the autofocus switch, the camera sets the focus mode to AF Macro. You can select the MF position for manual focus, though.

Figure 3-1. iA Icon on Shooting Screen

The camera turns on several settings, including Auto White Balance, scene detection, image stabilization, Quick AF, backlight compensation, Intelligent ISO, Intelligent Resolution, and Intelligent Dynamic, all of which are useful settings that will not unduly limit your options in most cases. I'll discuss all of those items in Chapter 4 in connection with Recording menu settings, except for scene detection and backlight compensation, which I will discuss here, because they are not menu options; the camera uses them automatically in the Intelligent Auto shooting mode.

With scene detection, the camera attempts to figure out if a particular scene type should be used for the current situation. The camera uses its programming to try to detect certain subjects or environments. For example, it looks for people; babies (if you have registered them using the Face Recognition menu option); night scenes; close-ups; sunsets; food; and portraits. It will identify scenes calling for the iHandheld Night Shot setting if that option is turned on through the menu system, as discussed later in this chapter. If the camera detects one of these factors, it displays an icon for that type of scene and adjusts its settings accordingly.

For example, in Figure 3-2, the camera detected a human face and displayed the icon for portrait scene detection in the upper left corner of the display.

Figure 3-2. Scene Detection Icon for Portrait

With backlight compensation, the camera will try to detect situations in which the subject of the photograph is lighted from behind. This sort of lighting can "fool" the camera's metering system into making the exposure too dark, because of the light shining toward the lens. With this setting, the camera automatically adjusts its exposure to be brighter, to overcome the effects of the backlighting.

Even though the LX100 II makes various automatic settings in Intelligent Auto mode, there are still several options that you can adjust using the menu system and, to some extent, the physical control buttons.

OPTIONS ON SPECIAL MENU FOR INTELLIGENT AUTO MODE

First, you can use the special menu for Intelligent Auto mode to turn on two settings that can improve your photographs in challenging lighting conditions. As shown in Figure 3-3, when the camera is in Intelligent Auto or Intelligent Auto Plus mode, the top icon in the column of menu system icons is the iA (or iA+) icon.

If you highlight that icon and press the Right button, the yellow selection bar will be in the single screen for these special menu options. There are three choices: Intelligent Auto Mode, iHandheld Night Shot, and iHDR, as seen in Figure 3-3. The first option lets you choose the basic Intelligent Auto mode or Intelligent Auto Plus mode, which is discussed later in this chapter.

The iHandheld Night Shot option is designed to minimize the motion blur that can result from taking a handheld shot at the slow shutter speed that is likely to be needed to get a sufficient exposure in low light. When iHandheld Night Shot is turned on, if the camera detects darkness and senses that it is handheld, the camera will raise its ISO setting in order to permit the use of a faster than normal shutter speed. Also, because using a higher ISO can increase the visual "noise" or grainy look in an image, the camera will take a burst of several shots and combine them internally into a final image. By blending the contents of several images together, the camera can reduce the noise in the final, composite result. This setting is a useful one to activate when shooting in low-light conditions without flash or a tripod.

Figure 3-3. Intelligent Auto Mode Menu Icon Highlighted

You cannot decide when to capture an image with this feature yourself—all you can do is turn it on and see if the camera determines that conditions call for it to be used.

The other choice on this special menu screen, iHDR, also will be activated only when the camera determines that its use is called for. If the iHDR option is turned on through the menu, it is triggered when the camera detects a scene with strong contrast between the dark and light areas. When the camera makes that determination, the LX100 II will take a burst of shots and combine them internally to create a final result. In this situation, the camera will place on the screen a message saying HDR Shutters 3 to let you know that the shutter will fire three times. You should try to hold the camera steady while it takes the burst of shots.

I will discuss high dynamic range, or HDR photography, further in Chapter 4. Essentially, with HDR, the camera combines the most normally exposed parts of multiple images in order to achieve a final result that appears to be properly exposed throughout most or all of its

various areas. This setting can be useful when you are taking photographs in highly contrasty conditions.

OPTIONS ON RECORDING MENU

Second, in Intelligent Auto mode you can use the Recording menu (designated in the menu system by the camera icon) to select certain settings, although the choices are sharply limited compared to the many options that are available in other shooting modes. In those other modes (including Intelligent Auto Plus), there are four screens of options available on the Recording menu; in basic Intelligent Auto mode, there is only a single screen of options. I will discuss those options in Chapter 4.

Third, when the shooting screen is displayed, you can use the focus switch, located on the left side of the lens barrel, to select either AF or AF macro for autofocus, or MF for manual focus. I will discuss those settings in Chapter 5.

Fourth, you can press the Down button from the shooting screen to call up the drive mode menu. In Intelligent Auto mode, you can select burst shooting, 4K Photo, Post Focus, or the self-timer from the drive mode menu. I will provide further information in Chapter 5.

You also can use other controls for their intended purposes in this mode, such as the function buttons to get access to their assigned settings and the Q.Menu button to get access to the Quick Menu. You can attach the flash unit and turn it on, but the camera will decide whether to use it; there are no flash mode settings you can make in this shooting mode. (In Intelligent Auto Plus mode, you can turn the flash on or off from the menu, but that is the only setting available.) I will discuss various options for the use of physical controls in Chapter 5.

In summary, although the Intelligent Auto shooting mode lets the camera make most of the technical decisions, you still can have a fair amount of involvement in making settings for photographs (and movies). Especially when you're just starting out to use the LX100 II, the basic Intelligent Auto mode provides a good start for exploring the camera's features. The automation in this mode is sophisticated and will often produce excellent results; the drawback is that you don't have as much creative control as you might like. But for ordinary picture-taking opportunities, vacation

photos, and quick shots when you don't have much time to decide on particular settings, Intelligent Auto is a useful tool to have at your fingertips.

Intelligent Auto Plus Mode

There is another important setting available when the LX100 II is set to the Intelligent Auto mode. That setting lets you choose between two different varieties of Intelligent Auto mode: basic Intelligent Auto and Intelligent Auto Plus. In this chapter, I have been discussing the use of basic Intelligent Auto mode, in which the camera controls most settings and leaves few menu options that you can change. If you choose Intelligent Auto Plus instead, the camera opens up numerous other options for adjustment.

To make this setting, with the camera set to Intelligent Auto mode, press the Menu/Set button, then press the Left button to highlight the column of menu icons at the far left. Using the Up and Down buttons, navigate to and highlight the iA icon at the top of the column, as seen earlier in Figure 3-3. Press the Right button to move the yellow highlight bar into the screen with three menu options. Highlight the Intelligent Auto Mode option at the top, and press the Menu/Set button to select it. The camera will display a small menu with choices of the iA icon or the iA+ icon, as shown in Figure 3-4. Highlight the iA+ icon and select it, then press the Fn3 button or press the shutter button halfway to return to the shooting screen. You should now see the iA+ icon in the top left corner of the screen. (You may instead see an icon showing what kind of scene the camera has detected, such as macro or portrait.)

Figure 3-4. Intelligent Auto Mode Menu Options Screen

For a quicker way to switch between Intelligent Auto and Intelligent Auto Plus modes, if the touch screen is turned on, touch the iA or iA+ icon in the upper left corner of the display, and the camera will display a screen for selecting one of those two modes. On that screen, touch the icon for the mode you want and then touch the Set icon in the lower right corner of the display to confirm the setting.

In Intelligent Auto Plus mode, three differences from standard Intelligent Auto mode are that you can adjust brightness, use the defocus control option, and adjust color tone. To adjust brightness, turn the exposure compensation dial on the top right of the camera, and you will see a screen with an exposure compensation scale at the bottom, as shown in Figure 3-5.

Figure 3-5. Exposure Compensation Scale

Turn the dial to the right or left to change the exposure value (EV) of the scene by up to three units in either direction to compensate for a subject that may be too dark or too light otherwise. In this mode, you also can assign exposure compensation to one of the function buttons. I will discuss exposure compensation further in Chapter 5, where I discuss the physical controls.

Another feature that is available in Intelligent Auto Plus mode is defocus control. That option lets you set a wider aperture, which may result in a pleasantly blurred background. As I will discuss later in this chapter, in Aperture Priority mode you can control the aperture setting more directly. The wider the aperture (the lower the aperture number, such as f/1.7), the more likely it is that the background will be blurred, while the foreground remains sharp.

In Intelligent Auto Plus mode, the camera selects the aperture initially, based on its automatic exposure

reading. However, when you activate defocus control, you can change that setting. To do this, press the Fn3 button. The camera will display graphic strips with numeric values, as shown in Figure 3-6.

Figure 3-6. Defocus Control Display

The top line of values shows the shutter speed, and the bottom one shows the aperture. If you turn the control dial or press the Left and Right buttons (or touch the scale with your finger), these settings will change. The lower the aperture number you can set, the better the chance there will be of having a blurred background.

When defocus control is in use, the camera sets the autofocus mode to 1-Area, which is discussed in Chapter 5. With that setting, the camera uses a single autofocus frame, which you can move around the screen with your finger.

In addition, when the camera is in Intelligent Auto Plus mode, if you press the Right button, the camera will display a screen for adjusting color tone, as shown in Figure 3-7.

Figure 3-7. Color Tone Adjustment Screen

Turn the control dial to the right or press the Right button to change colors to the bluish, or "cooler" side; an adjustment to the left will turn colors to the reddish, or "warmer" side. You also can use the touch screen for adjustments. If any adjustment is made, a small color block will appear in the lower right corner of the shooting screen after the adjustment scale is dismissed.

You also can activate defocus control and color control using the iA+ touch icon at the right of the display, as shown in Figure 3-5. After you touch that icon, the camera will display icons for adjusting defocus control and color tone. In addition, if exposure compensation has been assigned to a function button, the camera will display an icon for adjusting exposure compensation as well. (If that assignment has not been made, exposure compensation will be controlled only by the exposure compensation dial on top of the camera.)

Also, in Intelligent Auto Plus mode, the camera lets you choose more options from the Recording, Motion Picture, and Custom menus than in Intelligent Auto mode. For example, you can select Quality, Photo Style, Color Space, Stabilizer, and Shutter Type from the Recording menu. You can select Continuous AF, Photo Style, and others from the Motion Picture menu, as well as Half Press Release, Focus/Release Priority, MF Assist, and others from the Custom menu.

There still are some important settings you cannot make in Intelligent Auto Plus mode, such as ISO (Sensitivity), Metering Mode, Highlight Shadow, i.Dynamic, HDR, and Multiple Exposure. For those settings, you need to select an advanced shooting mode such as Program, Aperture Priority, Shutter Priority, or Manual. However, you may sometimes want to select Intelligent Auto Plus mode so you can make some settings that are unavailable in Intelligent Auto mode, while still getting the benefit of the camera's automation.

In Intelligent Auto Plus mode, as in basic Intelligent Auto mode, you can attach and turn on the camera's built-in flash unit, but you have no control over the flash mode the camera uses. However, in this mode, unlike the basic Intelligent Auto mode, you do have the ability to turn the flash on or off from the menu.

Figure 3-8 is an image I took using Intelligent Auto mode for a quick shot of the waterfront area at the James River in downtown Richmond, Virginia.

Figure 3-8. Intelligent Auto Mode Example

Program Mode

To set the camera to Program mode, the most automatic of the advanced (PASM) recording modes, set both the shutter speed dial and the aperture ring to their automatic settings, by moving the red A so it is lined up next to the indicator dot, as seen in Figure 3-9.

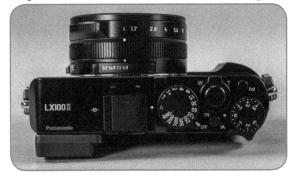

Figure 3-9. Aperture Ring and Shutter Speed Dial Set for P Mode

The camera will then display a P icon in the upper left corner of the display, as shown in Figure 3-10, to indicate the shooting mode. (If the iA icon is displayed, press the iA button on top of the camera to remove it.)

Figure 3-10. P Icon for Program Mode on Display

When you aim the camera at your subject, the exposure metering system will evaluate the light and choose both the shutter speed and aperture, which will be displayed in the lower left corner of the display when you press the shutter button halfway, as shown in Figure 3-10.

If these two values flash red, that means the camera is unable to find settings that will yield a proper exposure. In that case, you may need to adjust the ISO setting or change the lighting conditions by using flash or taking other appropriate steps.

If you want to alter the camera's settings by selecting a different shutter speed or aperture while keeping the same overall exposure, you can do that (if conditions permit) by using the feature known as Program Shift. After you press the shutter button halfway to evaluate exposure, you can turn the control dial (on back of the camera) within the next 10 seconds, and the camera will try to select another combination of shutter speed and aperture settings that will result in a normal exposure.

For example, if the camera initially selects settings of f/4.5 and 1/125 second, when you turn the control dial, the camera may change the settings to f/5.0 and 1/100 second, or f/5.6 and 1/80 second. If you turn the dial in the other direction, it may change the settings to f/4.0 and 1/160 second, or f/3.5 and 1/200 second.

Program Shift can be useful if you want to have the camera make the initial choice of settings, but you want to tweak them to use a slightly higher shutter speed to stop action, or a wider aperture to blur the background, for example. When Program Shift is in effect, the camera displays the P icon with a double-ended arrow, as shown in Figure 3-11.

In addition, if the Exposure Meter option is turned on through screen 5 of the Custom menu, the camera will show the shutter speed and aperture settings in two moving strips. Program Shift is not available when ISO is set to Intelligent ISO, when recording motion pictures, or when using the 4K Photo or Post Focus features.

With Program mode, as with Intelligent Auto mode, the camera will select both the shutter speed and the aperture. However, unlike Intelligent Auto mode, with Program mode you can control many settings besides shutter speed and aperture. You don't have to make a lot of decisions if you don't want to, however, because the camera will make reasonable choices for you as defaults.

Figure 3-11. Icon for Program Shift on Display

Program mode greatly expands the choices available through the Recording menu and control buttons. You will be able to make choices involving white balance, image stabilization, ISO sensitivity, metering method, autofocus area, and others. I won't discuss all of those choices here; to explore that topic, see the discussion of the Recording menu in Chapter 4 and the discussion of settings made with the Up, Down, Left, and Right buttons in Chapter 5.

Besides unlocking many options in the Recording menu, choosing Program mode provides you with access to settings in the Custom menu that are not available in Intelligent Auto Mode, such as various focus-related settings, activating the histogram, and options for changing how the camera's display operates. I will discuss those options in Chapter 7. Program mode also enables the use of the panorama shooting option in drive mode, as discussed in Chapter 5.

Using Program mode does involve some tradeoffs. The most obvious issue is that you don't have complete control over the camera's settings. You can choose many options, such as Photo Style, Quality, Picture Size, and ISO, but you can't directly control the aperture or shutter speed, which are set according to the camera's programming. You can exercise a good deal of control through exposure bracketing and exposure compensation (discussed in Chapters 4 and 5) and Program Shift (discussed above), but that's not quite the same as selecting a particular aperture or shutter speed at the outset. If you want that degree of control, you'll need to select Aperture Priority, Shutter Priority, or Manual exposure for your recording mode.

Figure 3-12 is an image I took using Program mode for street photography on a pedestrian bridge over the

river. It was convenient to use this mode and turn on burst shooting, so I could capture several shots and choose the best one later.

Figure 3-12. Program Mode Example

Aperture Priority Mode

This mode is similar to Program mode in the functions available for you to control, but, as the name implies, it also gives you more control over the camera's aperture. In this mode, you select the aperture setting and the camera will select a shutter speed that will result in normal exposure, if possible. The camera will choose a shutter speed anywhere from 60 seconds to 1/4000 second. (The range is 1 second to 1/16000 second when the electronic shutter is in use; that feature is discussed in Chapter 4.) If none of these values results in a normal exposure, both the shutter speed and aperture values will turn red and flash. In that case, you may need to adjust the aperture or ISO setting or change the lighting conditions.

The main reason to choose this mode is so you can select an aperture to achieve a broad depth of field, with objects in focus at different distances from the lens, or a shallow depth of field, with only one subject in sharp focus and other parts of the image blurred to reduce distractions. With a narrow aperture (higher f-stop number) such as f/11.0, the depth of field will be relatively broad; with a wide aperture such as f/1.7, it will be shallow, resulting in the possibility of a blurred background.

In Figure 3-13 and Figure 3-14, I made the same shot with two different aperture settings. I focused on the owl figurine in the foreground in each case.

For Figure 3-13, I set the aperture of the LX100 II to f/1.7, the widest possible. With this setting, because the depth of field at this aperture was shallow, the trees in the background are blurry. I took Figure 3-14 with the camera's aperture set to f/16.0, the narrowest possible setting, resulting in a broader depth of field, and bringing the background into sharper focus.

Figure 3-13. Aperture Set to f/1.7

Figure 3-14. Aperture Set to f/16.0

These two photos show the effects of varying the aperture by setting it wide (low numbers) to blur the background or narrow (high numbers) to achieve a broad depth of field and keep subjects at varying distances in sharp focus. However, you should avoid using the narrowest aperture settings, such as f/16.0 and f/11.0, when it is important to show the clearest details in your image. At these highest aperture settings, the diffraction effect comes into play and reduces the level of detail to some extent. If you can use f/5.6, you are likely to achieve the greatest level of sharpness and detail, if other factors are equal. But, if you need to use a narrow aperture setting because of bright lighting conditions or because you need to use a slow shutter

speed to blur the appearance of a waterfall, for example, you should not hesitate to make that setting.

To use Aperture Priority mode, turn the aperture ring until the chosen value is at the indicator dot and turn the shutter speed dial to its A setting, as shown in Figure 3-15.

Figure 3-15. Aperture Ring and Shutter Speed Dial set for Aperture Priority Mode

One of the nice features of the LX100 II is having a physical ring to set the aperture. As you turn the ring, it clicks into place for each f-stop, in one-third stop increments, and you can see the full-stop settings on the ring. If you have turned on the Exposure Meter option on screen 5 of the Custom menu, you can see the aperture (and shutter speed) in a graphic display on the camera's screen, as you turn the ring.

Even without the graphic display, the number of the f-stop will appear in the lower left corner of the screen as shown in Figure 3-16, where the value is f/5.6.

The shutter speed will be displayed also, but not until you have pressed the shutter button halfway down to let the camera evaluate the exposure.

Figure 3-16. Shooting Screen in Aperture Priority Mode

Here is an important note about Aperture Priority mode that might not be immediately obvious: Not all apertures are available at all times. In particular, the widest-open aperture, f/1.7, is available only when the lens is zoomed out to its wide-angle setting (moved toward the W indicator). At higher zoom levels, the widest aperture available changes steadily, until, when the lens is fully zoomed in to the 75mm level, the widest aperture available is f/2.8.

To see an illustration of this point, here is a quick test. Zoom the lens out by moving the zoom lever all the way to the left, toward the W. Then select Aperture Priority mode and set the aperture to f/1.7 by turning the aperture ring all the way to the 1.7 setting. Now zoom the lens in by moving the zoom lever to the right, toward the T. After the zoom is complete, you will see that the aperture has changed to f/2.8, because that is the widest the aperture can be at the maximum zoom level. (The aperture will change back to f/1.7 if you move the zoom back to the wide-angle setting; so you need to check your aperture after zooming out as well as after zooming in, to make sure you will not be surprised by an unexpected aperture setting.)

Finally, you should note that, when the aperture is wider than f/4.0, the camera cannot set a shutter speed faster than 1/2000 second using the mechanical shutter.

Shutter Priority Mode

The next shooting mode is a complement to Aperture Priority mode. In Shutter Priority mode, you choose the shutter speed, and the camera will set the corresponding aperture in order to achieve a proper exposure of the image. In this mode, you can set the shutter for a variety of intervals ranging from 60 full seconds to 1/4000 of a second when using the mechanical shutter. However, if the aperture is wider than f/4.0 (such as f/1.7 or f/3.0), the camera cannot use a shutter speed faster than 1/2000 second with the mechanical shutter. In that case you would have to use the electronic shutter to set a faster shutter speed. I discuss the use of the mechanical and electronic shutter types in Chapter 4.

With the electronic shutter, the range is from 1 second to 1/16000 second. (The available shutter speed settings are different for motion pictures.) The camera will pick an aperture from its full range of f/1.7 to

f/16.0, unless the lens is zoomed in. In that case, as discussed in connection with Aperture Priority mode, the widest aperture available is f/2.8.

If the camera cannot set an aperture to result in a normal exposure, the shutter speed and aperture values will flash red. If you are photographing fast action, such as a baseball swing or a hurdles event at a track meet, and you want to stop the action with a minimum of blur, you should select a fast shutter speed, such as 1/1000 of a second. You can use a slow shutter speed, such as 1/8 second or slower, to cause motion blur for effect, such as to smooth out the appearance of flowing water.

Figure 3-17. Shutter Speed Set to 1/1000 Second

Figure 3-18. Shutter Speed Set to 1/30 Second

In Figures 3-17 and 3-18 I photographed the same action using different shutter speeds to illustrate the different effects. In both cases, I dropped a group of colorful wooden beads into a transparent pitcher. In

Figure 3-17, using a shutter speed of 1/1000 second, the camera froze the beads in mid-air, letting you see each one individually. In Figure 3-18, using a shutter speed of 1/30 second, the beads appear to form long streams of color that blend together, because that shutter speed was not fast enough to stop their action.

To use Shutter Priority mode, turn the aperture ring to its red A setting and select the shutter speed by turning the shutter speed dial, as shown in Figure 3-19.

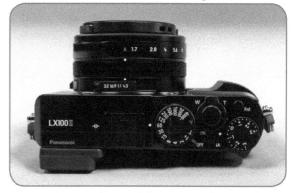

Figure 3-19. Aperture Ring and Shutter Speed Dial Set for Shutter Priority Mode

It is easy to select any of the speeds printed on the dial; just turn the dial to a setting, such as 4000 for 1/4000 second, 60 for 1/60 second, or 2 for 1/2 second. For the values in between or beyond the printed ones, you need to use the control ring or the control dial.

For example, to set a speed of 1/10000 second, turn the shutter speed dial to the 4000 setting, then turn the control ring (or control dial) until the 10000 value appears at the bottom of the display and on the graphic exposure dial, if the Exposure Meter option has been turned on. (Values faster than 1/4000 second are available only if the Shutter Type option on screen 4 of the Recording menu is set to Auto or Electronic, shown as ESHTR on the menu.) To set a value of 1/25 second, turn the dial to the 30 setting, then turn the control ring or dial to select 1/25 second. For a value of 15 seconds, turn the dial to the 1+ setting, then turn the control ring or dial until the 15" setting appears.

On the shutter speed display, be sure to distinguish between the fractions of a second and the times that are one second or longer. The longer times are displayed with what looks like double quotation marks to the right.

One aspect of the camera's display that can be confusing is that some times are a combination of fractions and decimals, such as 1/2.5 and 1/3.2. I find these numbers

hard to translate mentally into a time I can understand. Table 3-2, below, translates these numbers into a more understandable form:

Table 3-2. SI	nutter Speed	Equivalents
---------------	--------------	--------------------

3.2	1/3.2 = 0.31 or $5/16$ second
2.5	1/2.5 = 0.4 = 2/5 second
1.6	1/1.6 = 0.625 = 5/8 second
1.3	1/1.3 = 0.77 = 10/13 second (0.8 sec)

When Shutter Priority mode is in effect, you cannot use the Intelligent ISO setting. If it was set, the camera will reset it to Auto ISO.

Manual Exposure Mode

The LX100 II has a manual mode for control of exposure, which helps you exert full creative control over exposure decisions. For example, there may be times when you want to purposely underexpose or overexpose an image to convey a particular feeling or to produce a special effect, such as a silhouette. Or, there may be a tricky situation in which your most important subject is deeply shadowed and you prefer to use manual settings for aperture and shutter speed rather than relying on exposure compensation in order to expose the subject properly.

I also find Manual exposure mode to be useful when taking individual shots to be combined in software to create HDR (high dynamic range) composite images. The HDR technique, which I will discuss further in Chapter 4, often is used when the scene is partly in darkness and partly in bright light. To even out the contrast, you can take a series of shots, some considerably underexposed and others overexposed. You then combine these shots in special software that blends differently exposed portions from several shots, resulting in a composite image that is well exposed through a wide range of lighting values.

The technique for using Manual exposure mode is not far removed from what I discussed in connection with the Aperture Priority and Shutter Priority modes. To control exposure manually, set the shutter speed dial to your chosen value and set the aperture ring to a particular aperture, as shown in Figure 3-20.

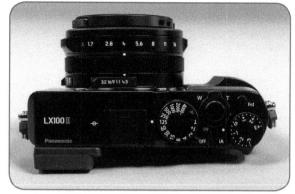

Figure 3-20. Aperture Ring and Shutter Speed Dial Set for Manual

The camera will not change either of these settings. The camera will display the letter M on a red icon to indicate Manual exposure mode, as seen in Figure 3-21.

You also will see a small exposure scale at the bottom center of the screen, ranging from -3 EV to +3 EV. As you change the exposure settings, the camera will display tick marks below the scale if the exposure as metered is too bright or too dark. For example, in Figure 3-21, there are tick marks to the right of zero, indicating that the exposure as metered is too bright.

Figure 3-21. Shooting Screen in Manual Mode

If no tick marks appear, that means the exposure is normal according to the camera's metering system. If the exposure gets too far out of the normal range in either direction, the shutter speed and aperture values will flash red when you press the shutter button halfway to evaluate exposure and focus. Of course, you do not have to be concerned with the indication on this exposure meter, because you can make any settings you want; you may want a darker-than-normal image to create a silhouette, for example. But the EV (exposure value) scale is useful to help you decide what settings to make.

You also should note that the camera's display will not show the effects of your settings unless you set it to do so. That is, with normal menu options, even if you set the aperture and shutter speed to values that would produce a very dark image, the image on the display will appear basically normal, provided there is sufficient ambient light to produce a normal view. If you want to see the effects of your exposure settings, go to screen 4 of the Custom menu and turn on the Constant Preview option. Then the display will become darker or brighter as the settings change. (This feature works only with Manual exposure mode, not with Aperture Priority, Shutter Priority, or Program.)

An important feature of Manual mode is that you can set ISO to Auto ISO. If you do that, then, even though the camera cannot change the aperture or the shutter speed you have set, it can vary the ISO setting within the range permitted by the ISO Auto Upper Limit (Photo) option (discussed in Chapter 4). Therefore, the camera may be able to achieve a normal exposure by setting the ISO to an appropriate level. This is a powerful feature, which amounts in effect to giving you a new recording mode, which might be called "Aperture and Shutter Priority" mode.

For example, you might use Manual exposure mode with Auto ISO when you are taking pictures of a person working with tools in a dimly lighted workshop. You might need to use a narrow aperture such as f/8.0 in order to keep the work in focus, and a fairly fast shutter speed such as 1/250 second to avoid motion blur. You can make both of those settings and be assured that they will not vary. The camera will automatically adjust the ISO setting to achieve the best exposure possible, given the lighting conditions.

You can use exposure compensation in Manual mode by adjusting the exposure compensation dial or another control that has been assigned to that function (either a function button or the control ring, as discussed in Chapter 5.) However, in this shooting mode, ISO must be set to Auto ISO for exposure compensation to work.

In other situations, such as when you purposely want to underexpose or overexpose an image, just set ISO to a specific numerical value and adjust the shutter speed and aperture to achieve the exposure you need. You cannot use Intelligent ISO in Manual exposure mode.

Another distinguishing feature of Manual exposure mode is that it gives you an additional option for setting the shutter speed. With Shutter Priority mode, you can set the shutter speed anywhere from 60 seconds to 1/4000 second (when using the mechanical shutter). With Manual mode, you have the additional option of setting the shutter speed dial to the T setting, for time exposure. Then, when you press the shutter button, the shutter opens up and does not close again to end the exposure until you press it again, up to a limit of about 30 minutes.

You can use this feature to take extra-long exposures of trails of cars' headlights, for fireworks, or to turn night scenes into unusual daylight vistas. Of course, it is advisable to use a solid tripod and to trigger the camera remotely when taking an exposure of this length. The time exposure feature is not available if you are using the electronic shutter, which is discussed in Chapter 4. If you use the T setting in Shutter Priority mode, the camera will set the shutter speed to 60 seconds.

In addition, if you use a smartphone or tablet as a remote control with a Bluetooth connection, as discussed in Chapter 9, the shutter speed can be set to Bulb, which means that the shutter stays open when the shutter button is activated, and does not close until the button is released. (With the T setting, you have to fully press the shutter button to start the exposure, and then fully press it again to end the exposure.)

As noted earlier, in other shooting modes the camera cannot set the aperture to f/1.7 and other low values when the lens is fully zoomed in. The same situation is true with Manual exposure mode; you cannot set the wide-open aperture of f/1.7 when the lens is zoomed all the way in to the 75mm setting. Also, as with other modes, the camera cannot set a shutter speed faster than 1/2000 second using the mechanical shutter when the aperture is wider than f/4.0.

Chapter 4: The Recording Menu and the Quick Menu

uch of the power of the LX100 II lies in the options provided in the Recording menu, which gives you control over the appearance of images and how they are captured. This menu is not the only source of creative tools for this camera; there are several important settings that can be controlled with physical buttons and dials, as I will discuss in Chapter 5, and there also is the convenient Quick Menu, which gives you ready access to several oftenused options. I will discuss both the Recording menu and the Quick Menu in this chapter.

The Recording Menu

As I have discussed earlier, the main menu system of the LX100 II incudes six major menus: Recording, Motion Picture, Custom, Setup, My Menu, and Playback. I will discuss the Playback menu in Chapter 6, the Custom, Setup, and My Menu menus in Chapter 7, and the Motion Picture menu in Chapter 8. In addition, the camera includes a special menu whose icon appears at the top of the line of menu icons only when the camera is set to the Intelligent Auto or Intelligent Auto Plus mode, as discussed in Chapter 3.

When you press the Menu/Set button, you will initially see the main menu screen, which looks generally like the screen shown in Figure 4-1 in one of the advanced shooting modes, such as Program. The actual screen that is displayed depends on the current shooting mode. In Figure 4-1, screen 3 of the Setup menu is active, with the camera set to Program mode.

If, as in this example, the Recording menu screen is not displayed, press the Left button. That action will move the highlight into the left column of the menu screen, as shown in Figure 4-2, where you can navigate up and down with the direction buttons, the control dial, or

the touch screen, to highlight the icons for the various menu systems.

Figure 4-1. Screen 3 of Setup Menu

Figure 4-2. Menu Icons Highlighted at Left

If the camera is currently displaying a screen from the Custom menu, as shown in Figure 4-3, the column of icons for the main systems is not shown at the left of the screen. Instead, there is a column of icons for the five subdivisions of the Custom menu: Exposure, Focus/Release Shutter, Operation, Monitor/Display, and Lens/Others. In that case, you have to press the Left button once to get to that column of subdivisions,

and then once more to reach the line of icons for the main menu systems.

Figure 4-3. Screen 2 of Custom Menu

Once the highlight is in the column with the icons for the main menu systems, use the Up and Down buttons to highlight the red camera icon at the top of the line of icons, indicating the Recording menu, as shown in Figure 4-4. (I'm assuming the camera is in an advanced shooting mode such as Program; in Intelligent Auto or Intelligent Auto Plus mode, a special icon for that menu system will be the top icon, just above the camera icon for the Recording menu.)

Figure 4-4. Icon for Recording Menu Highlighted at Left

Then press the Right button to move back over to the main part of the screen, with the Recording menu items. The yellow selection rectangle will highlight a menu item, as shown in Figure 4-5. You can then navigate through the Recording menu to find the item you want to adjust.

As I discussed earlier, the menu options will change depending on the recording mode in effect. If you're using the basic Intelligent Auto mode, the Recording menu is limited to one screen, because that mode is for a user who wants the camera to make most of the decisions without input. For the following discussion, I'm assuming you have the camera set to one of the advanced (PASM) modes, because in those modes all four screens of the menu are available.

Figure 4-5. Menu Item Highlighted by Yellow Rectangle

On the menu screens you will see a fairly long list of options, each occupying one line, with its name on the left and its current setting on the right. (In some cases, the current setting is not shown because it involves multiple options.) You have to scroll through four screens to see all of the items.

You can scroll through the items on any screen using the Up and Down buttons or by turning the control dial. If you find it tedious to scroll using those methods, you can use the zoom lever to speed through the menus one full screen at a time, in either direction. Or, you can use the touch screen capability, by touching a desired menu option, or by touching the scroll bars at the far right of the menu screen. You can tell which numbered screen you are on by checking the numbers at the right of the screen, which show the screen numbers as 1/4, 2/4, through 4/4.

Depending on the location of a particular menu option, you may be able to reach that option more quickly by reversing direction with the direction buttons and wrapping around to reach the option you want. For example, if you're on the top line of screen 1 of the menu, at Picture Size, you can scroll up to reach the bottom option on screen 4 of the menu, Multiple Exposure.

Whenever a menu option is highlighted by the selection bar, you can press the Display button to bring up a brief explanation of the item's purpose. For example, Figure 4-6 shows the screen that was displayed when I pressed the Display button with the Minimum Shutter Speed option highlighted on screen 2 of the Recording menu. Press the Display button again to dismiss the window. In some cases, you also can press Display to see an explanation when a sub-option is highlighted. For example, if you highlight the Raw setting for Quality and press Display, the camera will pop up a brief explanation of that setting.

Figure 4-6. Help Screen from Pressing Display Button

Some menu lines may have a dimmed, "grayed-out" appearance at times, meaning they cannot be selected under the present settings. For example, in Figure 4-7, two items are dimmed on screen 3 of the Recording menu.

Figure 4-7. Menu Screen with Two Items Dimmed

In this case, Quality is set to Raw and the recording mode is Program. With Quality set to Raw, you cannot select Intelligent Zoom or Digital Zoom. If you are in doubt as to why an item cannot be selected, navigate to it with the selection bar, which will be dimmed itself, and press the Menu/Set button. In many such cases, you will see a message explaining why the item could not be selected.

Because you cannot make some selections when Quality is set to Raw, if you want to follow along with the discussion of the options on the Recording menu, set Quality to Fine, which is the top setting, represented by the icon of an arrow pointing down onto two rows of bricks.

To do so, on screen 1 of the Recording menu, scroll down using the Down button until the Quality line is highlighted, then press the Right button to pop up the sub-menu. Scroll up if needed, to highlight the top icon with the six bricks, and then press the Menu/Set button to select that option.

With that setting, you will have access to most of the options on the Recording menu. I'll start at the top and discuss each option on the list. Screen 1 of this menu is shown in Figure 4-8.

Figure 4-8. Screen 1 of Recording Menu

PICTURE SIZE

This first item on the Recording menu controls the number of megapixels in the images you record with the camera, up to and including its maximum of 17 megapixels, which is shortened as MP or M. The maximum MP setting, using the L (for Large) setting for Picture Size, is affected by the aspect ratio that you have set using the aspect ratio switch on top of the lens. If you set the aspect ratio switch to 4:3, the maximum Picture Size setting is 17 MP, as shown in Figure 4-8, using the maximum number of available pixels. The number of megapixels decreases with other aspect ratio settings. (As discussed in Chapter 5, the camera's sensor actually has about 21.7 million pixels, but, because it offers multiple aspect ratios that crop the sensor in different directions, no one aspect ratio uses the full number of pixels on the sensor.)

The higher the Picture Size setting, the better the overall quality of the image, all other factors being equal. However, you can create a fuzzy and low-quality image with a high Picture Size setting with no trouble at all; this setting does not guarantee a great image. But if all other factors are equal, a higher megapixel count should yield noticeably higher image quality. Also, when you have a large megapixel count in your image, you have some leeway for cropping it; you can select a portion of the image to enlarge to the full size of your print, and still retain acceptable image quality.

On the other hand, images with high megapixel counts eat up storage space more quickly than those with low megapixel counts. If you are running low on space on your SD card and still have a lot of images to capture, you may need to reduce your Picture Size setting so you can fit more images on the card.

The Picture Size setting is not available for selection when you have selected Raw for the Quality setting (discussed later in this chapter), because Raw images are always captured at the largest possible size. However, if you set Quality to Raw & Fine or Raw & Standard, with either of which the camera records both a Raw and a JPEG image, the Picture Size option is available for setting the size of the JPEG image.

Extended Optical Zoom

Another point to consider in setting Picture Size is how much zoom power you need to have available. The LX100 II has a feature called Extended Optical Zoom, designated as EX on the menu screen and shooting screen. When you set the Picture Size to 4 MP (S), for example (with aspect ratio of 3:2 or 4:3), you will find that you can zoom in farther than you can with Picture Size set to its maximum. You will see an EX designation appear on the menu screen to the left of the Picture Size setting of S, as shown in Figure 4-9.

(You will not see the EX designation unless Quality is set to Fine or Standard, because Extended Optical Zoom is not available with Quality set to Raw. This feature also is incompatible with some other settings, such as 4K Photo, Multiple Exposure, HDR, and others.)

You will see that the zoom scale goes beyond the normal limit of 75mm as you move the zoom lever on top of the camera toward the T setting, for Telephoto.

Depending on the Picture Size setting, the scale will extend to a zoom level of as much as twice normal, or about an equivalent of 150mm. (If you turn on Intelligent Zoom or Digital Zoom, discussed later in this chapter, the zoom range will extend even farther; for now, I am assuming that both of those options are turned off.)

Figure 4-9. EX Designation on Picture Size Menu

To summarize the situation with Extended Optical Zoom, whenever you set Picture Quality to a level below Large, you gain additional zoom power because of the reduced resolution. You could achieve the same result by taking the picture at the normal zoom range with Picture Size set to the full 17M and then cropping the image in your computer to enlarge just the part you want. But with Extended Optical Zoom, you get the benefit of seeing a larger image on the display when you're composing the picture, and the benefit of having the camera perform its focus and exposure operations on the actual zoomed image that you want to capture, so the feature is not useless. You just need to decide whether it's of use to you in a particular situation.

I'll discuss Intelligent Zoom and Digital Zoom later, as other Recording Menu options.

QUALITY

The next setting on the Recording menu is Quality. It's important to distinguish the Quality setting from the Picture Size setting. Picture Size concerns the image's resolution, or the number of megapixels in the image. Quality has to do with how the image's digital information is compressed for storage on the SD card and, later, on the computer's hard drive. There are three levels of quality available in various combinations: Raw, Fine, and Standard, as shown in Figure 4-10. From the

top, the five icons stand for Fine, Standard, Raw & Fine, Raw & Standard, and Raw.

Figure 4-10. Quality Menu Options Screen

Raw is in a category by itself. There are both pros and cons to using Raw in this camera. First, the cons. A Raw file takes up a lot of space on your memory card, and, if you copy it to your computer, a lot of space on your hard drive. In addition, there are various functions of the LX100 II that don't work when you're using Raw, including panorama shooting, Intelligent Zoom, Digital Zoom, Resize, Cropping, Title Edit, Text Stamp, printing directly from the camera to a photo printer, White Balance Bracket, and Aspect Bracket.

You also cannot get the full benefit of using the Filter Settings menu option to add picture effects to your images, though you can use those effects when shooting with Raw for Quality. (The resulting image will show the effect when displayed in the camera, but not when opened on a computer unless you use a special program that may be able to display the effect, such as Irfanview, from Irfanview.com.)

You cannot shoot in Raw quality with the iHandheld Night Shot, iHDR, or HDR options, and burst shooting will be slowed down when shooting in Raw.

Finally, you may have problems working with Raw files on your computer because of incompatibility with editing software, though those problems can be overcome by getting updates for your program.

On the other hand, using Raw files has several advantages. The main benefit is that Raw files give you an amazing amount of control and flexibility with your images. When you open up a Raw file in a compatible photo-editing program, you can correct problems

with exposure, white balance, color tints, sharpness, and other settings. If the image was underexposed or overexposed, you can make adjustments in the software and recover the image to a proper brightness level. You can adjust the white balance after the fact and remove unwanted color casts. In effect, you get a second chance at making the correct settings, rather than being stuck with an unusable image because of unfortunate settings when you pressed the shutter button.

For example, Figure 4-11 is an image I took with Quality set to Raw, but with settings purposely made to result in underexposure and incorrect white balance.

Figure 4-11. Raw Image Captured with Abnormal Settings

Figure 4-12 is the same image after I opened it using Adobe Camera Raw software and made corrections after the fact. The corrected image looks essentially as if it had been shot with proper settings to begin with.

Figure 4-12. Raw Image with Settings Adjusted in Software

The drawbacks to using Raw files are either not too severe or they are counterbalanced by the flexibility Raw gives you. The large size of the files may be an inconvenience, but the increasing size of hard drives and SD cards, with steadily dropping prices, makes file size much less of a concern than previously. I have had problems with Raw files not loading when I didn't have the latest Camera Raw plug-in for Adobe Photoshop or Photoshop Elements, but with a little effort, you can download an updated plug-in and the software will then process and display your Raw images. Panasonic provides a free download of Silkypix, a program for processing Raw files, so you don't have to buy any additional software to process Raw files.

You don't have to use Raw, but you may be missing some opportunities if you avoid it.

The other two settings for Quality—Fine and Standard—are levels of compression for computer image files that use the JPEG standard. Images saved with Fine quality are subjected to less compression than those saved with Standard quality. In other words, Standard-quality images have their digital data "compressed" or "squeezed" down to a smaller size to allow more of the files to be stored on an SD card or computer drive, with a corresponding loss of image quality. The more compression an image is subjected to, the less clear detail it will contain. Unless you are running out of space on your storage medium, you probably should leave the Quality setting at Fine to ensure the best quality. (Of course, you may prefer to shoot in the Raw format for maximum quality.)

With the LX100 II, besides choosing one of the individual Quality settings (Raw, Fine, or Standard), you can set the camera to record images in Raw plus either Fine or Standard. With that option, the camera will record each image in two files-one Raw, and the other a JPEG file in either Fine or Standard quality, depending on your selection. When you play the image back in the camera, you will see only one image, but if you copy the files to your computer, you will find two image files—one with a .jpg extension and one with an .rw2 extension. The Raw file will be much larger than the JPEG one. In a few examples I just looked at on my computer, the Raw files from the LX100 II were all about 19 MB and JPEG files with Picture Size set to Large were between about 2 and 8 MB. (Note that MB stands for megabytes, a measure of file size, as distinguished from MP or M, meaning megapixels, a measure of the number of pixels in an image.)

If you're taking pictures of a one-time event such as a wedding or graduation, you may want to preserve them in Raw for highest quality and later processing with software, but also have them available for quick review on a computer or other device that does not have software that reads Raw files. Or, you might want to be able to send the images to friends or post them to social media sites without translating them from Raw into a JPEG format that most people can easily view on their computers. Also, as I discussed earlier, if you are using the Filter Settings menu option to add special effects to images, those effects generally will not show up in Raw files when the files are opened on a computer. In order to have the benefit of the special setting as well as the benefits of a Raw file, you can use the Raw & Fine or Raw & Standard option to record images both ways.

AFS/AFF/AFC

This next menu option lets you choose how the autofocus system operates when the focus switch is set to the AF or AF macro position. With AFS, for autofocus single, when you press the shutter button halfway, the camera locks focus on the subject and keeps it locked while the button is held there, even if the subject moves. With AFF, for autofocus flexible, the camera locks focus, but will adjust focus if the subject (or the camera) moves. With AFC, for autofocus continuous, the camera does not lock focus, but adjusts it continuously as the subject or camera moves.

If you are shooting images of a landscape or other stationary subject, AFS will work well. The camera will lock focus and keep it there, and the battery will not be drained by adjusting focus. If you are shooting handheld shots at a fairly close distance, though, you might want to use the AFF setting because the camera will adjust the focus if the camera moves slightly, and the focus could be thrown off by that movement, especially when the focus distance is small or the lens is zoomed in.

If you are shooting pictures of children or pets moving around unpredictably, you may want to use the AFC or AFF setting and let the camera continue to adjust focus as needed. With these settings, the camera's battery will be drained faster than with AFS, but it may be worth it to capture an action shot in sharp focus.

PHOTO STYLE

This next item on the Recording menu gives you several options for choosing a setting that determines the overall appearance of your images. These settings yield differing results in terms of warmth, color cast, and other attributes.

To select a Photo Style setting, highlight the Photo Style line on the Recording menu and press the Right button or Menu/Set to move to the screen that displays the current setting at the top of the screen, as shown in Figure 4-13. (For all menu settings, you also can use the touch screen to make selections. I will mention that possibility from time to time, but I won't keep repeating it for every menu option.)

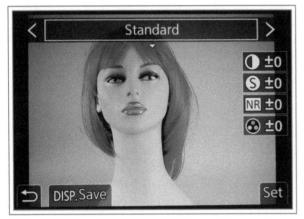

Figure 4-13. Photo Style Main Setting Screen

Then use the Left and Right buttons, the control dial, or the control wheel to scroll through the available settings: Standard, Vivid, Natural, Monochrome, L. Monochrome D, Scenery, Portrait, and Custom.

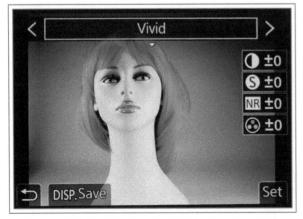

Figure 4-14. Vivid Setting Highlighted for Photo Style

When your chosen setting is highlighted at the top of the screen, as shown in Figure 4-14, where the Vivid setting has been highlighted, press the Menu/Set button to select it, then press the Fn3 button to exit to the shooting screen. Or, if you prefer, after highlighting the new setting, just press the shutter button halfway to select the setting and return to the shooting screen.

If you want to fine-tune the setting, the LX100 II's menu system lets you adjust four parameters that are associated with the Photo Style settings: contrast, sharpness, noise reduction, and saturation. To make adjustments to those parameters, press the Down button when the main setting (such as Vivid or Natural) is highlighted with a yellow rectangle, as in Figure 4-14. A new highlight will then appear in the block that contains the value for one of the four adjustable parameters, as shown in Figure 4-15.

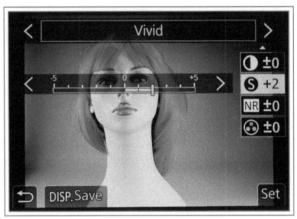

Figure 4-15. Photo Style Adjustment Screen

In this case, the second line is highlighted, which means you can adjust the sharpness setting; the word Sharpness appears for a few seconds at the top left of the screen, indicating that that value can now be adjusted.

Once you have placed the highlight block on one of the four parameters, press the Left and Right buttons or turn the control dial to change the value of that parameter up to five levels, either positive or negative. A yellow scale in the center of the screen will reflect those changes. Press Menu/Set or press the shutter button halfway to save the changes. The camera will remember those settings even when it is turned off.

There is one additional point to make about the three varieties of Monochrome settings for Photo Style. Monochrome means there is no color in the image,

only shades of black, white, and gray. Therefore, the saturation adjustment does not work to increase or decrease the saturation of colors for any of the three Monochrome settings. Instead of the saturation adjustment, the camera provides three additional parameters at the bottom of the list, immediately after the noise reduction setting: color tone, filter effect, and grain effect, as shown in Figure 4-16.

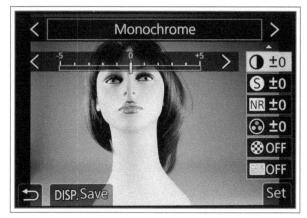

Figure 4-16. Adjustment Screen for Monochrome Setting

With color tone, a positive adjustment makes the monochrome effect increasingly bluish or "cooler," while a negative adjustment makes it increasingly yellowish or "warmer."

The filter effect adjustment lets you add a virtual filter, simulating the effect of a glass filter, which can be used on a camera's lens for black-and-white photography to enhance contrast and for other purposes. You can choose from a yellow, orange, red, or green filter, or choose the last setting, which turns the filter effect off.

The yellow, orange, and red effects provide increasing amounts of contrast for blue subjects and can be used to enhance the appearance of a blue sky. The green effect can be used to reduce the brightness of human skin and lips or to brighten the appearance of green foliage.

The grain effect setting lets you adjust the amount of grain in your images, at a level of Low, Standard or High, with a default value of Off, adding no extra grain. With this setting, you can simulate the look of a high-ISO image with a "rough" look.

When you set Photo Style to one of the Monochrome settings with Quality set to Raw, the picture you take will show up as black-and-white on the camera's LCD screen, but, when you import the image file into

software that reads Raw files, the image may show up in color, depending on how the software interprets the Raw data from the sensor. With the Silkypix software provided with the camera, Raw images taken with Photo Style settings retain the Photo Style appearance, but you can convert them to other settings in the software.

Photo Style settings are not available in the basic Intelligent Auto mode, but they are available in all other shooting modes. In Intelligent Auto Plus mode, you can select only Standard or Monochrome for Photo Style, and you cannot adjust either setting's contrast and other parameters.

The Photo Style settings also are available for recording a movie with the advanced shooting modes.

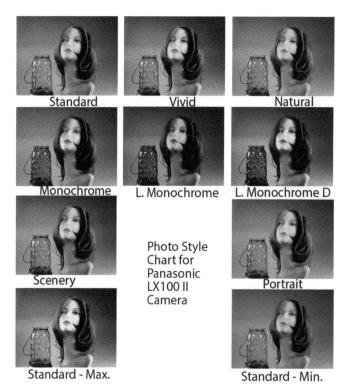

Figure 4-17. Photo Style Comparison Chart

Before I provide descriptions of how the Photo Style settings affect your images, I am providing a chart in Figure 4-17 that shows the same subject photographed with each of the various settings. The last two images show the use of the Standard setting, first with its parameters all adjusted to their maximum levels, and second with all parameters at their minimum levels.

Here are summaries of each of the Photo Style settings:

Standard: No change from the normal setting; good for general photography. The camera uses moderate sharpening and contrast to provide a clear image for everyday purposes.

Vivid: Increased saturation (intensity or vividness) and contrast of the colors in the image to make the colors "pop" out in dramatic fashion.

Natural: Reduced contrast to produce a softer, more subdued appearance.

Monochrome: Standard settings, but monochrome image, with all color removed (that is, saturation reduced to zero), unless you use the color tone adjustment to add a yellow or blue tone. You also can use the filter effect setting to add a yellow, orange, red, or green filter effect, or the grain effect setting to add grain, as you can with all three Monochrome options.

- L. Monochrome: Similar to Monochrome but with darker, richer grays and blacks, intended to give an appearance like that of images taken with black-and-white film.
- L. Monochrome D: Similar to L. Monochrome, but with a dynamic component added, to increase the dynamic range, resulting in an image with greater contrast and variation in shades.

Scenery: Increased emphasis on the blues and greens of outdoor scenes, with increased saturation of those hues.

Portrait: Emphasis on flesh tones.

Custom: The Custom slot is available to store a setting that you have customized using your own settings for the parameters that can be adjusted (contrast, sharpness, saturation, and noise reduction, as well as color tone, filter effect, and grain effect for the Monochrome settings). To use this option, select any one of the basic Photo Style settings (Standard, Vivid, Natural, Monochrome, L. Monochrome, L. Monochrome D, Scenery, or Portrait), then press the Down button and proceed to adjust any or all of the parameters for that setting as you want them. Next, press the Display button, as prompted by the DISP. Save message on the display, as shown earlier in Figures 4-13 through 4-16.

The camera will display a message asking you to confirm that you want to overwrite the current Custom setting with the settings you just made. If you highlight Yes and press Menu/Set, the settings you have made will be stored in the Custom slot of the Photo Style setting.

After you have stored the Custom setting, you can recall it at any time by selecting Custom for the Photo Style setting. You can alter the Custom setting in the future by choosing a different set of settings and storing it to the Custom slot, overwriting the previous entry.

FILTER SETTINGS

This next menu option provides a powerful feature for altering the appearance of images taken with the LX100 II. When you select this option, the camera displays a group of icons representing 22 picture effects you can apply to your images and videos. If you want some insurance against accidentally leaving one of the effects activated, you can turn on the Simultaneous Record Without Filter option, which is a second option under the Filter Settings menu item. When that option is on, the camera will take two images when a Filter Effect is selected—one with the effect and one without it—so you don't have to worry about ruining an image by applying an unwanted effect.

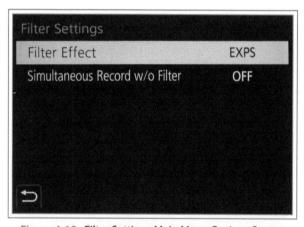

Figure 4-18. Filter Settings Main Menu Options Screen

Figure 4-19. Filter Effect Options Screen

To use this option, navigate to the Filter Settings menu item and select it. You will see a screen like that in Figure 4-18. Highlight Filter Effect and select it, and you will see a screen like that in Figure 4-19, with the choices On, Off, and Set. Select On or Off to activate or turn off the currently selected effect. Use Set to change to a different effect. When you select Set, you are taken to a screen for selecting one of the 22 available settings. This screen can appear in one of three different display arrangements.

Figure 4-20. Normal Display for Filter Effect

With the Normal display, as shown in Figure 4-20, the camera displays a vertical line of icons at the right. As you scroll up and down through that line using the Up and Down buttons, control dial, or touch screen, the camera highlights the selected icon and displays a large view at the left of the screen that applies that effect to the live view of the current scene that the camera is aimed at.

Figure 4-21. Guide Display for Filter Effect

With the Guide display, as shown in Figure 4-21, the setup is the same, except that, at the left of the screen, instead of displaying the appearance of the effect, the camera displays a brief description of the effect.

With the List display, as shown in Figure 4-22, the camera displays more icons on each screen, in rows and columns. As you scroll through them using all four direction buttons, the control dial, or the touch screen, the camera displays the name of the effect at the top of the display.

Figure 4-22. List Display for Filter Effect

When you have scrolled through the Filter Effect icons and highlighted the one you want to use, press Menu/Set (or use the touch screen) to select it and return to the recording screen. The camera's display will now show the name of the effect at the left, and the appearance of the scene on the display will reflect the chosen effect.

In addition to the settings from the Recording menu and physical controls discussed above, with the Filter Settings effects you can make several other adjustments, depending on which setting is in effect. These adjustments can be made in two ways. First, you can press the Right button, which will take you to the adjustment screen for the effect that is currently selected. For example, when the Expressive effect is active, pressing the Right button takes you to the screen shown in Figure 4-23, with a sliding scale at the bottom.

Using the control dial, the Left and Right buttons, or the touch screen, you can adjust the slider along that scale to make the vividness of the effect greater or smaller. With other effects you can adjust other values, such as coloring, contrast, or graininess.

You also can adjust all of the Filter Effect settings using the touch screen icons. To do that, touch the small icon that looks like a painter's palette at the right edge of the screen. You will then see a different palette icon at the far right edge of the screen, as shown in Figure 4-24.

Figure 4-23. Filter Effect Adjustment Screen

Press that icon to bring up the adjustment scale for the Filter Settings effect. Press the yellow artist's palette icon at the top of the right edge of the screen to turn off the effect.

You can use these effects with any one of the PASM shooting modes and when recording motion pictures. You cannot use them with Intelligent Auto or Intelligent Auto Plus mode. When you activate any of the effects, you cannot adjust the camera's white balance, Photo Style, Highlight Shadow, Intelligent Dynamic, HDR, or Color Space. Also, the flash is forced off.

Figure 4-24. Filter Effect Touch Screen Icon

However, you can set Quality to Raw. If you do that, the image that is displayed on the camera's screen will show the selected effect, but when you load the Raw file into post-processing software, the effect may not appear, depending on whether the software recognizes it. I have found one program called Irfanview, from irfanview.com, that can display the effects in a Raw image, but only from a small preview image embedded in the Raw file. So, if you want to have the benefit of shooting in Raw but also use the picture effect, I recommend you use the Raw & Fine

option for Quality, so you will have both a Raw image and a full-sized JPEG image for each shot.

You also can shoot panoramas with Filter effects, but the Toy, Toy Pop, Miniature, and Sunshine effects are not available. You can select an effect by using the menu system, or, for panorama shooting only, by turning the control dial or the control ring around the lens. If you do that, a list of text icons will scroll along the bottom of the display; just turn the ring or dial until the effect you want is highlighted, then press the shutter button halfway to return to the recording screen. (The Control Ring option on screen 3 of the Custom menu must be set to Default for this function to be available.)

Following are details about each of the 22 settings, with an example image for some of the effects.

Expressive. This setting increases the saturation and intensity of colors in the image to give a vivid appearance. When you press the Right button, the scale that appears lets you adjust the strength of this effect. This effect can be used to provide extra punch to your images without distorting their appearance.

Figure 4-25. Expressive Example

For example, in Figure 4-25, I used this setting to enhance a view of the city skyline at the river.

Retro. This option adds a yellowish or reddish color cast to give a faded look to the image, like the appearance of an old color print that has faded over time. With the adjustment slider, you can alter the color tone from yellowish at the left of the scale to reddish at the right.

Old Days. This effect is intended to give a "nostalgic" look by lowering the saturation of colors and reducing contrast for an old-fashioned look. With the

adjustment slider, you can vary the contrast. In Figure 4-26, I used this setting for a shot of a historic site on an island in the river at Richmond, Virginia.

Figure 4-26. Old Days Example

High Key. A high key image is one with bright, light colors and a light background. With the LX100 II, the camera increases brightness and emphasizes highlights. With the adjustment slider, you can add a slight color cast ranging from pinkish at the left to bluish at the right. This setting can be useful for brightening a dark scene. For Figure 4-27, I used this setting for a shot of rocks under a pedestrian bridge.

Figure 4-27. High Key Example

Low Key. With this setting, the camera darkens the overall image in a way that places an emphasis on any bright or highlighted areas. This option can be used for dramatic effect to isolate a small bright area within a scene. As with the High Key setting, you can add a color tone ranging from reddish to bluish.

Figure 4-28. Low Key Example

For Figure 4-28, I used this option for another view of the rocks seen in the previous image, to illustrate the differences between the two settings.

Sepia. With this option, the camera renders the image in monochrome, but with a sepia (brownish) tone, simulating the appearance of some old-fashioned photographs. With the adjustment slider, you can change the level of contrast.

Monochrome. This setting gives you another way, other than the Photo Style menu option, to capture an image in traditional black and white. The adjustment slider lets you add a color tone, ranging from yellowish to bluish.

Dynamic Monochrome. This option is another way to take a monochrome image, in this case with enhanced contrast to give a more dramatic appearance than an ordinary monochrome setting does. The adjustment slider alters the amount of contrast.

Figure 4-29. Dynamic Monochrome Example

For Figure 4-29, I used this setting for a shot of trees and structures in late afternoon shadows.

Rough Monochrome. With this setting, the camera again records a monochrome image, but this time with the appearance altered to add grain by inducing visual noise, like the noise that results from using a high ISO setting. This option can be good for street photography or for other situations in which you want the somewhat primitive look of a grainy image. The adjustment slider lets you reduce or increase the amount of graininess.

For Figure 4-30, I used this setting for an image of a tree in front of the city skyline.

Figure 4-30. Rough Monochrome Example

Silky Monochrome. This option gives you another way to take a monochrome image. In this case, the camera puts the image slightly out of focus to add a soft or dreamy look. With the adjustment slider, you can alter the amount of defocusing that is used. The left side of the scale provides a sharper, less defocused image.

Impressive Art. This setting provides one of the more dramatic effects for your images. The camera increases contrast and color saturation dramatically. With the adjustment slider, you can vary the color saturation all the way down to monochrome at the left and a high degree of intensity at the right.

For Figure 4-31, I used this setting for a scene at the time of sunset.

High Dynamic. With this option, the camera uses special processing to even out the dynamic range of the image to some extent, to reduce the contrast between dark and light areas. This setting provides an appearance somewhat like that of an in-camera HDR shot, but without the benefit of taking multiple images

from which to combine areas with different exposure levels. As with the previous setting, you can vary the color intensity from monochrome to intense color using the adjustment slider.

Figure 4-31. Impressive Art Example

Figure 4-32. High Dynamic Example

For Figure 4-32, I used this setting for another view of the sunset, to show the differences between the Impressive Art and High Dynamic settings.

Cross Process. This setting is straightforward in its operation. All it does is add a specific color cast to your images—either green, blue, yellow, or red. With the adjustment slider, you can choose one of those colors. For this setting, the slider does not move across a continuous scale; instead it moves to one of four blocks representing those colors. Just move the slider to highlight one of those blocks, and your images will take on that color as an overlay.

For Figure 4-33, I put together a composite image using all four settings for photos of a white model car, to illustrate the different options. Clockwise from top left, the colors are green, blue, yellow, and red.

Figure 4-33. Cross Process Example

Toy Effect. The Toy effect sets the camera to simulate the images taken by a camera that is designed to purposely degrade its pictures by using a cheap lens and other non-standard approaches, for creative effect. With the LX100 II, this effect uses vignetting and contrast adjustments to produce the toy-camera effect. With the adjustment slider, you can add a color cast, ranging from orange (warmer colors) at the left to blue (cooler colors) at the right.

Figure 4-34. Toy Effect Example

In Figure 4-34, I used this setting for a picture of a stone marker in a public park near the river.

Toy Pop. With this setting, the camera combines the vivid, bright appearance of the Expressive setting with the vignetting of Toy Effect, discussed above. In this case, the adjustment slider controls the amount of vignetting. At the left of the scale, the vignetting is reduced so more of the image is bright; at the right, the vignetting increases to darken more of the corners.

Figure 4-35. Toy Pop Example

For Figure 4-35, I found that this setting was a good one to add a framing effect and enhanced color to part of the foundation of a railroad bridge at the river.

Bleach Bypass. This option causes images to have increased contrast and lowered color saturation, to produce a bleached, washed-out appearance. You can reduce the contrast by moving the adjustment slider to the left or increase it by moving the slider to the right.

Miniature Effect. This is one of the most interesting of the 22 picture effects the LX100 II offers. This setting produces an image that looks as if the subject is a high-quality tabletop model. Such photographs generally have some areas in sharp focus and some areas blurry, because of the closeup nature of the photograph or because of the use of a tilt-shift lens. This effect is used for some television commercials and programs in connection with time-lapse photography to add interest to a speeded-up scene.

This effect yields good results from a high vantage point looking down on a street or intersection, or on any area that can be placed in the center of the shot and that includes objects such as automobiles, railroad cars, boats, or the like.

With this setting, four icons appear at the right side of the screen when you touch the artist's-palette icon at the right side of the screen. The top icon turns the effect on or off; the second one lets you change to another setting. The third one adjusts the intensity of the colors. In order to adjust the settings for the miniature effect itself, you use the bottom icon, which looks like a rectangle with arrows pointing up and down. When the Miniature setting has been selected, touch the artist's palette icon then touch the bottom (rectangle) icon, and a long yellow frame will appear on the screen, as shown in Figure 4-36.

Figure 4-36. Yellow Frame for Miniature Effect

This frame represents the area of the image that will remain in sharp focus. The areas outside of that frame will be defocused and fuzzy, contributing to the overall effect. So, for example, if you are shooting from an overpass down toward a highway intersection, you may want to line up the yellow frame over the road that you want to remain in focus, leaving the areas outside the frame to be out of focus.

To move the yellow frame, use the four cursor buttons. When you see triangles on the frame, press the buttons corresponding to those triangles to move the frame in the direction of the triangle. Use the other two cursor buttons to flip the frame to a different orientation (horizontal or vertical). Then, turn the control dial to change the size of the frame. When you have the frame oriented and sized as you want it, press the Menu/Set button to return to the shooting screen and take your picture. You also can use your fingers on the touch screen to move the rectangle, or to pinch it to make it larger or smaller. You can change the frame's orientation between horizontal and vertical by pressing the icon on the screen that looks like a set of frames with an arrow above it.

You can press the Right button to get to the adjustment slider, which adjusts color saturation. With this setting, you cannot use burst shooting or the flash, although you can use Raw image quality. You can use exposure compensation, but not bracketing. You can use the Miniature setting when shooting movies. If you do so, no audio is recorded, and the action is speeded up to about ten times normal speed, which helps reinforce

the illusion that you are filming a model scene rather than a life-sized one.

Figure 4-37. Miniature Effect Example

For Figure 4-37, I shot an image of a city street from an elevated vantage point, to give the impression of a model setup.

Soft Focus. With this effect, the camera defocuses the image to give it a soft, dreamlike appearance. You can use the adjustment slider to vary the degree of defocusing.

Fantasy. With this option, the camera alters the intensity of colors and adds a bluish color cast to the scene, with the idea of producing a hazy, fantasy-like appearance. With the adjustment slider, you can vary the intensity of the colors.

Star Filter. This setting produces rays of light wherever there are points of bright light in the scene. This is a good option to use if you want to add a sparkling, holiday-like appearance to a scene with festive lights, for example. When you press the Right button or the effect adjustment icon, the camera displays three adjustment sliders, selected with the Up and Down buttons or the touch screen. The top slider controls the size of the rays of light; adjust to the left for shorter rays, and to the right for longer ones. The second one controls the number of rays, with more rays produced as you move the slider to the right. The bottom slider adjusts the angle of the rays; they rotate to the right as you adjust the slider to the right, and vice-versa. You cannot use this effect with burst shooting or when recording movies.

Figure 4-38. Star Filter Example

For Figure 4-38, I took a shot of the river an a sunny day when bright reflections were coming off the water.

One Point Color. This option, like the Miniature effect, can produce dramatic, striking images. The purpose of this effect is to choose a single color, such as red, blue, yellow, or any other, and set the camera so that only objects of that color will retain their color. All other objects in the scene will appear in black and white. If this is done with a suitable subject, the effect of isolating a single item in color can be quite impressive.

To select the color that is retained, press the icon for the artist's palette at the right edge of the screen to bring up a line of four icons, as shown in Figure 4-39. Touch the bottom icon, which looks like an eyedropper, and a movable frame with arrows will appear in the center of the screen, as shown in Figure 4-40. Using the four direction buttons or your finger on the touch screen, place that square over the object whose color you want to retain and press the Menu/Set button (or touch the Set icon) to confirm the selection.

Figure 4-39. Touch Screen Icons for One Point Color Setting

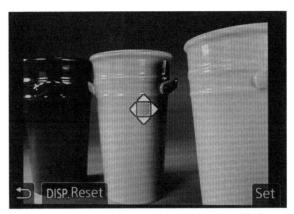

Figure 4-40. Frame to Select Color to Be Retained in Image

The setting's adjustment icon (which looks like a palette with a plus sign) is used to determine how closely an item must match the selected color in order to show up in color. Move the slider to the left to restrict the color selection to the minimum, and to the right to include a broader range of similar colors.

Figure 4-41. One Point Color Example

Then, as shown in Figures 4-39 and 4-40, only objects matching that color will appear in color on the shooting screen and in the final image after you take the picture. You can use burst shooting and record movies with this setting. You also can use exposure compensation and bracketing.

For Figure 4-41, I used this setting for a shot of the city skyline, leaving the blue shade of the sky as the only color in the image.

Sunshine. Finally, the Sunshine option lets you add a solar flare effect to your image. After you select this option, press the artist's palette icon at the right edge of the screen, then touch the bottom adjustment icon, which looks like the sun, and you will see a yellow circle on the display. You can move that circle around the

screen using the four direction buttons or your finger on the touch screen and resize it using the control dial or by pinching and pulling with your fingers on the screen.

When you have the solar flare sized and located as you want, press Menu/Set (or the Set icon) to lock it in. Then, press the Right button or touch the adjustment icon directly above the sun icon, and you can select yellow, red, blue, or white for the color of the flare. Press Menu/Set, and the effect will be locked in with your selections. You can move the flare outside the edges of the image to avoid having the large, bright ball in the scene.

Figure 4-42. Sunshine Example

For Figure 4-42, I used this option to add a solar flare to another picture of the skyline.

COLOR SPACE

With this option, you can choose to record your images using the sRGB "color space," the more common choice and the default, or the Adobe RGB color space. The sRGB color space has fewer colors than Adobe RGB; therefore, it is more suitable for producing images for the web and other forms of digital display than for printing. If your images are likely to be printed commercially in a book or magazine or it is critical for you to match many color variations, you might consider using the Adobe RGB color space. I always leave the color space set to sRGB, and I recommend that you do so unless you have a specific need to use Adobe RGB, such as a requirement from a service you are using to print your images.

If you are shooting your images with the Raw format, you don't need to worry so much about color space, because you can set it later using your Raw-processing software.

METERING MODE

The next option on the Recording menu lets you choose what method the camera uses to meter the light and determine the proper exposure. The LX100 II gives you a choice of three methods: Multiple, Center-weighted, or Spot. If you choose Multiple, the camera evaluates the brightness at multiple spots in the image shown on the display, and calculates an exposure that takes into account all of the various values. With Center-weighted, the camera gives greater emphasis to the brightness of the subject(s) in the center of the screen, while still taking into account the brightness of other areas in the image. With Spot, the camera evaluates only the brightness of the subject(s) in the small spot-metering area.

The Panasonic user's manual recommends Multiple mode for "normal usage," presumably on the theory that it produces a reasonable choice for exposure based on evaluating the overall brightness of everything in the scene. However, if you want to make sure that one particular item in the scene is properly exposed, you may want to use the Spot method, and aim the spot metering area at that object or person, then lock in the exposure. The Spot option is useful when you are photographing a performer on stage who is lit by a spotlight. For a shot with a central subject of prime importance, such as a portrait, the Center-weighted option may work best.

To make this selection, scroll to the line for Metering Mode, then press the Right button to activate the submenu with the three choices, as shown in Figure 4-43. The first icon, a rectangle with a pair of parentheses and a dot inside, represents Multiple mode; the second, a rectangle with a pair of parentheses inside, represents Center-weighted; and the third, a rectangle with just a dot inside, represents Spot.

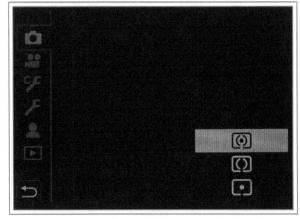

Figure 4-43. Metering Mode Menu Options Screen

With Multiple or Center-weighted, metering is simple: Point the camera at the subject(s) you want and let the camera compute the exposure. If you choose Spot as your metering technique, the process can be more involved. Presumably, you will have a fairly small area in mind as the most important area for having the correct exposure; perhaps it is a small object you are photographing for an online auction.

The LCD screen or viewfinder will display a small cross in the center of the focusing brackets, and you need to be sure that the cross is over the most important object.

If your subject is not in the center of the screen, you may need to lock the exposure while the Spot-metering cross is on the subject, and then move the camera so the subject is in the proper part of the frame. To do this, press the shutter button halfway while the cross is on the subject, and hold it in that position while you move the camera back to the final position for your composition. (You also can use the AF/AE Lock button for this function, as discussed in Chapter 5.)

If, in addition to using Spot metering, you are using one of the autofocus settings that lets you move the autofocus area, such as 1-Area or Face/Eye Detection, you can move the little cross around the camera's screen and place it over the area of the picture that you want properly exposed. When you move the focusing target, the Spot-metering target moves along with it, so the target serves two purposes at once.

The Metering Mode setting is not available in Intelligent Auto or Intelligent Auto Plus mode. When Multiple metering is selected and the Autofocus Mode is set to Face Detection, the camera will attempt to expose a person's face correctly, assuming a face has been detected. When Autofocus Mode is set to AF Tracking, the camera exposes for the tracked subject if Metering Mode is set to Multiple. The current setting for Metering Mode is indicated by an icon in the lower left of the display.

HIGHLIGHT SHADOW

This menu option gives you a powerful tool for adjusting the highlights and shadows in your images. When you select this menu option, the camera displays a screen like that shown in Figure 4-44, with seven small icons at the bottom available for selection.

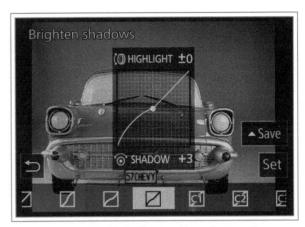

Figure 4-44. Highlight Shadow Menu Options Screen

(For this illustration I have scrolled to the fourth icon, so all seven icons are visible.) Each small icon represents a different curve shape for the larger graph in the center of the screen, which includes a line that represents the adjustments to highlights and shadows for your images. When the line is a straight diagonal, no adjustments are present. When the upper part of the line bulges to the left, highlights are increased. When it bulges to the right, the brightness of highlights is lowered. Similarly, the lower part of the line bulges to the left or right to increase or decrease the brightness of shadow areas.

The first four icons are presets for standard (no adjustments), higher contrast (highlights brighter and shadows darker), lower contrast (highlights darker and shadows brighter), and brighten shadows. The last three icons represent custom settings 1, 2, and 3.

If you want to use one of the four presets, just select it. If you want to make other adjustments, you can select any one of the seven icons and make adjustments to the settings. To make the highlights brighter, turn the control ring (around the lens) to the right; to make them darker, turn it to the left. To make the shadows brighter, turn the control dial (on the back of the camera) to the right; to make them darker, turn it to the left. You also can adjust the curves by moving the graph lines with your finger on the touch screen.

When you have adjusted the curves as you want, press the Up button to save the settings. You will then see a screen shown prompting you to select custom 1, 2, or 3 as the slot in which to save your settings.

Highlight any one of those and press the Menu/Set button to save the settings. Then, whenever you want to recall those settings, just go to the Highlight Shadow menu option and select the custom 1, 2, or 3 icon, depending on which slot you used to save your custom settings.

This option can be useful when your subject is partly in shadow and partly in bright light. It can be helpful because you can see the effects of the adjustments you make on the live view, as you use the controls or touch the screen to adjust highlights and shadows. Of course, the LX100 II also has other options to deal with that situation, such as the HDR setting, discussed later in this chapter, and the Intelligent Dynamic setting, discussed next.

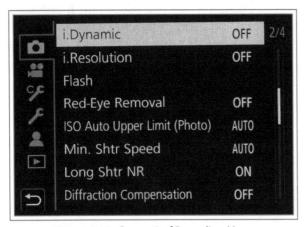

Figure 4-45. Screen 2 of Recording Menu

The options on screen 2 of the Recording menu are shown in Figure 4-45.

INTELLIGENT DYNAMIC

The first option on screen 2 of the Recording menu is shown as i.Dynamic, which I will refer to here as Intelligent Dynamic. This option gives you another way to accomplish what the Highlight Shadow option does—that is, to deal with a situation in which there is considerable contrast between the dark and bright areas of the scene. This option, unlike the previous one, does not let you make precise adjustments to the shadow and highlight curves. Instead, it adjusts contrast and exposure generally; it lets you set the intensity of the camera's adjustments to a level of Low, Standard, or High. You also can leave the option turned off, or you can set it to Auto and let the camera make the adjustments based on its analysis of the scene.

Figure 4-46 and Figure 4-47 are two views of a watering can sitting outdoors, partly in sunlight and partly in shade. As you can see, in the first image, with

Intelligent Dynamic turned off, the contrast is quite stark. In the second image, with Intelligent Dynamic set to High, the contrast is evened out and the shadowed areas are brightened noticeably. This is a good setting to use when you are taking photos in an area with both sunlight and shade.

Figure 4-46. Example with Intelligent Dynamic Off

Figure 4-47. Example with Intelligent Dynamic Set to High

INTELLIGENT RESOLUTION

The next setting on this menu screen is shown as i.Resolution, which I will call Intelligent Resolution. This option can be set to Off, Low, Standard, or High. This setting increases the apparent resolution in images by providing additional sharpening through in-camera digital manipulation. It does seem to improve image quality somewhat in certain situations. I recommend that you try shooting with it turned on and off to see if it provides actual benefits for your shots. I do not often use it myself, because I prefer to shoot with Raw quality and add sharpening with my editing software.

FLASH

The next item on the Recording menu, simply called Flash, is the gateway to a considerable number of options for using either the supplied flash unit or an optional external unit. This item will be unavailable for selection unless you have a flash unit attached to the camera's hot shoe and turned on. The Flash item does not even appear on the menu in the basic Intelligent Auto mode. In that shooting mode, the camera will make its flash settings based on its programming, with no input from you.

For this discussion, I will assume you have attached the small flash unit that is supplied with the LX100 II. When that unit is attached and turned on with the camera set to a compatible shooting mode, such as Program, the Flash menu item is available. When you highlight it and press the Right button or the Menu/Set button (or select it on the touch screen), the camera will display the screen shown in Figure 4-48. That screen has two sub-screens, as indicated by the 1/2 at the right side of the screen. I will discuss the items on those two screens next.

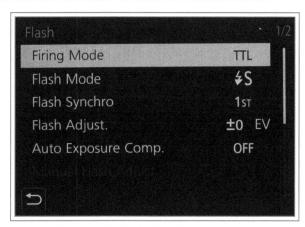

Figure 4-48. Flash Menu Options Screen

Firing Mode

The first sub-option for the Flash menu is Firing Mode. This option is available for selection only if you have attached and turned on a flash that is completely compatible with the LX100 II. In practice, the only unit I have found that lets me use this menu item is the unit supplied with the camera. I have tried attaching several other units, some of which will fire properly with TTL flash with this camera, but I have not found any units for which the camera will activate the Firing Mode menu option.

For example, I tried the Panasonic DMW-FL220, an older unit that I used with the other Panasonic Lumix cameras. That unit works well for automatic exposure with the LX100 II, but the camera will not display the Firing Mode menu option when that unit is attached to the hot shoe. Even with the DMW-FL360L, which works well with this camera as a wireless remote unit and for other purposes, this menu option remains dimmed and unavailable. That is not a problem, however, because with that unit you can change the firing mode and adjust the flash intensity from the unit itself.

When you are using the flash supplied with the camera, the Firing Mode menu option lets you choose whether to have the camera set the flash exposure automatically using its metering system (TTL) or to set the output of the flash manually (Manual). If you select TTL, the camera will do its best to achieve a normal exposure by regulating the flash output based on the camera's metering system.

If you choose Manual, the flash will fire at the output level it has been set to, regardless of the lighting conditions. It will be up to you to adjust the output of the flash unit to achieve a good exposure. The current output setting of the flash unit will be displayed on the camera's recording display screen, to the right of the flash mode icon. For full output, the indication will be 1/1. Using the Manual Flash Adjustment menu option, discussed below, you can change this setting to a lower level, down as low as 1/64 of full power, as shown in Figure 4-49.

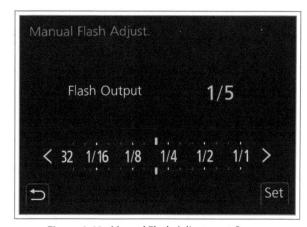

Figure 4-49. Manual Flash Adjustment Screen

For everyday use, you will probably want to select TTL, so the camera will communicate with the flash to calculate the best exposure. But if you are faced with an unusual situation when you want to adjust the output of the flash for a manual exposure, choose Manual and

then use the Manual Flash Adjustment option. If you are using a flash other than the supplied unit, make such adjustments on the flash itself, if possible.

Flash Mode

This next sub-option lets you set the flash mode for your shot. In this context, the mode means the procedure by which the flash fires. There are five options for this setting: Forced On, Forced On with Red Eye, Slow Sync, Slow Sync with Red Eye, and Forced Off, as shown in Figure 4-50.

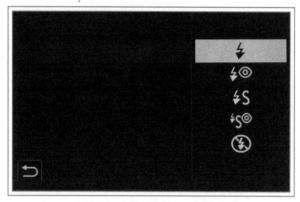

Figure 4-50. Flash Mode Menu Options Screen

If you choose Forced On, sometimes referred to as fill-flash, the flash will fire every time you press the shutter button, if the flash is operating properly and no other settings interfere. This is the mode to choose when you are certain you want the flash to fire, such as when you are taking snapshots in a dimly lighted area. It also is the mode to choose when you want to use flash to soften the shadows or brighten the scene slightly when you are taking a shot, especially a portrait, outdoors in sunlight. A bit of fill-flash can offset the harsh shadows and highlights from direct sunlight. For example, Figures 4-51 and 4-52 are two images I took outdoors.

Figure 4-51. Example with Flash Turned Off

Figure 4-52. Example with Fill-flash

For Figure 4-51, I left the flash turned off; for Figure 4-52, I used the Forced On setting. That image has more even lighting than the one without flash, because the on-camera flash overcame the contrast caused by the direct sunlight and deep shadows on the subject. However, to deal with strong shadows, you need to use a flash that is more powerful than the supplied unit.

The next option, Forced On with Red Eye, is for use when you are aiming the camera with flash directly at a person's face. In that situation, the flash can bounce off the person's retinas and light up blood vessels, resulting in the unpleasant "red eye" effect that is common in flash snapshots. With this setting, the camera will fire a pre-flash before the main flash, to narrow the subject's pupils before the image is captured and thereby reduce the risk of the red eye effect. This setting is available only if you have chosen TTL for the Firing Mode setting and have turned off the Wireless setting.

The next setting, Slow Sync, is for use in dark conditions when you want to give the ambient light time to illuminate the background. With a normal flash shot, the exposure may last only about 1/60 second, enough time for the flash to illuminate the subject in the foreground, but not enough time for natural lighting to reveal the background. So, you may end up with an image in which the subject is brightly lit but the background is black. With Slow Sync, the camera will use a relatively slow shutter speed so that the ambient lighting will have time to register on the image.

For example, Figures 4-53 and 4-54 were taken at the same time and in the same conditions except for the flash mode. Figure 4-53 was taken with the shutter speed set at 1/25 second, in normal flash mode (Forced On).

The background is quite dark, because the exposure was too short to light up the area beyond the mannequin. Figure 4-54 was taken in Slow Sync flash mode, which caused the camera to use a shutter speed of 1.0 second, allowing time for the ambient lighting to illuminate the room so the background showed up more clearly.

Figure 4-53. Example with Normal Flash Mode

Figure 4-54. Example with Slow Sync Flash Mode

The Slow Sync option is available on the Recording menu only when the camera is set to Program or Aperture Priority mode, because those are the only advanced shooting modes in which the camera selects the shutter speed. In Intelligent Auto mode, the camera may use the Slow Sync option, but you cannot select the setting yourself in that mode.

Slow Sync with Red Eye is the same as Slow Sync, except that the camera fires a pre-flash to try to reduce the red eye effect. It is available only when TTL is selected for Firing Mode, or you are using an external flash, like the Panasonic DMW-FL360L, that communicates fully with the LX100 II and is set to TTL mode on the flash itself.

The final option for Flash Mode is Forced Off. This setting is useful when you are in a museum or other

location where the use of flash is restricted. Of course, you also have the option of removing the flash unit from the camera or turning off the power on the flash unit, but it is convenient to have this other way to make sure the flash will not fire when you don't want it to.

Flash Synchro

The next sub-option for the Flash menu item, Flash Synchro, is one you may not have a lot of use for unless you encounter the situation it is designed for.

The Flash Synchro menu option has two settings—1st and 2nd. Those terms are references to 1st-curtain sync and 2nd-curtain (also known as rear-curtain) sync. The normal setting is 1st, which causes the flash to fire early in the process when the shutter opens to expose the image. If you set it to 2nd, the flash fires later, just before the shutter closes.

The 2nd-curtain sync setting can help you avoid a strange-looking result in some situations. This issue arises when you are taking a relatively long exposure, such as 1/4 second, of a subject with taillights, such as a car or motorcycle at night, that is moving across your field of view. With 1st-curtain sync, the flash will fire early in the process, freezing the vehicle in a clear image. However, as the shutter remains open while the vehicle continues on, the camera will capture the moving taillights in a stream that seems to extend in front of the vehicle.

If, instead, you use 2nd-curtain sync, the first part of the exposure will capture the lights in a trail that appears behind the vehicle, while the vehicle itself is not frozen by the flash until later in the exposure. Therefore, with 2nd-curtain sync in this particular situation, the final image is likely to look more natural than with 1st-curtain sync.

Figures 4-55 and 4-56 illustrate this concept with two images, both showing a flashlight in motion from right to left. Both images were shot with the LX100 II's built-in flash, using an exposure of 0.5 second in Shutter Priority mode.

In Figure 4-55, using the Forced On setting, the flash fired quickly, capturing an image of the flashlight, and the light beam continued on during the long exposure to make the streak of light appear to move in front of the flashlight's motion.

In Figure 4-56, using the 2nd setting for Flash Synchro, the flash did not fire until the flashlight had moved to the left, overtaking the place where the light had made its streak visible. If you are trying to convey a sense of natural motion, the 2nd setting for Flash Synchro is likely to give you better results than the default setting.

Figure 4-55. Example with Normal Flash

A good general rule is to always use the 1st setting unless you are sure you have a need for the 2nd setting. Using the 2nd setting makes it harder to compose and set up the shot, because you have to anticipate where the main subject will be when the flash finally fires late in the exposure process.

Figure 4-56. Example with Second-curtain Flash

The Flash Synchro setting is available for selection only in the PASM shooting modes. When the 2d setting is turned on, you cannot use either of the Red Eye Reduction settings for flash mode.

Flash Adjustment

The Flash Adjustment sub-option is available when Firing Mode is set to TTL (or a compatible flash unit is attached, in TTL mode) and the Wireless menu option

is turned off. This item lets you adjust the intensity of the flash when the camera is determining the flash exposure automatically. If the exposure seems too bright or too dark, you can use this setting to adjust it downward or upward in small increments.

Use the control dial, the Left and Right buttons, or the touch screen to select the amount of positive or negative EV adjustment you want. Of course, you also have the option of using regular exposure compensation, causing the camera to adjust the exposure using settings other than flash. (See the discussion of Auto Exposure Compensation below for how that option works.) This choice is up to you; it depends on what effect you are looking for. I rarely find a reason to increase the flash output, but I find that it can be useful to decrease the flash output to reduce the harshness of the lighting for a portrait in some cases.

If you have set Firing Mode to Manual, you can adjust the intensity of the flash using the Manual Flash Adjustment option, discussed below. As I noted earlier, that option appears to be available only with the flash unit supplied with the camera.

Auto Exposure Compensation

The next item on screen 1 of the Flash sub-options is Auto Exposure Compensation, which you can turn either on or off. This option controls the way the flash setting is affected when the flash is in TTL mode and you turn the exposure compensation dial. If you want the exposure compensation adjustment you make with the dial to be effective when using flash, turn this menu option on. Then, when the camera takes the shot, it will try to adjust the flash to give effect to the exposure compensation amount you selected.

If you leave this option turned off, then, when you adjust the exposure compensation dial and use TTL flash, the camera will adjust the exposure with aperture and shutter speed, but it also will adjust the flash to counteract that change. The result may be an exposure that does not reflect the adjustment made with the dial. In other words, the flash output will be automatically adjusted in the reverse direction from the exposure compensation. Depending on the ambient lighting, the result may be to cancel the effect of the flash.

I recommend leaving this option turned on so your exposure compensation choices will be effective, unless you have a particular reason to turn it off.

Manual Flash Adjustment

As I noted earlier, this option is available only when you have set the Firing Mode option to Manual. In that case, you can use this menu item to increase or decrease the intensity of the flash, assuming the flash is compatible with the camera's circuitry. As I also noted earlier, I have found that the only flash unit that allows you to set the Firing Mode option is the small unit that is supplied with the LX100 II.

This adjustment works in a similar way to the Flash Adjustment option, discussed earlier. The difference is that, in this case, you are setting the intensity of the flash manually, rather than adjusting the intensity as set by the camera based on its autoexposure metering. This option could be useful if you are faced with an unusual situation in which you are trying to achieve a particular result, such as by using a minimal amount of flash in a dark environment, and you do not want to rely on the camera's metering system.

The second screen of the Flash sub-options menu is shown in Figure 4-57.

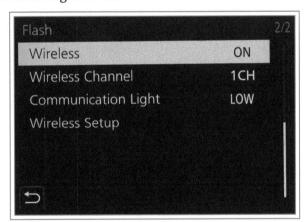

Figure 4-57. Screen 2 of Flash Options Menu

Wireless

The next few settings on the Flash menu have to do with the LX100 II's system for using wireless off-camera flash. To take advantage of this capability, you need to use one or more off-camera flash units that support the wireless protocol used by this camera. As of this writing, the only models I am aware of that support this protocol are the Panasonic DMW-FL200L, DMW-FL360L, and DMW-FL580L. You can use one or more of these units in each

of three groups. Panasonic recommends using no more than three flash units in each of the three groups, for a total of nine off-camera flash units.

Once you have one or more off-camera flash units, you also need to attach a compatible flash unit to the camera, to trigger the off-camera units wirelessly. For this function, you can use the small unit that is provided with the LX100 II camera. That flash cannot be used as an off-camera unit, because it does not receive the wireless signals, but it does transmit them. You also can use either of the larger Panasonic flash units mentioned above as the triggering unit that is attached to the camera.

When you have the compatible on-camera and off-camera units assembled, you have to set up the off-camera units within about 10 feet (3 meters) of the camera in a fairly straight line, or within about 6 feet (2 meters) if they are off to the sides, within a 50-degree angle from a line from the center of the lens. (See the diagram at page 153 of the Panasonic user's guide for more details on this point.) Once the transmitting unit and the receiving unit(s) are set up, it is time to use the menu options on the LX100 II. First, set the Wireless menu option to On. Then, you need to use more menu options, as discussed below.

Wireless Channel

Once the flash units are set up and the Wireless menu option is turned on, use the Wireless Channel option to select channel 1, 2, 3, or 4. Then make sure that each of the off-camera flash units is also set to that channel using the controls on the flash. On a unit such as the DMW-FL200L, set the flash's control switch to RC.

Communication Light

This next menu option can be set to High, Standard, or Low. It controls the brightness of the light that is emitted by the on-camera flash as it uses flashes of light to communicate with the off-camera flash units. If you are taking pictures in a relatively dark location, these flashes of light can affect your images. If that happens, you can set the intensity to a lower level to minimize those effects.

Wireless Setup

Finally, the Wireless Setup menu option lets you make individual settings for what Panasonic calls the

External Flash and for flash groups A, B, and C, as shown in Figure 4-58.

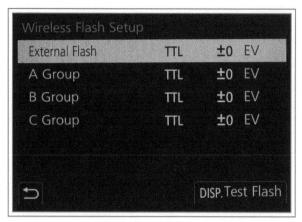

Figure 4-58. Wireless Setup Menu Options Screen

I find this terminology slightly confusing, because "External Flash" in this context refers to the flash that is attached to the camera. It is "external" in a sense because it is not built in to the camera, but it is not external in the sense of being separate from the camera. In any event, just realize that "External Flash" here really means something like "on-camera flash," while the A, B, and C groups are the remote flash units, and the setup process should be clear.

For the "External Flash" and each of the flash groups, you can make settings that are similar to those you can make for the single flash, when you are not using the wireless capability: Firing Mode, Flash Adjustment (when using TTL for Firing Mode), and Manual Flash Adjustment (when using Manual for Firing Mode). However, there are some significant differences. First, the Flash Synchro setting is not available, so you cannot turn on 2d-curtain flash. Second, and more significant, the Firing Mode menu item has two additional options when you are using wireless flash. Instead of having only the options of TTL or Manual, the Firing Mode item, when using wireless flash, lets you choose from TTL, Auto, Manual, or Off.

The effects of these choices are different for the external (on-camera) flash and the remote (off-camera) flash units. If you choose TTL, the camera sets the exposure of the flash, either on-camera or off-camera. You can adjust that exposure using the Flash Adjustment menu option, if you want. If you choose Auto for the external (on-camera) flash, then the flash unit determines the flash output. Note, though, that the Auto setting is dimmed and unavailable if you are using the supplied,

small flash unit as the external (on-camera) flash, because it does not have the ability to determine the flash exposure itself.

If you choose Manual for the external (on-camera) flash, then you will set the output of that flash yourself, using the Manual Flash Adjustment menu option. Finally, if you choose Off for the external (on-camera) flash, that unit will not fire its flash, but will still transmit wireless signals to the off-camera unit(s). You can use this setting if you don't want the on-camera flash to contribute to the exposure. In practice, I have found that the light from the on-camera flash is quite noticeable even if you choose Off for this setting, because of the triggering light this unit emits. If you set the Communication Light option to Low, that helps somewhat to reduce the intensity of that light.

For the off-camera units in Groups A, B, and C, you have the same options as for the external (on-camera) unit, but with some differences in how they work. For Firing Mode, if you select Auto, the remote flash unit will determine the exposure. If you select Manual, you can set the exposure for that group using the Manual Flash Adjustment menu option. If you select Off, then the flash units in that group will not fire at all.

Once you have all the flash units set up and the menu options configured, you can press the Display button (or press the DISP test flash icon on the screen) to test-fire the units, to make sure everything is working as you intended. You have to press the Display button while the Wireless Setup menu is displayed, as shown in Figure 4-58; otherwise, the button will have a different effect, such as switching display screens.

If you are using the Panasonic DMW-FL360L as your off-camera flash, you will notice one thing that can be annoying or disconcerting: When this unit is set up as a remote wireless flash, the bright LED on the front of the unit fires once every few seconds as a "ready" light to let you know that it is ready to fire wirelessly. Apparently there is no way to turn off this light in this mode, though you can try to cover it with gaffer's tape. You have to be careful not to cover up the two sensors that are located on either side of the LED, though, or this flash will not be triggered by the on-camera flash.

RED-EYE REMOVAL

This setting on the Recording menu is not to be confused with Red-eye Reduction, which is an aspect of how the flash fires. As I noted earlier, "red eye" is the unpleasant phenomenon that occurs when a flash picture is taken of a person, and the light illuminates his or her retinas, causing an eerie red glow to appear in the eyes. One way the LX100 II deals with this problem is with the Red-eye Reduction setting for the flash, which causes the flash to fire twice: once to make the person's eyes contract, reducing the chance for the light to bounce off the retinas, and then a second time to take the picture.

The LX100 II has a second line of defense against red-eye, called Red-eye Removal. When you select this option, which can be turned either on or off, then, whenever the flash is fired and Red-eye Reduction is activated, the camera also uses a digital red-eye correction method, to actually remove from the image the red areas that appear to be near a person's eyes. This option operates only when the Face Detection setting is turned on.

I do not usually use this option, because I process images using Photoshop or other software, and it's easy to fix red eye at that stage. But I tested it, and it did a remarkably good job of removing red spots from a mannequin's eyes on which I had pasted red dots to simulate red eye.

ISO AUTO UPPER LIMIT (PHOTO)

This menu option lets you set an upper limit for the value the camera will choose for ISO, or sensitivity to light, when you have selected either Auto ISO or Intelligent ISO for the ISO setting, as discussed in Chapter 5. (The basic ISO setting is made by pressing the ISO button on the back of the camera; that button is discussed in Chapter 5.) The choices for the ISO Auto Upper Limit setting are Auto, 400, 800, 1600, 3200, 6400, 12800, or 25600. If you choose Auto, then the ISO limit is automatically set to 3200.

If you want to make sure the camera will use a relatively low ISO to preserve image quality, you can set this value down to 400 or 800. If you are shooting in dark conditions and your priority is to make sure you can capture the image even if image quality suffers, you might want to set a high limit, such as 12800. As indicated by its name, this option does not have any effect for motion picture recording. (There is a similar setting for movies on the Motion Picture menu.)

MINIMUM SHUTTER SPEED

This next option on the Recording menu lets you set the minimum (slowest) shutter speed the camera should use when Auto ISO or Intelligent ISO is in use. This option is available for use only in the Program and Aperture Priority shooting modes. The purpose of this setting is to avoid having the camera set a low ISO value that results in the use of a relatively slow shutter speed, and possible motion blur. For example, if you are photographing active children at play, you may want to set the minimum shutter speed to a value such as 1/250 second, so you will be fairly sure to freeze their actions without blurring.

This setting can be anywhere from a full second to 1/16000 of a second, or Auto; just select the desired value on the sub-menu that pops up when you select this option. If you choose Auto, the camera will select a shutter speed based on its own evaluation of the lighting conditions. Even if you choose a specific value such as 1/500 second, the camera may set a slower shutter speed if necessary to achieve a normal exposure.

LONG SHUTTER NOISE REDUCTION

When you take a picture using a shutter speed of several seconds, the image sensor may generate visual noise because of the way its circuitry reacts to long exposures. If you turn on the Long Shutter Noise Reduction menu option, the camera will use noise-reduction processing that lasts as long as the exposure itself to reduce the noise. For example, if your exposure lasts for 12 seconds, the camera will continue processing the image for another 12 seconds after the exposure ends. This action will delay your ability to take another shot, and the processing can reduce the details in your image. If you don't want to experience this delay or if you want to deal with the possibility of noise some other way (such as using software to reduce it), turn this option off.

This option is available only in the PASM shooting modes. It is not available for motion picture or panorama recording, when Post Focus is active, when recording with the 4K Photo feature, or with the electronic shutter.

DIFFRACTION COMPENSATION

When the camera uses a narrow aperture such as f/11.0 or f/16.0, the diffraction effect comes into play and can cause distortion in the image. If you set the Diffraction

Compensation option to Auto, the camera uses its processing to counteract that effect, when needed. If you would rather deal with that issue with your post-processing software or leave it untouched, choose Off. This option is available with all shooting modes except Intelligent Auto and Intelligent Auto Plus.

The options on screen 3 of the Recording menu are shown in Figure 4-59

STABILIZER

The LX100 II is equipped with an optical image stabilization system that counteracts the effects of camera shake on the image. This system has three possible settings, as shown in Figure 4-60, from top to bottom: Normal, Panning, and Off.

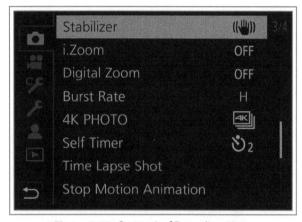

Figure 4-59. Screen 3 of Recording Menu

Figure 4-60. Stabilizer Menu Options Screen

With the Normal setting, the camera corrects for both horizontal and vertical motion. With the Panning setting, the camera assumes that you are moving the camera from side to side in order to pan over the scene, so it does not attempt to correct for horizontal motion, only vertical. I generally leave this setting at

Normal when I am hand-holding the camera. If I have the camera on a tripod, the setting is unnecessary and possibly could cause some distortion as the camera tries to correct for camera movement that does not exist.

The Normal stabilization setting is not available when you are shooting panoramas. The Panning setting is not available when recording movies or using 4K Photo or Post Focus. The Stabilizer menu option is not available for selection in the basic Intelligent Auto mode.

INTELLIGENT ZOOM

The Intelligent Zoom, or i.Zoom, option is related to the i.Resolution feature, discussed earlier, although you do not have to turn on i.Resolution in order to take advantage of i.Zoom. When i.Zoom is turned on, the camera automatically takes advantage of i.Resolution processing in the zoom range to improve the appearance of the image, so you can zoom to a higher level of magnification without image deterioration, using either normal optical zoom or Extended Optical Zoom. (As discussed earlier in this chapter, Extended Optical Zoom is available when Picture Size is set to Medium or Small, because extra pixels are available for enlarging the image.)

For example, without the i.Zoom setting, the limit for the optical zoom is about 3x; with i.Zoom turned on, the maximum is about 6x. The question of image quality in this situation is a matter of judgment; as with i.Resolution, I recommend that you try this setting to see if you are satisfied with the quality of the images. If so, you can use an effective zoom range up to 150mm, rather than the 75mm of the optical zoom alone. (The range can be even greater if combined with Digital Zoom and Extended Optical Zoom, although the quality of the image will suffer with excessive zoom range in effect.)

The i.Zoom feature is not available in conjunction with certain types of shooting that involve special processing, including panorama shots, shots with the Raw format, Multiple Exposure, shots using the HDR, iHDR, or iHandheld Night Shot options, or shots using the Filter Effect settings of Impressive Art, Toy, or Toy Pop. This feature is automatically turned on in Intelligent Auto and Intelligent Auto Plus modes.

DIGITAL ZOOM

With Digital Zoom, unlike Intelligent Zoom and Extended Optical Zoom, the image quality "deteriorates," to use Panasonic's terminology. As with many digital cameras, Digital Zoom is available on the LX100 II as a way of enlarging the pixels that are displayed so the image appears larger; there is no additional resolution available, so the image can quickly begin to appear blocky and of low quality.

As with Extended Optical Zoom and Intelligent Zoom, this option can help you in viewing a distant subject. Digital Zoom has a maximum power of four times the normal lens's magnification, or 300mm. When you combine all of the zoom options, including Digital Zoom and using a smaller picture size for Extended Optical Zoom, there is a maximum total zoom power of about eight times normal, or 600mm.

Digital Zoom is not available in Intelligent Auto or Intelligent Auto Plus mode, with panorama shooting, or with some other settings, including Raw quality, Post Focus, Multiple Exposure, HDR, or with the Filter Effect settings of Impressive Art, Toy, Toy Pop, or Miniature. It also is not available when either Monitor Display Speed or LVF Display Speed, both of which are on screen 2 of the Setup menu, is set to Eco30fps.

BURST RATE

This next item on the Recording menu controls the rate for burst shooting. The control for selecting burst shooting from the shooting screen is the Down button, which activates the drive mode settings, including burst shooting, 4K Photo, Post Focus, the self-timer, and panorama shooting, as discussed in Chapter 5.

When you press the Down button and activate burst shooting from the drive mode menu, you have the option to set the burst rate from that menu. However, you also can set the burst rate ahead of time from this Recording menu item. In that way, you will save a step when you press the Down button to select burst shooting from the drive mode options.

The choices for burst rate are H, M, and L, for high, medium, and low. I will discuss those options in Chapter 5, in connection with the drive mode options.

4К Рното

The 4K Photo menu option, like the Burst Rate option, works together with the continuous-shooting features of the LX100 II. 4K Photo is a special type of burst shooting that involves recording a sequence of images using the 4K video format. It has three sub-options, for use in different types of situations.

You can activate 4K Photo from the drive mode menu by pressing the Down button from the shooting screen, or by pressing a function button that has been assigned to that operation, as discussed in Chapter 5.

As with normal burst shooting, you can choose a sub-option for 4K burst shooting after you select 4K Photo using one of the above methods. However, you also can use the 4K Photo menu option to select the 4K shooting sub-option ahead of time, to save time when you press a button to activate 4K shooting. I will discuss the details of the various 4K Photo settings in Chapter 5, where I discuss the physical controls.

SELF-TIMER

The next menu option is another one that lets you adjust settings that are normally made through the drive mode menu after pressing the Down button from the shooting screen. With this option, you can set the self-timer to a delay of two seconds or ten seconds for a single shot, or to a delay of ten seconds with a series of three shots. In Chapter 5, I will discuss how to make these settings from the drive mode menu.

TIME LAPSE SHOT

The Time Lapse Shot option lets you shoot a time-lapse series of photographs. You probably have seen sequences in the movies or on television in which an event that takes a fair amount of time, such as a sunset, a flower opening, clouds moving across the sky, or a parking lot filling up with cars, is shown in a speeded-up series of images, so it appears to happen in a few seconds.

The LX100 II can use its time-lapse feature with any shooting mode, including Intelligent Auto. If you use the more advanced shooting modes, you have access to all of the major settings for your images, including Raw quality, white balance, ISO, and others.

To use this feature, highlight Time Lapse Shot on the Recording menu and press the Right button to move to the setup screen. On that screen, use the direction buttons or the control dial (or the touch screen) to navigate through the options. Select a start time, the interval between shots, and the total number of shots. The interval can be set to any value from one second to 99 minutes 59 seconds. One point to bear in mind when setting the interval is that, if the lighting is very dim, the camera may need to set a long shutter speed.

For example, if the camera is set to use a shutter speed of one minute, which requires a long time for in-camera processing after the exposure is made, this system will not succeed if the interval between shots is set to less than two minutes. The total number of shots can be any number up to 9,999.

You also have the option of setting the interval between shots to zero. You can do that by setting the Shooting Interval Setting option to Off. In that case, the camera will capture all of the images in succession, without pausing for any length of time between shots. You might want to use that option if you are taking a very large number of shots and you want to be able to have them spaced closely together so you can choose the ones you want to use later. In effect, this option can be used as a sort of unattended burst shooting, if you leave the camera on a tripod and set it to take hundreds of shots with no interval between them.

When you have made all of the settings as you want them, press the Menu/Set button, then select Start from the main options screen. The camera will display a message prompting you to press the shutter button when you're ready to start the sequence.

When you press the shutter button, the camera will take the images at the specified interval (if any) and will repeat the process until the total number of images has been recorded. Of course, if the battery runs down or the memory card fills up, the process will end prematurely. (You can use the optional AC adapter to avoid a power issue; see Appendix A.) At any time, you can press the Fn1 button and the camera will display a screen asking if you want to continue, pause, or end the process.

When the sequence is complete, either after the full series has been taken or after an interrupted series, the camera will display a message asking if you want it to create a movie using the recorded images. If you say yes, it will take some time to process the movie, which you can then play like any movie.

If you say no to creating the movie, assuming you have a detailed display screen selected in playback mode, the first image in the series will be displayed with indications showing that you can press the Up button to play back the sequence quickly, like a short movie.

If you press the Down button, you will see icons for two choices. If you press the Up button, the camera will display a sub-menu that gives you the options of displaying the images sequentially one by one or uploading them by Wi-Fi. (The uploading process is discussed in Chapter 9.) Otherwise, you can immediately play the images from the time lapse sequence sequentially. Press the Down button to return to normal playback mode.

If you don't create a movie from the shots at this point, you can do so later using the Time Lapse Video option on screen 3 of the Playback menu, as discussed in Chapter 6.

STOP MOTION ANIMATION

This next feature is similar to Time Lapse Shot, because it involves taking a series of still images, which the camera then combines into a movie. The difference is that this option is intended for use in animating objects, such as clay figures or puppets. You also can use it to make an animated movie based on drawings, as is done for cartoons and animated feature films. You need to move the figure or change the drawing very slightly for each new shot. You will need a large number of images to create a movie of any length. For example, if the final movie is to be shown at 30 frames per second, you will need to take 30 images for every second of the movie, changing the position or other aspect of the subject slightly for each successive image.

When you select this option, you will see a screen with options for Start, Auto Shooting, and Shooting Interval. The interval option will not be available unless you first turn on Auto Shooting. If you turn on Auto Shooting, the camera will capture images on its own at the interval you specify, from one second to 60 seconds. Otherwise, you will have to trigger the camera yourself when you are ready for each shot. Because it is critical to keep the camera absolutely still throughout the image-taking process, it is advisable to use the Auto Shooting option so you will not have to touch the camera to take each shot. If you do not use Auto Shooting, you can

control the camera from a smartphone or tablet by remote control, as discussed in Chapter 9.

Chapter 4: The Recording Menu and the Quick Menu

You may want to use the optional AC adapter, discussed in Appendix A, to make sure the camera does not lose power during the shooting. However, if the camera does turn off, you can resume the series of shots when it is turned back on. It will prompt you to do so if the series has been interrupted.

Figure 4-61. Stop Motion Animation Shooting Screen

While the shooting is in progress, the camera will display an icon showing a series of frames at the right side of the display with the cumulative number of shots taken so far, as shown in Figure 4-61. It also will display an overlaid image of the previous two shots, to help you line up the next shot properly with the figure or drawing in the proper position.

When you have finished your series of shots, press the Stop Motion icon, or press the Menu/Set button and go to the Stop Motion Animation menu item. Press Menu/ Set when that item is highlighted, and the camera will ask whether you want to stop the shooting series. If you say yes, it will ask if you want to create the video now. If so, it will prompt you for the settings to use, including recording quality, frame rate, and whether to run the sequence forward (normal) or in reverse. For the best quality, you should select 60p for the recording quality and 60 frames per second for the frame rate (in the United States), but 30p and 30 fps will still provide a smooth flow of action. Lower settings will produce more jerky footage. Select OK when the settings are made as you want, and the camera will create the video. You can play it back in the camera by pressing the Up button.

If you don't create a movie from the shots at this point, you can do so later using the Stop Motion Video option on screen 3 of the Playback menu, as discussed in Chapter 6. As with the Time Lapse Shot option, you can view the shots in playback mode as a quick sequence using the Up button or individually from the sub-menu called up by the Down button.

The items on screen 4 of the Recording menu are shown in Figure 4-62.

Figure 4-62. Screen 4 of Recording Menu

PANORAMA SETTINGS

Panorama shooting with the LX100 II is selected from drive mode, which is reached by pressing the Down button on the back of the camera. The Panorama Settings menu option gives you two sub-options for choosing the direction and size of the panorama shots you capture. When you select this menu option, you will see the two sub-options: Direction and Picture Size.

The Direction item determines the direction (right, left, up, or down) that you move the camera in while shooting the panorama. The Picture Size setting lets you choose Standard or Wide for the size of the panorama. With the Standard setting, a horizontal panorama has a width of 8176 pixels and a height of 1920 pixels. A vertical panorama has a width of 2560 and a height of 7680. With the Wide setting, a horizontal panorama has a width of 8176 and a height of 960, but it covers a wider area than a Standard panorama. If you want the highest quality, choose Standard; choose Wide if you need to include a very wide view in the image.

Because of the different sizes of panoramas taken with the horizontal and vertical orientations, you can use the direction settings with different orientations of the camera to achieve different results than usual. For example, if you set the direction to Down and then hold the camera sideways while you sweep it to the right, you will create a horizontal panorama that has 2560 pixels in its vertical dimension rather than the standard 1920.

I will discuss other aspects of panorama shooting in Chapter 5, where I discuss drive mode.

SILENT MODE

The Silent Mode option gives you a quick way to turn off the lights and sounds made by the camera that might distract a subject or cause a disturbance in a quiet area. When you turn this option on, the camera switches to using the electronic shutter, which is quieter than the mechanical shutter; silences all beeps and other sounds for matters such as focus and shutter operation; forces the flash off; and turns off the AF assist lamp. However, the lamp will still light up to indicate use of the self-timer, and the blue wireless connection lamp will illuminate if you use that feature. If you will often use this feature, you can include it as part of a group of saved settings with the Custom Set Memory option, or you can assign it to a function button.

SHUTTER TYPE

The LX100 II is equipped with two different types of shutter—electronic and mechanical. With this menu option, you can set up the camera to choose the shutter type automatically, or you can select one or the other shutter type for use. The three options for this setting are Auto, MSHTR, and ESHTR. With Auto, the camera will choose the shutter type based on the current settings and conditions. With MSHTR or ESHTR, it will use only the mechanical or electronic shutter, depending on your selection.

For most purposes, the mechanical shutter is the better option. With that choice, the camera operates a physical iris with leaves that open and close to allow light to pass through to the sensor. With the electronic shutter, the circuitry in the camera starts and stops the exposure, with no mechanical parts involved. So, in some cases, the electronic shutter can produce a faster shutter speed than the mechanical one. Also, because of the lack of moving parts, the camera can remain silent when the electronic shutter is activated. However, using the electronic shutter can result in a "rolling" effect that distorts images or videos, especially if the camera or subject is moving horizontally.

If you select Auto or ESHTR, the shutter speed can be set as fast as 1/16000 second; with MSHTR, the fastest speed available is 1/4000 second.

In some other cases, too, there are limitations on the ability of the camera to use certain shutter speeds with the mechanical shutter. For example, when the camera is set to an aperture value wider than f/4.0 (such as f/2.0), the fastest shutter speed available with the mechanical shutter is 1/2000 second. In Manual exposure mode, if you have Shutter Type set to Auto and set a shutter speed of 1/4000 second while aperture is set to a value wider than f/4.0, the camera will automatically switch to the electronic shutter so it can set the shutter speed you selected. The camera will place an icon with an E for electronic shutter in the top center of the display, as shown in Figure 4-63. If you have Shutter Type set to MSHTR, the shutter speed will be reduced to 1/2000 second.

Figure 4-63. Electronic Shutter Icon on Shooting Screen

I almost always leave this setting at Auto so the camera will use the electronic shutter when needed, but will use the mechanical shutter in most cases. One reason to turn on the ESHTR option would be if you want the camera to remain completely silent for a particular shooting session. Another way to make the camera silent is to select the Silent Mode menu option, discussed above. In that case, the camera will automatically activate the electronic shutter, even if the MSHTR option had been selected on the Recording menu.

BRACKET

The Bracket menu option gives you access to several ways to take a series of images with one press of the shutter button, using a different value for a particular setting for each of those images. In this way, you will

have several images to choose from, increasing your chance of having one that suits your needs for that setting. The settings that can be varied are exposure, aperture, focus, white balance, and aspect ratio. After highlighting the Bracket menu option, select it to move to the next screen, shown in Figure 4-64.

On that screen, select Bracket Type, and the camera will display the menu shown in Figure 4-65, with a vertical line of five icons.

From the top, the first four icons represent exposure bracket, aperture bracket, focus bracket, white balance bracket, and aspect bracket. I will discuss each of these in turn below.

Exposure Bracket

When you select this first bracket option, the camera varies the exposure within a range you select so you will have several differently exposed images to choose from. This option gives you an added chance of getting an optimal exposure. If you're shooting with Raw quality, exposure is not so much of an issue, because you can adjust it later with software, but it's always a good idea to start with an exposure that's as accurate as possible.

Figure 4-64. Bracket Main Options Screen

Figure 4-65. Bracket Type Selection Screen

Also, you can use this feature to take several differently exposed shots that you can merge into a single HDR (high dynamic range) image, to cover a wider range of lights and darks than any single image could. This merging can be accomplished with software such as Photoshop (use the command File-Automate-Merge to HDR Pro) or a specialized program such as PhotoAcute or Photomatix Pro. For HDR shooting, I suggest you set the interval between exposures to the largest available, which is 1 EV (exposure value). If possible, you should use a tripod so all images will include the same area of the scene and can be easily merged in the software.

Once you have selected this option from the Bracket menu, the More Settings menu option becomes available for selection. Select it, and the camera displays the screen shown in Figure 4-66, with options for Step, Sequence, and Single Shot Setting. First, select Step, which lets you choose the interval for the exposure difference among the multiple shots the camera will take.

Figure 4-66. Exposure Bracket Details Screen

When you press the Menu/Set button with that option highlighted, the camera displays the screen shown in Figure 4-67, which lets you set the number of exposures and the EV interval.

Figure 4-67. Exposure Bracket Shots and Intervals Screen

Turn the control dial, press the Up and Down buttons, or touch the screen icons to scroll through the nine possible options. These options let you choose three, five, or seven images, taken at EV intervals of 1/3, 2/3, or one. For example, if you select the 5•2/3 option, the camera will take five images with an interval of 2/3 stop between them. Press the Menu/Set button when your chosen option is highlighted, to confirm it.

After setting the Step option, select Sequence on the Exposure Bracket Details screen. The camera will display two options at the right side of the screen: 0/-/+ and -/0/+. With the first option (the default), the exposures will be in order of normal exposure, followed by lower and then higher. With the second option, the exposures will be in order of lowest to highest. As you can see in Figures 4-66 and 4-67, the camera will display markers at the bottom of the screen indicating the order in which the images will be taken, using your chosen settings.

Next, proceed to the Single Shot Setting option and select it. The camera will display two options, the top one showing an icon for a single frame and the bottom one with an icon for multiple frames and an arrow.

With the top option, the camera will take the multiple (three, five, or seven) shots individually; with the bottom option, the camera will take all of the shots in a continuous burst and you will hear multiple shutter sounds as the exposures are recorded. You may want to use the individual-shots option if you need to pause after each exposure so you can evaluate the scene, adjust costumes or props, and the like. With that setting, you have to press the shutter button to take each shot in the series.

When exposure bracketing is turned on, the camera displays a BKT icon above the EV scale in the bottom center of the display.

You also can get access to exposure bracketing from the exposure compensation screen, when exposure compensation is assigned to a function button or the control ring. After pressing the assigned button to display the exposure compensation scale, press the Up button again to select an option for exposure bracketing. (This option does not work when exposure compensation is adjusted using the exposure compensation dial.)

Aperture Bracket

This option, which is available only in Aperture Priority or Manual exposure mode, sets the camera to take a series of images using different aperture settings, so you can test various approaches in order to increase the depth of field or blur the background. After you select the F icon on the Bracket Type menu that represents the f-stop (aperture), select the More Settings menu option and you will see a screen with Image Count available for selection.

Select Image Count, and you will see a screen with choices of 3, 5, or All, to select the number of different aperture settings the camera will use in its aperture bracket set. Press Menu/Set when your selection is highlighted, then press the shutter button halfway or press the Fn3 button multiple times to return to the shooting screen. The camera will display a small BKT icon above the number of the f-stop that is currently selected. You can still change the initial aperture setting for the bracket; turn the aperture ring to do so.

When you are ready, press the shutter button and the camera will take the specified series of images in a burst, starting with the aperture that is currently set. The order of the images is determined by the initial aperture and that aperture's position on the aperture scale. For example, if the initial aperture is f/1.7 and three images are selected for Image Count, the resulting images will be at f/1.7, f/2.0, and f/2.8.

If the initial aperture is f/8.0, the three images will be at f/8.0, f/5.6, and f/11.0. If Image Count is set to All and the initial aperture is f/5.6, the order of the images taken will be f/5.6, f/4.0, f/8.0, f/2.8, f/11.0, f/2.0, f/16.0, and f/1.7, because it would not be possible for the images to proceed in ascending or descending order through the whole group of apertures. Of course, if the lens is zoomed in, the widest aperture that can be included in the series will be f/2.8, because that is the widest aperture available at the longer focal lengths.

As noted above, the Aperture Bracket option is available only with the two shooting modes in which it is possible for the user to change the aperture: Aperture Priority and Manual exposure. However, with Manual exposure, Aperture Bracket is available only when Auto ISO is in effect.

Focus Bracket

This next option for bracketing sets the camera to take a series of images with different focus settings, so you can decide later which image has the focus point in the best location for your needs. This option helps avoid the frustration of finding out after the fact that the camera focused on the wrong subject, or that the focus was slightly off of the subject you wanted to concentrate on. You can cause the camera to produce a large number of alternative shots and choose the one(s) with the best focus at your leisure.

After you select Focus on the Bracket Type menu, select the More Settings menu item, and the camera will display a screen with options for Step, Image Count, and Sequence. You can set Step to any value from 1 to 10, which determines how much the camera will alter focus from one image to the next. Image Count can be set to any number from 1 to 999. If Sequence is set to 0/-/+, the camera varies the focus to points both closer and farther from the lens than the original focus point. If Sequence is set to 0/+, then the camera varies the focus only to points farther from the lens than the original focus point.

You can use focus bracket with either autofocus or manual focus. When it is in effect, the camera displays a BKT icon above the focus mode icon in the upper right corner of the display. To take the bracketed images, press the shutter button once; you don't have to hold it down.

With the focus bracket option, the resulting images are treated by the camera as a burst of shots. That means that, in order to view them in the camera, you need to use the playback controls for bursts. For a burst of focus bracket images in playback mode, the camera displays an icon at the lower left of the screen that says Focus, with a down-pointing arrow. This means that, in order to view the images within the burst, you have to press the Down button.

After you do that, the icons on the screen change, indicating that you can now view the individual images in the focus bracket series by scrolling through them with the normal playback controls. You can then use the Right and Left buttons, the control dial, or the touch screen to scroll through the images to find the ones with the best focus.

The numbers in the upper right corner, such as 7/11 for example, indicate the position of the current image as the seventh in a series of eleven images. You will not be able to view any images outside of that set of images unless you press the Down button again to return to the normal playback mode, in which the focus bracket burst is displayed as a single image. You also can press the Up button, which takes you to a screen for uploading the images via Wi-Fi, as discussed in Chapter 9.

Of course, you also can use the Post Focus option, which uses the camera's 4K video recording capability to record a burst of images from which you can select those with the best focus, but focus bracket lets you use more of the advanced Shooting menu options, without the constraints imposed by using 4K video-oriented settings.

White Balance Bracket

Before selecting white balance bracket, make sure you have the white balance setting selected as you want it; as I will discuss in Chapter 5, that setting is made by pressing the Right button and selecting an option such as Auto White Balance, Daylight, Cloudy, Shade, and the like. Once that setting has been made, go to the Bracket menu option and select WB for the Bracket Type option, then select the More Settings menu item. The camera will display the white balance color axes screen, as shown in Figure 4-68. This screen includes a color chart with two axes, labeled G-M for greenmagenta and A-B for amber-blue.

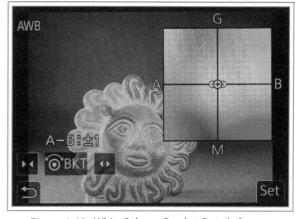

Figure 4-68. White Balance Bracket Details Screen

With this screen displayed, decide on which axis to set the bracketing: amber-blue or magenta-green. If you want to use amber-blue, turn the control dial to the right; if you want to use magenta-green, turn that dial to the left. As you turn the dial in either direction, you will see small circles spread apart on the chosen axis. The circles will move further apart as you continue to turn the dial. You also can adjust the circles using the touch screen arrow icons on either side of the BKT and dial icons on this screen.

The final positions of the circles on one of the color axes indicate the differences among the three shots that the camera will take. If you have also made an adjustment to the overall white balance setting using the adjustment screen (as discussed in Chapter 5), the white balance bracketing will take the adjustment into account and bracket the exposures with the adjustment factored in.

For example, Figure 4-69 shows white balance bracketing set up to take its three shots with fairly large differences along the amber-blue axis.

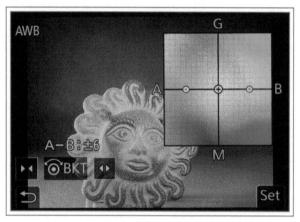

Figure 4-69. White Balance Bracketing Set Up

Once the circles are set up as illustrated here, press the Fn3 button until the shooting screen is restored, or press the shutter button halfway to return to that screen.

The display will show the BKT icon just above the icon for the white balance setting, in the lower right corner. When you press the shutter button, the camera will take three pictures with different white balance adjustments, from more amber to more blue. You will only hear the sound of the shutter once, though; the camera alters the white balance settings electronically. To cancel the bracketing, return to the adjustment screen and press the Display button.

This function does not work with Intelligent Auto mode, Raw images, or with certain other settings, including HDR, 4K Photo, Post Focus, burst shooting, Filter Effect settings, Time Lapse Shot, or panorama shooting.

You also can turn on White Balance Bracket without using this menu option. After pressing the Right button to get to the white balance menu, press the Down button to get to the adjustment screen, then turn the control dial (or use the touch screen) to set the bracketing as you want it.

Aspect Bracket

The last sub-option for the Bracket menu item is Aspect Bracket, represented by the icon showing four different frame shapes, as shown in Figure 4-65. This option has no additional settings. When you select Aspect Bracket, the camera will display four colored frames on the shooting screen that represent the four aspect ratio settings: 3:2, 16:9, 1:1, and 4:3. When you press the shutter button, the camera will capture four versions of the scene, one in each of those aspect ratios. This option does not work with Raw images, burst shooting, or the Toy Effect or Toy Pop settings for Filter Effect.

None of the bracketing options are available with the basic Intelligent Auto mode, Panorama shooting, or when shooting movies, nor with several other settings, including some Filter Effect options. The flash can be used with White Balance Bracket or Aspect Bracket, but not with the other Bracket settings. Bracket options are not canceled when the camera is turned off, so be sure to cancel any bracket setting when you have finished using the feature.

HDR

The HDR option lets you set the camera to take several images in a burst and combine them internally to form an HDR (high dynamic range) composite image, rather than using the conventional techniques of HDR photography. Those techniques were developed because cameras, whether using film or digital sensors, cannot record images that retain clear details when the scene includes wide variations in brightness. If part of the scene is in dark shadows and another part is brightly lighted, the scene has a "dynamic range" that may exceed the ability of the camera to expose both the dark and the bright areas in a way that looks good to the human eye.

A few years ago, the primary way to deal with this issue was to take multiple shots of the scene using different exposure settings, so the photographer has a range of shots, some exposed to favor dark areas, and some for bright areas. The photographer merges the images

using Photoshop or special HDR software to blend differently exposed portions from all of the shots. The end result is a composite image that can exhibit clear details in all parts of the image.

With the LX100 II, Panasonic provides several settings for processing shots with wide dynamic range. I discussed earlier the Highlight Shadow, Intelligent Dynamic, and iHDR menu options, as well as the High Dynamic Filter Effect setting. The HDR option is the most direct approach to using traditional HDR techniques.

To use this option, highlight the HDR menu item and press the Right button or the Menu/Set button (or the menu option on the touch screen) to pop up the menu with sub-options.

Select the Set item from that sub-menu, and you will see a menu with choices of Dynamic Range and Auto Align. Highlight Dynamic Range, press the Menu/Set button, and you will see the screen shown in Figure 4-70, letting you choose the exposure interval among the three shots the camera will take.

You can choose Auto, which causes the camera to choose an interval, or you can choose a specific EV interval of one, two or three stops. Use the higher settings for scenes involving relatively large degrees of contrast, such as a view including a shaded area next to an area in bright sunshine.

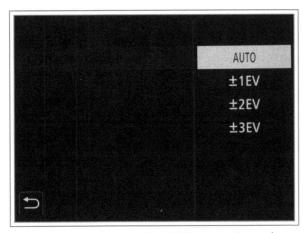

Figure 4-70. Screen to Set HDR Exposure Interval

When you have set the interval, go back to the Auto Align option on the menu and set it either on or off. If it is turned on, the camera will do its best to align the three shots automatically when it processes them internally. However, in doing so, it will crop them slightly in order to delete the outer edges of areas that

are not in alignment. This setting is useful for handheld shots. If you are using a tripod, it is better to leave Auto Align turned off.

When the settings are made, go back to the main HDR menu and set HDR to On. Then aim at the subject and press the shutter button. You will hear the shutter fire three times and a composite image will be saved to the memory card.

To test this feature, I took several shots of a garden area that was partly in sun and partly in shadow. In Figure 4-71, I took a shot with HDR turned off. In Figure 4-72, I used the HDR setting at an interval of EV1, and in Figure 4-73 I used an interval of EV3. Then, for Figure 4-74, I took a series of images using Manual exposure mode at various exposure levels and combined them using Photoshop's HDR merging feature.

As you can see, the camera's HDR menu option did a fairly good job of reducing the heavy contrast, with more even exposure at the higher HDR setting. The composite image from the HDR software did a better job, but that is to be expected. The in-camera HDR option is a useful one when you are confronted with a scene with sharp contrast between light and dark areas.

Figure 4-71. HDR Example: HDR Off

Figure 4-72. HDR Example: HDR EV1

Figure 4-73. HDR Example: HDR EV3

The HDR menu option is not available when using flash, burst shooting, Raw for quality, Time Lapse Shot, 4K Photo, Post Focus, any form of bracketing, panorama shooting, or Stop Motion Animation using the Auto Shooting setting. This option is available only in the four advanced (PASM) shooting modes.

Figure 4-74. HDR Example: Photoshop Composite

MULTIPLE EXPOSURE

Multiple Exposure, the final option on the Recording menu, is more in the category of creative photography than control of normal image-making. It lets you create double, triple, or quadruple exposures in the camera.

On the Recording menu, highlight Multiple Exposure, then press the Right button (or touch the menu option on the screen), which takes you to a screen with the word Start highlighted. Unless you want to overlay new images on an existing Raw image, as discussed below, make sure Overlay is set to Off. Then press the Menu/ Set button to select Start. The screen will have the words Fn3 End displayed; you can press the Fn3 button to end the process if you have had second thoughts.

If you are going to proceed, compose and take the first picture. At this point the screen will display the image you just took along with the choices Next, Retake, and Exit. If you're not satisfied with the first image, scroll to Retake and select that option with the Menu/Set button, then retake the first image. If you're ready to proceed to taking a superimposed image, leave Next highlighted and press the shutter button halfway down, or, if you prefer, press the Menu/Set button to select Next. Either action produces the interesting effect of leaving the first image on the screen and making the screen live at the same time to take a new image.

Compose the second shot while viewing the first one, and press the shutter button fully to record that image. You can repeat this process to add a third image, retake the second image, or exit the whole process. You can then add a fourth image if you want. When you are done, you will have a single image that combines the two, three, or four superimposed images you recorded.

Before you capture images using the Multiple Exposure procedure, the menu gives you the option of setting Auto Gain on or off. If you leave it on, the camera adjusts the exposure based on the number of pictures taken; if you turn it off, the camera adjusts the exposure for the final superimposed image. In my experience, the On setting produces results with clearer images of the multiple scenes; Off produces images that may have excessive exposure.

You also have the option of starting with a Raw image that was taken earlier by this camera. It has to be a Raw image, not a JPEG one, and it has to have been taken in a mode in which Multiple Exposure is available, which means one of the PASM modes.

To use this option, set the Overlay option of the Multiple Exposure menu item to On. Then, from the Multiple Exposure screen, highlight Start and press the Menu/Set button. The camera will display your images in playback mode. Scroll through them until you find the Raw image you want to use as the first image in the multiple exposure series. When it is displayed, press the Menu/Set button to select it as the first image of the series. Then line up the next image, with the Raw image displayed on the screen, and press the shutter button to take the next image; it will be overlaid over the existing Raw image. You can then proceed with the rest of the sequence, as before.

Figure 4-75. Multiple Exposure Example

Figure 4-75 shows the final result of using the Multiple Exposure feature to include images of a ukulele with its case both open and closed. I adjusted this image somewhat in Photoshop to add contrast and darken it.

The Multiple Exposure option is not available when doing panorama shooting or using Filter Settings, Time Lapse Shot, or Stop Motion Animation.

Another kind of multiple exposure, involving a series of images of a subject in motion along a path, can be created using the Sequence Composition feature, as discussed in Chapter 6.

Quick Menu

The LX100 II has another menu system with settings for recording images and videos. (I will discuss the menu for movie settings in Chapter 8.) The Quick Menu is not part of the regular menu system; instead, you get access to it by pressing the Fn2/Q.Menu button, located at the upper left of the control area on the camera's back. (I am assuming the Fn2 button is assigned to the

Quick Menu function, as it is by default; as discussed in Chapter 5, that button can be assigned to another function, and another button can be assigned to the Quick Menu function.)

When you press the Q.Menu button while the camera is in recording mode, a mini-version of the camera's menu system opens up, with several options in two lines, one at the top of the screen and one at the bottom, as shown in Figure 4-76 (showing the line of options at the top) and Figure 4-77 (showing the line of options at the bottom).

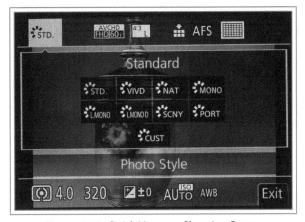

Figure 4-76. Quick Menu on Shooting Screen

Navigate through these menu options by pressing the Left and Right buttons, by turning the control dial, or by touching icons on the screen, until you find the category you want. The name of the setting that is currently active will appear near the top of the screen for items in the bottom row, and near the bottom of the screen for items in the top row.

For example, in Figure 4-76, the Photo Style icon is highlighted at the top of the screen, and its name appears near the bottom of the screen. The highlight will wrap around between the bottom and top of the screen, so you can keep turning the control dial or pressing the Left and Right buttons to cycle through all of the items continuously.

If the item you highlighted is at the top of the screen, you can press the Down button to move down to the row or rows of icons with settings for that item. If the highlighted item is at the bottom of the screen, press the Up button to move to the row or rows of icons with settings. For example, Figure 4-77 shows the white balance item highlighted at the bottom of the screen. To move to the icons with settings for white balance, you

would press the Up button to move the highlight into the area in the middle of the screen with those icons.

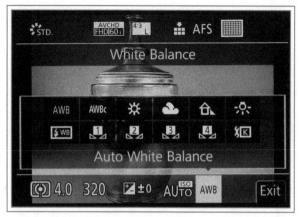

Figure 4-77. White Balance Highlighted on Quick Menu

Once you have highlighted the icons with settings, move left and right through the sub-menu with the direction buttons, control dial, or touch screen. When you have highlighted the setting you want to make, you can then move to another item in the Quick Menu to make another setting. When you have finished making settings, press the Menu/Set button, the Q.Menu button, or the Exit icon in the lower right corner of the screen to exit from the Quick Menu to the recording screen. You also can press the shutter button halfway to return to that screen.

The menu options vary according to what mode the camera is in; not surprisingly, the Quick Menu offers the largest variety of choices when the camera is in Program, Aperture Priority, Shutter Priority, or Manual mode. It offers a smaller variety in Intelligent Auto mode, though it still offers some choices.

The Quick Menu is a useful alternative to the Recording menu. This system lets you make certain settings very efficiently that otherwise would require a longer time, in part because you can see all available options at the same time on the screen as soon as you press the O.Menu button.

For example, I find that the Quick Menu is an excellent way to select Raw or Fine quality for still images. Access to the feature is very fast this way, and, even better, when you later press the Q.Menu button again to go back to change the Quality setting again, the Quality option is still highlighted, and it takes just a couple of button presses or touches of icons on the screen to change from Raw to Fine or vice-versa.

You can customize the settings included on the Quick Menu using the Quick Menu item on screen 3 of the Custom menu. I will discuss that process in Chapter 7.

CHAPTER 5: PHYSICAL CONTROLS

ot all settings that affect the recording of images and videos are on the Recording menu. Several important functions are controlled by physical buttons and switches on the LX100 II. I have already discussed some of them, but to include information about these controls in one place, I'll discuss each control in this chapter, some in greater detail than others. I'll start with the three items that are visible on the top of the lens barrel, as shown in Figure 5-1.

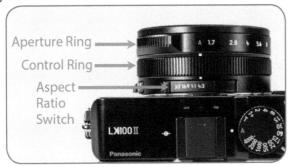

Figure 5-1. Controls on Top of Lens Barrel

Aspect Ratio Switch

This switch on top of the lens barrel has 4 settings: 3:2, 16:9, 1:1, and 4:3, representing the ratio of the width of an image to its vertical height. This setting does not affect just the shape of the image; it also helps determine how many megapixels (MP) an image contains. When the aspect ratio is set to 4:3, the maximum resolution of 17 MP is available. When the aspect ratio is set to 3:2, the greatest possible resolution is 16 MP. At 16:9, the greatest possible resolution is 15 MP. At the 1:1 ratio, the largest resolution available is 12.5 MP. If you want to view the scene using the entire area of the LCD screen, choose 3:2, which is the aspect ratio of the screen. With 4:3, there will be black bars at the sides of the screen as you compose your shot; with 16:9, there will be black bars at the top and bottom of the screen; with 1:1, there will be larger black bars.

Figure 5-2. Aspect Ratio 3:2

Figure 5-3. Aspect Ratio 16:9

Figure 5-4. Aspect Ratio 1:1

Figure 5-5. Aspect Ratio 4:3

Figures 5-2 through 5-5 illustrate the different shapes for images taken with the LX100 II's various aspect ratio settings. In Figure 5-2, the aspect ratio is set to 3:2. This aspect ratio crops the image slightly in the horizontal direction and somewhat more in the vertical direction. Figure 5-3 is an image taken with the 16:9 setting, which uses the maximum number of available horizontal pixels but the smallest number of vertical pixels of all aspect ratio settings. For Figure 5-4, the aspect ratio switch was set to the 1:1 position, which uses the maximum number of vertical pixels, and crops the horizontal pixels to match the number of vertical pixels. Finally, the 4:3 setting was used for Figure 5-5. This setting uses the maximum number of vertical pixels, but crops the pixels in the horizontal direction.

It's important to note that, even though the LX100 II does crop the image at least slightly with all aspect ratios, this cropping is not as severe as it is with many other cameras, because this camera uses an image sensor with 20.1 megapixels overall, but only uses up to 17.5 megapixels for any one image size, which gives the camera considerable leeway to produce the various aspect ratios without severely cropping any of them.

Aperture Ring

The aperture ring is the large ridged ring that surrounds the lens and is marked with aperture (f-stop) numbers from 1.7 (widest aperture) at the left to 16 (narrowest aperture) at the right. This ring is similar to the rings found on the lenses of some traditional film cameras. Its operation is simple and intuitive: Just turn the ring until the selected aperture is next to the white selection dot in front of the aspect ratio scale. Besides the aperture values that are designated on the ring, you

can turn the ring to intermediate values in 1/3-stop increments, such as f/2, f/2.5, f/3.5, f/4.5, f/7.1, f/9.0, f/13, and others. You can feel a gentle click as the ring stops at any of the values that can be selected.

In addition to selecting apertures, as discussed in Chapter 3, the aperture ring, along with the shutter speed dial, is used to select a recording mode. For example, to select Program mode, you set this ring and the shutter speed dial both to their A settings. For Shutter Priority Mode, set this ring to its A setting and set the shutter speed dial to a specific value. For Manual exposure mode, set this ring and the shutter speed dial both to specific values. For Aperture Priority mode, set the shutter speed dial to A and the aperture ring to a specific aperture value.

As I noted in Chapter 3, when the lens is zoomed in, the maximum aperture decreases. So, even if the aperture ring is set to the f/1.7 position, if the lens is then zoomed all the way in, the aperture value will change to f/2.8, which is the widest aperture available at that zoom setting. In that case, the aperture value will not agree with the setting on the ring.

Control Ring

The control ring is the unmarked ring located between the aperture ring and the aspect ratio switch. This control adds a great deal of convenience to the operation of the LX100 II through its ability to be customized according to your preferences.

Whenever the camera is set to manual focus mode, the control ring is used to adjust focus. Just turn the ring to adjust the distance at which the camera sets its focus. The display will vary according to settings you make for manual focus through the Custom menu.

When the camera is set to an autofocus mode, the control ring can control other options, according to how it is set through the Control Ring option on screen 3 of the Custom menu, as discussed in Chapter 7. If you use the default setting, the ring controls various functions depending on the shooting mode. In Shutter Priority and Manual exposure modes, turning the control ring selects shutter speeds other than those printed on the shutter speed dial, such as 1/1300 second and 1/5 second. In Intelligent Auto, Program, and Aperture Priority modes, the ring operates the step zoom feature,

discussed below. When you are shooting with the panorama setting of drive mode, turning the control ring selects a Filter Effect setting, unless you are using manual focus.

If you use the Control Ring menu option to select a setting other than the default, the ring can control a single setting, such as ISO, zoom, step zoom (discussed below), white balance, or Filter Effect settings. If you do that, the new setting will take effect for all recording modes, including when you are shooting panoramas, except when manual focus is in effect. With manual focus, the control ring always controls focus.

STEP ZOOM

As noted above, the step zoom feature is assigned to the control ring when the control ring is set to its default options, in Intelligent Auto, Program, and Aperture Priority modes. It also can be assigned to the ring for other modes, using the Control Ring menu option.

With this feature turned on, when you turn the control ring the lens zooms, but only to a series of specific focal lengths: 24mm, 28mm, 35mm, 50mm, 70mm, and 75mm. (Additional values are available if any of the extended zoom settings are turned on.) This setup allows you to select one of these specific settings easily. If you want to zoom the lens continuously instead, you can use the zoom lever, which will select any focal length, not just the designated steps. (You can set the zoom lever to use step zoom through the Zoom Lever option on screen 4 of the Custom menu.)

Next, I will discuss an important control that sits by itself on the left side of the lens barrel. This control, the focus switch, is seen in Figure 5-6.

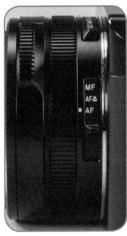

Figure 5-6. Focus Switch

Focus Switch

The focus switch has three positions: autofocus, autofocus macro, and manual focus. I have previously discussed autofocus, which is the standard setting to use for most shooting, when you want the camera to focus automatically on medium-range or distant subjects.

The next setting, autofocus macro, is for shooting macro, or closeup shots. When you move the focus switch to select this mode, the focusing range changes to a macro range. Instead of the normal focusing range of 1.6 feet (50 cm) to infinity at wide angle or telephoto, with the autofocus macro setting the lens can focus as close as 1.2 inch (3 cm) at wide angle and 12 inches (30 cm) at telephoto.

It is usually a good idea to turn the flash off when using macro focus, because the flash may not be useful at such a close range unless you diffuse it with translucent plastic or other material. It also is important to use a sturdy tripod for macro shooting when possible, because any camera motion can blur an image drastically at such a close distance. You also should use the self-timer, probably set to two seconds, to avoid causing blur by touching the camera during the exposure. As an alternative, you can control the camera remotely from a smartphone, as discussed in Chapter 9.

The other major option for focusing is manual focus, selected with the focus switch at the MF position. This option requires you to adjust focus yourself. In some situations, such as shooting in dark areas or areas behind glass, where there are objects at various distances from the camera, or when you're shooting a small object at a very close distance, and only a narrow range of the subject can be in sharp focus, it may be useful to control exactly where the point of sharpest focus lies.

To use manual focus, you turn the control ring to adjust focus manually. When you start turning the ring, the camera will enlarge the display to assist you in deciding when focus is sharp, as shown in Figure 5-7. (In recording modes other than Intelligent Auto, including Intelligent Auto Plus, you need to use the MF Assist option on screen 3 of the Custom menu to activate this enlargement feature. See Chapter 7 for details about the MF Assist menu option.)

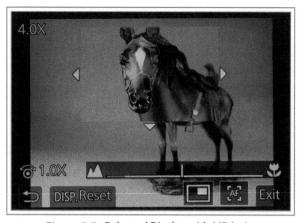

Figure 5-7. Enlarged Display with MF Assist

You can use the four direction buttons or scroll the touch screen with your finger to select the area that is enlarged, and you can turn the control dial (on the back of the camera), or pinch and pull the screen with your fingers, to change the enlargement factor. To reset the enlarged area to the center of the scene, press the Display button. To return to the normal-sized display, press the Menu/Set button. Continue turning the control ring until the part of the scene that needs to be in focus looks sharp and clear.

The camera also will add bright pixels to the display to outline areas that are in sharp focus, using a feature known as peaking. When an area of bright pixels appears at its strongest, the image should be in focus at that point. (The peaking feature is activated by default when the camera is in Intelligent Auto mode. You can turn it on or off through screen 5 of the Custom menu, when the camera is in any other recording mode.)

Next, I will discuss the several controls on the top of the camera, as shown in Figure 5-8.

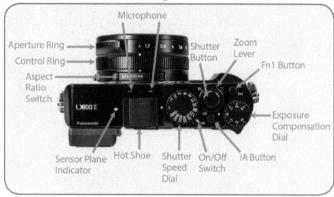

Figure 5-8. Controls on Top of Camera

Shutter Button

With default settings, you press this button halfway to check focus and exposure, and press it the rest of the way to record the image. You can press it halfway to wake the camera up from Sleep Mode, or to return to recording mode from a menu screen or from playback mode. You can press this button to take a still image while recording a video sequence, in most situations. When the camera is set for burst shooting or auto bracketing, you hold this button down to fire a burst of shots. When the shutter speed is set to T, for time exposure, in Manual exposure mode, you press this button once to open the shutter, and press it a second time to end the exposure. When you have turned on the 4K Photo option, pressing the shutter button starts and stops a 4K video recording. With that option selected, you cannot use the shutter button to take still images.

You can change the behavior of this button in a couple of ways using options on the Custom menu. With the Shutter AF item, you can disable the function of focusing when the button is pressed halfway. With the Half Press Release item, you can set the camera so a half-press of the shutter button will release the shutter. I will discuss those options in Chapter 7.

Zoom Lever

The zoom lever is the ring with a ridged handle that encircles the shutter button. The lever's basic function is to change the lens's focal length to various values ranging between wide-angle, by pushing it to the left, toward the W indicator, and telephoto, by pushing it to the right, toward the T indicator. When you are viewing pictures in playback mode, the lever enlarges the image on the LCD screen when pushed to the right, and selects different arrangements of thumbnail images to view when pushed to the left. Also, you can use this lever to speed through the menus a full page at a time, either forward or backward. The lever can be set to use step zoom, moving the lens only to certain focal lengths, using the Zoom Lever option on screen 4 of the Custom menu.

On/Off Switch

The on/off switch is at the rear of the camera's top, next to the shutter speed dial. Slide it forward to turn

Chapter 5: Physical Controls [67

the camera on and pull it back to turn it off. If you leave the camera unattended for a period of time, it automatically powers off, if the Sleep Mode option is turned on through the Economy item on screen 2 of the Setup menu. I'll discuss the Setup menu in Chapter 7, but this option can be set to be off altogether so the camera never turns off just to save power, or to turn the camera off after 1, 2, 5, or 10 minutes of inactivity. You can cancel the Sleep Mode shutdown by pressing the shutter button halfway.

Shutter Speed Dial

You use this dial, in conjunction with the aperture ring, to set the recording mode and, in some modes, to set the shutter speed. When you set this dial and the aperture ring to their A positions, the camera is set to Program mode. When you set this dial to the A position and the aperture ring to a specific aperture, the camera is set to Aperture Priority mode. When you set this dial to a specific shutter speed and the aperture ring to the A position, the camera is set to Shutter Priority mode. When you set both this dial and the aperture ring to specific values, the camera is in Manual exposure mode. (Of course, if you press the iA button, the camera will switch into Intelligent Auto mode, no matter what position this dial is in.)

To set a shutter speed that is printed on the dial, such as 1/30 second or 1/2000 second, just turn the dial to that value, in those cases 30 or 2000. To set intermediate shutter speeds, you have to turn the control ring around the lens or the control dial on back of the camera. (If manual focus is in use, the control ring adjusts focus, so you have to use the control dial to adjust shutter speed. In addition, if the control ring has been set to a function other than Default through the Control Ring option on screen 3 of the Custom menu, you have to use the control dial to adjust shutter speed.)

For example, to set the shutter speed to 1/400 second, turn the shutter speed dial to the 500 mark, then turn the control ring (or the control dial) until 400 appears at the bottom of the display. To set speeds faster than 1/4000 second, choose the 4000 mark, then turn the control ring or control dial to select a faster speed. To set speeds from 1 second to 60 seconds, choose the 1+ indicator on the shutter speed dial, then turn the control ring or the control dial to select the desired

speed. Speeds of 1 second or slower appear on the display with double quotation marks after them, as in 4" for 4 seconds.

To use the T setting for a time exposure, the camera must be set to Manual exposure mode. (If you use the T setting in Shutter Priority mode, the camera will set the shutter speed to 60 seconds.) Then, press and release the shutter button to start the exposure, and press and release it again to end the exposure. The maximum exposure time with this setting is about 30 minutes. You also can use the Bulb setting for shutter speed in Manual mode, but only when the camera is controlled by an external device through Bluetooth, as discussed in Chapter 9.

Exposure Compensation Dial

This dial at the right side of the camera's top provides a welcome simplicity for adjusting exposure settings. All you have to do is turn the dial to a positive or negative value, up to three EV (exposure value) units in either direction, to adjust the exposure to be brighter or darker than it would appear using the settings metered by the camera. You can use this adjustment in any shooting mode except the basic Intelligent Auto mode. However, in Manual exposure mode, you can adjust exposure compensation only if ISO is set to Auto ISO.

You will see the effects of the adjustment on the camera's display as you turn the dial. In Chapter 4, I discussed the Auto Exposure Compensation item, a sub-option of the Flash item on screen 2 of the Recording menu. If you turn that option on, the camera adjusts the flash output so any exposure compensation adjustment you make takes effect and is not counteracted by the flash.

With the LX100 II, you can also adjust exposure compensation by assigning exposure compensation to a function button, using the Function Button Set option on screen 3 of the Custom menu. If you do that, then, when you press the assigned button, a scale appears on the display, as shown in Figure 5-9. You can use the Left and Right buttons, the control dial, or the touch screen to adjust exposure compensation up to five EV units in either direction, as opposed to the limit of three EV units when using the dial. If a function button or the control ring is assigned to adjust exposure compensation, the

operation of the exposure compensation dial is disabled while that assignment is in effect.

Figure 5-9. Exposure Compensation Scale from Function Button

Figure 5-10 illustrates the adjustment of exposure compensation using a function button. In this case, I adjusted the exposure downward by one-third EV to darken the highlights on a duck figurine.

Figure 5-10. Exposure Compensation Adjustment in Effect

iA (Intelligent Auto) Button

This small button, directly behind the shutter button, has only one purpose—to switch the camera into and out of Intelligent Auto mode. No matter what other mode the camera is currently set to—Program, Aperture Priority, Shutter Priority, or Manual exposure—just press this button quickly and the camera switches immediately into Intelligent Auto mode. Press it again to switch back to the mode that was previously in effect. If you want, you can change the behavior of this button so you have to hold it down for about a full second for the recording mode to change. With that setting, there is less danger of accidentally pressing the button and switching modes when you don't want to. That behavior

is controlled by the iA Button Switch option on screen 3 of the Custom menu.

Fn1 Button

The Fn1 button, located in front of the exposure compensation dial, is one of five physical function buttons on the camera's top and back. Because most of these buttons are located on the camera's back, I will discuss them all together later in this chapter, when I discuss the controls on the camera's back.

The controls on the camera's back are seen in Figure 5-11.

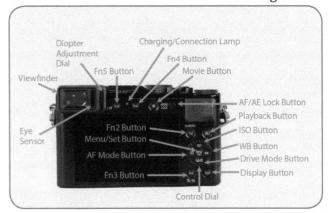

Figure 5-11. Controls on Back of Camera

Viewfinder, Eye Sensor, and Diopter Adjustment Dial

The viewfinder window at the left of the camera's back is where you can see the recording display and playback display when the viewfinder is in use. The vertical slot at the right of the window is the location of the eye sensor. That device senses when your head is near the viewfinder window, and switches the display from the LCD screen to the viewfinder, if the camera is set that way. This setting is made with the LVF/Monitor Switch sub-option under the Eye Sensor item on screen 3 of the Setup menu. If that item is set to LVF/Monitor Auto, then the view switches between the viewfinder and the LCD screen automatically when your head (or something else) approaches the eye sensor. Otherwise, it can be set to LVF or Monitor, to keep the viewfinder or LCD screen permanently activated. You also can select any of these options by pressing the LVF button, also marked as the Fn5 button, to the right of the viewfinder window, assuming the Fn5 button is set to its default function. You can control the sensitivity of Chapter 5: Physical Controls 69

the eye sensor using the Sensitivity sub-option of the Eye Sensor menu item.

You also can set the camera so it will use its autofocus mechanism to focus on the scene when your eye approaches the eye sensor. That option is controlled using the Eye Sensor AF option on screen 2 of the Custom menu, as discussed in Chapter 7.

You can adjust the view through the viewfinder for your eyesight using the diopter adjustment dial to the right of the eye sensor. If you wear glasses, you may be able to adjust this dial so you can see clearly through the viewfinder without your glasses.

The information displayed in the viewfinder is controlled by pressing the Display button. There are four different screens with various information; I will talk about those screens in the discussion of the Display button, later in this chapter.

Control Dial and its Buttons

One of the most important control groups on the LX100 II is the set of five buttons on the back of the camera, arranged on a circular platform with a ridged dial around the outside, known as the control dial. The edges of the control dial act as buttons that you press to activate various functions. In the center of the control dial is a fifth button. I generally refer to the four outer buttons as direction buttons (Left, Right, Up, and Down), and to the center button as the Menu/Set button.

CONTROL DIAL

The control dial is the ridged dial whose four edges act as the direction buttons. As a dial, this control is important in itself. You turn this dial to navigate through menu screens and settings and to adjust the values of various settings. When the camera is in Program mode, you can turn this dial to use the Program Shift feature, by which the camera finds a new pair of aperture and shutter speed values to maintain the same exposure it has set. When you are setting the shutter speed, you can turn this dial (or the control ring) to set values that do not appear on the shutter speed dial, such as 1/3200 second.

You can turn this dial to adjust the size of the focus frame when the focus mode permits that adjustment, the size of the frame used for the Miniature Effect setting of the Filter Settings effects, or the size of the light source for the Sunshine effect. This dial is used to adjust the settings for the Highlight Shadow option on screen 1 of the Recording menu. In playback mode, turning this dial moves through the recorded images, and it is used to adjust the audio volume during a slide show or motion picture playback.

DIRECTION BUTTONS

The direction buttons act as cursor keys do on a computer keyboard, letting you navigate up and down and left and right through menu screens and options. However, the buttons' functions do not stop there. Each of the four direction buttons performs at least one additional function, as indicated by the icon or label next to the button. I will discuss those functions for each button in turn.

Up Button: ISO

The Up button doubles as the ISO button. Pressing this button when the LX100 II is in recording mode gives you immediate access to the menu for setting the camera's ISO, or sensitivity to light. On the LX100 II, the available ISO settings range from 200 to 25600, though the range varies in some situations. With the lower settings, the camera produces the best image quality, but exposures require more light. With higher settings, the camera can produce good exposures in dim light, but there is likely to be an increasing amount of visual "noise" in the image as the ISO value increases.

Generally speaking, you should shoot images with the lowest ISO that will allow them to be exposed properly. (An exception is if you want the grainy look that comes with a high ISO value.) For example, if you are shooting indoors in low light, you may need to set the ISO to a high value (say, 1600) so you can expose the image with a reasonably fast shutter speed. If the camera were set to a lower ISO, it would need to use a slower shutter speed to take in enough light for a proper exposure, and the resulting image would likely be blurry and possibly unusable.

The ISO setting is available only when the camera is set to one of the advanced shooting modes (the PASM modes). To make the setting, press the ISO button and a horizontal menu will appear at the bottom of the display, as shown in Figure 5-12. You can scroll through the values on this menu by pressing the Left and Right

buttons, by turning the control dial, or by scrolling the menu with the touch screen. The possible numerical values are 200, 400, 800, 1600, 3200, 6400, 12800, and 25600, unless you change the settings for the ISO Increments and Extended ISO menu options, discussed in Chapter 7, to add intermediate values and values below 200.

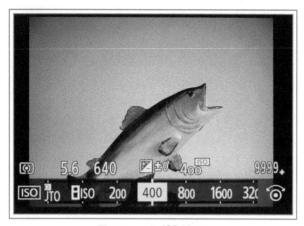

Figure 5-12. ISO Menu

When you set a numerical value for ISO, the ISO Auto Upper Limit (Photo) option (discussed in chapter 4) does not apply. When you set ISO to Auto ISO, the camera automatically adjusts ISO up to the maximum value set with ISO Auto Upper Limit (Photo), based on the brightness of the scene. As discussed in Chapter 3, you can use Auto ISO with Manual exposure mode, which lets you keep shutter speed and aperture fixed while the ISO varies, and still have normal exposure.

When you use the Intelligent ISO setting, the camera adjusts the ISO based on the movement of the subject as well as the brightness, so the camera can set a higher shutter speed to stop the motion. Intelligent ISO is available with the Intelligent Auto, Program, and Aperture Priority modes, but not with the Shutter Priority or Manual exposure modes, or when using the 4K Photo or Post Focus option.

You might want to use a numerical value for the ISO setting, rather than setting it to Auto ISO or Intelligent ISO, if you want the highest quality for your image and you aren't worried about camera movement, either because you are using a tripod so a slow shutter speed won't result in blur, or the lighting is bright enough to use a fast shutter speed. Then you could set the ISO to its lowest possible setting of 200 (or 100 if Extended ISO is turned on) to achieve high quality. On the other hand, if you definitely want a grainy, noisy look, you can

set the ISO to 3200 or even higher to introduce noise into the image. You also might want a high ISO setting so you can use a fast shutter speed to stop action or in low light. In many cases, though, you can just leave the setting at Auto or Intelligent and let the camera adjust the ISO as needed.

It is important to be aware of how much a high ISO value can affect the quality of your images. Figures 5-13 and 5-14 are two images of the same subject; Figure 5-13 was taken at ISO 200 and Figure 5-14 was taken at ISO 25600.

Figure 5-13. Image Taken with ISO Set to 200

Figure 5-14. Image Taken with ISO Set to 25600

As you can see, the high-ISO image shows considerable deterioration, both in the subject itself and in the plain background. You can use this high setting when absolutely necessary to get a shot, but it's advisable to avoid the highest ISO values when possible.

In playback mode, the Up button is used to start playing a motion picture, a panorama, or a burst of shots when the initial frame is displayed on the screen, such as shots taken with Focus Bracket. The button also serves as a play/pause button once a movie has started playing, and it has various duties to move among settings on certain

Chapter 5: Physical Controls 71

screens, such as the screen for saving Highlight Shadow values on the Recording menu, the screen for setting a custom white balance setting, and the screen for saving a Custom Multi frame for AF mode.

Right Button: White Balance

The Right button calls up the menu for setting white balance. The white balance menu option is needed because cameras record the colors of objects differently according to the color temperature of the light source that illuminates those objects.

Color temperature is a value expressed in Kelvin (K) units. A light source with a lower K rating produces a "warmer," or more reddish light. A source with a higher rating produces a "cooler," or more bluish light. Candlelight is rated about 1,800 K, indoor tungsten light (ordinary light bulb) is rated about 3,000 K, outdoor sunlight and electronic flash are rated about 5,500 K, and outdoor shade is rated about 7,000 K. If the camera is using a white balance setting that is not designed for the light source that illuminates the scene, the colors of the recorded image are likely to be inaccurate.

The LX100 II, like most digital cameras, has an Auto White Balance setting that attempts to set the proper color correction for any given light source. The Auto White Balance setting works well, and it will produce good results in many situations, especially if you are taking snapshots whose colors are not critical.

If you need more precision in the white balance of your shots, the LX100 II has settings for common light sources, as well as options for setting white balance by color temperature and for setting a custom white balance based on the existing light source.

You get access to this setting by pressing the Right button, which calls up the white balance menu screen at the bottom of the display, as shown in Figure 5-15.

This menu includes the following choices for the white balance setting, most of them represented by icons: Auto White Balance (AWB); Auto White Balance with reduced reds (AWBc); Daylight (sun icon); Cloudy; Shade; Incandescent; Flash; White Set 1; White Set 2; White Set 3; White Set 4; and Color Temperature. (Only the first six options are shown in Figure 5-15; you need to scroll to the right to reach the others.)

Figure 5-15. White Balance Menu

Most of these settings are self-explanatory. You may want to experiment to see if the named settings (Daylight, Shade, Incandescent, etc.) produce the results you want. The AWBc setting is intended for use with incandescent lighting, to reduce the excessive red or orange hues that the normal AWB setting does not always compensate for properly.

To set white balance manually, press the Right button to activate the white balance menu and scroll to select one of the four white set icons, as shown in Figure 5-16.

Figure 5-16. White Set Icon Highlighted

Then press the Up button, and a yellow rectangle will appear in the middle of the display, as shown in Figure 5-17. Aim the camera at a white or gray surface illuminated by the light source you will be using, and fill the rectangle with the image of that surface. Then press the Menu/Set button (or you can press the shutter button if you prefer) to lock in that white balance setting. The camera will display a Completed message if the setting was successful. Now, until you change that setting, whenever you select that preset value (white set 1 or another slot, as the case may be), it will be set for

the white balance you have just recorded. This system is useful if you often use a particular light source and want to have the camera set to the appropriate white balance for that source.

Figure 5-17. Screen for Setting Custom White Balance

To set the color temperature directly by numerical value, choose the Color Temperature option from the white balance menu, then press the Up button to pop up a screen with a value such as 2500K displayed. You then can press the Up and Down buttons, turn the control dial, or drag on the touch screen to adjust that value anywhere from 2500K to 10000K in increments of 100K.

One issue with this approach is that you have to know the color temperature of your light source in order to make this setting. One way to find that value is to use a color temperature meter like the Sekonic C-700 color meter. A meter is helpful when you're striving for accuracy, but it is fairly expensive, and you may not want to use that option.

In that case, you can still use the Color Temperature option, but you will have to do some guesswork or use your own sense of color. For example, if you are shooting under lighting from incandescent bulbs, you can use 3,000 K as a starting point, because, as noted earlier, that is the approximate color temperature of that light source. Then you can try setting the color temperature figure higher or lower, and watch the camera's display to see how natural the colors look. As you lower the color temperature, the image will become more "cool" or bluish; as you raise it, the image will appear more "warm" or reddish. Once you have found the best setting, leave it in place and take your shots.

Once you have made the white balance setting, either using one of the preset values such as Daylight, Incandescent, or Cloudy, or using a custom-measured

setting or a color temperature, you still have the option of fine-tuning the setting to an additional degree.

To make this further adjustment, after you make your white balance setting, before pressing the Menu/Set button to return to the recording screen, press the Down button, and you will be presented with a screen for fine adjustments, as shown in Figure 5-18.

Figure 5-18. Screen for Fine-tuning White Balance

You will see a box containing a pair of axes that intersect at a zero point, marked by a circle with a plus sign inside it. The four ends of the axes are labeled G, B, M, and A, for green, blue, magenta, and amber.

You can use all four direction buttons, or slide your finger over the colored square, to move the circle away from the center toward any of the axes, to adjust these four values until you have the color balance exactly how you want it. The camera will remember this value whenever you select the white balance setting that you fine-tuned. When you have fine-tuned the setting using this screen, the white balance icon on the camera's display changes color and/or adds an indicator to indicate what changes you have made along the color axes. If there was an adjustment to the amber or blue side, the icon changes color accordingly. If there was an adjustment to the green or magenta side, the icon will have a plus sign added for green or a minus sign added for magenta.

To reset the adjustment axes to the zero point, press the Display button (or touch the Reset icon) while the axes are displayed, and the circle will return to the center of the adjustment area.

When the color adjustment screen is displayed, you can also set up white balance bracketing, which I discussed in Chapter 4 in connection with the Bracket menu option. To do that, turn the control dial to the right or left to set up the bracketing interval along the amberblue or green-magenta axis.

If you're shooting with Raw quality, you don't have to worry about white balance so much, because, once you load the Raw file into your software, you can change the white balance however you want. This is one of the advantages of using Raw. If you had the camera's white balance setting at Incandescent while shooting under a bright sun, you can just change the setting to Daylight in the Raw software, and no one need ever know about the error of your shooting.

Besides giving access to white balance settings, the Right button has some miscellaneous functions. For example, when playing movies and slide shows, the Right button acts as a navigation control to move through the images, and it is used to navigate among the various portions of screens with settings, such as the Highlight Shadow and Photo Style screens. When you have activated a Filter Settings effect, you can press the Right button to get access to a screen for making an adjustment to that setting.

Left Button: Autofocus Mode/MF Assist

The Left button is marked with an icon that represents the focus mode used by the camera. In this context, focus mode means the area where the camera directs its focus. Pressing the button has different effects depending on whether the camera is in an autofocus mode or manual focus mode.

Use of Left Button in Autofocus Mode

When you press the Left button with the focus switch set to the AF or AF macro position, the camera displays a line of icons representing the six choices available for the AF mode setting: Face/Eye Detection; AF Tracking; 49-Area; Custom Multi; 1-Area; and Pinpoint, as shown in Figure 5-19.

Use the control dial or the Left and Right buttons (or the touch screen) to highlight the choice you want. Then press the Menu/Set button or the Set icon, or press the shutter button halfway, to select that setting and return to the recording screen.

In Intelligent Auto or Intelligent Auto Plus mode, only two of these options are available: Face/Eye Detection

and AF Tracking. Following are details about all six options that are available in other recording modes.

Face/Eye Detection

When you select this setting, the camera does not display any focusing brackets or rectangles until it detects a human face. If it does, it outlines the general area of the face with a yellow rectangle. Then, after you press the shutter button halfway down, the rectangle turns green when the camera has focused on the face. If the camera detects more than one face, it displays white rectangles for secondary faces, as shown in Figure 5-20.

Any faces that are the same distance away from the camera as the face within the yellow rectangle will also be in focus, but the focus will be controlled by the face in the yellow rectangle. If Metering Mode is set to Multi, the camera will also adjust its exposure for the main detected face.

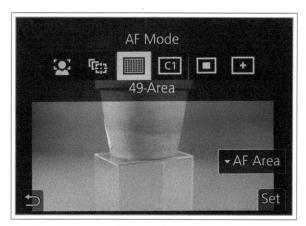

Figure 5-19. Autofocus Mode Menu Options Screen

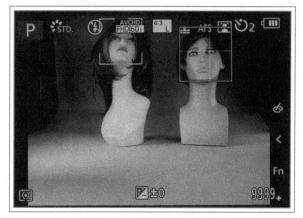

Figure 5-20. Face Detection in Use

With this setting, the camera also will look for human eyes. It will place a set of crosshairs across the closest eye it finds and fix focus there. If you want, you can change the eye that the camera focuses on. To do that, when the

camera is displaying frames over detected faces, press the touch screen over the eye you want the camera to focus on, then press the shutter button halfway to focus. (Touching a different eye does not work in Intelligent Auto mode; in that mode, if you touch the screen, the AF mode setting will change to AF Tracking.)

You also can change the face that the camera focuses on. One way to do this is to touch the screen and move the focus frame with your finger. To use that system, go to the Touch Settings item on screen 4 of the Custom menu and, under Touch Settings, set Touch AF to AF. Another way to do this is to use the Direct Focus Area option. To do that, turn on the Direct Focus Area option on screen 2 of the Custom menu. Then, when the Face/ Eye Detection frame is displayed on the screen, press any of the four cursor buttons to start moving the focus frame to the location where you want it. When the frame is being moved, you can also turn the control dial to change the frame's size.

When the focus frame is sized and located as you want, press the Menu/Set button to lock it in place. The camera will then shift its focus to the area inside that frame. You might want to use this option if you are aiming at two faces, but you want to focus on the one that is farther away from the camera. Ordinarily, the camera will focus on the closest face, but if you move the frame over the other face, the camera will direct its focus there. To reset the frame to its original position, press the Display button while the frame is movable.

AF Tracking

This next setting for AF mode allows the camera to maintain focus on a moving subject. On the menu screen, highlight the second icon, which is a group of offset focus frames designed to look like a moving focus frame. Press the Menu/Set button or half-press the shutter button to select this option.

The camera will display a special focus frame with spokes sticking out of it, in the center of the display. Move the camera to place this focus frame over your subject and press the shutter button halfway, then release the button. If the camera can identify a subject at this location, the frame will turn yellow. The camera will then do its best to keep that target in focus, even as it (or the camera) moves. The yellow bracket should stay close to the subject on the display.

When you are ready, press the shutter button to take the picture. If you want to cancel AF Tracking, press the Menu/Set button.

If the camera is not able to maintain focus on the moving subject, the focus frame will turn red and then disappear. AF Tracking will not work when Time Lapse Shot is in use. With several Filter Effect settings, including all of the Monochrome options, and with the monochrome options for Photo Style, the camera will use 1-Area mode if AF Tracking is set.

To use this option with the touch screen, touch the subject on the screen to select it, and press the AF Off icon on the screen to cancel the tracking focus.

Using AF Tracking can reduce the time to take a picture of a moving subject. If you are trying to snap a picture of a restless four-year-old child or a fidgety pet, AF Tracking can give you a head start, so the camera's focus is close to being correct and the focusing mechanism has less to do to achieve correct focus when you suddenly see the perfect moment to press the shutter button.

49-Area

This next option for AF mode causes the camera to focus on a specified area within 49 small focus zones within the overall autofocus area, which is the same area as that of the current aspect ratio setting. The camera looks within the specified focus zones and selects however many subjects it detects that are at the same distance from the camera and can be focused on.

To make this setting, select the third icon on the AF mode menu, which looks like a screen with multiple focus points. Then, when you press the shutter button down halfway, the camera will display green rectangles to show you which of the specified focus areas it has selected to focus on.

The name of this setting is somewhat misleading, because, even though the camera has 49 focus zones, it will only use a few of those zones at any one time in this mode. By default, the camera uses the nine zones in the center of the screen. With the default setting, if you focus on a scene with a prominent object at the far right, the camera will choose whatever object it can find in the center of the display to focus on, and will ignore the object at the right.

If you want the camera to direct its focus somewhere other than the center of the scene, press the Down button while the 49-Area icon is highlighted on the menu screen, and then move the block of focus zones where you want them using the cursor buttons, control dial, or touch screen, as shown in Figure 5-21.

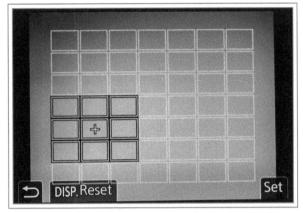

Figure 5-21. Movable Focus Zones for 49-Area Setting

If the Direct Focus Area option is enabled through screen 2 of the Custom menu, you can use the cursor buttons to move the focus area around the screen when the camera is in shooting mode with the 49-Area option selected. If the Touch AF option is turned on through the Touch Settings item on screen 4 of the Custom menu, you can touch the screen in shooting mode to select the area for the block of focus zones.

When you have set the focus area using the touch screen or cursor buttons, the camera displays a small white cross on the screen to indicate the center of the block of focus zones it is currently using. (The cross will disappear if you press the Menu/Set button or the AF Off icon.)

The blocks near the center of the overall focus area have nine zones each, but the blocks near the edges of the display area have only six or four blocks.

The 49-Area method can be useful if your subject is likely to be located within a predictable area, and you want to have the option to adjust that area somewhat. It is a good mode to use when you are shooting landscapes or general scenes that do not require you to focus on faces or on any one particular object.

Custom Multi

This setting lets you create a custom-tailored focus zone out of the 49 available blocks. For example, you can create a horizontal focus area that is seven blocks across, or a vertical one of the same size. You can create a zone that has 13 blocks arranged in a pattern in the center of the screen. Or, you can create a completely free-form zone with any arrangement of blocks. Somewhat oddly, with the free-form option you can create a focus area that uses all 49 of the focus blocks, resulting in a true 49-Area focus mode, unlike the mode with that name, which can use only up to nine blocks. The process for using this option is a bit complicated, so I will lay out the steps below.

 Press the Left button to call up the AF mode menu and scroll to the fourth icon from the left, with the label Custom Multi below it, as shown in Figure 5-22.

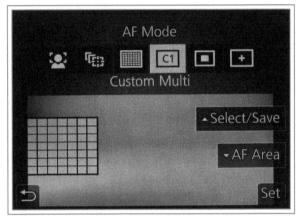

Figure 5-22. Custom Multi Highlighted for AF Mode

2. Press the Up button to move to the line of possible patterns for the focus zone, as shown in Figure 5-23.

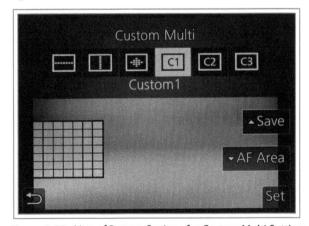

Figure 5-23. Line of Pattern Options for Custom Multi Setting

3. Scroll through these icons to select the one you want. The last three—C1, C2, and C3—are for free-form custom patterns you can create and save to these numbered slots.

- 4. When you have selected horizontal, vertical, central, or free-form for the shape, press the Down button to move to the AF Area option. There you will see a screen with all 49 blocks, some of which will be highlighted in yellow for the horizontal, vertical, or central choices, but all of which will be blank for the free-form options.
- 5. For the horizontal, vertical, or central option, turn the control dial to the right to increase the size of the focus area, or turn it to the left to reduce it. You can move the line or lines across the display by pressing the appropriate direction buttons or by touching the screen. When you have the focus area positioned where you want it, press the Fn2 button, to the right of the LCD screen, to set the focus area in place. The blocks will display for a moment and then disappear, and this focus area will be in effect. (If AF Area Display on screen 2 of the Custom menu is turned on, the blocks will turn white rather than disappearing.)
- 6. For any of the three free-form options, after pressing the Up button, scroll to the icon that says C1, C2, or C3, then press the Down button to move to the AF Area screen. You will then see a display with all 49 blocks, none of which are highlighted, with a cross in the center block. Use the direction buttons to move the cross to a block you want to add to the focus pattern, and press the Menu/Set button to highlight it. You also can touch a block with your finger to highlight it. Figure 5-24 shows this screen after several blocks have been selected in this way.

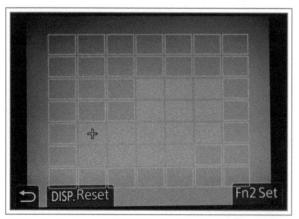

Figure 5-24. Several Blocks Selected for Custom Multi Option

7. The blocks do not have to be contiguous; they can be in any pattern, up to and including selecting all

- 49 blocks. When you have finished selecting blocks, press the Fn2 button to lock in the pattern you have created.
- 8. To create and save a custom focus pattern, use the same procedure as in Steps 1 through 7. Then press the Left button to bring the AF mode menu back on the screen, and scroll to the Custom Multi option. Press the Up button to move to the line of options, and scroll to the focus pattern you just created, whether horizontal, vertical, central, or free-form, then press the Up button. The camera will display a screen asking which Custom slot you want to save it to.
- 9. Highlight the one you want and press Menu/Set, then select Yes when asked if it should overwrite the existing settings. To select the saved pattern in the future, just select C1, C2, or C3, depending on what slot the pattern was saved to.

The Custom Multi option is useful if you have a need for specially shaped focus zones. You might want to use a horizontal zone if you are focusing on a group of artifacts that are displayed in a straight line, to make sure the camera does not accidentally focus on an object outside of that line. You also might want to create a pattern that uses all 49 focus zones, so the camera will focus on the closest object, regardless of whether it is in the center of the image, or in a particular sector of the image.

However, there is one quirk with this setting: If you don't select any blocks at all, the camera will treat the focus area as containing all 49 blocks, and will focus on any object in its view. So, to use all 49 blocks for the focus area, select Custom Multi and leave all blocks unselected. If you select one or more blocks, the camera will focus only on an object within those blocks, but if you select no blocks, the camera will use all 49 blocks.

1-Area

This AF mode setting is selected with the next-to-last icon on the AF mode menu, as shown in Figure 5-25. With this option, the camera uses a single focus frame, which by default is in the center of the screen. You can customize the setting by moving the frame to any position on the display and changing its size.

Chapter 5: Physical Controls | 77

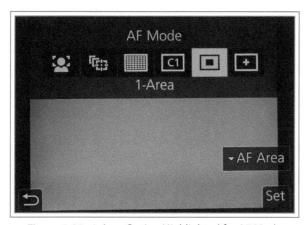

Figure 5-25. 1-Area Option Highlighted for AF Mode

When you have highlighted the 1-Area icon on the AF mode menu, press the Down button to move directly to setting the location of the autofocus frame using the direction buttons or the touch screen, as shown in Figure 5-26. You can change the size of the frame by turning the control dial or by pulling or pinching on the touch screen.

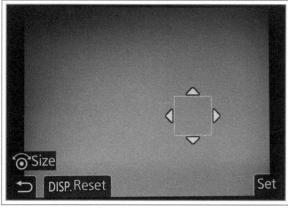

Figure 5-26. Movable Frame for 1-Area Setting

When you have finished moving and resizing the frame, press the Menu/Set button or touch the Set icon to fix the frame in place. To move the frame back to the default location in the middle of the screen or reset its size to normal, press the Display button at the bottom right of the camera's back, while the frame is movable. If the frame has been both moved and resized, you have to press Display once to reset the location and once more to reset the size.

The 1-Area method is a good setting for general shooting, because it lets you quickly position the focus area just where you want it. It is particularly helpful when you need to make sure the camera focuses on a fairly small item that is not in the center of the scene.

Pinpoint

The last icon at the right of the line of AF mode icons, highlighted in Figure 5-27, is used to select the Pinpoint option. With this setting, you can move a single focus frame around the display and resize it, and the camera will enlarge the focus area to help you get the focus frame positioned precisely where you want it.

Figure 5-27. Pinpoint Option Highlighted for AF Mode

After pressing the Left button to bring up the AF mode menu, highlight the Pinpoint icon and press the Down button to move to the AF Area screen. Move the focus area around the display using the four direction buttons and resize it using the control dial, then press the Menu/ Set button to set the focus area in place. You also can move and resize the focus area using the touch screen.

You can control the amount of enlargement for this display using the Pinpoint AF Display item under the Pinpoint AF Setting item on screen 2 of the Custom menu. If you select Full for that item, the image will be enlarged from three times to ten times and the enlargement will fill the display. If you select PIP, for picture-in-picture, the enlarged area will not take up the entire display, and the enlargement will only range from three times to six times. While the display is enlarged, you can vary the amount of enlargement within the specified range by turning the control dial or by pinching/pulling on the screen. When the focus frame is located where you want it, press the Menu/Set button to exit to the recording screen.

When you focus on an item using this setting, place the small white cross over the subject and press the shutter button halfway. The camera will enlarge the display at that area for a short time while you keep the shutter button half-pressed, to help you determine whether focus is sharp. The length of time that the display

remains enlarged with this option is determined by the Pinpoint AF Time option under the Pinpoint AF Setting item on screen 2 of the Custom menu; the time can range from 0.5 second to 1.5 second. The display then returns to normal size so you can evaluate the entire scene before pressing the shutter button to take the picture.

Moving the Focus Frame or Focus Area

With all of the AF mode options except AF Tracking, you have the ability to move the focus frame or zones. There are several ways to do this, even after you have returned the camera to the recording screen. One way to do this is to call up the AF mode menu with the Left button and select the current AF mode option. Then press the Down button (or touch the AF Area icon on the screen) to go to the screen for moving the frame. Move the frame with the cursor buttons or touch screen and resize it with the control dial or touch screen if necessary, then press Menu/Set and you're ready to focus again with the frame in a new location.

For a faster way to move the focus frame (or broader focus area, for the 49-Area or Custom Multi setting), there are three other options. First, you can set one of the function buttons to the Focus Area Set option through the Function Button Set option on screen 3 of the Custom/Operation menu, as discussed later in this chapter. Then, if you press that function button, the screen for moving the focus area will appear immediately.

Second, you can turn on the Direct Focus Area option on screen 2 of the Custom menu. Then, from the recording screen, as soon as you press any of the four direction buttons, the focus area moving screen will appear. (A drawback of that option is that you cannot then use the direction buttons to call up options such as ISO, white balance, AF mode, and drive mode. You can use the Quick Menu to activate those items, though, or you can assign function buttons to those settings.) Third, you can use your finger to move the focus frame, if the Touch AF option is turned on through the Touch Settings item on screen 4 of the Custom menu.

Use of Left Button in Manual Focus Mode

If you press the Left button when the focus switch is set to the MF position for manual focus, the button activates the MF Assist frame so you can move it around the screen to determine the area to concentrate on for adjusting manual focus. Pressing the button also can immediately enlarge the manual focus area, depending

on the setting of the MF Assist option on screen 3 of the Custom menu, as discussed in Chapter 7.

Besides giving access to the AF mode and MF Assist settings and navigating through menu and settings screens, the Left button has various miscellaneous duties. For example, in Intelligent Auto mode, you can press this button to switch between Face/Eye Detection and AF Tracking for focus mode. In playback mode, this button acts as a navigation control to move through images and videos.

DOWN BUTTON: DRIVE MODE

The last of the cursor buttons to be discussed, the Down button, provides access to drive mode, which includes settings for the camera's burst shooting, 4K Photo, Post Focus, self-timer, and panorama shooting options.

When you press the Down button, you will see a line of icons, as shown in Figure 5-28.

Figure 5-28. Drive Mode Menu

Scroll through them with the control dial, the Left and Right buttons, or by touching the icons on the touch screen. As you highlight each one, the camera places a label underneath it listing its function. From left to right, these icons have the following functions: burst shooting off; single shooting; burst shooting on; 4K Photo; Post Focus; self-timer; and panorama shooting. I will discuss all of these functions below.

The first two icons on the drive mode menu have the same function—to turn off all burst shooting, including the self-timer. There is no functional difference between these icons; you can select either one when you want to make sure the camera is not set to use the burst, 4K Photo, Post Focus, self-timer, or panorama options. There are some camera settings, such as white balance

bracketing and HDR, that do not function when one of the burst shooting options is selected. So, if you find a feature is not working, you may want to select the first or second drive mode icon to disable all burst features and see if that removes the conflict.

The third icon is used to activate burst shooting, which I will discuss now.

Burst Shooting

With burst shooting, sometimes called continuous shooting, the camera takes a continuous series of images while you hold down the shutter button. This capability is useful in many contexts, from shooting an action sequence at a sporting event to taking a series of shots of a portrait subject to capture changing facial expressions. I often use this setting for street photography to increase my chances of catching an interesting image.

To activate burst shooting, press the Down button, then scroll to the third icon from the left. It looks like a stack of frames with the letter H, M, or L beside it, for high, medium, or low speed bursts. Once this icon is highlighted, press the Up button (or touch the More Settings icon) to get access to more settings, and you will see icons with all three of those speed notations, as shown in Figure 5-29.

Figure 5-29. Speed Settings for Burst Shooting

Scroll through those icons to highlight one, then press the Menu/Set button (or press the shutter button halfway) to activate it and return to the recording screen. I will discuss these three options in turn.

The first burst option is H, for high-speed shooting. With this setting, the maximum speed available is 11 frames per second (fps) with single autofocus or

manual focus, and 5.5 fps with flexible or continuous autofocus. The camera provides an updated live view on its display during shooting with focus mode set to AFF or AFC, but not with AFS or MF. You can shoot with Raw quality. If the focus mode is set to AFS or MF, the exposure setting will be fixed with the first shot. However, if you set the focus mode to AFF or AFC, the camera will adjust focus and exposure for each shot, at the expense of a loss in speed of shooting.

With the next lower speed, M, for medium, the camera can shoot at up to 7 fps with AFS or MF and 5.5 fps with AFF or AFC. It provides an updated live view throughout the shooting, and performs almost the same as with the H setting with respect to focus and exposure.

The one difference is that the focusing behavior varies according to the setting of the Focus/Release Priority option on screen 2 of the Custom menu. If that option is set to Focus when AFF or AFC is in use, the camera will focus normally, rather than using predicted focusing. If that option is set to Balance or Release, the camera will use predicted focusing, just as it does with the H setting for burst speed. (The Focus/Release Priority option, which is discussed in Chapter 7, lets you specify whether the camera should require an image to be in focus before releasing the shutter.)

Finally, with the lowest speed, L, for low, the speed drops to 2 fps with all focus modes. The live view is available and focus behavior is the same as with the M setting.

When the camera is set for burst shooting, if you press the shutter button halfway with one of the detailed information screens displayed, the camera displays the letter "r" at the lower right, followed by the number of images the camera can capture in a continuous burst.

Figure 5-30. Shooting Screen with Burst Images Remaining Shown

For example, in Figure 5-30, the display shows that the camera can capture 33 images, with Burst Rate set to H, Quality set to Raw+JPEG-Fine, and AFS selected for autofocus. When you press the shutter button down to capture the burst, that number will continuously decrease; it should reach zero at the point when the rate of shooting starts to slow down. However, in my tests, I found that the number did not decrease by one unit for each shot. Instead, the camera often shot several shots before the number would decrease, so the total number of images captured in the burst often was greater than the "r" number indicated on the screen.

With all burst shooting, the specifications for speed and numbers of images will vary according to conditions. When conditions are dark and the camera has to use a slower shutter speed, that factor alone will slow down the shooting. Other factors that affect shooting capacity and speed include image quality and the speed and capacity of the memory card in the camera.

The burst-shooting options are available in every shooting mode for still images. However, there are several limitations on the use of burst shooting. You cannot use it with flash, or with the Rough Monochrome, Silky Monochrome, Miniature, Soft Focus, Star Filter, or Sunshine Filter Effect settings. You also cannot use it with some of the other special settings such as Multiple Exposure, white balance bracket, Time Lapse Shot, during motion picture recording, or when using Stop Motion Animation with Auto Shooting turned on.

After shooting with any of the burst options, you are likely to see for at least a few seconds the red icon indicating that the camera is writing images to the memory card; while that icon is displayed, you not open the battery compartment cover or otherwise interfere with the camera's operation.

4K Photo

The fourth icon from the left for drive mode, labeled 4K, gives you access to the powerful 4K Photo features. The term 4K originated with 4K video recording, which is available with the LX100 II and other modern cameras. 4K is a video format that has about 4,000 (4K) pixels in the horizontal dimension, as opposed to the more standard HD (high-definition) formats that have about 1,920 (2K) pixels in that dimension. The 4K format is sometimes referred to as Ultra-HD.

With the LX100 II camera, a single frame of 4K video has 3840 horizontal pixels and 2160 vertical ones, for a total of about 8.3 megapixels. (Those figures are for an aspect ratio of 16:9; they are different for other aspect ratio settings.) So, a single frame of 4K video has about the same resolution as a still image taken picture size set to M. Because of the relatively high resolution of each frame of 4K video, you can use the 4K capability of the camera as another option for taking a high-speed burst of single images.

The difference from normal burst shooting is that, with 4K Photo, the camera actually records a video sequence at its normal rate of 30 frames per second, and it can continuously record at that fast rate for up to 15 minutes, rather than the relatively short time the camera can record at a fast rate with normal burst shooting. As a result, you can record thousands of medium-resolution still images and then select the best ones from that group.

In order to use this option, as with 4K video recording, you need to use a memory card that is rated in UHS speed class 3.

The 4K Photo option has three sub-options with somewhat different functions, as discussed below. You select these settings in the same way as for the normal burst settings of drive mode. After you highlight 4K Photo on the drive mode menu, press the Up button to move to the screen shown in Figure 5-31, with three sub-options.

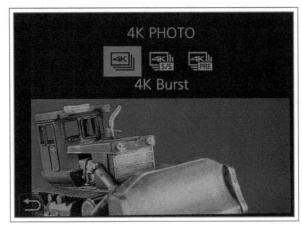

Figure 5-31. 4K Photo Options Screen

Highlight the one you want and press the Menu/Set button or select the icon on the touch screen.

Chapter 5: Physical Controls 81

You also can call up the 4K Photo Mode menu by pressing the Fn1 button, assuming it remains assigned to its default setting as the 4K Photo button. (Or another button could be assigned to this option.)

4K Burst

The basic option for the 4K Photo feature is called 4K Burst. With this setting, the camera records a 4K video sequence while you press the shutter button and hold it down. This approach is useful when you are trying to capture a burst of shots of an activity with a fairly clear duration. For example, if a group of bicycle racers is approaching your position, when the cyclists get close, you can press the shutter button and hold it down until the racers have passed out of view. With this setting, the camera can record for up to 15 minutes at a time.

4K Burst S/S

The second selection is 4K Burst Start and Stop. With this option, the camera starts recording its 4K video sequence when you press and release the shutter button, and it records continuously until you press and release the button again. This approach lets the camera run so it can capture a burst of shots of an unpredictable activity. For example, if you are photographing a group of geese on a pond and you want to catch them in flight, you can start the camera recording and not stop it until they have actually taken off and flown away. While the recording is in progress, you can press the Fn2 button to insert a marker into the video file, to help locate points of interest during the editing process. You can insert up to 40 of these markers for a given recording. As with the 4K burst setting, the camera can record a sequence using this option for up to 15 minutes.

4K Pre-burst

With this final option, the camera actually records continuously, even before you press the shutter button. It retains only a short amount of action in its memory—about one second. When you press the shutter button fully down and release it, the camera records the scene for the one second that is already in its memory and for about one additional second, resulting in a sequence lasting about two seconds. You can use this option for a situation when you believe an action is about to happen, and you don't want to miss the beginning of it. For example, if you are watching a batter at a baseball game, you can press the shutter

button as soon as the bat hits the ball, and you should catch the entire swing and impact.

With this option, because the camera records continuously even when you are not pressing the shutter button, the battery is run down more quickly than usual. So, you should not activate this setting until you are ready to use it.

All of the 4K Photo options are available for use in all still-image shooting modes. Therefore, you can shoot these high-quality bursts in the more advanced modes, including Shutter Priority and Manual exposure. It often may be useful to select one of those modes, because you can then set the shutter speed to a fast setting, such as 1/1000 second, to increase the chance of capturing an image that is free from motion blur. Of course, you can only use a shutter speed that fast when there is plenty of light, or the ISO setting is high. But, if you can do so, you should consider that possibility. You can use any aspect ratio you want by setting the aspect ratio switch.

With the 4K Burst and 4K Pre-burst options, no audio is recorded. However, with the 4K Burst (S/S) option, audio is recorded through the camera's built-in microphone. This audio is not played back when you play back the sequence in the camera. However, if you copy the sequence's .mp4 file to a computer and play it back, the audio track will be present. So, if you want to capture both still images and video with audio for a scene, this option can be a useful one.

Extracting a 4K Photo Still Image

Once you have recorded a 4K Photo sequence, you need to take further steps to extract a still image from it. The steps for the 4K Burst and 4K Burst (S/S) options are set forth next; the steps are slightly different for the 4K Pre-burst option, as discussed later.)

When you press the Playback button and find a 4K Burst or 4K Burst (S/S) sequence, press the Up button to enter 4K Photo playback mode, as indicated by an upward-facing triangle icon in the upper left corner of the screen.

The camera will display a screen with a set of DVR-like controls at the bottom of the screen, as shown in Figure 5-32. You can touch those icons (or press the button associated with each icon, as indicated by the arrow next to each icon, to play or rewind, or to advance or go backward a frame at a time. (For example, to play through the frames at normal speed, press the Up

button, or touch the play icon next to the upward-facing triangle.)

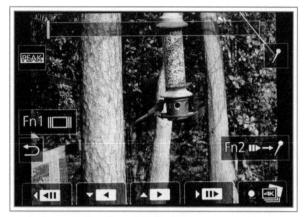

Figure 5-32. 4K Photo Playback Screen - DVR Controls

If you press the Fn1 button, as indicated by the icon on the screen, instead of the DVR-like controls, the camera will display a stack of frames outlined in yellow in the bottom left corner of the display, as shown in Figure 5-33. (The camera may initially display this screen instead of the DVR-controls screen. You can switch between these two screens by pressing the Fn1 button.)

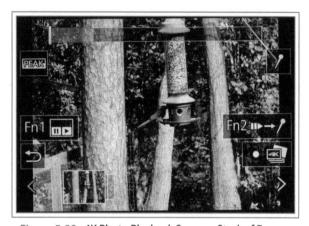

Figure 5-33. 4K Photo Playback Screen - Stack of Frames

With your finger, swipe along that stack to drag through the series of images, or turn the control dial or press the Left and Right buttons to move through the stack. A vertical yellow line will move through the progress bar at the top of the display to show how far through the group of images you have moved. If there are more than 60 images in the group, you can touch the right or left arrow icon on the screen, on either side of the stack of image icons, to move to the next or previous group.

You also can use markers to find single frames to extract from the file. You can use markers that you added during the recording process by pressing the Fn2 button. You also can add new markers during the playback and editing process. To do that, press the icon that looks like a pin with a round head, shown in the upper right corner of the display screen in Figures 5-32 and 5-33. Once you have inserted one or more markers, the camera will display the marker icon with a trash can icon when it displays the marked frame; you can press that icon to delete the markers.

Below the icon for inserting manual markers there may be a pin icon with the words Auto Mode. (This icon appears only if the camera has detected a face, or motion of a significant subject in the scene.) If you press that icon, the camera will display the screen shown in Figure 5-34, with choices of Auto, Face Priority, Motion Priority, or Off.

Figure 5-34. 4K Photo Playback - Auto Mode Options

If you select Auto, the camera will automatically insert markers on frames where it detects the significant movement of a subject or the appearance of a person's face. If you select Face Priority, it will automatically insert markers on frames in which it detects the appearance of a face. If you select Motion Priority, it will automatically insert markers on frames in which it detects the significant motion of a subject. If you select Off, it will not automatically insert any markers; only markers that you inserted yourself will be available. The auto marking feature is not available for recordings made with the 4K Pre-burst setting. Markers you insert yourself, either during recording or during editing, are white; those inserted automatically are green.

Once the markers have been inserted, manually, automatically, or both, you can move from one marker to the next in the file in 4K Photo playback mode. To do that, press the icon on the right side the screen that shows the Fn2 label followed by a pause/playback icon

Chapter 5: Physical Controls [83

and a right arrow pointing to a pin icon, or press the Fn2 button. When you do that, the screen will change to look like Figure 5-35. In this mode, you can move to the previous or next marker by pressing the Left or Right button. You can press the Fn2 button or the touch screen icon again to switch back to the normal navigation mode.

Figure 5-35. 4K Photo Playback - Screen to Move to Markers

Once you have moved through the file, using either markers or normal navigation or both, and found a frame you want to extract from the 4K Photo sequence as a still image, press the Menu/Set button, or touch the icon in the lower right corner of the screen that shows a white button next to the 4K label on a stack of frames. The camera will display the message shown in Figure 5-36, asking if you want to save the image. If you highlight and select Yes, the camera will save that frame.

Figure 5-36. 4K Photo - Confirmation Screen to Save Image

I have found the 4K Photo feature to be of great use, especially when I am trying to capture an image of a bird at a bird feeder. The birds come and go rapidly and unpredictably. With this option, I can set up the camera on a tripod, activate 4K Photo (S/S), and leave the camera alone for 15 minutes. When I return, the

chances are good that I will have captured an image like that in Figure 5-37, showing a bird in flight.

Figure 5-37. 4K Photo Example

There are two other ways to create still images from 4K Photo bursts, using options on the Playback menu: Light Composition and Sequence Composition. Those options let you extract multiple images from a 4K burst to create a still image from a combination of multiple shots, either shots with bright lights or shots from a motion sequence. Those options are discussed in Chapter 6.

Post Focus

This next option on the drive mode menu represents a powerful feature of the LX100 II. As its name indicates, this feature lets you choose the focus point of an image after it was captured. In order to accomplish this feat, the camera records a short 4K video sequence, continuously adjusting the focus for different parts of the scene. When the recording is finished, you can select one or more frames with the sharpest focus on the areas you are most interested in, and the camera will save JPEG images from those frames.

The only setting for Post Focus is to turn the feature on or off. You can do that by selecting it from the drive mode menu, or with the Fn4 button, if that button remains assigned to its default setting of Post Focus. (Of course, you could assign a different button to activate this feature, though it makes sense to leave the Fn4 button with this assignment, if you expect to use the feature.) You can use this option in any shooting mode.

Once Post Focus is turned on, either through the drive mode menu or by pressing a function button, aim the camera at the subject and press the shutter button halfway. Because the camera is using 4K video mode, which crops the frame somewhat, you will see that the camera zoomed in slightly when the feature was turned on. You may have to adjust the framing of the image to account for the increased focal length.

If the camera finds a focus point, it will display a steady green circle in the upper right corner. If it cannot find a focus point, the green circle will blink. When you are ready, hold the camera as still as possible and press the shutter button all the way down and release it. The camera will record a video sequence for several seconds, during which it will change the focus to every focus point it can find throughout the scene.

When the recording has finished, press the Play button to enter playback mode. You will see a screen like that in Figure 5-38, with a Post Focus icon in the upper left corner.

Figure 5-38. Post Focus Sequence Ready to Play in Camera

Press the Up button or touch that icon, and you will see a screen like that in Figure 5-39, with various icons including a plus sign, a return arrow, Fn1, Fn2, and an icon in the lower right corner for saving an image from the sequence.

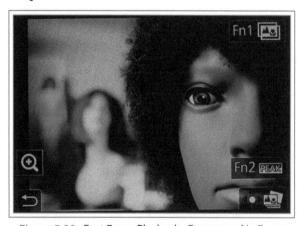

Figure 5-39. Post Focus Playback - Foreground in Focus

On this screen, move your finger to any point where you would like focus to be fixed. If the camera is able to show an image with that focus point, it will briefly display a green frame at that point and change the focus to that location. For example, in Figure 5-39, after I touched the mannequin in the foreground of the scene, the camera displayed an image with sharp focus at that point.

In Figure 5-40, after I touched the mannequin in the background of the scene, the camera displayed a frame with focus fixed on that area.

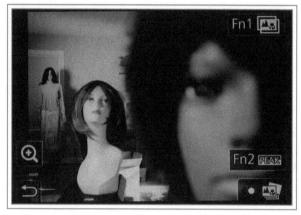

Figure 5-40. Post Focus Playback - Background in Focus

To adjust a chosen focus point in more detail, touch a focus point, then press the magnifying glass icon with the plus sign, or move the zoom lever to the right, to enlarge the image at the point you touched. The camera will display a sliding scale at the bottom of the screen, as seen in Figure 5-41.

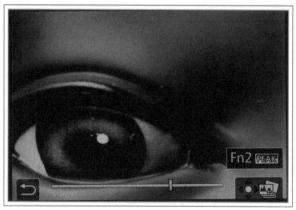

Figure 5-41. Post Focus Magnification Screen

Slide your finger along that scale, or use the Left and Right buttons or the control dial, to adjust the focus point in small increments until you have adjusted the focus at that location as precisely as possible. Then touch the return arrow in the lower left corner of the screen, or move the zoom lever to the left, to return the image to normal size.

You also can press the Fn2 button or its on-screen icon, which causes the camera to turn on its peaking display, placing colored pixels at the areas of sharpest focus to help you determine where focus is sharp. Successive presses of that button or icon cycle through various levels of peaking.

When you have focus adjusted as you want it, touch the icon in the lower right corner of the screen, or press the Menu/Set button, and the camera will display a message asking if you want to save this image. If so, highlight and select Yes, and the camera will save a JPEG image with the focus point set as you have selected. You can then repeat this process with other points, and save other images if you want.

Focus Stacking

Once you have captured a Post Focus sequence, you also can use its images to create a composite using shots with different focus points, with sharp focus throughout much or all of the area in the scene. To do this, when you are viewing a Post Focus series in playback mode, press the Up button to call up the Post Focus editing screen, as seen earlier in Figures 5-39 and 5-40. On that screen, press the Fn1 button or touch its icon in the upper right corner of the display. The camera will display a screen with choices of Auto Merging or Range Merging, as shown in Figure 5-42.

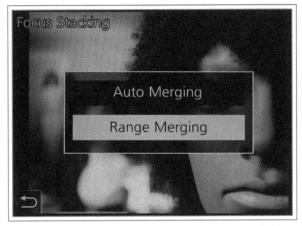

Figure 5-42. Screen to Select Focus Stacking Method

If you choose Auto Merging, the camera will automatically select the shots that it deems to be the best for merging into a final image, giving preference to shots with focus points closer to the lens. The camera

will create and save a final image that should have sharp focus in many or all areas, as shown in Figure 5-43.

Figure 5-43. Focus Stacking Final Merged Image

If you choose Range Merging, the camera displays a screen with an Fn2 Set/Cancel icon in the upper right corner. On that screen, touch a point to select it for inclusion in the range of focus points to be used for the final image. Touch it again to deselect it. You can keep touching more points or drag on the screen to include an area of the scene. You also can use the direction buttons to move a green selection frame around the screen and press the Fn2 button to select or deselect the points where the frame is placed.

When you have selected two or more focus points, the camera will display those points and all other points between those focus points in a green shade, to show that they will be included in the final image, as shown in Figure 5-44. The camera will display gray frames for points that are not included in the focus area. You can press the Display button to select or deselect all points in the image at any time, to start over with a completely full or empty set of focus points.

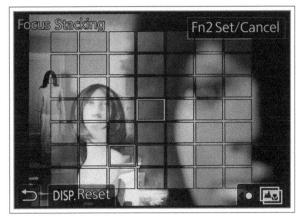

Figure 5-44. Range Merging Screen with Points Selected

When you have finished selecting the focus points to be included in the final image, press the focus stacking icon in the lower right of the image, or press the Menu/Set button, and the camera will display a message asking you to confirm the merging of the focus points. Choose Yes if you want to proceed.

Post Focus and Focus Stacking cannot be used with several settings of Filter Effects, or when the Multiple Exposure option is being used. The camera cannot use the Raw setting for Quality, and the image will be limited to a size of eight megapixels. The camera will use the electronic shutter with a limited range of shutter speeds. However, you still can adjust many settings, and these features are very useful in situations where focus is critical or uncertain, such as macro photography. In a sense, Post Focus acts for focus as the Raw format does for white balance and exposure, which can be adjusted after the fact in a Raw image.

Self-timer

The next-to-last icon in the line of drive mode options represents the self-timer. When you activate the self-timer, the camera delays for the specified number of seconds (ten or two) after you press the shutter button before taking a picture. The ten-second setting is useful when you need to place the camera on a tripod and press the shutter button, and then run around to join a group of people the camera is aimed at. The two-second setting is helpful when you need to avoid jiggling the camera by pressing the shutter button as the exposure is taken. This is the case when taking extreme closeups or other shots for which focus is sensitive.

To activate the self-timer, scroll to the last drive mode icon and press the Up button (or touch the More Settings icon) to select further settings. You will see the display shown in Figure 5-45, with three options.

From left to right, these selections are ten-second self-timer; ten-second self-timer with three images taken; and two-second self-timer. Select the setting you want with the Left and Right buttons, by turning the control dial, or by touching an icon on the screen. (You also can press the Up button repeatedly to cycle through the choices.) You can then press Menu/Set or half-press the shutter button to return to the recording screen.

An icon in the upper right corner of the display will show the current self-timer setting.

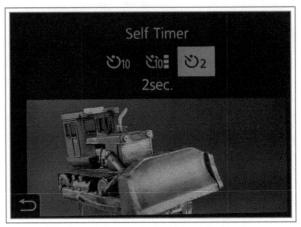

Figure 5-45. Self-timer Options Screen

Now you can wait as long as you want before actually taking the picture (unless the camera times out by entering Sleep Mode or you take certain other actions, such as turning on the 4K Photo option). Compose the picture and press the shutter button. The AF assist lamp, which also serves as the self-timer lamp, will blink and the camera will beep until the shutter is automatically tripped at the end of the specified time. The beeps and blinks speed up for the last second as a warning, when the timer is set to ten seconds. For the two-second option, the camera beeps four times and blinks five times as it counts down. You can cancel the shot while the self-timer is running by pressing the Menu/Set button.

If you choose the option with which the camera takes three pictures after the ten-second timer runs, the three shots will be spaced about two seconds apart, so tell your subject(s) to maintain their pose until all three images have been captured.

You can select one of the self-timer options from the Self Timer item on screen 3 of the Recording menu. However, to activate the self-timer, you still have to select its icon from the drive mode menu. The self-timer can be set to remain active even after the camera has been powered off and back on. To make that setting, go to screen 6 of the Custom menu and set the Self Timer Auto Off option to Off. If, instead, you set that option to On, the self-timer will be deactivated when the camera is powered off. I use the two-second self-timer often, because I do a lot of shooting from a tripod and I like to avoid camera shake whenever possible. Therefore, I usually leave that menu option turned off, so the self-timer will be active when I turn the camera on for a new shooting session.

You cannot use the self-timer option for multiple shots when the camera is set for bracketing or Multiple Exposure, or when Simultaneous Record Without Filter is turned on. You cannot use the self-timer at all when recording motion pictures or using 4K Photo, Post Focus, Time Lapse Shot, or Stop Motion Animation with Auto Shooting turned on.

Panorama

The final icon at the right of the drive mode menu is for shooting panoramas. If you follow the fairly simple steps involved, the LX100 II will stitch together a series of images internally to create a wide (or tall) view of a scenic vista or other subject that lends itself to panoramic depiction. Just select the drive mode icon that looks like a long, squeezed rectangle with an arrow inside, seen at the far right back in Figure 5-28. You will see a message telling you to press the shutter button and move the camera in the direction of the arrow that appears on the screen.

At that point, you can press the shutter button, pan the camera, and likely get excellent results. However, the camera also lets you make several choices for your panoramic images using the Recording menu. Once the message telling you to press the shutter button has disappeared from the display, press the Menu/Set button, and you will go to the menu screen.

Navigate to the Recording menu, which limits you to fewer choices than in most other shooting modes because several options are not appropriate for panoramas. For example, the Picture Size, AFS/AFF/AFC, Highlight Shadow, i.Dynamic, HDR, and several other settings are dimmed and unavailable. The Quality setting will be available, but you cannot select Raw or Raw & JPEG for that setting.

In addition, you will not be able to zoom the lens in; it will be fixed at its wide-angle position. (If the lens was zoomed in previously, it will zoom back out automatically when you switch drive mode to panorama.) The setting of the aspect ratio switch will have no effect on the panorama. You cannot shoot panoramas while the camera is set to Intelligent Auto mode.

One menu option that will be available is Panorama Settings on screen 4 of the Recording menu, which includes two sub-options: Direction and Picture Size. The Direction item determines the direction (right,

left, up, or down) that you move the camera in while shooting the panorama. The Picture Size setting lets you choose Standard or Wide for the size of the panorama.

With the Standard setting, a horizontal panorama has a width of 8176 pixels and a height of 1920 pixels. A vertical panorama has a width of 2560 and a height of 7680. With the Wide setting, a horizontal panorama has a width of 8176 and a height of 960, but it covers a wider area than a Standard panorama. If you want the highest quality, choose Standard; choose Wide if you need to include a very wide view in the image.

Because of the different sizes of panoramas taken with the horizontal and vertical orientations, you can use the direction settings with different orientations of the camera to achieve different results than usual. For example, if you set the direction to Down and then hold the camera sideways while you sweep it to the right, you will create a horizontal panorama that has 2560 pixels in its vertical dimension rather than the standard 1920.

It is advisable to use a tripod if possible, so you can keep the camera steady in a single plane as it moves. Focus, exposure, and white balance are fixed as soon as the first image is taken for the panorama, and you cannot adjust aperture or shutter speed; the camera determines exposure automatically.

To shoot a panorama with one of the Filter Effect settings in place (such as Expressive, Retro, Old Days, and the like), you can use the Filter Settings menu option, or just turn the control ring or control dial. (A few effects are not available: Toy, Toy Pop, Miniature, and Sunshine.) If the control ring does not work for this function, make sure its function is set to Default through the Control Ring option on screen 3 of the Custom menu.

One other setting you can make when shooting panoramas is exposure compensation, using the exposure compensation dial. This feature can be useful because the camera will not change the exposure if the camera is pointed at areas with varying brightness.

For example, if you start sweeping from a dark area on the left, the camera will set the exposure for that area. If you then sweep the camera to the right over a bright area, that part of the panorama will be overexposed and possibly washed out in excessive brightness. To correct for this effect, you can reduce the exposure using exposure compensation. In this way, the initial dark area will be underexposed, but the brighter area should be properly exposed. Of course, you have to decide what part of the panorama is the most important one for having proper exposure.

Another way to deal with this issue is to point the camera at the bright area before starting the shot and press the shutter button halfway to lock the exposure, and then go back to the dark area at the left and start sweeping the camera. In that way, the exposure will be locked at the proper level for the bright area.

Once you have made the settings you want, follow the directions on the screen. Press and release the shutter button and start moving the camera at a steady rate in the direction you have chosen. I tend to shoot my panoramas moving the camera from left to right, but you may have a different preference. You will hear a steady clicking as the camera takes multiple shots during the sweep of the panorama. A white box and

arrow will proceed across the screen; your task is to finish the camera's sweep at the same moment that the box and arrow finish their travel across the scene, which should take about four seconds. If you move the camera either too quickly or too slowly, the panorama will not succeed; if that happens, just try again.

Generally speaking, panoramas work best when the scene does not contain moving objects such as cars or pedestrians, because, when items are in motion, the multiple shots are likely to capture images of the same object more than once in different positions.

When a panoramic shot is played back in the camera, it is initially displayed at a small size so the whole image can fit on the display screen. You can press the Up button to make the panorama scroll across the display at a larger size, using the full height of the screen.

Figure 5-46 is a sample panorama, shot from left to right, handheld.

Figure 5-46. Panorama: James River, Richmond, Virginia

Besides activating drive mode, the Down button has other duties. For example, pressing this button takes you to the screen for fine-tuning a white balance setting, and it provides access to the screen with options for setting the location of focus points from the AF mode screen. When the camera is in playback mode, pressing the Down button initiates the process to upload images by Wi-Fi, as discussed in Chapter 9.

When you are playing a slide show or a movie, the Down button acts like a Stop button on a DVR to stop the playback completely. When you use the Video Divide function from the Playback menu, the down button is used to "cut" a movie at your chosen dividing point. When you are viewing a group of images that were taken with the focus bracket, Time Lapse, or Stop

Motion options, you can press the Down button to view the images individually rather than as a group.

CENTER BUTTON: MENU/SET

The last button to discuss among those in the control dial assembly is the button in the center of the dial, labeled Menu/Set. You use this button to enter and exit the menu system, and to make or confirm selections of menu items or other settings. In addition, when you are playing a motion picture and have paused it, you can press the Menu/Set button to select a still image to be saved from the motion picture recording. This button also selects an image to be saved from a 4K Photo sequence.

Movie Button

You press this red button once to start recording a movie and press it again to stop the recording. You can use this button no matter what shooting mode the camera is set to. In Chapter 8, I will provide details about how the various menu and control settings affect the recording of movies.

If you are not going to be recording motion pictures for a while (or ever), you can disable the use of this button, to keep from pressing it by accident and starting a recording. To do that, go to screen 4 of the Custom menu and set the Video Button option to Off. Then, if you press the button, the camera will display an error message and will not start a motion picture recording. I have pressed the red button by accident several times, and I appreciate having the ability to lock out its operation in this way.

AF/AE Lock Button

The AF/AE Lock button is located at the upper right of the camera's back, just below the shutter speed dial. Using the AF/AE Lock item on screen 1 of the Custom menu, you can set this button to lock both autofocus and autoexposure, or just one or the other. Then, you can press this button to lock whichever of those settings have been selected through the menu option.

With the same menu option, you also can select AF-On. If you turn on that option, pressing this button operates the camera's autofocus system. That option gives the camera a capability for "back button focus," so named because you can press a button on the camera's back to focus the lens. If you want to turn off the shutter button's focusing function, you can do that by turning off the Shutter AF option on screen 1 of the Custom menu.

You cannot lock exposure with the AF/AE Lock button when the camera is set to Manual exposure mode, and the button does not function at all in either variety of Intelligent Auto mode. When manual focus is in use, the button cannot lock focus. Zooming the lens cancels either type of lock. You can set the button to hold its setting without keeping it pressed, using the AF/AE Lock Hold item on screen 1 of the Custom menu.

Playback Button

This button, located to the upper right of the control dial, is marked with a white triangle. You press this button to put the camera into playback mode. Press it again to switch back into recording mode. When the camera is placed into playback mode, by default the lens barrel will retract automatically after about 15 seconds, because the lens is not needed during playback operations. However, you can change that behavior by turning off the Lens Retraction item on screen 6 of the Custom menu.

If you hold down the Playback button while turning the camera on, the camera will start up in playback mode.

Display Button

The Display button is at the bottom right of the camera's back, to the lower right of the control dial. It has several functions, depending on the context. Its primary function is to switch among the several available display screens for the LCD monitor or the viewfinder, in both recording mode and playback mode.

In recording mode, there are different information screens displayed with presses of the Display button: The full information display with shooting settings; a blank display except for focus frame if one is in use (although basic exposure settings appear for a few seconds); full information with level gauge, as well as histogram and focus area if applicable; level gauge with focus area if applicable; monitor information screen with no live view, if that option has been activated through the Monitor Information Display option on screen 6 of the Custom menu; and blank screen, completely black, with no information.

In basic Intelligent Auto mode, the Display button produces the screens listed above, but the histogram does not appear, even if it was turned on through the Custom menu. There also are other items that will appear on the information screens, such as the Guide Line grid if selected on screen 5 of the Custom menu, and icons for items such as the self-timer when they are activated.

The viewfinder uses the same display screens as those discussed above, except that it does not include the monitor information screen or the blank screen. The items displayed are affected by the LVF/Monitor Display Setting option on screen 6 of the Custom menu.

If the camera is set for playback, repeated presses of the Display button produce the following screens:

- Image with basic shooting settings and icon showing that you can press the Down button to upload images via Wi-Fi.
- A smaller image with the same information, plus date and time of image capture and some other settings, including focus mode and Photo Style. On this screen, you can scroll down through four other information screens, including screens showing histogram, white balance, focal length, and other information about the image.
- Just the recorded image, with no other information, but flashing the highlights in areas that are overexposed. (This screen appears only if the Highlight option is turned on through screen 5 of the Custom menu. The highlights also will flash on the detailed information screens; this screen is added so you can see the overexposed areas without interference from information items.)
- Just the recorded image with no other information, and with no flashing highlights.

If you are playing back a motion picture, the display is similar, except for some added information that applies to that mode, including an icon showing that you can press the Up button to start the motion picture playing.

The Display button also has several other functions: You can press it to restore the focus frame to normal after you have moved it off center or resized it when using the 1-Area focus mode or one of the other modes that allows you to move or resize the focus point or points. If you need a reminder of the current date and time, with the camera in recording mode, press the Display button enough times to cycle back to the screen with the most recording information, and the date and time will appear on the lower left of the screen for about five seconds. Also, when you are viewing a menu screen, you can press the Display button when a menu option (or, in some cases, a sub-option or setting) is highlighted, to see a brief explanation of that item.

Charging/Wireless Connection Lamp

This small lamp, located between the Fn5 and Fn4 buttons at the top of the camera's back, has two functions. When you have plugged in the charger to charge the battery inside the camera, the lamp lights up red while charging continues and turns off when charging is complete. It blinks red if there is a problem affecting the charging process, such as excessive heat or cold. The lamp lights up blue when a wireless connection by Bluetooth or Wi-Fi is being initiated or is active; it blinks blue when data is being sent over that connection. You can disable the connection lamp using the Wireless Connection Lamp option on screen 2 of the Setup menu.

Function Buttons

The LX100 II has five physical function buttons, labeled Fn1, Fn2, Fn3, Fn4, and Fn5. (There also are five virtual buttons called Fn6 through Fn10 that can appear on the touch screen; I will discuss them in connection with the touch screen, later in this chapter.)

Each of the five physical function buttons has an assigned function by default, and each button also can be programmed to handle any one of a large number of possible operations in recording mode. Four of the buttons can also be assigned to handle a function in playback mode, as discussed later in this chapter.

To program a button for a new assignment, you use the Function Button Set option on screen 3 of the Custom menu, which is discussed in Chapter 7. Some of the items that can be assigned to these buttons are not available through any menu or other control, while some of them are options that can also be selected through the menu system or through another control. I will discuss all of those possible assignments later in this chapter. First, I will discuss duties assigned to these buttons by default in recording mode, when the camera first comes from the factory.

Fn1/4K Photo Button

The Fn1 button, located at the far upper right of the camera's back, is assigned by default as the 4K Photo button. With that assignment, when you press the button the camera displays a menu for selecting one of the 4K Photo burst modes or turning 4K Photo off. You

can reach a similar menu by pressing the Down button to bring up the drive mode menu, and then pressing the Up button when 4K is highlighted on the Drive menu.

The Fn1 button also has some other miscellaneous duties. For example, when are editing a 4K Photo sequence, you can press the Fn1 button to switch between a screen with frames that you can drag through and a screen with DVR-like playback controls. When you are viewing a sequence captured using the Post Focus feature, you can press this button to switch to the Focus Stacking option.

Fn2/O.Menu Button

The Fn2 button is located to the upper left of the control dial. As you can see from its label, it is assigned by default to act as the Quick Menu or Q.Menu button. I discussed that menu system in Chapter 4. When you press this button while the shooting screen is displayed, you have instant access to several of the more important settings on the camera. You can customize the available choices using the Quick Menu option on screen 3 of the Custom menu, as described in Chapter 7. If you assign the Fn2 button to a new function through the Function Button Set option on screen 3 of the Custom menu, the button will no longer call up the Quick Menu.

The Fn2 button also has some miscellaneous functions permanently assigned to it. When you are setting up the autofocus area using the Custom Multi option of AF mode, in which you select one or more of 49 possible focus zones, you press this button to lock in your selections after highlighting the desired zones. When you are recording a sequence using the 4K Photo Burst (S/S) option, you can press this button to insert a marker at any point you want to be able to find easily when playing back the sequence.

When you are using the 4K burst playback screen to select a still image from a 4K Photo burst sequence, you can press the Fn2 button to switch to or away from the screen that is navigated with markers embedded in the file. When you are using the Post Focus playback screen, you can press this button to highlight the in-focus areas of the image with focus peaking.

Fn3/Delete/Cancel Button

The Fn3 button, located to the lower left of the control dial, has several functions. First, as indicated by the

trash can icon below the button, it serves as the Delete button. When the camera is set to playback mode, press this button while an image or image group is displayed, and you are presented with several options: Delete Single, Delete Multi, and Delete All.

Use the direction buttons, the control dial, or the touch screen to navigate to your choice. If you select Delete Single, the camera will display a confirmation screen; if you confirm the action, the camera will delete the currently displayed image or image group (unless it is protected, as discussed in Chapter 6).

If you select Delete Multi, the camera presents you with a display of recent pictures, up to nine at a time per screen.

You can scroll through these thumbnail images and press the Menu/Set button to mark any picture you want to be included in the group for deletion, up to 100 in total. You can press Menu/Set a second time to unmark a picture for deletion. When you have finished marking pictures for deletion, press the Display button or press the DISP.OK icon on the touch screen to start the deletion process. The camera will ask you to confirm, and you can highlight Yes and press Menu/Set to delete the marked images.

The Delete All option deletes all images on the memory card, unless you have rated some images with stars (as discussed in Chapter 6) and choose to delete all except those with ratings, as prompted by the camera after you select Delete All. You can interrupt a deletion process with the Menu/Set button, though some images may have been deleted before you press the button.

The Fn3 button also serves as a Cancel button, as indicated by the backward-curving arrow below the button. When you are viewing menu screens, you can press this button to cancel out of a selection or other event, such as the use of the Format command on the Setup menu to erase and re-format a memory card. When the Fn3 button can be used to cancel an action and return to a previous screen, the camera displays the curving arrow, as shown in Figure 5-45, for example.

FN4/Post Focus Button

The Fn4 button is located at the top of the camera's back, to the left of the movie button. With its default assignment, pressing this button brings up a brief menu allowing you to turn the Post Focus feature on

or off. The other way to get access to this feature is through the Post Focus item on the drive mode menu, as discussed earlier in this chapter.

FN5/LVF BUTTON

The Fn5 button is located just to the right of the electronic viewfinder's eye sensor window. As indicated by its label, this button is assigned by default to control the operation of the electronic viewfinder, also known as the live viewfinder (LVF). Pressing the button repeatedly calls up the three possible settings for the LVF/Monitor Switch setting, which is an option found under the Eye Sensor item on screen 3 of the Setup menu. The three settings for that item are LVF/ Monitor Auto, LVF, and Monitor. With the first option, the camera automatically switches the view from the monitor to the viewfinder when your head (or another object) comes close to the eye sensor, located to the right of the viewfinder. With the LVF setting, the view stays in the viewfinder. With the Monitor setting, the view stays on the LCD monitor. It is convenient to be able to switch this setting just by pressing this button, rather than digging through the menu system to find it.

Assigning Functions to Function Buttons

As I noted above, you can assign any one of numerous functions to any of the five physical function buttons, using the Function Button Set option on screen 3 of the Custom menu. You also can bring up that menu option by pressing and holding any of the five physical function buttons for about two seconds. You also can assign a function to each of the five virtual function buttons, Fn6 through Fn10, which are activated from the touch screen.

The function you assign to a button will be carried out whenever you press the assigned button. Of course, the function will be carried out only if the present context permits. For example, if you assign the Fn1 button to activate the HDR option, and then press the Fn1 button while the camera is in Intelligent Auto mode, nothing will happen, because the HDR option is not available in that recording mode.

Similarly, if you assign the Fn1 button to activate the level gauge option, and then press that button while using the Time Lapse Shot option from screen 3 of

the Recording menu, the level gauge will not appear, because the Fn1 button is permanently assigned to interrupt the Time Lapse Shot operation.

Each of the ten function buttons can be assigned an option for use when the camera is in recording mode. Four of the physical buttons—Fn1, Fn2, Fn4, and Fn5—also can be assigned one of a few functions for use in playback mode. A button can have both assignments at the same time, though, of course, only one of the options can be used at a time because the camera has to be in recording or playback mode for the given function to operate.

Table 5-1, below, lists the functions that can be assigned to each button for use in recording mode. The buttons listed in parentheses are the default assignments for the listed functions. There are no default assignments for Fn9 and Fn10.

With those caveats, Table 5-1 lists the options that can be assigned to any one of the function buttons.

Table 5-1. Possible Function Button Assignments

Menu & Screen No./Normal Control Used for Function	Function
Down Button	4K Photo Mode (Fn1)
Down Button	Post Focus (Fn4)
Expos. Comp. Dial	Exposure Compensation
Setup 1	Wi-Fi (Fn6)
***	Q.Menu (Fn2)
Red Movie Button	Video Record
Setup 3 (Eye Sensor option)	LVF/Monitor Switch (Fn5)
Custom 6 (LVF/Monitor Display Setting option)	LVF/Monitor Display Style
AF/AE Lock Button	AF/AE Lock
AF/AE Lock Button	AF-On
	Preview
Touch Screen	Touch AE
Display Button	Level Gauge (Fn7)
	Focus Area Set
	Operation Lock
Recording 1	Photo Style
Recording 1 (Filter Settings option)	Filter Effect
Recording 1	Picture Size
Recording 1	Quality
Recording 1	AFS/AFF/AFC
Recording 1	Metering Mode

Chapter 5: Physical Controls

Recording 4	Bracket
Recording 1	Highlight Shadow
Recording 2	i.Dynamic
Recording 2	i.Resolution
Recording 2	Minimum Shutter Speed
Recording 4	HDR
Recording 4	Shutter Type
Recording 2	Flash Mode
Recording 2	Flash Adjustment
Recording 2	Wireless Flash Setup
Recording 3	i.Zoom
Recording 3	Digital Zoom
Recording 3	Stabilizer
Motion Picture 1	Motion Picture Settings
Motion Picture 2	Picture Mode in Recording
Motion Picture 3	Sound Recording Level Adj.
Setup 1	Utilize Custom Set Feature
Recording 4	Silent Mode
Custom 5	Peaking
Custom 5	Histogram (Fn8)
Custom 5	Guide Line
Custom 5	Zebra Pattern
Custom 4	Monochrome Live View
Custom 4	Constant Preview
Custom 4	Live View Boost
Custom 6	Recording Area
Custom 4	Zoom Lever
Up Button	Sensitivity
Right Button	White Balance
Left Button	AF Mode/MF
Down Button	Drive Mode
Playback Button	Record/Playback Switch
-	Off
	Restore to Default

There are four functions that cannot be assigned to the virtual function buttons, Fn6 through Fn10: LVF/Monitor Switch, AF/AE Lock, AF-On, and Operation Lock. Also, the virtual buttons cannot be used when the viewfinder is in use. The Fn9 and Fn10 buttons do not have default assignments, unlike the other eight buttons.

Most of the settings in Table 5-1 are self-explanatory; they are options that also can be activated from one of the menus or with a dedicated control. For example, if a button is assigned to the Photo Style option, pressing the button calls up a menu or settings screen for that

option from screen 1 of the Recording menu. The screen that is called up by pressing the function button may look different from the screen that is called up from the menu, but it will let you make the basic selection of the menu option. The level gauge is normally activated by pressing the Display button until a screen with that item appears. I will not discuss those assignments here; you can find details about those settings in the chapters that discuss the menu systems and physical controls.

However, there are several possible button assignments that are not found on the regular menus and are not normally activated by any control button. I will discuss those functions below.

Preview

The first non-menu setting, Preview, lets you see the effects of the current aperture and shutter speed settings on the final image before you take a picture. Ordinarily, when you aim the camera at a subject, the live view on the camera's display is set to provide a clear view of the scene, without giving effect to the current settings.

For example, suppose you are using Manual exposure mode for an indoor shot of two objects at different distances. Suppose you have set the aperture to f/11 to keep both items in focus with a broad depth of field and you have set the shutter speed to 1/125 second. If you aim the camera at the subjects, you will see a view like that in Figure 5-47, which does not show the effects of these settings.

Figure 5-47. Preview Example - Before Pressing Button

Now, if Preview is assigned to the Fn1 button, press that button once and you will see a screen like that in Figure 5-48.

Figure 5-48. Preview Example - After First Button Press

For this view, the Preview feature has caused the camera to close the aperture down to the actual setting of f/11, which shows the effect of the broad depth of field, bringing the background into sharper focus. The message on the screen, Fn1 Shtr Speed Effect On, means that, if you press Fn1 again, the camera will display the effect of the shutter speed setting, as shown in Figure 5-49.

Figure 5-49. Preview Example - After Second Button Press

In this case, the Preview display in Figure 5-49 shows that this shutter speed would result in a dark image. (In addition, though this effect is not noticeable in the image shown here, if a slow shutter speed were set, the image on the LCD display would smear if the camera moved, as the preview showed how the slow shutter speed would cause motion blur.) With this view, the camera displays the message, Fn1 Exit Preview, meaning if you press Fn1 again, the Preview display will end.

If you have turned on the Constant Preview option through screen 4 of the Custom menu, the Preview function will not work in Manual exposure mode, because the preview will already be in effect. (The

Constant Preview option works only in Manual exposure mode.)

Focus Area Set

If you assign this option to a function button, when you press the button, the camera will immediately display a screen for adjusting the current focus setting. The actual result of pressing the button will depend on the current setting. For example, if you are using autofocus with the 1-Area AF mode setting, pressing the assigned button will place the focus frame on the display with arrows, ready to be moved using the direction buttons. If the current AF mode setting is Custom Multi, pressing the assigned button will call up the screen for selecting the pattern of focus zones for that area. If you are currently using manual focus, pressing the button will call up a screen for adjusting the MF Assist area.

This option can be useful if you often adjust the focus area, so you don't have to go through extra steps to reach the screen to make that adjustment.

Touch AE

This option can also be activated by touching the Touch AE icon on the touch screen, as discussed later in this chapter. If you assign Touch AE to a function button, you can turn on this option with one button push. Then, touch the LCD display at the point to optimize exposure. The camera will move a small blue cross over the area you touched, as shown in Figure 5-50.

Figure 5-50. Blue Cross on Screen for Touch AE

Then press the Set icon or press the Menu/Set button to accept the new exposure setting. You can press the Display button or touch the DISP. Reset icon to reset the exposure point to the center of the display.

95

Operation Lock

When this function is assigned to a button, pressing that button locks out the operation of the four direction buttons and the Menu/Set button, or the touch screen, or all of the above, while the camera is in recording mode. In order to specify whether the assigned button locks the operation of the cursor buttons, the touch screen, or both categories, you use the Operation Lock Setting option on screen 3 of the Custom menu.

You might want to use this feature if you don't want the current settings to be disturbed by the accidental press of a button or a touch of the screen. Once you have pressed this button, you will not be able to use the controls that were locked until you press the assigned function button again to cancel the lock. The camera will display an Operation Lock message at the top of the screen if you try to use a locked control.

The lock remains in place even when the camera is powered off and then on, so, if you find you cannot use the Menu/Set button when the camera is first turned on, try pressing the function buttons to see if the direction buttons and Menu/Set button have been locked with this feature. The lock applies only when the camera is in recording mode, so you can still use the cursor buttons and/or touch screen in playback mode, even while the lock is in effect.

AF Mode/MF

With this setting, if you are using autofocus, pressing the assigned function button calls up the screen for selecting an autofocus mode (Face/Eye Detection, 1-Area, Custom Multi, etc.). If you are using manual focus, it calls up the screen for adjusting the position of the MF Assist focus frame. This option assigns the same functions that are assigned by default to the Left button.

You might want to use this assignment for a function button if you have activated the Direct Focus Area option on screen 2 of the Custom menu, which causes the four direction buttons to be used only for moving the autofocus frame or manual focus frame. With that option, the Left button would no longer give you access to the AF mode/MF options, so you could use this assignment to cause a function button to take over those duties.

Record/Playback Switch

If you assign this option to a function button for recording mode, pressing the assigned button will switch the camera into playback mode. However, pressing the button again while the camera is in playback mode will not necessarily switch the camera back into recording mode. The action the button carries out will depend on what assignment, if any, it has been given for playback mode, as discussed below. You can assign it to Record/Playback Switch for playback mode, in which case it will switch the camera back into recording mode. Otherwise, it will not do so.

Restore to Default

If you choose this option for a given function button, that button will be restored to its default setting. Those defaults are as follows: Fn1—4K Photo; Fn2—Q.Menu; Fn3—Preview; Fn4—Post Focus; Fn5—LVF/Monitor Switch.

Assigning Options to Function Buttons for Playback Mode

As I noted earlier, the camera also lets you assign a function to each of four physical function buttons—Fn1, Fn2, Fn4, and Fn5—for use when the camera is in playback mode. The functions that can be assigned are the following:

- Wi-Fi
- LVF/Monitor Switch
- Record/Playback Switch
- 4K Photo Play
- Delete Single
- Protect
- Rating★1
- Rating★2
- Rating★3
- Rating★4
- Rating★5
- Raw Processing
- 4K Photo Bulk Saving

- Off
- Restore to Default

By default, the Fn1 button is assigned to Wi-Fi, the Fn2 button is assigned to Rating ★3, the Fn4 button has no assignment, and the Fn5 button is assigned to LVF/Monitor Switch.

The functions listed above are self-explanatory, except for Record/Playback Switch and the Rating entries. Record/Playback Switch switches the camera into recording mode, as discussed above for the assignment of options for recording mode. As noted above, pressing it again will not switch back to playback mode unless the button has been assigned the Record/Playback Switch option for recording mode as well as for playback mode.

Rating entries let you quickly assign a rating to an image for video with a number of stars, from 1 to 5, though you can assign only four buttons to have functions in playback mode at any one time. The Rating function also is available on screen 1 of the Playback menu. When you have rated some images, you will have the option to delete all images except rated ones, by selecting Delete All after pressing the Fn3 button in playback mode, and then selecting Delete All Nonrating. You also can view rating information (for JPEG images only) in software such as Adobe Bridge, where the rating shows up as stars in the thumbnail display.

LCD Monitor

The LX100 II's LCD monitor has a diagonal dimension of three inches or 76mm, with a resolution of about 1.2 million dots. It cannot tilt or swivel, but it has excellent features as a touch screen, which I will discuss below, as well as in discussions of menu options and other camera functions that use the touch screen.

Using the Touch Screen

A few basic pointers are helpful in understanding the use of the touch screen. First, the Touch Settings option, on screen 4 of the Custom menu, controls several important settings. I will discuss the details in Chapter 7. If the Touch Screen sub-option of Touch Settings is turned off, no touch screen functions are available. If the Touch Tab sub-option is turned off, there will be basic touch options, but none of the special tabs that appear at the right edge of the shooting screen. The Touch AF

and Touch Pad AF sub-options control other aspects of the camera's touch screen functions.

Second, watch for icons that appear to be touchsensitive, and try them out. It can't hurt to experiment, and you will eventually come to realize which icons on the screen are responsive to your touch and which ones are there only to provide information.

Third, don't forget that the touch screen operates in playback mode and with menu screens, not just with recording functions. In this discussion, though, I will concentrate on using the touch screen in recording mode.

Figure 5-51 shows the shooting screen in Program mode, with the touch screen settings turned on. At the right edge of the screen are three icons. From the top, these are the touch icons for controlling Filter Effect settings, for activating the touch tab, and for getting access to the virtual function buttons. In this image, all three of those icons are white.

Figure 5-51. Touch Screen Icons at Right of Display

Figure 5-52. Display After Touching Top Icon

If you touch the top icon, the icons change, as shown in Figure 5-52. You will now see a larger Filter Effect icon

Chapter 5: Physical Controls [97

with an X beside it. That icon means that Filter Effects are turned off. If you touch that icon, the currently selected filter effect, such as Impressive Art (IART), turns on, and the icons change again. To change the effect, touch the IART icon, and the camera will display a screen for selecting a different Filter Effect. When you are done with Filter Effects, touch the top icon again to turn off the effect. Then touch the small, yellow Filter Effect icon to collapse the touch tab area.

The second of the three icons at the right of the screen is the left-facing arrow, which is the touch tab icon. When you touch that icon, the display changes as seen in Figure 5-53, to show various items in the touch tab area. From the top, these are the Touch Zoom icon, the Touch AF/Touch Shutter icon, the Touch AE icon, and the Peaking icon.

Figure 5-53. Touch Tab Icons Activated

If you touch the Touch Zoom icon, it will turn yellow to show that it is active and the camera will display the Touch Zoom controls, as shown in Figure 5-54. You can then touch those controls to zoom the lens in or out.

Figure 5-54. Touch Zoom Control Activated

Touch the yellow icon again to turn off touch zoom and get access to other items in the touch tab area.

The icon below the Touch Zoom icon is the Touch AF icon. If you touch it, it cycles through three settings: Touch AF, Touch Shutter, and Off. When it is set to Touch AF, as in Figure 5-55, you can touch the screen to set the focus point, using the current AF mode setting. If you touch the icon, it switches to Touch Shutter, with a shutter icon next to the pointing finger. You can then touch the screen on any object you want the camera to direct its focus on, and the camera will take a picture without your having to press the shutter button. Touch the icon one more time to turn Touch Shutter and Touch AF off.

Figure 5-55. Touch AF Icon Activated

The next icon is the Touch AE icon. When you touch that icon, a small blue cross appears on the display, as shown earlier in Figure 5-50. Move that cross with your finger over the subject where you want the exposure to be evaluated, or just touch that area, then touch the Set icon. Touch the Touch AE Off icon at the left of the screen to cancel Touch AE. The Touch AE option is not available if Touch AF is set to AF+AE under the Touch Settings item on screen 4 of the Custom menu.

Finally, you can press the Fn icon at the bottom of the touch tab area to activate the display of the virtual function buttons, Fn6 through Fn10.

Figure 5-56. Virtual Function Buttons on Shooting Screen

The display will then look like Figure 5-56, with the icons for those buttons visible. Touch any one of those icons to activate the function assigned to it. Earlier in this chapter I discussed how to assign a function to a function button. In this illustration, Fn6 is assigned to Wi-Fi, Fn7 to the level gauge, and Fn8 to the histogram option. Fn9 and Fn10 are not assigned until you choose assignments for them. When you have finished using the virtual function buttons, press the yellow Fn icon to collapse the Fn tab.

There is another screen displayed in recording mode that has touch features, as long as the Touch Screen menu option is turned on. That is the Monitor Information Display screen, shown in Figure 5-57.

Figure 5-57. Monitor Information Display Screen

That screen is included in the cycle of screens displayed with successive presses of the Display button in recording mode. It is displayed only if the Monitor Information Display item is turned on through screen 6 of the Custom menu. When this screen is displayed with the touch screen settings turned on, you can touch many of the items on the screen to adjust them, including ISO, white balance, exposure compensation, and others. Of course, an item can be adjusted only if the context permits, so you cannot adjust ISO in Intelligent Auto mode, for example.

I will discuss other touch screen functions in connection with the appropriate menu items and camera operations as they come up in later chapters of this book.

The one item remaining to be discussed is the AF Assist/Self-timer Lamp, shown in Figure 5-58.

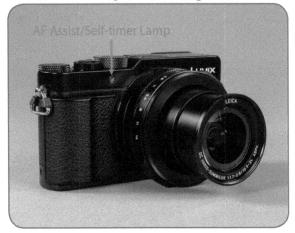

Figure 5-58. AF Assist/Self-timer Lamp

AF Assist/Self-timer Lamp

This small lamp gives off a bright reddish light when it carries out either of its two functions. First, when the camera is set to use autofocus, this light turns on when lighting is dim, in order to assist the autofocus mechanism in observing the scene and detecting focus points. You can control that behavior using the AF Assist Lamp item on screen 2 of the Custom menu. If you set that option to Off, the lamp will never turn on for autofocus assistance. You might want to make that setting in order to avoid disturbing a child or pet, or to avoid drawing attention to your camera. Even with that option set to turn the lamp off, the lamp will still illuminate when the self-timer is used. The lamp will blink several times during the self-timer countdown.

CHAPTER 6: PLAYBACK

Review on screen 4 of the Custom menu, which determine whether and for how long a newly recorded image stays on the screen for review. If your major concern is to check images right after they are taken, the Auto Review settings may be all you need to use.

For ordinary images, not using the 4K Photo or Post Focus features, you can leave Auto Review turned off or set it to one, two, three, four, or five seconds, or to Hold. If you choose Hold, the image will stay on the display until you press the shutter button halfway to return to recording mode. You can set up different hold options for regular images, 4K Photo images, and Post Focus images, as discussed in Chapter 7.

To control how images are viewed later on, you need to use the options available in playback mode. For ordinary review of images, press the Playback button, marked by a small triangle, to the upper right of the cursor buttons. Once you press that button, the camera is in playback mode, and you will see the most recent image that was viewed in playback mode. To move back through older images, press the Left button or turn the control dial to the left. To see more recent images, use the Right button or turn the control dial to the right. To speed through the images, hold down the Left or Right button.

You also can use the touch screen to scroll through images and videos, if the Touch Settings item on screen 4 of the Custom menu has Touch Screen turned on. Drag across the screen with a finger in either direction to scroll backward or forward through the images.

Index View and Enlarging Images

When you are viewing an individual image in playback mode, press the zoom lever once to the left, and you will see a screen showing 12 images, one of which is outlined by a yellow frame, as shown in Figure 6-1. You also can touch the index screen icon, located above the trash can icon on the individual image.

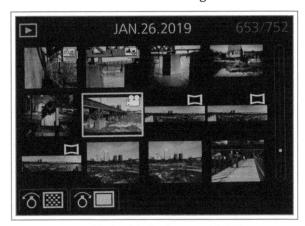

Figure 6-1. Playback Index Screen with 12 Images

Press the zoom lever to the left once more or touch the index screen icon in the lower left of the index screen, to see an index screen with 30 images.

You can press the Menu/Set button to view the outlined image, or you can move through the images and videos on the index screen by pressing the four direction buttons or by turning the control dial. You can also drag on the touch screen to scroll the images.

From the 30-image index screen, one more press of the zoom lever to the left or a touch of the CAL icon brings up a calendar display, as seen in Figure 6-2.

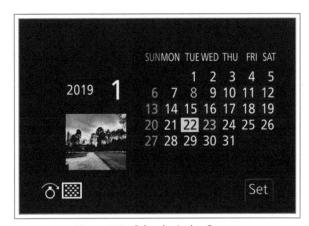

Figure 6-2. Calendar Index Screen

On that screen, you can move the highlight to any date with a lighter gray background and press the Menu/Set button or touch the Set icon to bring up an index view with images from that date.

When you are viewing a single image or video, one press of the zoom lever to the right enlarges the image (or first video frame). You will briefly see a display in the upper right corner showing a green frame with an inset yellow frame that represents the area of the image that is filling the screen in enlarged view, as shown in Figure 6-3. When that inset frame disappears, you will just see the enlarged image with a few icons.

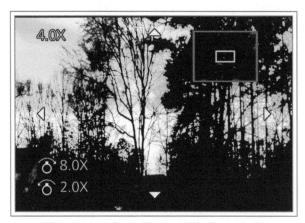

Figure 6-3. Enlarged Image in Playback Mode

If you press the zoom lever to the right repeatedly, the image will be enlarged to greater levels, up to 16 times normal. While it is magnified, you can scroll in it with the four direction buttons or by dragging on the touch screen. The yellow inset frame will reappear and will move around inside the green frame. To reduce the image size again, press the zoom lever to the left as many times as necessary or press the Menu/Set button to revert immediately to normal size. To move to other images while the display is magnified, turn the control dial.

You can enlarge an image to two times normal size by tapping on the touch screen twice. If you tap twice again, an enlarged image returns to normal size.

The Playback Menu

The Playback menu is represented by a triangle icon that turns green when highlighted. It is the last icon at the bottom of the line of menu icons at the left of the main menu screen, as seen in Figure 6-4.

Figure 6-4. Icon for Playback Menu Highlighted at Left

This menu has three screens of options that control how playback operates and that give you access to special features. The first menu screen is shown in Figure 6-5.

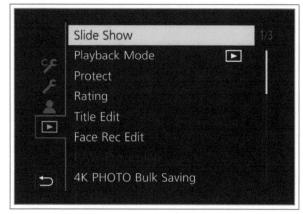

Figure 6-5. Screen 1 of Playback Menu

SLIDE SHOW

The first option on the Playback menu is Slide Show. Navigate to this option, then press Menu/Set or the Right button (or press the menu option on the touch screen), and you are presented with the choices All, Picture Only, and Video Only.

[Play] All

If you choose All from the Slide Show menu, you are taken to a menu with the choices Start, Effect, and Setup, shown in Figure 6-6.

You can choose Start to begin the slide show, or you can select Effect or Setup first and make some selections. Setup lets you choose a duration of one, two, three, or five seconds for each still image, but you can only set the duration if Effect is set to Off. If you turn on any

Chapter 6: Playback

effect, the camera will automatically set the duration to two seconds per still image.

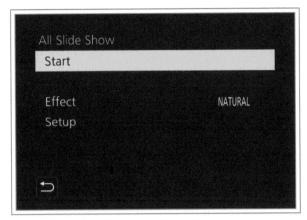

Figure 6-6. Slide Show Menu Options Screen

You can also choose to set Sound to Off, Audio, Music, or Auto, but only if some effect is selected. If no effect is selected, the Sound option can be set only to Audio or Off. With Off, no sound is played. With the Auto setting, the camera's music is played for still images, and motion pictures have their own audio played. The Music setting plays music as background for all images and movies, and the Audio setting plays only the movies' audio tracks.

Also, you can set Repeat On or Off. Note that you can set a duration even when there are videos included along with still images; the duration value will apply for the still pictures, but not for the videos, which will play at their normal, full length.

For effects, you have the following choice of styles: Natural, Slow, Swing, Urban, or turning effects off altogether.

Once the slide show has begun, you can control it using the direction buttons as a set of playback controls, the same as with playing motion pictures. The Up button controls play/pause; the Left and Right buttons move back or forward one slide; and the Down button is like a stop button; pressing it ends the slide show. The control dial adjusts audio volume. A small display showing these controls appears briefly on the screen at the start of the show. After it disappears, you can press the Display button or the Menu/Set button to make it appear again. You also can use touch screen icons to control playback.

[Play] Picture Only/Video Only

These next two options for playing the slide show are self-explanatory; instead of playing all images and videos, you can play either just still images or just videos. If you select Picture Only, the camera will also include photos recorded in 4K burst mode or with the Post Focus feature. For Post Focus, though, the camera will only include one, well-focused image for each group of images.

The only difference between the options for these two choices is that, as you might expect, you cannot select an effect or a duration setting for a slide show of only videos; the slide show will just play all of the videos on the memory card, one after the other. You can use the Setup option to choose whether to play the videos with their audio tracks or with the sound turned off.

PLAYBACK MODE

The second option on the Playback menu, Playback Mode, is similar to the Slide Show option, in that it provides choices for which images and videos are played. This option, though, controls which items are viewed when you are viewing them outside of a slide show. The LX100 II offers three choices for this option: Normal Play, Picture Only, and Video Only.

Normal Play is the mode for ordinary display of your images. This mode is automatically selected whenever the camera is first turned on or switched into playback mode. I described its use at the beginning of this chapter. You can scroll through images, enlarge them, and view them on index screens.

The Picture Only and Video Only options work for playback just as they do for the Slide Show option, as discussed earlier.

PROTECT

The next option on screen 1 of the Playback menu, Protect, is used to lock selected images or videos against deletion. To use this feature, choose Protect from the Playback menu, and then choose the images and videos to mark as protected, either a single item or multiple items. The camera will display your images and videos, either singly or as thumbnails, and you can mark any item as protected by pressing the Menu/Set button or touching the Set/Cancel icon when the image or its thumbnail is displayed. A key icon will appear on each marked image.

When all images to be protected have been selected, press the Fn3 button or the curved-arrow icon to exit from this screen. (Don't press Menu/Set on this screen; if you do, the protection will be removed.)

When you later display an image or video that was marked as protected, a key icon will appear in its upper left corner if you are viewing the playback screen that displays full information and the full-sized image. The Protect function works for all types of images, including Raw files and motion pictures. Note, however, that all images, including protected ones, will be deleted if the memory card is re-formatted.

RATING

This menu option lets you apply a rating system based on stars to images and videos on the memory card in the camera. You can rate any item with one to five stars, or leave it unrated. Once the ratings have been made, there are three ways you can use the system. First, if you press the Fn3/Delete button in playback mode, and then select the option to Delete All, you will see a screen like that in Figure 6-7, giving you the choices of Delete All or Delete All Non-rating. If you select the second option, the camera will delete all items that were not rated with at least one star.

Figure 6-7. Delete Screen from Pressing Fn3 Button

Second, once the ratings have been entered, they will be visible and useful for sorting images in compatible software. For example, in Adobe Bridge, the stars show up below the image thumbnails. Also, the ratings show up in the Image Properties window when the images are viewed using the Silkypix software provided by Panasonic for users of this camera. If you download the latest version of Panasonic's PHOTOfunSTUDIO software, you can view the ratings and change them.

Third, you can print all images with ratings when you are printing directly from the camera to a PictBridge-compatible printer.

You also can rate images and videos by assigning a star rating from one to five to one or more function buttons for playback mode, as discussed in Chapter 5.

TITLE EDIT

This next option on the Playback menu lets you enter a string of text, numerals, punctuation, and symbols for a given JPEG image or group of images through a system of selecting characters from several rows.

Figure 6-8. Text Entry Screen for Title Edit Option

After you select this option from the Playback menu, choose one or more images to have text added and press Menu/Set or touch the Set icon to go to the screen with tools for entering text, shown in Figure 6-8. Navigate using the direction buttons to the block that contains the character to be entered. Then cycle through the choices in each block, such as ABC, using the Menu/Set button, and advance to the next space using the control dial. You can toggle between displays of capital letters, lower case letters, and numerals and symbols using the Display button. You also can touch the letters and icons using the touch screen to select them.

The maximum length for your caption or other information is 30 characters. You can use the Multi option to enter the same text for up to 100 images. You cannot enter titles for motion pictures, images from 4K Photo bursts, Post Focus images, protected images, or Raw images.

Once you have entered the title or caption for a particular image, it does not show up unless you use the Text Stamp function, discussed below, or the Chapter 6: Playback | 103

PHOTOfunSTUDIO software that you can download from Panasonic. The title is then attached to the image, and it will print out as part of the image. There is no way to delete the title in the camera other than going back into the Title Edit function and using the Delete key from the table of characters, then deleting each character until the title disappears. You also can alter the title using the PHOTOfunSTUDIO software.

FACE RECOGNITION EDIT

This Playback menu option is of use only if you have previously registered one or more persons' faces in the camera for face recognition. If you have, use this option to select the picture in question, then follow the prompts to replace or delete the information for the person or persons you select. Once deleted, this information cannot be recovered.

RAW PROCESSING

The Raw Processing option gives you tools for processing your Raw files in the camera. As I discussed in Chapter 4, the Raw format gives you great flexibility for adjusting settings such as exposure, white balance, sharpening, and contrast in post-processing software. But with the LX100 II you don't have to transfer your images to a computer to convert Raw files to JPEGs. You can adjust several settings in the camera and save the altered image as a JPEG, or just convert the Raw file to a JPEG with no alterations, if all you need is a file that is easier to send by e-mail or to view on another device.

If you're not certain whether a given image was shot with Raw image quality, press the Display button until one of the detailed information screens appears; the Raw label will appear next to the aspect ratio for all Raw shots.

Once you have a single Raw image displayed on the screen in playback mode, highlight Raw Processing on the Playback menu, and press the Menu/Set button to select it. Then press the Menu/Set button again (or press the Set icon on the touch screen). The camera will display the Raw Processing screen overlaid on the image you selected for processing.

At the left of the display will be a series of thumbnail images, each with a label displayed to the right. Scroll through those thumbnail images using the control dial, the Up and Down buttons, or the touch screen, and press Menu/Set or the Set icon when the block for that

thumbnail is highlighted with a yellow frame. Each of those thumbnail images represents an action you can take or a setting you can adjust.

For any setting other than Noise Reduction, Intelligent Resolution, and Sharpness, you can press the Display button to switch between the main setting screen, as shown in Figure 6-9, and a comparison screen, as shown in Figure 6-10, on which the camera displays several thumbnail images on the same screen so you can compare the effects of different settings as you scroll through them.

Figure 6-9. Raw Processing Setting Screen for White Balance

Figure 6-10. Raw Processing Comparison Screen for White Balance

Also, for any setting, you can press the zoom lever to enlarge the image on the main setting screen so you can see the effects of the adjustment with a magnified view.

Following are descriptions of the individual items you can adjust.

Begin Processing. If you select this block, the camera will process all of the adjustments you have set using the other blocks. Before it proceeds to make those changes, it will show you a preview of how the

processed image will look before you confirm the operation, as shown in Figure 6-11.

Figure 6-11. Raw Processing Preview Screen

If you choose Yes, the camera will save a new JPEG image using all of the settings you have made. The new image will appear right after the existing Raw image on the camera's display, but it will have an image number at the end of the current sequence on the memory card.

White Balance. With this item, the camera will display the Raw image with the complete line of white balance adjustment icons at the bottom of the screen. (If you don't see that screen, press the Display button to make it appear.) As you scroll through those icons, the display will change to show how the image would look with the selected setting. If you select the color temperature option, you can press the Up button to select the numerical color temperature. For any setting, you can press the Down button to get to the screen with color axes for fine-tuning the white balance appearance.

Brightness Correction. If you select this adjustment, you will be able to increase or decrease the exposure of the image, but only by up to plus or minus two EV levels, in 1/3 EV increments.

Photo Style. With this item, you can change the Photo Style setting to any option you want. If you choose Monochrome, L. Monochrome, or L. Monochrome D, you will also be able to set the Color Tone adjustment, the Filter Effect adjustment that simulates the use of a glass filter for black-and-white film, and Grain Effect, which lets you add grain to an image. (Those three additional adjustments will appear later in the list of Raw Processing options.) If you select any other Photo Style setting, the Color Tone, Filter Effect, and Grain Effect adjustments will not be available. (The

Saturation item will be available in place of the Color Tone adjustment.)

Intelligent Dynamic. The Intelligent Dynamic (or i.Dynamic) screen lets you set this adjustment at a level of Off, Low, Standard, or High, regardless of how it was set when the image was captured.

Contrast. This adjustment is somewhat unusual because, ordinarily, it is made as part of the Photo Style adjustment. With the Raw Processing option, it is separated out. With this item, you can adjust the contrast of your Raw image by as many as five units positive or negative.

Highlight. On the Recording menu, the Highlight item is included as one aspect of the Highlight Shadow item. With the Raw Processing option, Highlight and Shadow are provided as two separate adjustments. If you select this item, you can alter the brightness of the highlights in the image by up to five units in either direction.

Shadow. This item is similar to the previous one, but deals with shadow rather than highlight adjustments.

Saturation. As noted earlier, this item is available for adjustment if you have selected a Photo Style other than Monochrome, L. Monochrome, or L. Monochrome D. If you selected one of the Monochrome settings, the Raw Processing menu option includes Color Tone as an adjustment in place of Saturation.

Color Tone. As noted above, if you choose one of the Monochrome settings for Photo Style, the camera presents this item for adjustment in place of Saturation.

Filter Effect. As discussed earlier, if you choose one of the Monochrome settings for Photo Style, the Filter Effect item is available to adjust; otherwise, it does not appear.

Grain Effect. As noted above, this effect is available only if you have selected a Monochrome setting for Photo Style. This item lets you adjust the level of graininess in the image.

Noise Reduction. With this item, you can adjust Noise Reduction up to five units positive or negative.

Intelligent Resolution. With the Intelligent Resolution, or i.Resolution item, you can set this feature to Off, `Low, Standard, or High.

Chapter 6: Playback | 105

Sharpness. The last item in the line of boxes for adjustment is Sharpness, which, like Contrast and Resolution, is separated out from the Photo Style adjustment. You can change the level of this item up to five units in either direction.

More Settings. If you select this item, the camera will display a sub-menu with three items: Reinstate Adjustments, Color Space, and Picture Size. If you select Reinstate Adjustments, the camera will show you the image as it now stands with any adjustments you have made with the other settings. You can then proceed to cancel all of those adjustments if you want. The Color Space option lets you keep the color space setting the image was shot with, or change it to the other option, either Adobe RGB or sRGB. The Picture Size option lets you set the Picture Size to L, M, or S.

4K PHOTO BULK SAVING

This last option on screen 1 of the Playback menu gives you a way to save a portion of a 4K Photo burst as a group of individual pictures. As discussed in Chapter 5, the ordinary way to extract a single image from a 4K Photo burst is to scroll through the 4K Photo burst and select a single image to extract and save.

With 4K Photo Bulk Saving, instead of extracting a single image, you can extract a segment of images lasting up to five seconds, and save that group of 100 or more images as a burst, just as if it had been taken using the focus bracket, Time Lapse Shot, or Stop Motion Animation option. That is, the burst of images will be displayed as a single image in playback mode, until you press the Up button to view the individual images in the burst one by one. Here are the steps to use this feature:

- 1. Select the 4K Photo Bulk Saving menu option.
- 2. The camera will display all 4K Photo bursts that are available. Scroll through them to find the one you want to use, and press Menu/Set (or touch the Set icon) when it is displayed. If the sequence of shots is longer than five seconds in duration, the camera will display a message on a black screen saying it can produce a crop of five seconds' length, and telling you to select the start position. If the sequence is shorter than five seconds, the camera will display a message asking if you want to proceed with 4K Photo Bulk Saving; there is no need to select a start position in that case.

- 3. Use the on-screen controls to move through the burst of images and stop when the yellow cursor at the top of the screen is at the place where you want to start the five-second group of images. Press the Menu/Set button to select that position, and confirm it when the camera prompts you.
- 4. The camera will extract the five-second segment you identified, and save the individual frames from that 4K footage as images within a burst group. This process will take a fairly long time, probably several minutes.
- of up to 150 images (125 for cameras using the PAL video system) with an icon in the upper left corner indicating that you can press the Up button for burst play and an icon in the lower left corner indicating that you can press the Down button to play the images individually.
- 6. If you press the Up button, the images will play back in a continuous stream, though you can pause and resume with the Up button. If you press the Down button, you will see a screen on which you can use normal playback controls to scroll through the images one by one, or press the Up button to reach a menu for uploading the images by Wi-Fi, as discussed in Chapter 9.

The options on screen 2 of the Playback menu are shown in Figure 6-12.

Figure 6-12. Screen 2 of Playback Menu

LIGHT COMPOSITION

This next menu option gives you a way to select and combine multiple frames from a sequence that was shot using 4K Photo mode. This feature lets you build a composition with dramatic areas of light in different

locations, such as from a series of fireworks bursts. Figures 6-13 through 6-15 illustrate this effect. Figures 6-13 and 6-14 are two images of a flashlight swinging back and forth, from a 4K Photo burst; Figure 6-15 is a composite that resulted from combining those two images along with one other, using the Light Composition option.

Figure 6-13. First Image for Light Composition

Figure 6-14. Second Image for Light Composition

Figure 6-15. Final Light Composition Image

To use this option, select it from the menu, and the camera will display any 4K Photo bursts on the memory card in the camera. Scroll through those choices and press the Menu/Set button or the Set icon on the screen to select an image. On the next screen, select

Composite Merging or Range Merging. With Composite Merging, you can select any images from the 4K Photo burst. With Range Merging, you select the beginning and ending images of a range, and the camera includes all images within that range.

Then use the on-screen icons to select the images you want to include in the final composite. When you have finished, select Save, and the camera will display a message asking you to confirm, and telling how long it will take to produce the composite. If you confirm, the camera will create the composite image.

To achieve good results, you should have the camera on a tripod when capturing the 4K Photo sequence, so the backgrounds of the combined images will blend together seamlessly. Also, note that the camera will create the image using only the brightest parts of the component images, so, if the parts you want to combine are not the brightest parts, they will not be included in the composite image. Of course, if you are shooting a fireworks display, the fireworks bursts almost certainly will be the brightest parts of the image, but in other contexts this feature may not work as expected.

SEQUENCE COMPOSITION

This option is similar to Light Composition in that it lets you create a composition using multiple frames from a 4K Photo burst, but this feature does not involve the use of bright lights. Instead, it involves the selection of multiple images of a moving person or object, to create a multiple-exposure effect that conveys a sense of motion by a single subject, such as a running or jumping person or a basketball in flight toward the basket.

To use this option, you first have to have captured a 4K Photo burst. For this feature to work well, the burst should be shot against a background that does not move, because the end result will combine three or more images against the background, and if the background has moved, the subject will not be seen clearly. So, if possible, shoot the 4K Photo burst using a tripod, against a relatively plain background.

Once the burst has been captured, select this menu option, and the camera will display all available 4K bursts on the memory card. Select the one you want to use, and press the Menu/Set button or the Set icon in the lower right corner of the screen. The camera will then display a screen with controls for navigating

Chapter 6: Playback | 107

through the file. Using those on-screen controls, navigate to the first frame you want to include in the final composition and press the Menu/Set button or the OK icon in the lower right corner.

The camera will display that frame and the choices of Next or Reselect. Choose Next, then navigate to the next frame to include and press Menu/Set or the Set icon again. (Or, if you want to discard the last frame chosen, choose Reselect.) The screen after selecting two frames will look like that in Figure 6-16.

Figure 6-16. Sequence Composition Frame Selection Screen

When you have selected at least three frames, up to a maximum of 40, the choices on the screen will be Next, Reselect, or Save. At that point, you can continue selecting more frames or select Save to create the final product. An example is shown in Figure 6-17.

Figure 6-17. Sequence Composition Final Image

When you are selecting frames to include in the composition, try to select ones in which the subject does not overlap the subject from a previous frame. If they overlap, the subject will appear to "eat" away part of the adjacent frame, spoiling the overall effect.

CLEAR RETOUCH

This feature lets you erase parts of a recorded image by touching them with your finger on the camera's screen. It works only with normal JPEG images, not with Raw images, panoramas, movies, 4K Photo burst shots, or shots taken with the Post Focus option.

To use this option, select it from the Playback menu and scroll through your images until you find one to retouch. When that image is displayed, press the Menu/Set button or touch the Set icon on the screen. The camera will display a screen with Remove and Scaling icons at the right. Touch Remove and then drag or tap your finger on areas you want to erase from the image. The camera will color those areas red, as shown in Figure 6-18.

Figure 6-18. Clear Retouch Screen with Colored Area for Removal

Touch Scaling if you want to enlarge the screen before designating areas to remove. After you touch Scaling, you can pinch the screen apart with your fingers to enlarge it. Then press Remove to activate the removal process.

When you have finished touching areas to be removed, press the Set icon or press the Menu/Set button to finish the process. The camera will display a preview screen; touch the Save icon or press the Menu/Set button to save that version of the image. The camera will display a final confirmation screen for you to save the image as a new picture. Figures 6-19 and 6-20 represent the before and after versions of an image that I edited with this option to remove one of the people from the scene.

Figure 6-19. Clear Retouch Example - Before Removal

Figure 6-20. Clear Retouch Example - After Removal

This feature could be useful if you are preparing some images for a quick presentation and need to remove an object from one or two shots, but it is no substitute for editing with a program such as Photoshop using a computer. It can work fairly well with a plain background like the one in the images here, but it can be difficult to get good results with a more complex background.

TEXT STAMP

The Text Stamp function takes information associated with a given image and attaches it to the image in a visible form. For example, if you have entered a title or caption using the Title Edit function discussed above, it does not become visible until you use this Text Stamp function (or compatible software) to "stamp" it onto the image.

Once you have done this, the text or other characters in the title will print out if you send the picture to a printer. Besides the information entered with the Title Edit function, the Text Stamp function lets you stamp the following other information: year, month, and day

the shot was made, with or without the time of day; travel date (if set); location (if set). Also, you can apply this function to information from pictures taken with names for Baby 1 or 2 and Pet, if you have entered a name for your baby or pet, and to pictures that have names registered with the Face Recognition function.

To use this function, highlight Text Stamp on the menu screen and press Menu/Set. On the next screen, choose Single or Multi, and then select the image or images you want to add text to. When you have selected one or more images, press Menu/Set, highlight Set on the next screen, and press Menu/Set. You will then see a screen where you can select the items to be imprinted on the image or images.

When you have made the selections, press the Fn3 button to return to the previous screen, select OK, and press Menu/Set. The camera will ask if you want to save the stamped image as a new picture; select Yes and press Menu/Set to carry out the operation. The text will be set in small, orange characters in the lower right corner of the image, as shown in Figure 6-21.

Figure 6-21. Text Stamp in Use on Image

This function cannot be used with Raw images, movies, 4K bursts, Post Focus images, or panoramas. The camera saves the text-stamped image to a new file, so you will still have the original. I have never found this function useful, but if you have an application that could benefit from it, it is available and ready to assist you.

RESIZE

This function from the Playback menu is useful if you don't have access to software that can resize an image, and you need to generate a smaller file that you can attach to an email message or upload to a website. After

Chapter 6: Playback

selecting this menu item, on the next screen you choose whether to resize a single image or multiple ones. Then navigate to the image you want to resize, if it's not already displayed on the screen.

Once an image to be resized is on the screen, press the Menu/Set button or touch the Set icon to start the resizing process. Following the prompts on the screen, highlight the size to reduce the image to. The choices may include M and S for Medium and Small, or just S for Small, depending on the size of the original image. When the option you want to use is highlighted in yellow, press Menu/Set to carry out the resizing process. The camera will ask you to confirm that you want to save a new picture at the new size.

As with the Text Stamp function, resizing does not overwrite the existing image; it saves a copy of it at a smaller size, so the original will still be available. The new image will be found at the end of the current set of recorded pictures. Raw images, 4K Photo or Post Focus images, panoramas, and motion pictures cannot be resized, nor can pictures stamped with Text Stamp. To convert up to 100 images at the same time, select the Multi option and follow the same procedure.

CROPPING

This function is similar to Resize, except that, instead of just resizing the image, the camera lets you crop it to show just part of the original image. To do this, select Cropping from the Playback menu and navigate to the image to be cropped, if it isn't already displayed, and press the Menu/Set button or touch the Set icon. Then use the zoom lever or touch the zoom icon to enlarge the image, and use the direction buttons or scroll with the touch screen to position the part of the image to be retained.

When the enlarged portion is displayed as you want, press Menu/Set or the Set icon to lock in the cropping, and select Yes when the camera asks if you want to save the new picture. Again, as with Resize, the new image will be saved at the end of the current set of recorded images, and it will have a smaller size than the original image, because it will be cropped to include less information (fewer pixels) than the original image. The Cropping function cannot be used with Raw images, motion pictures, 4K Photo or Post Focus images, panoramas, or pictures stamped with Text Stamp.

ROTATE

When you take a picture in a vertical (portrait) orientation by holding the camera sideways, you can set the camera to display it so it appears upright on the horizontal screen, as in Figure 6-22.

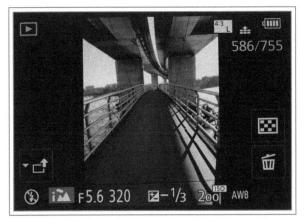

Figure 6-22. Vertical Image Displayed on Horizontal Screen

The setting to make such images appear in this orientation is the Rotate Display option, which is discussed later in this chapter. If you have that option turned on, then the Rotate option becomes available, so you can manually rotate the image back to the way it was taken. If the Rotate Display option is not turned on, then the Rotate option is dimmed and unavailable for selection.

Figure 6-23. Rotate Screen

To use the Rotate menu option, select it and scroll to the image you want to rotate. Then press Menu/Set and the camera will display two arrows, as seen in Figure 6-23. Select the top arrow to rotate the image 90 degrees clockwise or the bottom one to rotate it 90 degrees counter-clockwise and press Menu/Set to do the rotation.

VIDEO DIVIDE

The Video Divide option gives you a basic ability to trim videos in the camera. Using this procedure, you can, within limits, pause a video at any point and then cut it at that point, resulting in two segments of video rather than one. You can then, if you want, delete an unwanted segment.

To do this, highlight Video Divide on the Playback menu and press the Right button or Menu/Set to go to the playback screen. If the video you want to divide is not already displayed, scroll through your images using the Left and Right buttons, the control dial, or the touch screen until you locate it.

You can recognize videos when scrolling with this option, because they display the length of the video in the upper left quarter of the screen.

The camera displays all your images here, including stills, so you may have to scroll through many non-videos until you reach the video you want. If you want to narrow the choices down to videos only, choose Video Only for Playback Mode on screen 1 of the Playback menu before selecting the Video Divide menu option.

With the desired movie on the screen, press Menu/Set to start it playing. When it reaches the point where you want to divide it, press the Up button to pause the video. While it is paused, move through it a few frames at a time using the Left and Right buttons, until you find the exact point where you want to divide it.

Once you reach that point, press the Down button to make the cut. You will see an icon of a pair of scissors in the display of controls at the bottom of the screen. After you press the Down button, the camera will display a message asking you to confirm the cut.

Highlight Yes and press Menu/Set to confirm. Now you will have two new videos, divided at the point you chose.

As I noted above, this is a basic form of editing. It can't be used to trim a movie too close to its beginning or end, or to trim a very short movie at all. But it's better than nothing, and it gives you some ability to delete unwanted footage without having to edit the video on a computer. Note, though, that this operation does not save a copy of the original video, so use it only if you are sure you want to divide the video file.

The options on screen 3 of the Playback menu are shown in Figure 6-24.

Figure 6-24. Screen 3 of Playback Menu

TIME LAPSE VIDEO

This option lets you create a movie from a series of shots you took using the Time Lapse Shot feature on screen 3 of the Recording menu. As I discussed in Chapter 4, when you use that feature, the camera will ask at the end of the process if you want to create a movie from the group of time-lapse shots. If you say no, you can use this option on the Playback menu at a later time to create the movie.

When you select this option, the camera will display any groups of images that were taken with the Time Lapse Shot option. Scroll through those and select the one you want to make into a movie. Then press the Menu/Set button, and the camera will display the screen shown in Figure 6-25, where you can set the recording quality, frame rate, and whether to play the sequence normally or in reverse. Make your choices and press Menu/Set; the camera will then create the video.

Figure 6-25. Time Lapse Video Menu Options Screen

STOP MOTION VIDEO

This option, similar to the previous one, is for creating a video from images you took using the Stop Motion Animation feature discussed in Chapter 4. As with the Time Lapse Video option, select this option, scroll to the group of shots you want to use to create the video, and select your desired options from the screen that appears, which has the same options as in Figure 6-25.

ROTATE DISPLAY

As I noted above in connection with the Rotate option, when the Rotate Display option is turned on, images taken with the camera turned sideways are automatically rotated so they appear upright on the horizontal display. If you want to rotate such an image so you can see it at a larger size, taking up the full display, use the Rotate menu option, discussed above.

PICTURE SORT

With this option, you can choose the order in which the camera displays images from the memory card. If you choose the default, File Name, the camera arranges them by folders, then by numbers within the folders. For example, the file names of your images might include entries such as P1000003, P1000010, P1020023, etc. If you have taken all of your images with the same camera, all of these images should appear in chronological order according to when they were taken. However, if you have taken images with several different cameras you may have multiple images with the same file names, or with file names that do not match the order in which the images were taken. In that case, you can choose the other option for this menu item, Date/Time, and the images will be displayed in order by the dates and times they were taken.

DELETE CONFIRMATION

This final option on the Playback menu has two possible settings, as shown in Figure 6-26: "Yes" First or "No" First.

Figure 6-26. Options for Delete Confirmation Menu Item

This option lets you fine-tune how the menu system operates for deleting images. Whenever you press the Delete button to delete one or more images in playback mode and then choose Delete Single, Delete Multi, or Delete All, the camera displays a confirmation screen, as shown in Figure 6-27, with 2 choices: Yes or No.

Figure 6-27. Delete Confirmation Screen

One of those choices will be highlighted when the screen appears; you can then press the Menu/Set button to accept that choice and the operation will be done. You also can use the control dial, the Left or Right button, or the touch screen to highlight the other option before you press the Menu/Set button to carry out your choice.

Which setting you choose for this menu item depends on how careful you want to be to guard against accidental deletion of images. If you like to move quickly in deleting images, choose "Yes" First. Then, as soon as the confirmation screen appears, the "Yes" option will be highlighted and you can press the Menu/ Set button to carry out the deletion. If you prefer to have some assurance of avoiding an accidental deletion, choose "No" First, so that, if you press the Menu/

Set button too quickly when the confirmation screen appears, you will only cancel the operation, rather than deleting one or more images.

Unless you use this process often and need to save time, I recommend you leave this menu item set at the "No" First setting to be safe.

Printing Directly from the Camera

The LX100 II camera is compatible with the PictBridge protocol, which lets the camera communicate directly

with a printer that uses that protocol. To do this, connect the camera to the printer using the camera's USB cable, or a similar one. The larger end of the cable connects to the rectangular USB slot on the printer, not the more square-shaped one that is used for connecting the printer to a computer.

Once the printer and computer are connected and turned on, the camera should automatically display a screen with the PictBridge logo, followed by a print selection screen. On that screen, choose the images you want to have printed.

Chapter 7: The Custom Menu and the Setup Menu

The Custom Menu

fter pressing Menu/Set, press the Left button to move the highlight into the left column of menu choices, then use the Up and Down buttons to move to the wrench icon with the letter C, as shown in Figure 7-1. (You also can use the camera's touch screen features to navigate through the menu system.)

Figure 7-1. Icon for Custom Menu Highlighted at Left

Once that icon is highlighted, press the Right button to move to the next screen to the right, which reveals an intermediate set of categories: Exposure, Focus/Release Shutter, Operation, Monitor/Display, and Lens/Others. These five categories are subdivisions of the Custom menu. Panasonic presumably included these subdivisions to help you locate various Custom menu options quickly according to their functions, because there are so many menu options to keep track of. The other menu systems do not have this intermediate set of categories.

In any event, to get to the actual Custom menu screens, press the Right button one more time to navigate to the list of menu options, which occupy seven menu screens, discussed below. (If the camera is set to the basic Intelligent Auto mode, the Custom menu displays only

one screen with three items.) If necessary, navigate to the top of the menu's first screen.

If you have to move forward or backward through several menu screens, you can press the zoom lever to move through them a screen at a time in either direction.

I will discuss all of the Custom menu items below, starting with the first screen, shown in Figure 7-2.

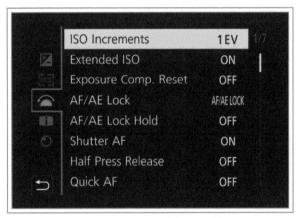

Figure 7-2. Screen 1 of Custom Menu

ISO INCREMENTS

Using this option, you can expand the range of values available for the setting of ISO. Normally, when you set ISO to a numerical value, you can use only 200, 400, 800, 1600, 3200, 6400, 12800, or 25600. However, if you select the increment of 1/3 EV instead of the normal 1 EV for this menu option, then several interpolated values for ISO are added, such as 250, 320, 500, 640, 1000, 8000, and others. You can then set these values from the ISO menu, reached by pressing the Up button.

Note that this menu option applies only to the settings you make yourself. Even if the ISO Increments option is set to 1 EV, the camera can still set intermediate ISO values when Auto ISO or Intelligent ISO is in effect and the camera is choosing the ISO value. I have never found a need to use the 1/3 EV option, so I leave this setting at its default value of 1 EV.

EXTENDED ISO

The next option on the Custom menu, Extended ISO, can be turned either on or off. When it is turned on, you get access to the lowest ISO level of 100, which is not available otherwise. If you have set the ISO Increments option, discussed above, to 1/3 EV, then you will also get access to the ISO settings of 125 and 160.

The additional ISO values of 100, 125, and 160 are considered "extended" because they are not native to the sensor. Therefore, using one of them does not increase the dynamic range or improve the image quality; it just acts to change the light sensitivity of the sensor. Using a low value such as 100 ISO can be useful when you need to reduce the light sensitivity so you can use a slower shutter speed or wider aperture than you could otherwise. Using one of the very high values can be helpful when light is low, as long as you don't mind the increased noise from using such a high value.

EXPOSURE COMPENSATION RESET

This option controls whether an exposure compensation value that has been set with an assigned function button or the control ring will be retained in memory when the camera is turned off or the recording mode is changed. By default, this option is turned off, and any positive or negative value is not reset to zero. In other words, the value stays in memory for the next time the camera is turned on, or the current recording mode is selected again. If you turn this option on, the exposure compensation value is reset to zero when the camera is powered off or the recording mode changes.

This option applies only to exposure compensation set with a function button that has been assigned to that option or with the control ring; any exposure compensation set by the exposure compensation dial stays in effect according to the position of the dial. (The dial is disabled when exposure compensation is assigned to a function button or the control ring.)

I generally leave this option set to On, because I am unlikely to want to use the same amount of exposure compensation the next time I use the camera, and I

might forget to reset it to zero on my own. However, if you have a practice of usually shooting with a certain amount of exposure compensation, you might want to leave this option off, so the value will be retained in memory from one shooting session to the next.

AF/AE LOCK

This menu item lets you choose the function of the AF/AE Lock button, which is located beneath the shutter speed dial on the back of the camera. You can use this option, shown in Figure 7-3, to control how that button locks autofocus (AF) and autoexposure (AE) settings.

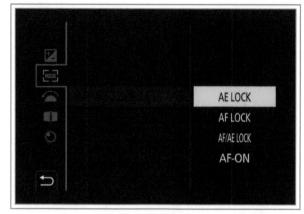

Figure 7-3. AF/AE Lock Menu Options Screen

If you select AE Lock or AF Lock, the camera locks only the one designated setting. If you choose AF/AE Lock, the camera locks both settings at the same time.

The camera will place icons on the recording display to indicate which of the values are locked, once you press the AF/AE Lock button and the values are locked in. The AF Lock icon will appear in the upper right corner and the AE Lock icon in the lower left corner.

It is not possible to lock exposure using the AF/AE Lock button in Manual exposure mode, or to lock focus when manual focus is in use. None of the button's settings function in either version of Intelligent Auto mode.

If you select the final option, AF-On, pressing the AF/AE Lock button will cause the camera to use its autofocus system to focus on the subject, using whatever AF mode setting is in effect to determine what area to focus on. If manual focus is in effect, the camera will still use the autofocus system when you press this button. This is a useful option as backup when you are using manual focus. You also can use it if you have set the Shutter AF option to Off, as discussed

below, so pressing the shutter button halfway does not cause the camera to use its autofocus. You will then be able to press the AF/AE Lock button when you need to get the camera to focus again quickly. The ability to use a button on the back of the camera for focusing is sometimes called "back button focus."

AF/AE LOCK HOLD

This next menu option determines how the AF/AE Lock button operates. If you set AF/AE Lock Hold to On, then, when you press this button and release it, the camera retains the locked value(s). If you set this option to Off, you have to hold the button down to retain the value(s); when you release it, the locked value(s) will be released. This option is dimmed and unavailable for selection when AF/AE Lock is set to AF-On. With that setting, pressing the AF/AE Lock button causes the camera to use its autofocus, but not to lock focus, so it is not possible to "hold" the locked setting.

SHUTTER AF

This option lets you choose whether the camera will use its autofocus when you press the shutter button halfway, or not. With the default setup, with Shutter AF turned on, when the camera is set to an autofocus mode, it will evaluate the focus when you half-press the shutter button. With single autofocus (AFS), the focus will be locked as long as you hold the button in that position; with flexible autofocus (AFF), the camera will refocus if it detects movement, and with continuous autofocus (AFC), the camera will continue to adjust focus as movement occurs.

If you use this menu option to turn Shutter AF off, then the camera will not use its autofocus at all when you half-press the shutter button. There are several reasons why you might choose that setting. First, if you are taking a series of shots at the same distance, such as when you have the camera on a tripod and are taking shots of flat objects for auctions, you might focus once and then have no need to keep focusing. You can avoid using up the camera's battery for repeated uses of the autofocus system by turning Shutter AF off.

Another reason for using this option is if you prefer using the AF/AE Lock button to adjust autofocus. To do that, go to screen 1 of the Custom menu and set the AF/AE Lock menu option to AF-On. Then, when you press the AF/AE Lock button, the camera will adjust

autofocus. With this setup (back button focus), you can adjust the focus whenever you want, and once you have it set as you want it, you can compose your shot and have the camera evaluate exposure without worrying that the camera will reset the focus to a different subject. You will be able to trigger the shutter to take another shot at any time.

Some photographers use this system with the autofocus mode set to AFC for continuous autofocus. Then, they can adjust focus at any time using the AF/AE Lock button, and press the shutter button at any time without being concerned about focus. It's probably a good idea to give this setup a try and see if it works well for your style of shooting.

HALF PRESS RELEASE

This option lets you set the camera to capture an image when the shutter button is pressed halfway down, rather than requiring a full press, as is the normal situation. If you turn this setting on when Shutter AF is turned on, the camera will still adjust focus just before the image is captured, so the half-press of the button carries out both the autofocus operation and the image capture. If you have Shutter AF turned off, then you would have to use the AF/AE Lock button to adjust autofocus, with the AF-On option turned on for that button. (Or, of course, you could use manual focus.)

Using the Half Press Release option can speed up your shooting, because you don't have to go through the sequence of half-press followed by full press of the shutter button; you can just touch the button lightly to capture an image, or a burst of images if the camera is set for burst shooting. This system can work well if you won't be needing to make adjustments to focus or exposure after half-pressing the shutter button. When you are shooting in predictable, steady lighting at a constant distance and you need to shoot quickly, this option can be useful. Also, the ability to trigger the shutter with a light touch can help reduce the risk of motion blur from camera shake.

Quick AF

This next option on the Custom menu, Quick AF, can be turned either on or off. If you turn this setting on, the camera will focus on the subject whenever the camera has settled down and is still, with only minor movement or shake. You do not need to press the shutter button halfway down to achieve focus; the camera focuses on its own, as long as an autofocus mode is in use.

The advantage of turning Quick AF on is that you will have a slight improvement in focusing time, because the camera does not wait until you press the shutter button (or the AF/AE Lock button, if it is set for focusing) to start the focusing process. The disadvantage is that the battery will run down faster than usual. So, unless you believe a split second for focusing time is critical, I would leave this setting turned off. The camera will still focus automatically when you press the shutter button halfway down; it just will take a little bit longer to bring the subject into focus.

The next items to be discussed are on screen 2 of the Custom menu, which is shown in Figure 7-4.

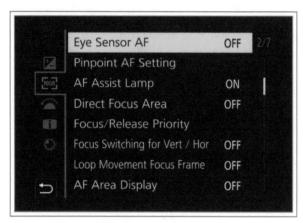

Figure 7-4. Screen 2 of Custom Menu

EYE SENSOR AF

When this option is turned on and the camera is set to an autofocus mode, the camera will automatically use its autofocus mechanism to adjust focus as soon as your head approaches the eye sensor and turns on the electronic viewfinder.

Eye Sensor AF will trigger the autofocus system only once, even if the camera is set for continuous autofocus. So, when you first put the camera up to your eye, the focus will be adjusted for whatever subject the camera is aimed at at that instant. The camera will not readjust the focus unless you then press the shutter button halfway or use the AF/AE Lock button, if that button is set up to adjust focus. If Quick AF is turned on, though, the camera will continue to adjust focus through that

feature. The camera does not beep when focus is set with Eye Sensor AF.

This option can give the autofocus system a head start by bringing the scene into focus with an approximate setting, so it can quickly reach an exact focusing position when you press the shutter button halfway or use the AF/AE Lock button to make the final focus adjustments. I generally leave it turned off, but for snapshots it can be useful to have an approximate first cut at focusing take place as soon as you use the viewfinder.

This option works only when the viewfinder is turned on, either permanently or as your eye approaches it, through use of the LVF button or the Eye Sensor option on screen 3 of the Setup menu.

PINPOINT AF SETTING

This menu option has two sub-options that control the operation of the Pinpoint setting for AF mode. As I discussed in Chapter 5, with Pinpoint AF you can set a precise point for the focus area. Then, when you press the shutter button halfway to evaluate focus, the camera focuses at that point and enlarges the display briefly with that point centered, so you can judge the sharpness of the focus. The two sub-options of the Pinpoint AF Setting option, Pinpoint AF Time and Pinpoint AF Display, are discussed below.

Pinpoint AF Time

The Pinpoint AF Time option controls how long the Pinpoint AF display stays enlarged when you press the shutter button halfway. The choices are Short (0.5 second), Medium (1.0 second), or Long (1.5 second). If you release the shutter button before the specified time has passed, the display will revert to normal size. Because of that behavior, I prefer to set this option to Long. Then, the display will stay enlarged for a long enough time to let me judge the focus, but I can always release the shutter button early to revert the display to its normal size.

Pinpoint AF Display

This second sub-option lets you choose one of two options for the size of the enlarged display that appears when you use the Pinpoint option for AF mode—Full or PIP (picture-in-picture). With Full, the entire display is enlarged by a factor of between three and ten times; with PIP, only the central part of the display is enlarged, by a factor of between three and six times. You can

vary the enlargement factor by turning the control dial or pinching/pulling on the touch screen when the enlargement is active as you are setting the focus point using the AF mode menu option. That enlargement factor will then take effect when you half-press the shutter button to focus using the Pinpoint AF option.

AF ASSIST LAMP

The autofocus (AF) assist lamp is the reddish light on the front of the camera, near the lens below the shutter speed dial. The lamp illuminates when the ambient lighting is dim, to help the autofocus mechanism work by providing enough light to define the shape of the subject. Ordinarily, this option is left turned on for normal shooting, because the light only activates when it is needed in low-light conditions. However, you have the option of turning it off using the AF Assist Lamp menu option, so it will not turn on to help with autofocus. You might want to do this if you are trying to shoot your pictures without being detected, or without disturbing a subject such as a sleeping animal.

In Intelligent Auto mode, you cannot turn off the AF assist lamp using this menu option, but you can use the Silent Mode option on the Recording menu to turn off the lamp, along with the flash and camera sounds. The lamp does not illuminate when you are using manual focus (unless you have set up the AF/AE Lock button to use the AF-On option and you press that button to cause the camera to use its autofocus).

The AF assist lamp also serves as the self-timer lamp. Even if you set the AF Assist Lamp menu option to Off, the lamp will light up when the self-timer is used; there is no way to disable the lamp for that function.

DIRECT FOCUS AREA

This is another option that can be turned either on or off; it is off by default. If you turn it on, then, in recording mode, if you press any of the four direction buttons, the camera immediately displays a screen for adjusting the position of the focus area.

For example, if AF mode is set to 1-Area, Pinpoint AF, or Face/Eye Detection, then, when you press, say, the Left button, that button immediately activates the focus frame and starts moving it across the display. If you have AF mode set to 49-Area or Custom Multi, then, when you press a direction button, the camera

immediately displays the screen for selecting the focus zones to be included in the focus area. You can then keep pressing any of the direction buttons to adjust the area or use other controls to make other adjustments. If you are using manual focus, the buttons move the location of the MF Assist area, which is discussed later in this chapter.

This option could be useful if you were in a situation when you need to adjust the focus area often, particularly with the 1-Area or Pinpoint AF options. I would not recommend using it with the 49-Area or Custom Multi options, because you need to do considerable adjusting with those options, and a split second of added speed will not be of that much use.

I do not use this option myself, because it is so easy to adjust the focus area without it. If you turn on Touch AF through the Touch Settings option on screen 4 of the Custom menu, you can just touch the screen to activate a movable focus area. Also, if you turn on Direct Focus Area, you lose the other functions of the direction buttons while this option is in effect. If you wanted to set white balance, exposure compensation, drive mode, or AF mode, you would have to use the Quick Menu, assign those functions to another button or to the control ring, or turn off this menu option before making that adjustment.

FOCUS/RELEASE PRIORITY

This option has two sub-settings to control whether or not the camera requires that sharp focus be achieved before the shutter can be released. The two sub-settings, AFS/AFF and AFC, let you set the camera's autofocus release behavior for the AFS/AFF settings separately from its behavior for the AFC setting.

For either AFS/AFF or AFC, you can set this option to Balance, the default option, Focus, or Release. If it is set to Focus, the camera will not take a picture until focus has been confirmed, when autofocus is in use. So, if you aim the camera at a subject that is difficult for the autofocus system to bring into sharp focus, such as an area with no sharp features in dim lighting, the camera may display a red focus frame and beep four times, indicating focus was not achieved. In that situation, if this menu option is set to Focus, the camera will not take the picture when you press the shutter button. If you set this option to Release, then the camera will take the

picture even if it is not in focus. If you are using manual focus, then the camera will take the picture regardless of focus, even if you set the priority to Focus. If this option is set to Balance, the camera uses a compromise approach and tries to achieve focus, but will still release the shutter after some time has passed, even if it cannot get a focused shot.

The use of this option is a matter of personal preference and the situation you are faced with. If you are taking images of a one-time event, you may want to use the Release option so you don't miss a shot just because focus is slightly off. It's much better to get an image that is slightly out of focus than no image at all. But if you have time to make sure focus is sharp, you can use the Focus option to make sure you have focus properly adjusted before you capture an image. The Balance option is an appropriate compromise when focus is not absolutely critical.

This option also has an impact on the speed of burst shooting. As I discussed in Chapter 5, if this option is set to Focus, shooting may be slowed down as the camera attempts to adjust focus before recording each image, when you are using a burst setting with continuous focus adjustments.

FOCUS SWITCHING FOR VERTICAL/ HORIZONTAL

When you have AF mode set to AF Tracking, 1-Area, or Pinpoint AF, the camera remembers where the focus frame was located for the last image you captured with that setting. So, if you turn the camera off and then back on, that frame will be located in the same place on the display as it was for the last shot. However, by default, the camera will only remember one location for the frame, and that location will not change if the camera is rotated 90 degrees from the horizontal to vertical position.

If you turn on the Focus Switching for Vertical/Horizontal menu option, the camera will remember the last position for the focus frame for the horizontal position as well as the last position for the vertical position. So, if you are rotating the camera to take different views of the same subject, moving the focus frame to the proper location for each orientation, the camera will remember those two locations and switch them as you rotate the camera.

This option works for the frame displayed for MF Assist enlargement when using manual focus, as well as for the autofocus frames mentioned above.

This option can be useful, and it does not cause any distraction when not needed, so I generally leave it turned on.

LOOP MOVEMENT FOCUS FRAME

This is another option which, like the previous one, controls the way the camera handles the positioning of movable focus frames and the MF Assist frame. Ordinarily, when you are using an AF mode setting such as Face/Eye Detection, 49-Area, Custom Multi, 1-Area, or Pinpoint AF, when you move the focus frame or focus area around the screen, it stops at the edge of the screen. If you turn on the Loop Movement Focus Frame option, the frame or area will "loop" around from one edge of the screen to the opposite edge. For example, if you move the frame to the far right edge of the display, the frame will then appear at the far left edge and continue moving to the right. You may find that this feature gives you added flexibility in positioning the focus frame, focus area, or MF Assist enlargement frame exactly where you want it.

Note that this feature does not work when you are moving the frame or area with your finger on the touch screen, only when you are moving it with the cursor buttons. It does work with all four edges of the screen, not just the sides.

AF AREA DISPLAY

This option lets you set the camera to display the area that is currently set for autofocus when AF mode is set to 49-Area or Custom Multi and the focus zones have been changed from the default setting for that option.

For example, if you have moved the focus zones for the 49-Area option to the right side of the screen, the camera will display the focus zones in white on the LCD screen in shooting mode, as shown in Figure 7-5.

However, if you are using the 49-Area option with its default setting of focus zones in the center of the screen, the camera will not show any focus zones on the display. This option is useful as a reminder of where the camera will direct its focus with these two AF mode settings. It does not work when recording videos or 4K photos.

Figure 7-5. Focus Zones Displayed at Right of Screen

The options on screen 3 of the Custom menu are shown in Figure 7-6.

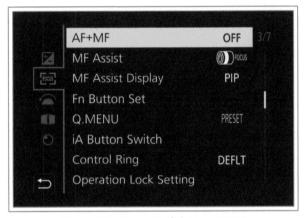

Figure 7-6. Screen 3 of Custom Menu

AF+MF

This is an on-or-off option that is turned off by default. If you turn it on, then, when the autofocus mode is set to AFS, for single autofocus, once you have pressed the shutter button halfway to lock focus, while holding the button in that position, you can turn the control ring to fine-tune the focus manually. Features such as MF Assist and peaking will operate if they are turned on through the Custom menu. This option also takes effect if you have locked focus with the AF/AE Lock button, when that button is set to lock autofocus or to the AF-On setting through screen 1 of the Custom menu.

This option is useful when, for example, you have locked focus on a group of small objects, and you want to make sure the focus is precisely set on one of those objects, such as on an object behind the others, or on a portion of one of them. Once the autofocus system has locked on the group, start turning the control ring while keeping the shutter button pressed halfway (or the AF/

AE Lock button pressed, if applicable) to adjust the focus manually until you have it set exactly as you want.

Manual Focus (MF) Assist

This option controls whether and how the recording screen display is magnified when you're using manual focus. With the MF Assist option highlighted, press the Right button to pop up the sub-menu that lets you choose one of four settings, represented by icons.

If you choose the top option, which shows icons for the control ring and the AF mode button (Left button), then, when you start turning the control ring to focus or you press the Left button, the screen will immediately be magnified to help you adjust the focus.

With the second option, turning the control ring will immediately magnify the display, but pressing the AF mode button will not immediately magnify the screen, though it will still activate the manual focus assist frame, so you can move that frame around the display. With the third option, pressing the button will immediately enlarge the display, but turning the control ring will not immediately enlarge the display, though it will still adjust the manual focus.

With the Off setting, the display will not be magnified until you press the Left button or tap the touch screen twice to activate the MF Assist frame. When you have moved the frame where you want it, the display will be magnified in the area where the frame is located. You can then adjust focus with the control ring. Press the Menu/Set button to return the display to normal size.

The MF Assist option is not available for recording motion pictures, using the 4K Photo pre-burst option, or when Digital Zoom is activated.

MF Assist Display

The MF Assist Display option lets you set the area of magnification with MF Assist to Full or PIP (picture-in-picture. If you choose Full, the magnification uses the whole display and varies between three and ten times normal. If you choose PIP, the magnification appears in a smaller window and the enlargement varies between three and six times normal.

As soon as you tap the touch screen twice or turn the control ring to start the magnification, the display will

appear similar to Figure 7-7, which shows the MF Assist display when the Full setting is in effect.

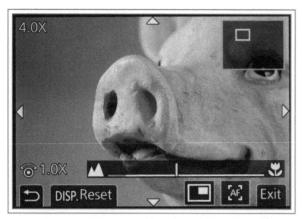

Figure 7-7. MF Assist Enlarged Display - Full Setting

You can use all four direction buttons or the touch screen to move the enlarged area around the display, and you can turn the control dial or pinch the touch screen to change the magnification factor. To reset the focus point to the center of the display, press the Display button.

To dismiss the MF Assist display, press the shutter button halfway or press the Menu/Set button. Or, if you turned the control ring to start the magnification, the screen will return to normal size on its own after about ten seconds. You can then turn the control ring to bring the MF Assist display back on the screen if you want, or you can just press the shutter button to take the picture. You can switch between the full-screen and PIP views by touching the rectangular icon at the bottom of the display with a small inset white rectangle in its upper right corner.

FUNCTION BUTTON SET

As I discussed in Chapter 5, the LX100 II has five physical function buttons labeled Fn1, Fn2, Fn3, Fn4, and Fn5. It also has five virtual function buttons represented by icons on the touch screen, labeled Fn6 through Fn10. Each of those buttons, except for Fn9 and Fn10, has a particular function assigned to it by default. For all ten buttons, you can choose the function that is assigned when the camera is in recording mode. For the Fn1, Fn2, Fn4, and Fn5 buttons, you also can choose a function to be assigned when the camera is in playback mode. To make those assignments, you use the Function Button Set menu option. (You also can change a physical button's assignment for recording mode by pressing and holding the button for a few

seconds to call up the list of assignment options. And, you can assign a function button to a new option using the Monitor Information Display screen, if that option has been activated through the Custom menu.)

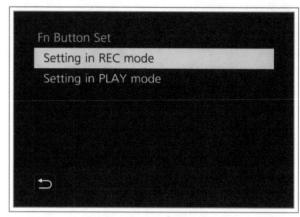

Figure 7-8. Function Button Set Main Options Screen

When you highlight this option and press the Menu/ Set button or the Right button, the camera will display the screen shown in Figure 7-8, letting you choose the settings in recording mode or playback mode.

For now, select recording mode, and the camera will display the special screen shown in Figure 7-9, with a graphic display of the assignable buttons.

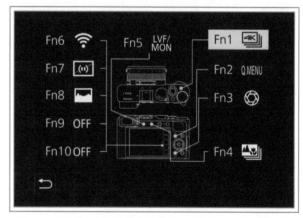

Figure 7-9. Screen to Select Button for Recording Mode

On that screen, turn the control dial or press the Up and Down buttons to move the highlight to the button whose assignment you want to change, and press Menu/Set. (Or, just touch the button's icon on the touch screen.) You will then see a display like that in Figure 7-10, which highlights the current setting for that button on a sub-menu screen. Scroll through that series of nine or ten screens until you find the new setting you want to make, and press Menu/Set to confirm it. I listed the possible settings in Chapter 5.

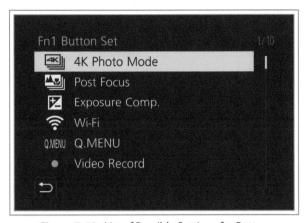

Figure 7-10. List of Possible Settings for Button

Don't forget that several of the items that can be assigned, including Photo Style, Flash Mode, Quality, AFS/AFF/AFC, and Metering Mode, also can be adjusted using the Quick Menu system by pressing the Q.Menu button and navigating through the easy-access menu that appears.

Also, although most of the items that can be assigned to the function buttons also can be reached through the menu system or with a control button, there are some items that cannot readily be reached in those ways: Preview, Focus Area Set, and Operation Lock. I discussed those settings in Chapter 5.

You also can assign the Fn1, Fn2, Fn4, and Fn5 buttons to carry out a function when the camera is in playback mode. To do that, go back to the main options screen for this menu item and select Setting in Play Mode, and the camera will display a screen similar to Figure 7-9, but showing only those four buttons. On that screen, select the button you want to assign a function for playback mode.

As discussed in Chapter 5, there are several settings available for assignment during playback mode: Wi-Fi, LVF/Monitor Switch, Record/Playback Switch, 4K Photo Play, Delete Single, Protect, Rating★1-Rating★5, Raw Processing, 4K Photo Bulk Saving, Off, and Restore to Default.

QUICK MENU (Q.MENU)

This option gives you the ability to customize the settings that are available from the Quick Menu. As I discussed in Chapter 4, when you press the button assigned to the Q.Menu function (Fn2 by default), the camera displays an easy-access menu system that lets you select various settings quickly. By default, the

Quick Menu includes 11 settings: Photo Style, Flash mode, Motion Picture Setting, Picture Size, Quality, AFS/AFF/AFC, AF mode, Metering mode, Exposure Compensation, Sensitivity, and white balance. (Flash mode appears only if a compatible flash unit is attached to the camera and turned on, and exposure compensation appears only if exposure compensation has been assigned to a function button, which disables the exposure compensation dial.)

To keep those settings in place or restore them after custom settings have been used, select the Preset option for this menu item. If you want to set up the Quick Menu with your own selection of settings, select the Custom option for this menu item.

Once you have selected Custom for the Quick Menu item, exit this menu system and, from the shooting screen, press the button assigned to Q.Menu. On the screen that appears, use the Down button to move to and highlight the tool icon at the lower left of the display, as shown in Figure 7-11. (Or select that icon using the touch screen.)

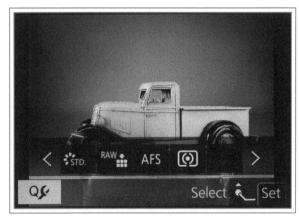

Figure 7-11. Tool Icon Highlighted at Lower Left of Display

When you highlight and select that icon, you will see the Q. Menu Customize screen, shown in Figure 7-12, after a screen with instructions appears briefly. On the Customize screen, navigate through the icons at the top of the display until you find the icon for a setting you want to install in the Quick Menu. With that icon highlighted in yellow, press Menu/Set and the camera will prompt you to move to the "desired position." At that point, one of the icons in the bottom row will be highlighted; use the control dial or the Left and Right buttons to move that highlight to the position where you want to locate the setting whose icon you selected from the top rows. If there is no blank space available in the

bottom row, just highlight an occupied space and press Menu/Set; the new icon will replace the existing one.

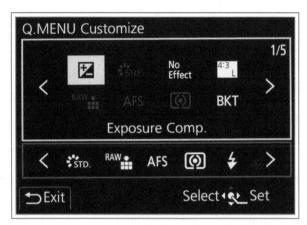

Figure 7-12. Screen to Customize Quick Menu

An easier way to add icons to the bottom row is simply to touch an icon with your finger and drag it to the bottom row, onto an empty spot, or drag it onto an occupied slot to replace the icon that is already there. When you have finished adding icons to the Quick Menu, press the Q.Menu button to return to the shooting screen.

IA BUTTON SWITCH

This option lets you control the way the iA button on top of the camera operates. By default, when you press that button quickly, the camera switches into or out of Intelligent Auto mode. With this option, you can change the button's behavior from Single Press to Press and Hold. With that setting, you have to hold down the button for about a second to carry out the change in recording modes. I prefer the Press and Hold option, because it avoids the problem of accidentally changing modes through the mistaken press of a button, while still letting you easily switch modes when you need to.

CONTROL RING

This next option on screen 3 of the Custom menu lets you set the function or functions of the control ring, the large ring around the lens. As I discussed in Chapter 5, whenever the camera is set to manual focus mode, the control ring is used to adjust focus. When the camera is set to an autofocus mode, the control ring can control other options, according to how it is set. By default, in Shutter Priority and Manual exposure modes, turning the control ring selects shutter speeds other than those that are printed on the shutter speed dial, such

as 1/1300 second and 1/5 second. In Intelligent Auto mode, Aperture Priority mode, and Program mode, the control ring operates the step zoom feature.

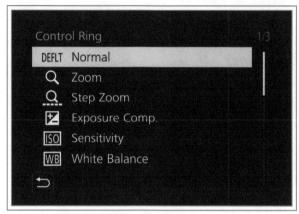

Figure 7-13. First Screen of Control Ring Menu Option

This menu option, whose first of three screens is shown in Figure 7-13, lets you choose whether to leave the ring set to its default settings, or to one of the following options: Zoom; Step Zoom; Exposure Compensation; Sensitivity (ISO); White Balance; AF mode; Drive Mode; Photo Style; Filter Effect; Highlight Shadow; i.Dynamic; i.Resolution; Flash Mode; Flash Adjustment; or Not Set. The zoom function causes the ring to zoom continuously through all focal lengths, rather than using the specific steps of step zoom.

If you choose one of the listed settings, the control ring will have that assignment in all shooting modes (unless the assigned function is not available in the current mode, such as Intelligent Auto). However, it always will control manual focus, whenever the camera is set to manual focus mode.

My preference is to use the default settings, but it is useful to have the choice of setting the ring to control a setting such as ISO (Sensitivity) or Filter Effect if you expect to be adjusting that setting frequently during a particular shooting session.

OPERATION LOCK SETTING

This setting is related to the Operation Lock option, which can be assigned to a function button through the Function Button Set item on screen 3 of the Custom menu. If you assign Operation Lock to a function button, when you press the assigned button, the effect will be to lock the operation of the cursor buttons, the touch screen, the control dial and control ring, any

combination of those, or none of them, depending on the setting for the Operation Lock Setting menu item.

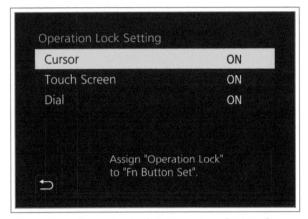

Figure 7-14. Operation Lock Setting Menu Options Screen

As shown in Figure 7-14, you can set the locking of the cursor buttons, the touch screen, or the control dial and control ring to Off or On. (Off means the controls will not be locked; On means they will be locked.)

The assigned settings will be effective when the camera is in recording mode, but not when it is in playback mode. This option can be useful when you have made settings that you want to keep locked in, such as when you are shooting a series of items at a particular distance from a tripod and you don't want the focus distance, focus point, white balance, or exposure to be changed.

The items on screen 4 of the Custom menu are shown in Figure 7-15.

Figure 7-15. Screen 4 of Custom Menu

VIDEO BUTTON

You can use this option to lock out the operation of the red movie button, or video button, as it's called on the menu. If you turn this option on, the button operates normally to start and stop the recording of a motion picture. If you turn it off, the button will not operate at all and the camera will display an error message if you press it. This is a convenient option to have available, because it is easy to press this button by mistake when you are trying to press the AF/AE Lock button.

Touch Settings

With the four sub-options of this menu item, you can control several aspects of the operation of the LX100 II's touch screen capability. Those four sub-options are Touch Screen, Touch Tab, Touch AF, and Touch Pad AF, as shown in Figure 7-16.

Figure 7-16. Touch Settings Menu Options Screen

Touch Screen

This first option can be turned either on or off. If it is on, the touch screen works as expected. If it is off, none of the touch screen operations are active, and the touch screen icons do not appear at all. The next three suboptions on this menu will be dimmed and unavailable in that case. However, even when the Touch Screen option is turned off, you can use the Clear Retouch option on screen 2 of the Playback menu, which requires that you touch the areas of an image that you want to remove.

If you prefer the classic operation of a camera that uses only traditional buttons and dials, you can leave this setting turned off and not have to worry about using the touch screen options. I find it useful to turn the touch screen off when I am using the viewfinder on a sunny day, because my nose may bump into the screen and activate a focus frame or otherwise cause distraction. However, the touch screen adds a great deal of convenience to using the camera, and in most situations I leave it turned on.

Touch Tab

In Chapter 5, I discussed the operation of the touch tab, a set of touch controls at the right edge of the shooting screen. When you touch the small left-facing arrow, the tab opens up to reveal controls for touch zoom, touch AF/touch shutter, touch autoexposure, and touch peaking (available when manual focus is in use). If you want to use the camera's other touch capabilities but not the particular functions available through the touch tab, you can turn this option off.

Touch AF

This sub-option enables or disables the use of the Touch AF and Touch AE functions. There are two possible settings for this item: AF or AF+AE. If you choose AF, you can change the location of the focusing area on the shooting screen just by touching the screen. If AF mode is set to Face/Eye Detection, 1-Area, or Pinpoint AF, touch the focus frame that is displayed on the screen, and you can then move that frame around the screen. You can change the size of the frame by pinching or pulling the area of the frame with your fingers. When you have the frame located as you want it, press the Set icon in the lower right corner of the screen, or press the Menu/Set button.

If the 49-Area option for AF mode is in use, touching the screen brings up the screen for adjusting the area of the focus zones. If AF mode is set to Tracking, touch a subject on the screen to start tracking that subject.

For Touch AF to operate properly, the Touch Shutter option must be turned off. Otherwise, the camera will take a picture when you touch the screen. To turn off the current AF operation, touch the AF Off icon on the left side of the screen.

The second choice of setting for Touch AF is AF+AE. If you choose this option, when you touch the screen, the camera places a single focus frame at that location, like the frame used with the 1-Area AF mode setting, regardless of the AF mode setting that is in effect. You can change the location and size of the focus frame by moving it with your finger and resize it by pinching and pulling the screen. In addition, the camera places a small, blue cross in the center of the frame and optimizes exposure for that area. When this option is in effect, the Touch AE option is not available for selection through the Touch Tab system.

Touch Pad AF

The last sub-option for the Touch Settings menu item is Touch Pad AF. This option controls how the touch screen works when you are using the viewfinder and moving the autofocus frame around the display with your finger.

There are three sub-options: Exact, Offset, and Off. If you choose Off, this option is not activated at all. With Exact, you press on the screen in the position where you want the focus frame to be located on the viewfinder display. If you choose Offset, you can cause the focus frame to move just by moving your finger a certain distance in the desired direction, without pressing at the exact location of the frame in the viewfinder. I prefer the Exact option, because I can just press the screen where I want the focus frame to be located.

This option can be useful if you are taking pictures on a sunny day and need to move the focus frame around on the viewfinder display. However, if you don't need to move the focus frame often, it can be distracting, because your nose can touch the screen and put a confusing focus frame display in the viewfinder. If you find that problem arising, turn this option off.

DIAL GUIDE

When this option is turned on, the camera places a diagram in the lower right corner of the display for a few seconds that shows the current functions of the control ring and control dial. The diagram appears when you switch the recording mode by turning the shutter speed dial and/or the aperture ring. For example, in Figure 7-17, the display shows that the control ring adjusts step zoom and the control dial adjusts Program Shift, because the camera is in Program mode.

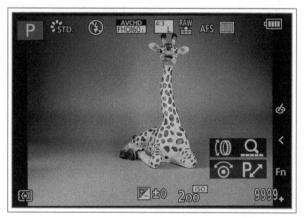

Figure 7-17. Dial Guide in Use in Program Mode

If you move the aperture ring or shutter speed dial to change the recording mode, the display will change accordingly and appear for another few seconds. I find this display helpful, and it disappears soon after appearing, so I generally leave it turned on.

ZOOM LEVER

This next option lets you control how the zoom lever operates. By default, this lever zooms the lens continuously through its full range of focal lengths, which is 24mm to 75mm if no enhanced zoom settings are in use. If you choose the second option here, the zoom lever uses step zoom, which allows the lever to zoom only to several preset zoom ranges: 24mm, 28mm, 35mm, 50mm, 70mm, and 75mm, when only the optical zoom is in use. It will not stop at any other focal length.

If you turn on other options for zooming, such as Digital Zoom, Intelligent Zoom, and Extended Optical Zoom, the step zoom function will take the focal length to further stages of 90mm, 135mm, and others, depending on what settings are in effect.

As I discussed in Chapter 5, the control ring also can be assigned to operate step zoom, through the Control Ring option on screen 3 of the Custom menu (discussed earlier in this chapter). And, if the control ring is set to its default setting through that menu option, it operates step zoom in Aperture Priority, Program, and Intelligent Auto modes. So, if you want to use step zoom, you can choose either the control ring or the zoom lever (or both) for that function. Of course, the control ring always adjusts focus when the focus switch is at the MF position.

My preference is to leave the zoom lever set to its normal operation of zooming through the full range of focal lengths, rather than limiting it to the step zoom increments. However, if there are situations in which you want to have the lever move the lens in specific increments, you can use this option.

AUTO REVIEW

This option controls how long your still images are displayed immediately after they are recorded by the camera, and how the camera behaves during that display. The Auto Review menu option has four suboptions, as shown in Figure 7-18: Duration Time

(Photo), Duration Time (4K Photo), Duration Time (Post Focus), and Playback Operation Priority.

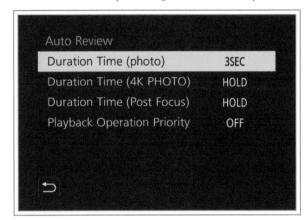

Figure 7-18. Auto Review Menu Options Screen

When you select Duration Time (Photo), for images not taken using 4K Photo or Post Focus, the possible settings are Off, one second, two seconds, three seconds, four seconds, five seconds, or Hold. After the shutter button is pressed, the recorded image appears on the screen (or not) according to how this option is set. If you choose Hold, the image stays on the screen until you press the shutter button halfway.

For the other two categories of images, 4K Photo and Post Focus, the only options are Off or Hold.

The final sub-option, Playback Operation Priority, controls whether you can perform playback operations on an image while it is displayed for a specific number of seconds under the Duration Time option. If Playback Operation Priority is turned on, then, when an image is displayed for one to five seconds under Auto Review, if you press a button such as Fn3 to delete an image, or a navigation button such as the Left or Right button, the camera will respond as if it were in playback mode, and carry out that operation.

If Playback Operation Priority is turned off, pressing a button will have the effect it would have in recording mode. For example, if you press the Fn3 button, the camera will carry out whatever function is assigned to that button for recording mode, which, by default, is the Preview function.

If Duration Time (Photo) is set to Hold, then Playback Operation Priority is automatically turned on, and the camera will act as if it were in playback mode at all times while a new image is displayed immediately after capture. Auto Review does not work when recording motion pictures.

MONOCHROME LIVE VIEW

When you turn this feature on, the camera converts the shooting screen display to black-and-white. This feature might help you concentrate on composition and geometry in your image, without being distracted by colors. You also might find it easier to adjust manual focus with this view, because you can turn on peaking with a color that contrasts clearly with all parts of the display. The monochrome view does not affect the recorded image, which will be in color unless you have also selected a monochrome setting for the final image using the Photo Style menu option or one of the Filter Effect settings that produce monochrome images.

CONSTANT PREVIEW

This option lets you see a preview of the effects of your exposure settings when the camera is in Manual exposure mode. When you turn this option on with the camera in that recording mode and then adjust shutter speed, aperture, or ISO, the display will grow darker or brighter to show how the settings would affect the final image. The display also will show how the aperture setting would affect the depth of field.

For example, if you set shutter speed to 1/125 second, aperture to f/8, and ISO to 1600 in a moderately lighted room with this option turned off, the camera's display will appear normal, showing the scene clearly. If you then press the shutter button halfway (assuming default settings for focus and shutter behavior), the display will grow dark and you will see more items in focus, reflecting the effects of the current settings. If you then turn this menu option on, you will see the same view you did when you pressed the shutter button halfway, even before pressing that button.

This setting can help by showing the effects of settings as you change them. However, in some situations it is better to leave this option turned off. For example, if you are shooting an image in dark conditions and you want to underexpose the scene to achieve an effect, the display screen may be quite dark with the settings you are using. In that situation, you might not be able to see the display to compose your image with this option activated, so you may want to leave Constant Preview turned off.

If you have a function button set to the Preview option and have the Constant Preview option turned on, pressing the function button in Manual exposure mode will not activate the Preview function, because it is already in effect through this menu option. The Constant Preview option has no effect when the camera's built-in flash is in use.

LIVE VIEW BOOST

This menu item gives you a way to increase the gain of the sensor so the image on the LCD screen or in the viewfinder will appear brighter when you are shooting in very dark conditions, such as in a darkened room or outdoors at night. It has three sub-options: On, Off, and Set. Choose On or Off to turn the feature on or off. Choose Set to set the option to work with all of the four advanced shooting modes (PASM) or to work only with Manual exposure mode.

This feature is of use only when conditions are very dark, so I do not turn it on unless I am going to be shooting in such conditions, to avoid using up battery power more rapidly than normal. It does not work when recording movies or using the 4K Photo option, or with Filter Settings or Constant Preview in effect.

The options on screen 5 of the Custom menu are shown in Figure 7-19.

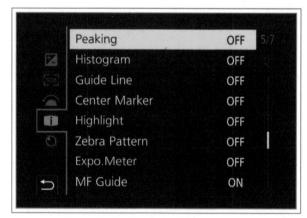

Figure 7-19. Screen 5 of Custom Menu

PEAKING

This menu option controls another feature that assists with manual focus. The peaking feature, when it is turned on, places bright (white or colored) pixels on the screen at areas that the camera determines are in sharp focus. As you turn the control ring to adjust focus, watch for the bright areas to reach their maximum intensity.

When you see the largest areas of glowing pixels, focus will be sharp for the areas where those pixels appear.

The peaking item has three main options: On, Off, and Set. In most cases, I leave it turned on, because it operates only when manual focus is in effect and I find it helpful for most manual focus situations. The Set option has two sub-options: Detect Level and Display Color.

The Detect Level can be set to High or Low. If you set it to High, the camera will require a higher degree of sharpness before it places pixels at a given focus area. With that setting, there will be fewer peaking pixels displayed than with the Low setting. You may find that it is easier to gauge the focus with fewer pixels, because you can adjust focus until those few pixels appear. However, in some situations, such as with objects that are lacking in straight lines or sharp features, it may be preferable to set Detect Level to Low, so there will be more peaking pixels visible.

With the Display Color sub-option, you can choose light blue, yellow, yellow green, pink, or white for the peaking color if Detect Level is set to High. You can choose dark blue, orange, green, red, or gray if the level is set to Low. It is a good idea to choose a color that contrasts with the scene you are photographing, so you can distinguish the peaking pixels from other parts of the image.

Figure 7-20 and Figure 7-21 illustrate the use of this feature. Figure 7-20 shows the view with peaking turned off, and Figure 7-21 shows it with peaking turned on with Detect Level set to Low.

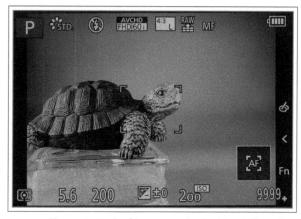

Figure 7-20. Peaking Example: Peaking Off

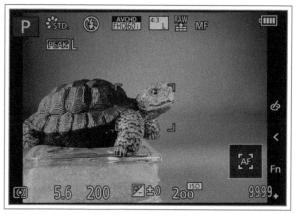

Figure 7-21. Peaking Example: Detect Level Low

As noted above, peaking operates only when the camera is set to manual focus. If you set the AF/AE Lock button to the AF-On function on screen 1 of the Custom menu, peaking pixels will appear when you press that button to cause the camera to use autofocus, if manual focus is in effect. Peaking also operates if you adjust manual focus using the AF+MF option, discussed earlier in this chapter. Peaking does not operate when the Rough Monochrome filter effect setting is in use or when Live View Boost is turned on.

HISTOGRAM

This next menu option controls the display of the histogram in recording mode. A histogram is a graph showing the distribution of dark and bright areas in the image that is being viewed on the camera's screen. The darkest blacks are represented by vertical bars on the left, and the brightest whites by vertical bars on the right, with continuous gradations in between.

If an image has a histogram in which the pattern looks like a tall ski slope coming from the left of the screen down to ground level in the middle of the screen, that means there is an excessive amount of black and dark areas (tall bars on the left side of the histogram), and very few bright and white areas (no bars on the right). The histogram in Figure 7-22 illustrates this situation.

A pattern moving from the middle of the graph up to peaks at the right side of the graph would mean just the opposite—too many bright and white areas, as in the histogram shown in Figure 7-23.

A histogram that is "just right" would be one that starts low on the left, gradually rises to a medium peak in the middle of the graph, then moves gradually back down to the bottom at the right. That pattern indicates a good balance of whites, blacks, and medium tones. An example of this type of histogram is shown in Figure 7-24.

Figure 7-22. Histogram for Underexposed Image

Figure 7-23. Histogram for Overexposed Image

Figure 7-24. Histogram for Normally Exposed Image

In playback mode, the LX100 II includes one display screen with a histogram. (You have to scroll down from the detailed screen with a thumbnail image.) The camera does not, by default, display the histogram for the live view in recording mode. To turn on the histogram when you are shooting, you need to use this menu option.

The Histogram menu option has only two choices: On or Off. If you turn the histogram on, it will appear on

the camera's display in recording mode, if a detailed display screen has been selected using the Display button, as shown in Figures 7-22 through 7-24.

The histogram does not display in the basic Intelligent Auto mode. When the histogram is first activated, it appears in a yellow frame with arrows indicating that you can move it to any position on the display.

You can move it with the cursor buttons or by dragging it on the touch screen. Once you have it located where you want it, press the shutter button halfway down to lock it in place. While it is movable, press the Display button to reset it to the center of the display. If you need to move it after it has been locked in place, you can touch it on the screen to reactivate it for moving. Or, you can go back to this menu option and select On for the Histogram item.

The histogram is an approximation, and you should not rely on it too heavily. It provides some information as to how evenly exposed your image is likely to be. (Or, for playback, how well exposed it was.) If the histogram is displayed in orange, that means the recording and playback versions of the histogram will not match for this image, because the flash was used, or in a few other situations.

GUIDE LINE

This option lets you set grid lines to be displayed on the LCD screen (or in the electronic viewfinder) to assist you with the composition of your pictures. When you select Guide Line from the Custom menu, you see a screen with four options: Off, and three patterns of lines, as shown in Figure 7-25.

Figure 7-25. Guide Line Menu Options Screen

If you choose Off, no grid lines will be displayed. If you choose the top option, the camera will display a

grid that forms nine equal rectangles on the screen. This choice can help you line up subjects, including the horizon, along straight lines. The second option is a pattern of 16 rectangles along with a pair of intersecting diagonal lines, which can help you locate your subject along diagonals as well as along horizontal or vertical lines. Finally, with the third option, the camera displays just two intersecting lines, one horizontal and one vertical, and lets you set their positions using the direction buttons or the touch screen. This option can be useful if you need to compose your shot with an off-center subject.

When any of the Guide Line options is turned on, the grid lines will display whenever the camera is in recording mode, regardless of the shooting mode. They will not display when you select the display screens with no live view. An example of the first option as displayed in shooting mode is shown in Figure 7-26.

Figure 7-26. First Guide Line Option in Use

CENTER MARKER

This option, when turned on, places a small cross in the center of the display, as shown in Figure 7-27, to help you keep the subject centered.

Figure 7-27. Center Marker in Use

This option can be particularly useful when recording video, because you may be distracted by the action and this marker may remind you to keep the most important part of the scene in a safe zone near the center of the display so it won't accidentally be cut off. This cross appears in all shooting modes and on all display screens that include the live view in recording mode.

HIGHLIGHT

This feature produces a flashing area of black and white on areas of the image that are oversaturated with white, indicating they may be too bright. The flashing effect takes place only when you are viewing the pictures in Auto Review or Playback mode, on the LCD or in the viewfinder. That is, you will see the Highlight warning only when the image appears briefly on the screen after it has been recorded (Auto Review) or when you view the picture in Playback mode. This feature alerts you that the image may be washed out (overexposed) in some areas, so you may want to reduce the exposure for the next shot. If you find that sort of warning distracting, just turn this feature off. The flashing does not occur on one playback screen that shows the image only, with no information. So, even if this option is turned on, you can see your image without the flashing, by pressing the Display button to view that screen.

ZEBRA PATTERN

This feature helps you gauge whether an image or video will be overexposed by setting the LX100 II to place a striped "zebra" pattern on the display in recording mode. You can select either left-slanting or right-slanting stripes to match the scene as well as possible, and you can set either type of stripes to a numerical value from 50% to 105% in 5% increments. For Zebra2, but not Zebra1, you can also choose Off for the value. I will discuss the reason for that setting later in this section.

The numbers from 50 to 105 are a measure of relative brightness or exposure on a scale where 0 represents black and 100 represents bright white. A value of 100 or 105 indicates overexposure. To make the settings, select the menu option and pop up the menu with suboptions of Zebra1, Zebra2, Off, and Set.

Zebra1 generates stripes that slant from lower left to upper right and appear to move down to the right; Zebra2 generates stripes in the opposite direction. Use the Set option to set a numerical level for either Zebra1 or Zebra2, and then choose Zebra1 or Zebra2 from the menu to display that pattern on the screen.

When you turn this option on to any level less than about 90, you very likely will see, on some parts of the display, the "zebra" stripes that give this feature its name. When you see the stripes on part of the image, that means that area is at or above the brightness level that was set for the stripes. For example, if you select stripes set to the 65% level and aim the camera at the scene, the stripes will appear on any part of the display where the brightness level reaches 65% of bright white.

There are various approaches to using these stripes, which originated as a tool for professional videographers. Some photographers like to set the zebra function to 90% and adjust the camera's exposure so the stripes just barely start to appear in the brightest parts of the image. Another recommendation is to set the option to 75% for a scene with Caucasian skin, and expose so that the stripes appear in the area of the skin.

In Figure 7-28, I set the pattern to Zebra1 at 65% and exposed to have stripes appear on the subject's face.

Figure 7-28. Zebra1 in Use at 65%

As I noted earlier in this section, for Zebra2, you can set the brightness to any value from 50 to 105, and also to Off, which is not available for Zebra1. The reason for this setting is that, if you assign Zebra Pattern to a function button, when you press that button the camera cycles from Zebra1 to Zebra2 and then to Off. If you want to be able to turn Zebra on and off in the quickest way possible, you can set Zebra2 to a value of Off, so pressing the button will immediately switch from Zebra1 (at a numerical value) to Zebra2, which will be equivalent to Off.

Zebra Pattern is a feature to consider, especially for video recording, but the LX100 II has an excellent metering system, including both live and playback histograms, so you can manage without this option if you don't want to deal with its learning curve.

EXPOSURE METER

This feature gives you the option of having the camera display its Exposure Meter feature, which is a set of two graphical strips that appear when you are adjusting shutter speed, aperture, exposure compensation, or Program Shift, as shown in Figure 7-29. The top strip shows the shutter speed value and the bottom one displays the aperture setting.

Figure 7-29. Exposure Meter in Use for Program Shift

I find this display distracting and not all that helpful, so I leave it turned off, but you might find it useful in some situations.

MF GUIDE

If this option is turned on, then, when you are turning the control ring to adjust manual focus, the camera displays a scale at the bottom of the screen with an indicator that shows the approximate focus distance along the scale from far to near, with no numerical value for the distance. With this option turned off, the scale does not appear. An example of the scale is shown in Figure 7-30.

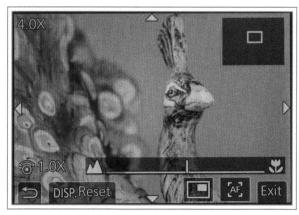

Figure 7-30. MF Guide in Use

Screen 6 of the Custom menu is shown in Figure 7-31.

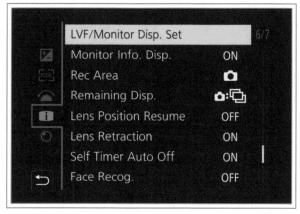

Figure 7-31. Screen 6 of Custom Menu

LVF/MONITOR DISPLAY SETTINGS

This menu item has two sub-options, LVF Display Setting and Monitor Display Setting, that let you adjust to some extent the display of information on the LCD screen and in the viewfinder.

LVF Display Setting

This first sub-option controls how informational icons are displayed in the viewfinder. There are two choices, indicated by graphic icons, as shown in Figure 7-32.

With the top choice, known as live viewfinder style, several icons, including those for Metering Mode, ISO, exposure compensation, and number of images remaining, are displayed below the live view area, so you can see more of the live view with no icons blocking it. The view of the image is scaled down, letting you judge its composition more clearly. With the bottom choice, known as monitor style, all icons are placed within the live view area and that area extends farther down to accommodate them. The view of the image is slightly larger, letting you see details more clearly. I find

the differences between these views to be minimal, but this is one way to tweak the viewfinder's operation.

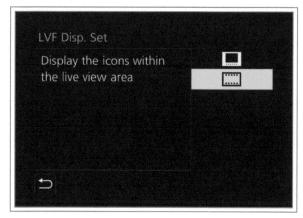

Figure 7-32. LVF Display Setting Menu Options Screen

Monitor Display Setting

This option is the same as the previous one, except that it applies to the LCD display, rather than the viewfinder. For this setting, I prefer the bottom option, which places all of the icons within the live view of the image, so you have a slightly larger view of the scene. I find that the icons do not significantly block the view.

MONITOR INFORMATION DISPLAY

This option controls whether or not the camera displays the screen with shooting information but no live view of the scene in recording mode, when you cycle through the various shooting displays by pressing the Display button. This screen, shown in Figure 7-33, is displayed after the second screen that shows the level gauge, but only if the Monitor Information Display menu option is turned on.

Figure 7-33. Monitor Information Display Screen

When this screen is displayed and the touch screen is turned on through the menu system, you can touch any of the items displayed in white to change the setting, including exposure compensation, ISO, white balance, and several other items.

RECORDING AREA

This option lets you set the camera's recording screen to display either the recording area used for still photos or the area used for motion pictures. For still photos, that area is determined by the aspect ratio setting; for motion pictures, it is 16:9 for all settings.

The reason for having this menu option available is that the LX100 II does not ordinarily show the area available for motion picture recording until you press the red motion picture button to start the recording. So, if the aspect ratio menu option is set for, say, 3:2, you will not see the actual shape of the motion picture recording screen until the recording starts, so you will not be able to compose the scene on the camera's monitor or in the viewfinder properly. But, if you set the Recording Area menu option to the Motion Picture option, then you will see the available recording area on the camera's screen before you start the recording.

The choice here depends on whether you are planning to capture still images or record motion picture sequences in your shooting session. To make the choice, just use this menu item to select the icon for the still camera or the icon for a movie camera.

REMAINING DISPLAY

This feature lets you choose whether the camera's shooting screen shows how much video can be recorded with current settings, as shown in Figure 7-34, where the display in the lower right corner of the screen shows that amount as 29 minutes 59 seconds in this case, or the number of still images that can be recorded.

Figure 7-34. Remaining Display in Use on Shooting Screen

As shown in Figure 7-35, there are two options, illustrated graphically: the top option selects the display of still images remaining, while the bottom one selects the amount of video recording time available.

Figure 7-35. Remaining Display Menu Options Screen

As with the previous menu option, the choice depends on whether you are shooting mostly stills or videos.

LENS POSITION RESUME

If you turn on this option, then, after you turn the camera off and back on, the lens will return to its last zoom position and focus position. If this setting is turned off, the lens will zoom out to its 24mm setting when the power is turned on. This option is convenient if you need to use a particular focal length, such as 50mm, for a series of shots that will be interrupted by turning the camera off for periods of time. The focus position is restored for either autofocus or manual focus.

LENS RETRACTION

This menu option lets you control whether or not the lens automatically retracts about 15 seconds after the camera enters playback mode. If you turn this option off, then the lens does not retract in that situation; if it is turned on, the retraction takes place. I usually leave this option turned on, but if you want to alternate between reviewing your images in playback mode and taking more images, you might want to turn this option off so the lens does not have to extend repeatedly every time you return to recording mode.

SELF TIMER AUTO OFF

This next option controls whether the self-timer remains set after you turn the camera off and back on. If this option is turned on, then, when the camera turns off, the self-timer will be deactivated and will not be in effect when the camera is turned on the next time. If this option is turned off, then the self-timer will remain in effect even after the camera has been powered off.

How you use this feature depends on your particular needs. If you often use the self-timer, it can be convenient to leave it activated so it will be ready the next time you turn on the camera. Or, if you use it rarely, you can turn this option on so the self-timer will not be in effect when you don't want it.

FACE RECOGNITION

With this option, you can register the faces of up to six people so the camera will recognize them when Face Recognition is turned on. Here are the steps to follow.

First, go to the Face Recognition menu item and select the third option, Memory. Press Menu/Set (or use the touch screen) to go to the screen with six blue blocks, shown in Figure 7-36. Move the yellow highlight to the first available blue block that says New, and press Menu/Set; you will see the screen shown in Figure 7-37, which prompts you to position the face to be registered in the yellow frame.

Figure 7-36. Memory Option for Choosing New Registration

When you have the face properly positioned, press the shutter button to take a picture. If the registration fails, you will see an error message. If it succeeds, you will see a screen asking if you want to register this person. You can then proceed to enter data for the person, including name and birthdate.

Once you have one or more faces registered, you can turn Face Recognition on through this item on the Custom menu whenever you want the camera to try to recognize those faces. You also have to have AF mode set to Face/Eye Detection using the AF mode button (Left button) for the camera to use face recognition.

When the camera recognizes a face, it will place a frame over the face and display the name, if one was entered into the camera's memory, as shown in Figure 7-38, along with the age if it was entered, though that information does not become part of the image.

The camera will adjust its focus and exposure for the recognized face or faces. It can recognize up to three faces at a time. If you have registered two or more faces, you can set the priority for each, using the Priority option for each face. The camera will set focus and exposure for higher-priority faces.

Figure 7-37. Screen to Register New Face

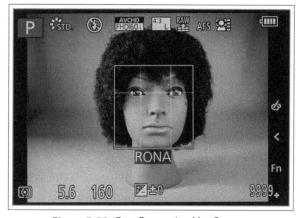

Figure 7-38. Face Recognized by Camera

You can add additional images for any person, taken from different angles and in different lighting, to increase the camera's ability to recognize that person. To do that, choose the Memory option and then select the person for whom you want to add images. You also can edit the person's information, including name and birthdate.

I do not often use this feature, but I can appreciate how useful it could be if, for example, you are taking photos at a school event and you want to make sure the camera focuses on your child when you are aiming at a group of children. If you don't want the camera to use face recognition, just turn this menu item off.

The single item on screen 7 of the Custom menu is shown in Figure 7-39.

Figure 7-39. Screen 7 of Custom Menu

PROFILE SETUP

This final option on the Custom menu lets you create profiles for two babies and one pet, so the camera will display the name and age of the baby or pet when you take a picture of him or her. For example, you can enter a profile for a baby named Charles, born January 15, 2019. Then, when you take a picture of Charles, you can recall that profile and the camera will display his name and age as of the date the picture is taken. So, if you take his picture on December 20, 2019, with his profile activated, the camera will display: Charles 11 months. This information will be recorded with the image and it will display in playback mode with the detailed information screen, but it will not become a permanent part of the image unless you take further steps.

One way to imprint the information in the image is to use the PHOTOfunSTUDIO software that is available from Panasonic for Windows-based computers. Another way is to use the Text Stamp option on the Playback menu, as discussed in Chapter 6.

This option does not cause the camera to recognize a pet or baby; it just lets you call up the profile for Baby 1, Baby 2, or Pet. So, you actually could enter any name and birthdate in any of those three profiles. When you

call up the profile and take a picture with the profile activated, the camera will record the name and age, regardless of the actual subject matter of the image.

The Setup Menu

The Setup menu, designated by the solitary wrench icon, has four screens of options for adjusting settings having to do with general camera functions. Its first screen is shown in Figure 7-40.

Figure 7-40. Screen 1 of Setup Menu

ONLINE MANUAL

This first option on the Setup menu provides information about where to download the online user's guide for this camera from Panasonic. The item has two sub-options, URL Display and QR Code Display.

With the URL Display option, you can use a computer to go to the URL that is provided in this item and download the manual from that address: http://panasonic.jp/support/dsc/oi/index.html?model=DC-LX100M2&dest=P. With the QR Code Display option, you can display the QR code. When that code is displayed, you can aim the camera of a smartphone at the code, and, using a QR reading app on the phone, download the manual to the phone (or tablet).

UTILIZE CUSTOM SET FEATURE/CUSTOM SET MEMORY

I am discussing the next two Setup menu options together, because they work together to let you create what amounts to a set of custom shooting modes, with which you can save your preferred settings. This feature gives you a way to quickly change several shooting parameters without having to remember them or use

menus or physical controls to set them. The camera lets you record three different groups of settings, each of which can be recalled instantly using the Utilize Custom Set Feature option.

Here is how this works. First, you need to have the camera set to recording mode rather than playback mode, so if it's in playback mode, press the shutter button halfway or press the playback button to exit to recording mode. Then, set the camera to Program, Aperture Priority, Shutter Priority, or Manual exposure mode (You can't use the Custom Set feature in Intelligent Auto mode.)

Next, make all the menu settings you want to store for quick recall, such as Photo Style, ISO, AF mode, Metering mode, white balance, and the like. Your custom set can include all of the items on the Recording Menu except Face Recognition and Profile Setup; all items on the Custom Menu; all items on the Motion Picture menu; and all items from the Playback menu except Rotate Display, Picture Sort, and Delete Confirmation. You cannot include any items from the Setup menu. You can include white balance, AF mode, drive mode, and ISO, even though they are not set from the menu.

Once you have all of the settings as you want them, leave them that way and go to the Setup menu. Navigate to Custom Set Memory and press the Right button, which gives you choices of C1, C2, and C3, as shown in Figure 7-41.

Figure 7-41. Screen to Choose Slot for Saving Settings

Highlight the slot you want to save your settings in and press Menu/Set. The camera will display a message asking you to confirm this action; highlight Yes and press Menu/Set to confirm.

When you later want to use your set of saved settings, go to the Setup menu and select Utilize Custom Set Feature. On the sub-menu that appears when you press the Right button, shown in Figure 7-42, select C1, C2, or C3. Once you have selected the custom mode you want, you are still free to change the camera's settings, but those changes will not be saved into the Custom Set Memory unless you go back to the Custom menu and save the changes there with the Custom Set Memory option.

Figure 7-42. Screen to Choose Slot to Recall Settings From

When you have finished using the saved settings, be sure to go back to the Utilize Custom Set Feature and select the final option, Off, which will return the camera to the settings it was using before you loaded the saved group of settings and will keep the saved settings from taking effect for further shooting.

If you want to speed up your ability to choose a saved group of settings, go to screen 3 of the Custom menu, choose the Function Button Set option, and assign Utilize Custom Set Feature to one of the function buttons. Then, when you press that button in Recording mode, a small menu for choosing a slot with saved settings will appear at the top of the screen.

Note, though, that there is a trick to using this approach. When you call up the saved group of settings, you will not be able to use the function button to turn it off using the Utilize Custom Set Feature, unless you assigned the same function button to that menu option inside the saved group. So, if you are planning to use a function button to switch groups of settings often, you should assign the same function button to call up this menu option within every group of settings you will be using.

Once you have called up a set of saved settings, the camera displays the slot in use (C1, C2, or C3) just above

the shooting mode icon in the upper left of the display, as shown in Figure 7-43. You can change to another slot or turn off the Custom Set feature altogether by touching that icon on the screen and selecting C1, C2, C3, or Off from the menu that appears.

Figure 7-43. Custom Set Icon on Shooting Screen

Although it has some limitations, Custom Set Memory is a powerful capability, and anyone who has or develops a favorite group of settings would do well to save one or more groups to the available three slots.

CLOCK SET

When you use your LX100 II camera for the first time, it should prompt you to set the clock. If it does not do so, or if you later need to adjust the date and time, use this menu option. When you select it and press the Right button or Menu/Set, the camera will display a screen like that shown in Figure 7-44.

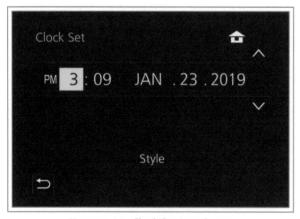

Figure 7-44. Clock Settings Screen

On that screen, navigate through the blocks for time and date using the control dial or the Left and Right buttons (or the touch screen), and adjust the settings with the Up and Down buttons. You can then highlight the Style block to select the order for month, day, and year and whether to use 24-hour format for the time. When everything is set properly, navigate to the Set block in the lower right corner of the display and press Menu/Set to confirm the settings. (The Set block appears only if some change has been made.)

WORLD TIME

This is a handy function when you're traveling to another time zone. Highlight World Time, and press the Right button to access the next screen. If you haven't used this menu item before, you'll be prompted to select the Home area. If so, press Menu/Set and then use the Left and Right buttons, the control dial, or the touch screen to scroll through the world map, and use the Menu/Set button to set your Home area.

Then, on the World Time screen, use the Up button to highlight Destination, and again scroll through the world map to select the time zone you will be traveling to. The map will show you the time difference from your home time. Press Menu/Set to select this zone for the camera's internal clock. Then, any images taken will reflect the correct time in the new time zone. When you return from your trip, go back to the World Time item and select Home to cancel the changed time zone setting.

On both the Home and Destination screens, you can press the Up button or touch the sun and clock icon in the lower right corner to turn Daylight Saving Time on or off for that time zone.

TRAVEL DATE

This menu item has two sub-options for entering information when you take a trip, so the camera can record that information with your images. First, Travel Setup lets you set a range of dates for the trip, so the camera can record which day of the trip each image was taken. Then, when you return from your trip, if you use the Text Stamp function to "stamp" the recorded data on the images, the images will show they were taken on Day 1, Day 2, etc., of the trip. The date entries for Travel Setup are self-explanatory; just follow the arrows and the camera's prompts.

After you set departure and return dates, you also can set the location, which will display along with the day number. To do that, after setting up the dates, select Location from the Travel Date menu item and then select Set from the sub-menu. The camera will display a screen where you can enter the name of the location using the same text-entry tools as are used for the Text Edit item, discussed earlier.

Wı-Fı

This option is used to set up a Wi-Fi connection with the LX100 II. I will discuss Wi-Fi operations in Chapter 9.

BLUETOOTH

This option is used to set up a Bluetooth connection with the camera. As with the previous option, I will discuss this topic in Chapter 9.

Screen 2 of the Setup menu is shown in Figure 7-45.

Figure 7-45. Screen 2 of Setup Menu

WIRELESS CONNECTION LAMP

This option lets you set whether the blue connection lamp located between the Fn5 and Fn4 buttons will light up when the camera is establishing or maintaining a Wi-Fi or Bluetooth connection. If this option is turned off, the lamp will not light for that purpose. It will still light up red when the battery is charging inside the camera.

BEEP

This next option on screen 2 of the Setup menu lets you adjust several sound items. First is the volume of the beeps the camera makes when you press a button, such as when navigating through the menu system. You can set the beeps to off, normal, or loud, as represented by the icons shown in Figure 7-46. It's nice to be able to turn the beeps off if you're going to be in an environment where such noises are not welcome.

Figure 7-46. Beep Menu Options Screen

Second is the volume of the shutter operation sound. Again, it's good to be able to mute the shutter sound. Finally, you can choose from three shutter sounds. If you want to silence all sounds quickly, while also disabling the flash and the AF assist lamp, use the Silent Mode option on screen 4 of the Recording menu.

ECONOMY

The next option on the Setup menu, Economy, has three sub-options: Sleep Mode, Sleep Mode (Wi-Fi), and Auto LVF/Monitor Off.

Sleep Mode

The Sleep Mode option puts the camera into a dormant state after a specified period when you have not used any of the camera's controls. The period can be set to one, two, five, or ten minutes, or the option can be turned off, in which case the camera never turns off automatically (unless it runs out of battery power). To cancel Sleep Mode, press the shutter button halfway and the camera will come back to life. Sleep Mode does not turn off the camera during a slide show or when an AC adapter is connected, or during the recording or playback of a motion picture, along with a few other situations.

Sleep Mode (Wi-Fi)

With this setting, the camera goes dormant after 15 minutes, but only if there is no Wi-Fi connection active. This setting is useful if you are using the camera for transferring images or another activity using a wireless network connection, which may require the camera to sit for fairly long periods without any controls being activated. If there is no Wi-Fi connection active, there is no need to let the camera stay active, so it can be powered down.

Auto LVF/Monitor Off

The Auto LVF/Monitor Off setting controls how soon the viewfinder or monitor turns off when no controls have been used for a time. The possible choices are five minutes, two minutes, one minute, or Off. After the display goes blank, you can press any control button or touch the screen to restore the display. As with the Sleep Mode setting, this setting does not operate during slide shows, during a Time Lapse Shot session, and in a few other situations.

MONITOR DISPLAY SPEED

This option lets you choose either 60 fps (frames per second) or Eco30 fps for the operation of the camera's LCD display screen. The setting of Eco30 fps reduces battery use, but the display may not always refresh quickly enough to keep up with a fast-moving subject. In addition, with some settings, such as the Rough Monochrome or Silky Monochrome settings, the display slows down as the camera processes the effect. If you choose the 60 fps setting, the display will be better able to show any action smoothly, or to maintain a smooth appearance as you pan across the scene. The quality of the display may suffer slightly, but not badly. So, if you find the display stuttering or smearing, you may want to try the 60 fps option.

If you have this item set to Eco30fps, the Digital Zoom option is not available. The Eco30fps setting is not available when the camera is recording 4K photos or using Post Focus.

LVF DISPLAY SPEED

This setting is similar to the above item, but it applies to the viewfinder rather than the LCD screen. Again, with the Eco30fps in effect for this setting, Digital Zoom is not available for use, and the other restrictions on the use of the Eco30fps option apply as well.

MONITOR DISPLAY/VIEWFINDER

This menu option is unusual because its name changes depending on whether you are viewing the menu on the LCD monitor or in the viewfinder. If you are viewing it on the monitor, it is called Monitor Display; if you are using the viewfinder, it is called Viewfinder. It operates the same way in either case. However, if you make adjustments to this item while using the monitor, those adjustments will affect only the monitor. You can make

separate adjustments while using the viewfinder, and those adjustments will affect only the viewfinder.

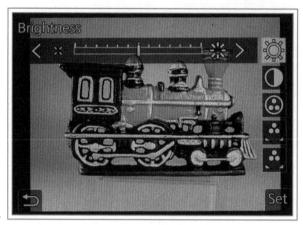

Figure 7-47. Monitor Display Adjustment Scales

As shown in Figure 7-47, which shows the version for adjusting the monitor, this option has five linear scales for making adjustments. Use the Up and Down buttons or the touch screen icons to select a scale, and then use the Left and Right buttons, the control dial, or the touch screen to adjust the settings on the scale for each item. The normal settings are in the middle of the scale; move the yellow blocks to the left of the scale to decrease a setting, or to the right to increase the value.

Starting from the top, the scales control brightness, contrast, saturation, red tint, and blue tint. When you have made your adjustments on each scale, you have to press the Menu/Set button to make them take effect.

I have never found a need to adjust the settings for either the LCD display or the viewfinder, but if you find the color, contrast, or brightness of either display is not to your liking, you can use these adjustments as you wish.

MONITOR LUMINANCE

This setting affects the brightness of the LCD display, but not the viewfinder, though you can adjust it while using the viewfinder. This setting is different from the brightness setting of the previous menu option in that it provides overall, on-or-off adjustments, rather than a sliding scale. This menu item has four settings, each accompanied by an asterisk: A*, 1*, 2*, and 3*.

With the A* (Auto) setting, the brightness will adjust according to ambient lighting conditions. With the 1* setting, the screen becomes extra-bright to compensate for sunlight or other conditions that make it hard to see

the screen. It reverts to normal after 30 seconds, but you can press any control button or the touch screen to restore the brightness. The 2* setting provides standard illumination, and the 3* setting sets the display to a dimmer level than normal.

Using the A* or the 1* setting decreases battery life. If you find it hard to see the screen in bright sunlight and don't want to use the viewfinder, you might want to try the 1* setting to see if the added brightness gives you enough visibility to compose your shots or view your recorded images clearly.

I use the A* setting myself, and always keep an extra battery handy.

M/FT

This option lets you choose whether distance is displayed using meters or feet as the unit of measure on the zoom scale.

Screen 3 of the Setup menu is shown in Figure 7-48.

Figure 7-48. Screen 3 of Setup Menu

EYE SENSOR

This next item on the Setup menu has two sub-options with controls for the operation of the eye sensor, the small slot at the right of the viewfinder that detects the presence of your eye (or another object). Those sub-options are Sensitivity and LVF/Monitor Switch.

You can set Sensitivity to High or Low. I have not found much difference between these settings. If you find that the eye sensor is triggering the switch from LCD to viewfinder when you don't want it to, you can try setting this option to Low to see if that helps.

The other setting for Eye Sensor is LVF/Monitor Switch. There are three possible choices for this item: LVF/Monitor Auto, LVF, and Monitor. With the first choice, the camera will switch automatically between the LCD screen and the viewfinder as your eye approaches or moves away from the eye sensor. If you choose LVF, the viewfinder will always be in use; if you choose Monitor, the LCD display will always be in use.

I find it convenient to use the LVF/Monitor Auto option, so the camera will switch to using the viewfinder whenever my head comes near to the viewfinder. However, in some cases, such as if you are doing close-up shots from a tripod, you might want to leave the monitor always in use, even though your head may come near to the camera as you adjust a setting. Or, you might want to set the viewfinder to be in effect at all times when you don't want to have the LCD display illuminate to distract those around you.

You can also switch the behavior of the eye sensor by pressing the Fn5/LVF button, assuming it remains assigned to this option. (You can assign another button to this option if you want, but it makes sense to leave the Fn5 button with this duty, because it is located next to the eye sensor and the LVF label.)

USB Mode

If you are going to connect the camera directly to a computer or printer, you need to go to this menu item and select the appropriate setting from the three choices shown: Select on Connection, PC (Storage) (for connecting to a computer to transfer images and videos), or PictBridge (PTP) (for connecting to a printer). PTP stands for Picture Transfer Protocol, a standard used for a direct-to-printer connection.

If you choose Select on Connection, you don't select the setting until after you have plugged the USB cable into the device to which you are connecting the camera. The LX100 II connects to a computer using the USB 2.0 connection standard, assuming your computer has a USB port of that speed. (If not, the camera will still connect at the slower speed of the computer's older USB port.)

TV CONNECTION

This menu item has two sub-options: HDMI Mode (Play) and Viera Link. The HDMI Mode option sets the output resolution for the images that are sent to an HDTV

when the camera is connected to the TV with a micro-HDMI cable in playback mode. The available choices are Auto, 4K/30p, 1080p, 1080i, 720p, and 480p. Ordinarily, if you select Auto the images should appear properly on the HDTV. If they do not, you can try one of the other settings to see if the display improves.

The Viera Link option is for use when you are connecting the LX100 II to a Panasonic Viera HDTV using a micro-HDMI cable. If you leave this option turned off, then the operations of the camera are controlled by the camera's own controls. If you turn it on, the Viera TV's remote control can also control the operations of the camera, so you can play slide shows or review individual images and movies. This option also may work with some other brands of HDTVs.

LANGUAGE

This option gives you the choice of language for the display of commands and information on the LCD screen and in the viewfinder. Figure 7-49 shows the first of the two screens of the language selection option for my U.S. version of the camera.

Figure 7-49. Language Menu Options Screen

Presumably, models sold elsewhere offer different choices. If your camera happens to be set to a language that you don't read, you can find the Language option by going into the Setup menu (look for the wrench icon), and then scrolling to this option, which is marked by an icon showing a person's head with a word balloon, as shown earlier in Figure 7-47.

VERSION DISPLAY

This item has no settings; when you select it, it displays the version of the camera's firmware that is currently installed. Firmware is somewhat like both software and hardware; it is the programming electronically recorded into the camera, either at the factory or through your computer if you upgrade the firmware with an update provided by Panasonic. A new version of the firmware can fix bugs and can even provide new features, so it's well worthwhile checking the Panasonic website periodically for updates. Instructions for installing an update are provided on the website. The process usually involves downloading a file to your computer, saving that file to an SD card formatted for the camera, then placing that card in the camera so the firmware can be installed.

As I write this, my LX100 II has version 1.1 of the firmware installed, as shown in Figure 7-50. The camera originally came with version 1.0, but Panasonic released an update in December 2018 to fix a "bug in the contrast adjustment of [the] monitor." I had not noticed the bug, but I always like to have the latest version of the firmware installed, in case it may have fixed or improved items other than what is listed for the update.

Figure 7-50. Version Display Screen

To check for firmware updates, go to http://av.jpn.support.panasonic.com/support/global/cs/dsc/download/LX100M2/index.html.

FOLDER/FILE SETTINGS

This menu item has three sub-options that let you control the camera's use of folders to store images and videos on the memory card in the camera.

Select Folder

When you select this option, the camera displays a screen showing the names of folders that are currently available on the memory card in the camera.

On the right side of each line on that screen is the letter R for Remaining images, followed by a number

indicating how many more items can be stored in that folder, such as R71. (The maximum capacity of a folder is 1,000 files.) You can select the folder for storing images you are about to create. This option can be useful to separate business photos from personal ones, or travel ones from home ones, for example.

Create a New Folder

This option lets you create a new folder for storing images. This item has two sub-options: OK and Change. If you select OK, the camera will name the folder using the default label (which is _PANA for my camera). If you select Change, the camera will name the folder using a three-character prefix (by default, the folder number) plus a five-character label you enter yourself. For example, the folder name can be in the form of 100_PANA, or, say, 100PARIS, to hold images from your trip to Paris. You enter the label using the same text-entry screen that was discussed earlier in connection with the Title Edit menu option on the Playback menu.

File Name Setting

This menu option has two sub-options for choosing how the camera names images: either Folder Number Link or User Setting, as shown in Figure 7-51. If you choose Folder Number Link (the default), a typical file name for an image stored in a folder named 102_PANA would be P1021430.jpg, with the number 102 in the file name taken from the folder number.

Figure 7-51. File Name Setting Menu Options Screen

If you choose User Setting, you can specify any three characters (numbers, upper-case letters, or the underscore character) instead of the folder number. You can use your initials, the date, or any other three-character string that would be useful to you. With the same example as above, if I chose my initials for the

file name setting, the same image would be named PASW1430.jpg.

The first character of the file name will always be P or the underscore character, because those characters designate the color space setting for the image. P designates the sRGB color space, and the underscore character designates the Adobe RGB setting.

Number Reset

This function lets you reset the folder and image number for the next image to be recorded in the camera. If you don't use this option, the numbers of your images will keep increasing until they reach 9999, even if you change to a different memory card. If you want each new card to start with images numbered from 1 up, use the Number Reset function each time you start a new card, or a new project for which you would like to have freshly numbered images. For example, my camera was displaying its last image, number 101-1495. I used this menu option to reset the numbers, and the next image was numbered 102-0001.

I prefer not to reset the numbers, because I find it easier to keep track of my images if the numbers keep getting larger; I would find it confusing to have images with duplicate numbers on my various SD cards.

RESET

This menu option resets all Recording menu and drive mode settings to their original states. It also resets all Setup and Custom menu settings to their original states, except for Face Recognition and Profile Setup settings, which can be reset separately using this option. This is a convenient way to get the camera back to its default mode, so you can start with fresh settings before you experiment with new ones.

The camera prompts you several times, asking if you want to reset all Recording menu and drive mode settings; then all network settings; then all Face Recognition and Profile Setup settings; and then all other Setup/Custom menu parameters. Folder numbers and date and time settings are not reset by this option.

The fourth and final screen of the Setup menu is shown in Figure 7-52.

Figure 7-52. Screen 4 of Setup Menu

RESET NETWORK SETTINGS

This option resets all Wi-Fi and Bluetooth settings for the camera. You might want to use this option if you are selling your camera, to avoid giving away information about your wireless networks. You also might want to use this option if you are having trouble getting the Wi-Fi or Bluetooth settings configured and you want to make a fresh start. The settings for a Lumix Club account are not reset.

LEVEL GAUGE ADJUSTMENT

This option gives you a way to make sure that the level gauge display is properly aligned. To use it, select the menu option, which will then display the screen with choices for Adjustment and Level Gauge Value Reset. To make an adjustment, select the first option, and the camera will prompt you to place it on a surface known to be horizontal. When you press OK, the camera will display a screen with three horizontal lines and a Start icon. When the camera is set on a horizontal surface, press the Start icon on the screen or press the Menu/Set button, and the camera will carry out the adjustment.

If you later change your mind about using the adjusted calibration, select the second option, Level Gauge Value Reset, and the camera will restore its original default setting for the level gauge.

DEMO MODE

If you choose this option, the camera takes quite a while to carry out an internal process and then places a demonstration image on the screen, with several different areas of possible focus. You can then touch the screen to see how the Post Focus option works. You

also can touch the Peak icon for a demonstration of focus peaking. To cancel this demonstration, press the shutter button halfway.

FORMAT

This last item on the Setup menu is one of the more important menu options. Choose this process only when you want or need to completely wipe all of the data from a memory card. When you select the Format option, the camera will ask you if you want to delete all of the data on the card. If you reply by selecting Yes, the camera will proceed to erase all images and videos, including any that have been locked using the Protect option on the Playback menu. It's a good idea to use this command with any new memory card you place in the camera for the first time so the card will be properly formatted to store new images and videos.

My Menu

The My Menu system lets you create a customized menu system that holds up to 23 of your most-used options from the other menu systems. The My Menu option is represented by the figure of a human head and shoulders in the line of menu icons at the left of the menu screen, as shown in Figure 7-53.

Figure 7-53. My Menu Icon Highlighted at Left

When you first use this system, select the My Menu Setting option, and you will be taken to a screen with the option to add items. Select Add, and you will see a screen like that in Figure 7-54, with the first items on a long list that spans 26 screens. Scroll through those options using the Up and Down buttons, the control dial, or the touch screen. You can speed through the screens using the zoom lever.

Figure 7-54. Screen for Adding Item to My Menu

When you reach an item you want to add to My Menu, press Menu/Set (or touch the item on the screen) and the camera will display a confirmation box, asking if you want to save that item. If you select Yes to confirm, that item will appear on the My Menu list and it will be dimmed on the list of selections, so you don't accidentally select it a second time.

When you have selected up to 23 items, press the Fn3 button to go back to the main menu screen. You can now select the options on the My Menu screen without having to find them in their original locations on other menus. An example is shown in Figure 7-55, after I added several items to My Menu.

Figure 7-55. My Menu with Several Items Added

If you go back to the My Menu Setting option, you can now use the other options: Sorting, Delete, and Display from My Menu. The Sorting option lets you change the order of the options on the menu. The camera will prompt you to select an item and then select the new location for that item. The Delete item lets you delete items singly or all at once.

The Display from My Menu option lets you set what menu is displayed when you press the Menu/Set button to enter the camera's menu system. If you turn this option on, then the camera will display the options on My Menu, so you can go directly to your most-used options. If you turn this option off, then the camera will display whatever menu was last used.

CHAPTER 8: MOTION PICTURES

few years ago, the video recording features of compact cameras seemed to be included almost as afterthoughts, so the user would have some ability to record video clips but without many advanced features. Recently, though, camera makers, particularly Panasonic, have increased the sophistication of the video functions of small cameras to a remarkable level. The LX100 II is not ready to take the place of a dedicated video camera for professional productions, because it lacks features such as live HDMI output and jacks for external microphones. But in terms of pure video recording capability, it has great abilities. I will discuss how to take advantage of those features in this chapter.

Basics of LX100 II Videography

In one sense, the fundamentals of making videos with the LX100 II can be reduced to four words: "Push the red button." Having a dedicated motion picture recording button makes things easy for users of this camera, because anytime you see a reason to record a video clip, you can just press that easily accessible button while aiming at your subject, and you will get results that are likely to be usable. So, if you're more of a still photographer and not particularly interested in moviemaking, you don't need to read further in this chapter. Be aware that the red button exists, and if a newsworthy event starts to unfold before your eyes, you can press the button and get a serviceable record of the action.

But for those LX100 II users who would like to delve further into their camera's motion picture capabilities, there is considerably more information to discuss.

Here are two introductory notes: First, I am located in the United States, where the LX100 II comes set up for NTSC video, using the standard frame rate of about 30 or 60 frames per second (fps). The version of the camera sold in Europe and some other locations is set up for PAL video, using frame rates of 25 or 50 fps. So, if you are using a PAL version of the camera, be aware

that references in this book to 30 or 60 fps should be read as 25 or 50 for your model.

Second, there are limitations on motion picture recording time with the LX100 II. Like most cameras that are designed primarily for still photography, this camera has limits on recording length that are required in order to meet tariff requirements in some locations, to avoid having the camera classified as a video camera.

With the LX100 II, this means you cannot record a single video sequence longer than 29 minutes and 59 seconds in any format, and when recording with 4K quality the limit is 15 minutes. You can always start another video recording after the first one ends, but you cannot record a single video that exceeds the above limits in duration. There also is a 4 GB limitation on file size, which may result in the camera dividing a long video into multiple files.

Quick Start for Motion Picture Recording

First, I will list some basic steps for recording a motion picture sequence if you don't need to make many settings, but just want to get a clear record of the action.

- 1. Turn the camera on and let the lens cap dangle by its string.
- 2. Turn the aperture ring and shutter speed dial to their A positions.
- Press the iA button on top of the camera until the iA icon appears in the upper left corner of the display.
- 4. Press the Menu/Set button, go to the Motion Picture menu (icon of movie camera at left of menus), and select the Recording Format item. Set it to MP4, as shown in Figure 8-1.

Chapter 8: Motion Pictures 145

Figure 8-1. Recording Format Set to MP4

- 5. Move down to the Recording Quality item on that menu and select FHD/20M/30p, the next-to-bottom option.
- Move down to the AFS/AFF/AFC item and select AFS.
- 7. Aim the camera at your subject and zoom the lens to the desired focal length.
- Press and release the red Movie button, hold the camera steady, and record your video. Zoom if necessary, but try to keep zooming to a minimum.
- 9. To take a still picture during the video recording, just press the shutter button. You will not hear a shutter sound.
- 10. Press and release the Motion Picture button to stop the recording.

With those steps, the result should be a video sequence that has good image quality and sound and is relatively easy to work with on a computer. But there are other settings you can use for more advanced techniques, which I will discuss in the rest of this chapter.

General Settings for Motion Picture Recording

One of the great things about the video features of the LX100 II is that there is less complication with this camera than with many other compact models. With some other models, the recording modes do not work the same way for recording videos as they do for recording still images, and there are numerous other features that do not function normally when recording video. With the LX100 II, you can use the still-image

recording modes for recording video and get the results you would expect. There are some features that work differently for video shooting, but those differences are not that drastic. In the next two sections, I will discuss the various settings you can make for exposure and focus; after that, I will discuss the available menu options and other settings.

EXPOSURE

With the LX100 II, you do not have to worry about selecting a special shooting mode for motion picture recording, and you do not have to keep track of many limitations. You can set the camera to any one of its recording modes—Intelligent Auto, Program, Aperture Priority, Shutter Priority, or Manual exposure—and record movies using that mode, just as if you were shooting still images.

If you want the camera to make most decisions for you, press the iA button to turn on Intelligent Auto mode. The camera will adjust exposure as you shoot and use its scene-detection programming to try to optimize its settings for the subject you are recording. If you are using Intelligent Auto Plus mode, you can adjust exposure compensation by turning the exposure compensation dial either before or during the recording.

For more access to the camera's wide variety of menu options, choose Program mode by setting the aperture ring and the shutter speed dial to their A positions. The camera will still adjust both aperture and shutter speed automatically according to the lighting conditions and you will be able to adjust settings such as white balance, ISO, metering mode, and others.

If you use Aperture Priority mode, by setting the shutter speed dial to its A position and turning the aperture ring to set an aperture value, the camera will maintain the aperture you set and adjust the shutter speed automatically. You will have access to many menu options, and you also can adjust the aperture, either before or during recording. With this ability, you can set the aperture to a wide value, such as f/1.7, to blur the background, or to a narrow value, such as f/11, to maintain a broad depth of field.

Also, you may be able to produce a fade-in or fadeout effect by varying the aperture setting during the recording. For example, if you are shooting at f/1.7 with ISO set to 200 in fairly dim indoor lighting, you may be able to gradually close the aperture down to f/16, making the picture fade to black. One problem with adjusting the aperture ring during video recording is that the sound of the clicking ring is quite audible on the sound track. This is not a problem if you are going to record a separate sound track later, but if you need to use the sound recorded by the camera, you will have to take this issue into account.

With Shutter Priority mode, the situation is similar. You can adjust many settings, and you can set the shutter speed as you want it. However, the shutter speed settings for motion picture recording work differently than for still images. As I will discuss later in this chapter, the frame rates for recording video with this camera (in the United States) are 60 fps, 30 fps, and 24 fps. Therefore the camera is recording at least 24 frames every second, which amounts to a shutter speed no slower than 1/24 second. Because of this situation, the slowest shutter speed available for video recording is 1/25 second when you are using the 24 fps speed and 1/30 second for the other speeds. (When you use the 60 fps setting, the camera converts it to 30 fps for playback, so it can use the 1/30 second shutter speed.)

In addition, you can use the super-fast settings for shutter speed that are available with the electronic shutter, ranging to as fast as 1/16000 second. To do that, turn the shutter speed dial to the 4000 setting and turn the control dial on the back of the camera to select the faster speeds. As with Aperture Priority mode, you can adjust the shutter speed either before or during the recording, and you can cause a fade-out effect by moving it to a very fast value during the recording. As with the aperture ring, though, the shutter speed dial makes a good dial of noise on the sound track, so you should avoid adjusting shutter speed during recording if you need to use the live sound track for your video.

Finally, you can use Manual exposure mode, and adjust both aperture and shutter speed before or during the recording. The considerations are similar to those for Aperture Priority and Shutter Priority mode, though, of course, you have more flexibility because you can adjust both values.

However, there is one more benefit in terms of creative options if you shoot your video in Manual mode: If you also have the focus switch set to manual focus, you can set the shutter speed as slow as 1/2 second. This shutter

speed setting results in a video frame rate of two frames per second, considerably slower than the normal (U.S.) frame rate of 30 frames per second. It lets you record usable footage in conditions of very low light and can result in interesting effects, such as ghost-like streaks on the video frames if you move the camera. You would not want to use this slow shutter speed for taking video of a sporting event, but if you're making a science-fiction or horror movie, this feature could present some promising possibilities.

When using Manual mode for video recording, you can adjust the ISO setting, as with other advanced modes, and you can set ISO to Auto ISO or to a numerical value, though the highest value available for ISO is 6400 for motion picture recording. The lower limit is 200, unless Extended ISO is turned on, in which case the lower limit is 100. You can set the ISO upper limit for movie recording using the ISO Auto Upper Limit (Video) item on screen 2 of the Motion Picture menu.

When recording movies with the Intelligent Auto Plus, Program, Aperture Priority, and Shutter Priority modes, you can adjust exposure compensation, just as with still photography, by turning the exposure compensation dial or by using a function button or the control ring, if a button or the control ring has been assigned to that option. However, the scale when using a function button or the control ring while recording motion pictures permits adjustments only up to plus or minus 3 EV, rather than the plus or minus 5 EV range for still photography.

You also can adjust exposure compensation when recording movies in Manual mode, but only when ISO is set to Auto ISO.

Focus

Your focus options while recording video are somewhat more limited than for shooting still images, but they still give you considerable flexibility. First, you can use manual focus for video recording with all shooting modes, including Intelligent Auto, and you can use peaking to assist in achieving sharp focus. The control ring adjusts focus smoothly, so you can carry out a very nice pull-focus operation to bring an object into or out of focus while you record. However, the enlarged display of the MF Assist option is not available during movie recording.

Chapter 8: Motion Pictures | 147

You also can use autofocus. In Intelligent Auto mode, the camera will automatically use continuous autofocus during video recording, if the focus switch is at an AF position. In the other recording modes, you have a choice, which is controlled using the Motion Picture menu. On screen 1 of that menu, you can set the focus mode to AFS, AFF, or AFC, for single, flexible, or continuous autofocus. However, the focus method is also controlled by a second menu option, Continuous AF, also on screen 1, which can be turned either on or off.

If you turn Continuous AF on, then it doesn't matter what you choose for AFS/AFF/AFC. The camera will adjust focus continuously as the distance to the subject changes. If you turn Continuous AF off, then you need to press the shutter button halfway to focus, and you can cause the camera to refocus at any time by pressing the button again. This focusing operation does not add any sounds to the sound track.

Other Settings

You likely will get excellent results if you use the camera's default settings and shoot your video using Intelligent Auto mode and following the guidelines for exposure and focus discussed above. But there are numerous other settings you can make using the camera's physical controls and the menu system. I will discuss those settings next, so you can take advantage of the flexibility they provide for motion picture recording with the LX100 II.

THE MOTION PICTURE MENU

First, I will discuss the one menu system I have not discussed in detail before—the Motion Picture menu, which is designated by the movie camera icon, just below the icon for the Recording menu, as shown in Figure 8-2.

Before I discuss the individual items on the menu, there are a couple of general points to mention. First, the menu has three screens in the more advanced (PASM) modes and Intelligent Auto Plus mode, but only one screen with three items when the camera is in the basic Intelligent Auto mode. In that mode, the only Motion Picture menu settings you can adjust are Recording Format, Recording Quality, and AFS/AFF/AFC.

Figure 8-2. Motion Picture Menu Icon Highlighted at Left

Second, when the full Motion Picture menu is available, 11 of the items on that menu also appear as items on the Recording menu: AFS/AFF/AFC, Photo Style, Filter Settings, Metering Mode, Highlight Shadow, i.Dynamic, i.Resolution, Diffraction Compensation, Stabilizer, i.Zoom, and Digital Zoom. These settings are included on the Motion Picture menu for convenience in setting them. You actually can adjust any of these 11 settings using either menu system, and the adjustment will take effect for both menus at the same time.

So, for example, if you set Photo Style to Monochrome on the Recording menu, you can then go to the Motion Picture menu and you will see that the Photo Style setting on that menu has changed to Monochrome. Or, if you turn on Digital Zoom on the Motion Picture menu, you will see that Digital Zoom has been activated on the Recording menu as well.

With that introduction, following is the list of all items that can appear on the Motion Picture menu, whose first screen is shown in Figure 8-3. I will not include detailed information here for the settings that also appear on the Recording menu; for more information about them, see Chapter 4.

Recording Format

With this setting, you choose the video format for any movies you make: AVCHD or MP4. Both options have advantages and disadvantages, and with either one, you have to also select Recording Quality, the next option on the menu. One major consideration is whether you want to shoot video using 4K quality, an advanced option that provides the highest possible resolution. If you want to shoot in 4K, then you have to choose MP4 for Recording Format. If you don't plan to use 4K, then AVCHD gives the best results for HD (high definition) footage. If you

want to record video just to make a general record of a trip or to make an inventory of household goods, MP4 lets you create files that are easier to manipulate with a computer than AVCHD files.

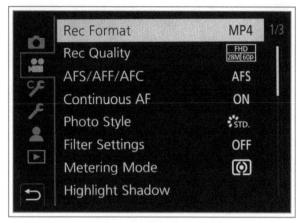

Figure 8-3. Screen 1 of Motion Picture Menu

AVCHD stands for Advanced Video Coding High Definition. This format, developed jointly by Sony and Panasonic, has become increasingly common in advanced digital cameras in recent years. It provides excellent quality, and movies recorded in this format on the LX100 II can be used to create Blu-ray discs.

However, files recorded in the AVCHD format can be complicated to edit on a computer. In fact, just finding the AVCHD video files on a memory card can be a challenge. (For information about the locations of video files, see the discussion at the end of this chapter.)

Recording Quality

The choices for this next menu option depend on what you select for Recording Format, above. If you choose AVCHD, the choices for Recording Quality are FHD/28M/60p, FHD/17M/60i, FHD/24M/30p, and FHD/24M/24p. All of these provide Full HD (FHD) video with a resolution of 1920 x 1080 pixels. The 28M, 17M, and 24M figures state the maximum bit rate for each format, meaning the number of megabits of information recorded per second. For example, the highest-quality format can record up to about 28 million bits of information per second. The higher the bit rate, the more information is available to provide a clear image.

The last three characters of each format state the frames or fields per second that are recorded, along with the "p" or "i" standing for progressive or interlaced. With progressive formats, the camera records full frames of information; with interlaced

formats, the camera records fields, or half-frames, and then interlaces them to form full video frames. In the United States the normal rate for recording and playing back video is about 30 frames per second (fps). So, the FHD/24M/30p format yields full HD video with the normal frame rate, recording 30 full frames each second. The FHD/17M/60i option yields the same frame rate by recording 60 fields and interlacing them to form 30 full frames.

The FHD/24M/24p option is provided for those who prefer a 24 fps video format. That frame rate is the one traditionally used by film-based movie cameras, and some people believe that using this standard provides a more "cinematic" appearance than the 30 fps option.

Finally, with the FHD/28M/60p standard, the LX100 II records 60 full frames per second, which yields higher quality than the alternative, which is "interlaced" video. The 60 frames are later translated into 30 frames for playback at the standard rate of 30 fps. However, if your video editing software has this capability, you can play back your 60p footage in slow motion at one-half the normal speed and still maintain full HD quality.

This possibility exists because, as noted above, the 60p footage is recorded with twice the number of full frames as 60i footage, so the quality of the video does not suffer if it is played back at one-half speed. (With other video formats, playback at half speed will appear choppy or jerky, because not enough frames were recorded to play back smoothly at that speed.) So, if you think you may want to slow down your footage significantly with a computer for playback, you should choose the 60p setting.

If you choose MP4 for the Recording Mode, the Quality choices are the following, in descending order of quality: 4K/100M/30p; 4K/100M/24p; FHD/28M/60p; FHD/20M/30p; and HD/10M/30p.

The two available 4K options are special cases. The ability to shoot 4K video is one of the distinguishing features of the LX100 II camera. The standard known as 4K, sometimes known as UHD for ultra HD, is a relatively recent option for HDTVs. The 4K stands for 4,000, meaning each frame has a horizontal resolution of about 4,000 pixels. A standard HDTV outputs frames with a horizontal resolution of 1920 pixels and a vertical resolution of 3840 and a vertical resolution

of 2160. The overall resolution of the 4K TV image is about eight megapixels, while the resolution of full HDTV is about two megapixels, so a 4K picture has four times the resolution of full HDTV.

To get the full benefit of 4K video footage, you need to view it on a 4K-capable TV set or monitor. However, if your editing software permits, you can shoot using the 4K format and then convert it to the more standard 1080 format for ordinary HDTV sets. With that approach, your video footage will contain considerably more detail than if you just recorded it using one of the 1080 formats.

There is one caveat about recording with the 4K quality setting: As noted earlier in this chapter, according to Panasonic you have to use a memory card of the fastest speed class, which is UHS speed class 3.

If you are not planning to record using the 4K settings, the other MP4 formats give you excellent options. You can record in full HD with a 28 megabit-per-second bit rate, giving you excellent quality. You can choose 60p for highest quality and the ability to produce slow-motion footage at one-half speed, or the more standard 30p option. If you would like to work with smaller files that still produce excellent quality, you can choose to record with the HD/10M/30p option, which records using HD rather than FHD, meaning the video frame size is 1280×720 pixels, rather than 1920×1080 .

Remember, if you are using the PAL recording system, as with many users in the UK, Europe, and elsewhere, the video options will include numbers in multiples of 25, such as 4K/100M/25p and FHD/28M/50p. Otherwise, the operations of the video functions are the same as discussed above for the NTSC system in use in the United States, with its 30 fps frame rate.

AFS/AFF/AFC

This next menu option, as discussed earlier, mirrors the same setting on the Recording menu. It really does not matter which one of these choices you select for purposes of video recording, so you should select the option that you will want to use for recording still images. The camera's autofocus behavior for video recording is controlled by the Continuous AF menu option, discussed next. If you have Continuous AF turned off, the camera will not focus on its own during video recording; you have to press the shutter button halfway to cause the

camera to use its autofocus mechanism. If you have Continuous AF turned on, then the camera will focus continuously during video recording. (Of course, the focus switch has to be set to the AF or AF macro setting for the camera to use autofocus at all.)

Continuous AF

As I noted above, this setting controls how the camera uses its autofocus during video recording, assuming you have the focus switch set to either the AF or the AF macro setting. If this menu option is turned on, the camera will adjust its focus continuously as the distance to the subject changes. If it is turned off, the camera will use its autofocus only when you press the shutter button halfway.

Photo Style

This setting lets you choose the "look" of your footage. It works the same for movies as it does for still photos. The choices are Standard, Vivid, Natural, Monochrome, L. Monochrome D, Scenery, Portrait, and Custom. For more details, see Chapter 4.

Filter Settings

This next item on the Motion Picture menu lets you select a filter effect for your video. Several of the settings are not available for movie recording: Rough Monochrome, Silky Monochrome, Soft Focus, Star Filter, and Sunshine. You cannot use the Miniature setting when recording 4K video, and you cannot select or change a Filter Settings option during any movie recording.

Metering Mode

This menu option gives you access to the same three metering methods found on the Recording menu: Multiple, Center-weighted, and Spot. As with several other Motion Picture menu options, this one mirrors the same item on the Recording menu; if either one is changed, the corresponding entry on the other menu is changed to the same setting.

Highlight Shadow

This option, also, is identical to the corresponding one on the Recording menu.

Screen 2 of the Motion Picture menu is shown in Figure 8-4.

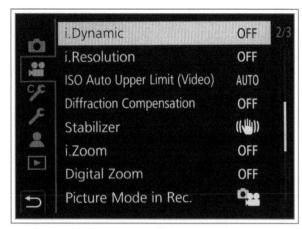

Figure 8-4. Screen 2 of Motion Picture Menu

Intelligent Dynamic

This setting works the same as the similar setting on the Recording menu and mirrors its setting.

Intelligent Resolution

This setting also works the same as its still-photo counterpart.

ISO Auto Upper Limit (Video)

This setting works in the same way as the ISO Auto Upper Limit (Photo), on screen 2 of the Recording menu, works for still photos. This option sets the upper limit for ISO when ISO is set to Auto ISO on the Motion Picture menu. This value can be set to Auto, 400, 800, 1600, 3200, or 6400. If it is set to Auto, the upper limit will be 3200.

Diffraction Compensation

This setting operates the same way as the option on the Recording menu.

Stabilizer

This option works the same as the corresponding option on the Recording menu, except that, when recording motion pictures, the camera cannot use the Panning option, which corrects only for vertical motion of the camera.

Intelligent Zoom

This setting is another one that is no different from the version on the Recording menu.

Digital Zoom

This is another setting that's the same as that on the Recording menu.

Picture Mode in Recording

When you are recording video footage with the LX100 II, you can press the shutter button during the recording to take a still picture, with certain limitations. This menu option controls the settings the camera uses for those still pictures. There are two options, as shown in Figure 8-5: Motion Picture Priority (top icon) and Still Picture Priority (bottom icon).

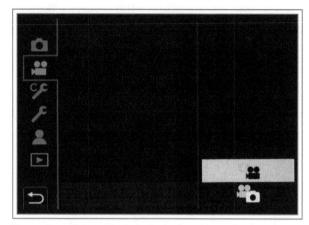

Figure 8-5. Picture Mode in Recording Menu Options Screen

If you choose the first option, the still pictures will be captured as JPEGs at the same size as the video format, no matter what menu settings are in effect for still image recording. This means that the still images will be in the 16:9 aspect ratio. They will be of Small size for HD and FHD video formats, and Medium size for 4K formats. With this setting, the camera can record up to 40 still images while recording the video, without disrupting the video recording. (The limit is 10 images when recording 4K video).

With the second option, the camera will take the still pictures using the settings made through the Recording menu for Picture Size and Quality for still images, but you can take only 10 images during the video recording (five with 4K video recording), and each time you do there will be a very brief interruption in the audio of the video recording. Also, the camera's display will black out briefly while the still image is being recorded.

Still photos cannot be captured during video recording when Recording Quality on the Motion Picture menu is set to 4K/100M/24p, or when 4K Photo is in effect, if Photo Priority is set using the Picture Mode in Recording option.

The items on screen 3 of the Motion Picture menu are shown in Figure 8-6.

Chapter 8: Motion Pictures | 151

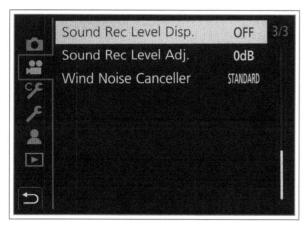

Figure 8-6. Screen 3 of Motion Picture Menu

Sound Recording Level Display

This is one of the few settings that apply only to video recording. If you turn it on, the camera puts two small graphic audio meters in the lower left corner of the display, as shown in Figure 8-7.

Figure 8-7. Sound Recording Level Display Meters

Those displays react to changes in the audio levels being recorded by the left and right sides of the stereo microphone built into the camera. You can use those meters to decide whether you need to adjust the audio recording level using the next menu option.

Sound Recording Level Adjustment

This option displays a pair of graphic audio meters in the middle of the screen, as shown in Figure 8-8, so you can test the audio input level and adjust it. (These meters are temporary, for the purpose of level adjustment, unlike the meters set by the previous menu option, which remain in place on the display screen during video recording.)

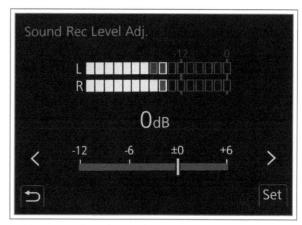

Figure 8-8. Sound Recording Level Adjustment Screen

With this display on the screen, aim the camera at your subject and adjust the audio level using the Left and Right buttons, the control dial, or the arrows on the touch screen. More of the empty blocks on the display will turn white as the volume of the test sound increases. There are only four levels of adjustment available, so there is not much leeway for increasing or decreasing the level.

Wind Noise Canceller

This last setting on the Motion Picture menu can be turned on or off. If it is turned on, the camera attempts to reduce the noise from wind while recording a video sequence. This processing may have an adverse effect on the quality of the audio, though. If you are recording casual scenes from a vacation, I would recommend turning this option on when recording in a windy area. If you will be using video-editing software, you may want to turn this setting off, because it can reduce some wanted sounds, and you can adjust the sound track later with your software to minimize the unwanted sounds.

USING EXTERNAL MICROPHONES

Although the Lumix LX100 II has excellent features for recording video, Panasonic did not include a jack for accepting an external microphone, which makes it challenging to record high-quality audio with this camera. The stereo microphone built into the LX100 II records good-quality sound, but, with the superior video quality available with this camera, you may want to record audio using higher-quality microphones.

Fortunately, it is not difficult to do this with the LX100 II, using current technology and software. The best solution I have found is to use a separate digital audio recorder and then synchronize the sound from the

recorder with the video from the camera. Here are the steps I took to use this system:

- Get a good digital recorder like the Zoom H1, the Zoom H6, the Shure VP83F, the Tascam DR-40, or the Tascam DR-100mkII, which is discussed in Appendix A.
- Make sure the camera is set to record audio at a reasonable level by setting the Sound Recording Level Adjustment option on screen 3 of the Motion Picture menu.
- Set the external recorder to record high-quality audio in a .wav file and place it, or one or more microphones connected to it, in a location to receive the sound clearly.
- 4. Start the audio recorder, then start the camera recording video and audio.
- 5. When the recording is done, load the video file and its attached sound track, along with the separate audio file from the external recorder, into a video-editing program such as Adobe Premiere Pro CC, Final Cut Pro, or others. You also can use Plural Eyes, a program from redgiant.com that synchronizes audio and video. The software will compare the waveforms from the camera's sound track and the external audio track to move them into sync. With Premiere Pro CC, which I use,

the procedure is to select the video track and the two audio tracks, right-click on them, and select Synchronize-Audio-Mix Down. The software will move the external audio track into sync with the video track.

Once the external audio track has been synchronized with the video track, you can delete the audio track recorded by the camera.

Of course, this system introduces more complexity and expense into your video-recording process. But, if you want the highest quality audio for your movies, it is worth exploring this method.

PHYSICAL CONTROLS

Next, I will discuss your options for using the camera's physical control buttons, switches and dials in connection with video recording. There are a lot of these controls, and the situation is complicated because each of the 10 function buttons can be assigned to any of about 40 options. Table 8-1 lists all of the physical controls and shows whether their settings will have an effect during video recording, as well as whether the control can be activated during video recording. For the function buttons, the second part of the table lists all of the possible assignments.

Table 8-1. Use of Phy	sical Controls of LX100 II	Camera Before and During Video	Recording
Control	Effective if Used Before Recording	Can Be Used During Recording	Remarks
Aperture Ring	Yes	Yes	
Shutter Speed Dial	Yes	Yes	
Control Dial	Yes	Yes	Adjust Shutter Speed
iA Button	Yes	No	
Exposure Comp. Dial	Yes	Yes	
Zoom Lever	Yes	Yes	
Control Ring	Yes	Yes	
ISO Button	Yes	Yes	ISO Range only up to 6400
WB Button	Yes	No	
Drive Mode Button	No	No	
Autofocus Mode Btn	Yes	Yes	Pinpoint AF not available
Display Button	Yes	Yes	
Aspect Ratio Switch	Yes	No	
Focus Switch	Yes	Yes	
Menu/Set Button	Yes	No	Cannot access menus
AF/AE Lock Button	Yes	Yes	AF-On works if Continuous AF is off

		Settings Assigned to Fu	nction Buttons
4K Photo	No	No	
Post Focus	No	No	
Exposure Compensation	Yes	Yes	Only 3 EV adjustment plus or minus
Wi-Fi	No	No	
Q. Menu	Yes	No	
Video Record	Yes	Yes	
LVF/Monitor Switch	Yes	Yes	
LVF/Monitor Disp. Style	Yes	Yes	
Preview	No	No	
AF/AE Lock	Yes	Yes	
AF-On	Yes	Yes	If Continuous AF is off
Touch AE	Yes	Yes	
Level Gauge	Yes	Yes	
Focus Area Set	Yes	Yes	
Operation Lock	Yes	Yes	
Photo Style	Yes	No	
Filter Effect	Yes	No	
Picture Size	No	No	
Quality	No	No	
AFS/AFF/AFC	Yes	Yes	
Metering Mode	Yes	No	
Bracket	No	No	
Highlight Shadow	Yes	No	
i.Dynamic	Yes	No	
i.Resolution	Yes	No	
Min. Shutter Speed	No	No	
HDR	No	No	
Shutter Type	Yes	No	
Flash Mode	No	No	
Flash Adjustment	No	No	
Wireless Flash Setup	No	No	
i.Zoom	Yes	No	
Digital Zoom	Yes	No	
Stabilizer	Yes	No	
Motion Picture Setting	Yes	No	
Picture Mode in Rec.	Yes	No	
Sound Rec. Level Adjust.	Yes	Yes	
Utilize Cust. Set Feature	Yes	No	
Silent Mode	Yes	No	
Peaking	Yes	Yes	
Histogram	Yes	Yes	
Guide Line	Yes	No	
Zebra Pattern	Yes	Yes	
Monochrome Live View	Yes	Yes	
		No	

Drive Mode	No	No	
AF Mode/AF	Yes	Yes	
White Balance	Yes	No	
ISO Sensitivity	Yes	Yes	Auto or 200-6400
Zoom Lever	No	No	
Recording Area	Yes	No	
Live View Boost	No	No	

As you can see from this table, there are many options for controlling the camera with physical controls before and during video recording, though there are some limitations. For example you can adjust ISO using the ISO button or other control assigned to that setting, but you can only set it to Auto ISO or a value from 200 through 6400 (and settings below 200 if Extended ISO is on), and you cannot use the Intelligent ISO feature.

You can switch focus mode between autofocus and manual focus, even during recording, and you can move the autofocus area around the display during recording. You also can turn on or off the zebra patterns, the histogram, or the peaking feature for manual focus. You can adjust exposure compensation during recording, but only up to 3 EV in either direction, as opposed to the 5 EV adjustments available for still images.

You can use the Filter Effect settings before recording to select a picture effect, but you cannot use a button assigned to that option during the recording. You cannot record a motion picture using the Rough Monochrome, Silky Monochrome, Soft Focus, Star Filter, or Sunshine effect. You cannot record a video at 4K quality using the Miniature setting. When you use the Miniature effect for a motion picture, the camera does not record sound, and the footage is recorded at about one-tenth the normal speed, resulting in playback that is speeded up ten times faster than normal to help simulate the appearance of a tabletop model layout.

Using the Touch Screen During Video Recording

The touch screen is available for use during motion picture recording, provided the appropriate options are turned on through the Touch Settings option on screen 4 of the Custom menu. If Touch Screen, Touch Tab, Touch AF, and Touch Pad AF are turned on, you can use all of those functions while the camera is recording

a motion picture. However, these actions are limited by the same restrictions set out above in Table 8-1. For example, although you can use the Touch Tab to get access to various settings, you cannot turn on or off a filter effect during motion picture recording, because that function cannot be controlled during recording.

You can, however, use the touch screen to adjust zoom, autoexposure, and function button actions, provided the functions in question are available for use. If AF mode is set to an option with a movable frame, such as 1-Area, you can use the Touch AF function to move the frame around the screen and resize it during a video recording. In addition, you can use the Touch Shutter function to take still pictures while recording a video, if Touch Shutter is activated from the Touch Tab. If the Monitor Information Display option is turned on through the Custom menu, you can touch that screen to control items such as exposure compensation and ISO.

SILENT OPERATION

Whenever the LX100 II is recording video, the camera gives you a special set of touch screen icons that you can use to control settings during the recording, to avoid using physical controls that might make sounds that are recorded with the video.

Figure 8-9. Touch Screen Icons During Video Recording

Figure 8-10. Silent Operation Icons Activated

To use this feature, once the recording has started, touch the movie camera icon at the top of the line of touch icons on the right side of the screen, as shown in Figure 8-9. The camera will open up a tab with a set of video-related icons, as shown in Figure 8-10.

Touch one of those icons to control the setting it represents. From the top, they stand for zoom, exposure compensation, and ISO. To control a setting, use the touch slider control that appears beneath the active tab.

If you want to change to another setting, touch the top icon to open up the line of control icons again, and touch another one. When you are finished using the Silent Operation controls, press the movie camera icon on the screen to close this panel of controls.

Recommendations for Recording Video

Now that I have covered the essentials of how to record video footage with the LX100 II, here are some recommendations for how to approach that process. For everyday use, such as for video clips of a vacation trip or a birthday party, it's probably a good idea to stick with the Intelligent Auto setting and, on the Motion Picture menu, set Recording Mode to MP4 and Recording Quality to FHD/20M/30p. The result should be excellent-quality video, well exposed, and ready to show on an HDTV or to edit in your favorite video-editing software.

If you aren't ready to deal with a whole host of manual settings, but would like to add some flashy coloring to your movie scenes, consider shooting in Program mode, and use the Filter Effect setting to select a picture effect such as Impressive Art. If you would like to produce

slow-motion footage, use a 60p setting for Recording Quality and slow the footage to one-half speed using your editing software.

The possibilities for creativity with the LX100 II's movie-making apparatus are, if not unlimited, at least sufficient to provide a framework for a great array of experimentation.

Motion Picture Playback and Editing

To play a motion picture in the camera, display the file you want and press the Up button to start playback, as indicated by the movie camera icon and up arrow, shown in Figure 8-11. (If the icons have disappeared, press the Display button to bring them back on the display.) The motion picture will start to play. The camera will briefly display a line of control icons at the bottom of the screen: Up button for playback/pause; Right button for fast forward (or frame advance when paused); Down button for stop; and Left button for fast reverse (or frame reverse when paused). Either during playback or when playback is paused, you can adjust the volume using the control dial.

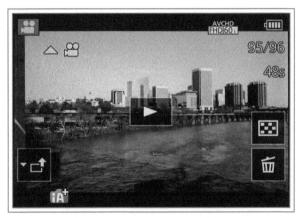

Figure 8-11. Movie Ready to Play in Camera

You cannot do much editing of a video in the camera, but you can trim its length or split it into two segments. To do that, follow the steps below.

- Find the movie you want to divide and display it in playback mode. (You can use the Playback Mode menu option on the Playback menu to find all videos.)
- 2. Press the Menu/Set button and select Video Divide from the Playback menu.

- 3. Press the Menu/Set button to start playing the video in the camera.
- 4. Press the Up button to pause the video at the approximate place where you want to divide it.
- 5. Use the Right and Left buttons to locate the splitting point more precisely.
- 6. When you are satisfied with the position, press the Down button to divide the video into two sections, as indicated by the scissors icon in the group of icons at the bottom of the display.
- 7. The camera will display a message asking you to confirm the operation. If you confirm it, the camera will divide the video into two parts. You will then have two separate video files; the original will no longer exist. You can delete either segment if you want, or keep them both.

You also can save a still image from a video file. To do that, follow the steps below.

- 1. Find the video that contains the image you want and start playing it in the camera.
- 2. At the approximate place where the image is located, press the Up button to pause the video.
- 3. Use the Right and Left buttons to find the location of the desired image.
- 4. Press the Menu/Set button, and the camera will display a message asking if you want to save this image, as shown in Figure 8-12.

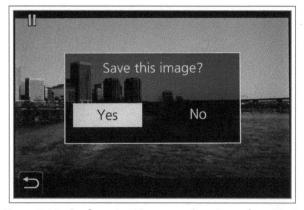

Figure 8-12. Confirmation Message to Save Frame from Movie

If you confirm the operation, the camera will save the image in Standard quality with an aspect ratio of 16:9. The image's size will be 8 MP if the video was recorded with 4K quality, or 2 MP for other quality settings.

EDITING WITH A COMPUTER

You can edit video files from the LX100 II camera using most standard editing software that has been updated to handle recent video formats. For example, I have found it easy to import all formats of video from the LX100 II into the iMovie software on my Macintosh. One way to do that is to copy the video files from your camera's memory card to your computer. The MP4 files are easy to find on the card; they are in the same folders as the still images. For example, an SD card I am using now has .rw2 (Raw), .jpg (JPEG), and .mp4 files in a folder whose path is LUMIX:DCIM:101_PANA.

The AVCHD video files are harder to locate. The actual video files that you can import into your editing software have the extension .mts. They are located in a folder with the path LUMIX:PRIVATE: AVCHD:BDMV:STREAM. On my Macintosh, you cannot see the contents of the AVCHD and BDMV folders directly; you have to right-click on those folder names in the Finder and select the menu command, Show Package Contents. Once you do that, you can find all of the .mts files and import them into iMovie or any other modern video editing software, which can edit them readily.

On a computer running Microsoft Windows version 10, I was able to find the .mts files just by using Windows Explorer with no special steps. I then imported them readily into the Windows Movies & TV app, where they played with no problems.

I also had no problems using the videos I recorded using the 4K quality setting. Because those files use the .mp4 format, they can be imported just like ordinary MP4 files. Of course, they contain a great deal more data than ordinary files, so they may play in a slow and choppy manner in some software, but they can be imported and edited on a Windows-based PC using the Movies & TV app, for example. Using Adobe Premiere Pro CC, I had no problem importing, playing and editing the 4K video files on my Macintosh.

CHAPTER 9: WI-FI AND OTHER TOPICS

he Panasonic LX100 II camera can connect wirelessly to a smartphone or tablet using Wi-Fi and Bluetooth. Once those connections are established, you can accomplish several tasks using the smart device, such as controlling the camera remotely, transferring images to the device from the camera, adding location information to images, and others. In the first part of this chapter, I will provide a general introduction to these features. In the later parts of the chapter, I will discuss some topics that were not covered earlier in the book, including macro photography and street photography.

Using Wi-Fi and Bluetooth Features

The first step in using the various features made possible by Wi-Fi and Bluetooth is to establish the Wi-Fi and Bluetooth connections between the LX100 II camera and your smartphone or tablet. There are various approaches to making those connections. I will list below a series of steps I used to make the connections between my LX100 II camera and my iPhone SE, to illustrate one way that works.

- 1. Download the Panasonic Image App from the App Store for Apple devices or the Google Play Store for Android devices. The icon for the app is shown in Figure 9-1.
- 2. On screen 1 of the camera's Setup menu, select Wi-Fi. Press the Right button or the Menu/Set button to go to the next screen and select Wi-Fi Setup. Under that option, go to the Wi-Fi Password option and make sure it is set to Off.
- 3. On screen 1 of the camera's Setup menu, select Bluetooth. Press the Right button or the Menu/ Set button to go to the next screen and highlight another item also called Bluetooth, and choose Set. The camera will display a screen with the

Pairing option highlighted. Select that option, and the camera will display a screen like that shown in Figure 9-2, displaying the Bluetooth ID of the camera and telling you to select that ID by pressing the Bluetooth button in the Panasonic Image App.

Figure 9-1. Panasonic Image App Icon on iPhone Screen

- 4. Open the Image App on the phone and press the Bluetooth button, seen at the upper left of the phone's screen in Figure 9-3. The phone should then display a screen saying the camera has been registered as a Bluetooth device with the Image App.
- 5. You should see a screen on the phone like that in Figure 9-4, with the heading Camera Enable to Be Registered in the lower part of the display, with the network ID of the camera listed below. In this illustration, the ID is LX100M2-244F52. Tap that network ID to select it, and you should see a screen like that in Figure 9-5, advising you to go to the Settings/Wi-Fi screen on the phone to complete the setup.

Figure 9-2. Camera Screen for Connecting to Bluetooth

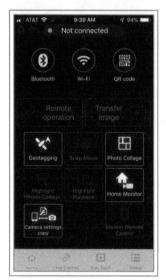

Figure 9-3. Bluetooth Button on Image App Screen

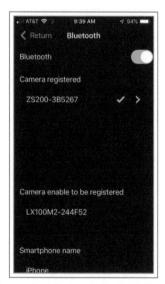

Figure 9-4. Image App Screen to Register Camera with App

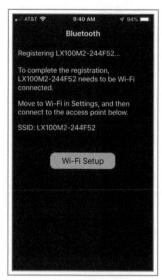

Figure 9-5. Image App Screen Advising Going to Settings

6. On the phone's Settings/Wi-Fi screen, select the network ID of the camera to complete the connection of the camera to the phone. That screen should then look like Figure 9-6, with that ID selected by a blue check mark.

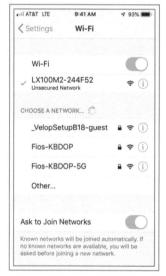

Figure 9-6. Camera's Network ID Selected on iPhone

7. Return to the Image App on the phone to carry out the activities that will now be available, as discussed below in this chapter. You should see a screen on the phone saying Registration is Complete, and then the home screen of the Image App, as shown in Figure 9-7.

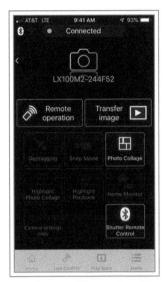

Figure 9-7. Home Screen of Image App After Connection

CONTROLLING THE CAMERA WITH A SMARTPHONE OR TABLET

Once you have established a connection between the camera and the phone using the steps above, you are ready to control the camera using the Image App. Select the Remote Operation icon at the upper left of the phone's screen, as shown in Figure 9-7, and you will see a display on the phone like that in Figure 9-8.

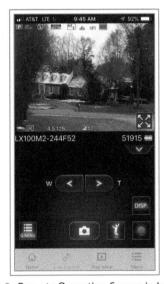

Figure 9-8. Remote Operation Screen in Image App

You can touch the icons on this screen to zoom the lens in and out; change the mix of icons on the display with the DISP. icon; and get access to various settings, including Photo Style, Filter Settings, Picture Size, Quality, Metering Mode, Stop Motion Animation, Bracket, and others by pressing the Q. Menu icon, as shown in Figure 9-9.

Figure 9-9. Quick Menu Settings for Remote Operation

To take a picture, press the camera icon at the center bottom. To record a video, press the red button in the lower right corner. If you press the down-pointing arrow below the battery status icon, as seen in Figure 9-8, you will get access to additional settings, as shown in Figure 9-10.

Figure 9-10. Additional Settings for Remote Operation

The touch focus icon causes the camera to focus where you touch the screen; the touch exposure icon does the same for exposure. The drive mode icon lets you select burst shooting, 4K Photo, Post Focus, or the self-timer, and the focus mode icon lets you choose Face/Eye Detection, Tracking, 49-Area, 1-Area, and other options. The WB and ISO icons let you adjust those settings.

The ability to use the other icons in this part of the screen depends on the setting of the Priority of Remote Device option, on the Setup menu under Wi-Fi—Wi-

Fi Setup. If that option is set to Camera, the ability to change settings with the Image App is limited. To change the recording mode, you have to move the aperture ring and/or shutter speed dial on the camera, and press the iA button for Intelligent Auto mode. The icons for adjusting aperture, shutter speed, and Program Shift will be dimmed and unavailable; to change those settings, you have to use the controls on the camera.

When the Camera setting is in effect, you can adjust exposure compensation using the Image App, but only if exposure compensation has been assigned to a function button or the control ring; otherwise, the exposure compensation dial on the camera must be used for that adjustment.

However, if Priority of Remote Device is set to Smartphone, you can change the shooting mode, adjust the aperture, shutter speed, and Program Shift (depending on the shooting mode), and adjust exposure compensation from the Image App, even if the exposure compensation dial is active.

You can touch the block with four arrows pointing in different directions, at the lower right corner of the live view area, to rotate the view to fill the screen, moving the controls to the edges of the screen, as shown in Figure 9-11.

Figure 9-11. Remote Operation Live View Rotated

You also can use a feature called Jump Snap, represented by the icon at the bottom of the app's screen that looks like a jumping person, as seen to the left of the red video recording icon in Figures 9-8 and 9-10. If you select that icon, you will see the screen in Figure 9-12, with settings for this option.

You can leave it turned off or set the sensitivity to low or high. If it is turned on, you use it by aiming the camera at a person who is holding the phone while the app is active. The camera will sense when the person jumps, and will snap a still picture at the highest point of the jump. The result should be an image like that in Figure 9-13, showing the subject in a candid but awkward position.

Figure 9-12. Jump Snap Settings Screen in Image App

Figure 9-13. Jump Snap Example

SENDING IMAGES AND VIDEOS TO A SMARTPHONE OR TABLET

Once the LX100 II is connected to your smartphone or tablet, instead of controlling the camera from your device, you can choose the option at the upper right of the home screen of the Panasonic Image App, Transfer Image. When you select that icon, the phone will display a screen with choices of Transfer Selection or Batch Transfer, as shown in Figure 9-14.

Figure 9-14. Transfer Image Screen in Image App

If you choose Transfer Selection, the phone app will display a screen like that in Figure 9-15, with thumbnail images for the images and videos on the camera's memory card.

Figure 9-15. Transfer Selection Screen in Image App

You can scroll through these images by flicking up and down the screen. It may take quite a while for all of the images and videos to load.

The thumbnails with a movie camera icon in the lower left corner represent motion picture files. Other thumbnails may have an icon showing a camera and a phone with a line through the circle around them, as seen in Figure 9-15. That icon means that item cannot be transferred to the phone because it is an AVCHD or 4K video, or a 4K Photo or Post Focus burst. (Raw

images can be sent only to phones with fairly recent operating systems.)

If you want to transfer one of the images or videos to your phone, first, tap on it to enlarge it on the display, as shown in Figure 9-16. If it is a video that can be played on the phone, you can press the Play icon on the phone's display to play it.

Figure 9-16. Image Enlarged for Transfer in Image App

If you select the icon at the lower left, showing an arrow going to a phone, the phone will display a message saying it is copying the file. You will then have a copy of that image or video in the standard area for photos or videos on the phone.

Figure 9-17. Images Marked for Transfer in Image App

On the main playback screen in the Image App, you can tap the camera icon in the upper left corner to

switch between viewing the images and videos from the camera or those stored on the phone or tablet. Also on that screen, if you press the Select icon in the upper right corner, you can mark images and videos with green check marks by tapping them, as shown in Figure 9-17; once you have selected them, you can select the download icon (arrow going to phone) at the bottom of the screen to download them to the phone or tablet.

From any screen that displays the sharing icon (two arrows going up out of a circle, as seen in Figure 9-18), you can tap that icon to bring up a menu that will let you upload an image or a group of selected images or videos to a social media site, including Facebook, Twitter, and others, as shown in Figure 9-18. However, it appears that this option is, as of this writing, available only with an Android device, which is what I used for Figure 9-18.

Figure 9-18. List of Sites for Transferring Images To from App

You also can tap on the star icon at the bottom of the screen for an individual image to bring up a screen that lets you assign a rating of from one to five stars to the image, as shown in Figure 9-19. That rating will be available in software such as Adobe Bridge and Silkypix.

Figure 9-19. Rating Screen in Image App

Adding Location Data to Images

Using the wireless capabilities of the camera, you can add location information to images taken by the LX100 II, using GPS data transmitted to the camera from a connected smartphone. To carry out this function, follow the steps below.

- 1. Connect the camera to the phone using the steps set forth earlier in this chapter, or, if you have previously established a connection, go to the Bluetooth menu option on the camera, select Bluetooth, and turn it on. Make sure Auto Transfer is turned off on the camera's Bluetooth options screen. Then start the Image App on the phone, making sure Bluetooth is active on the phone.
- 2. On the camera, go to the Setup menu, select Bluetooth, then Location Logging, and turn it on, as shown in Figure 9-20. The letters GPS should appear, along with a Bluetooth symbol, in the upper right corner of the camera's recording screen, as shown in Figure 9-21. (If a Wi-Fi connection is still active also, a Wi-Fi symbol will appear instead of a Bluetooth symbol.)
- 3. Take pictures or record MP4 videos with the camera, and location information will be recorded in the metadata. That data can be read by many programs, such as Adobe Bridge, as seen in Figure 9-22. (Location information will not be recorded for AVCHD videos.) The GPS label will appear near the top center of the image when it is played back in the camera with a detailed playback screen.

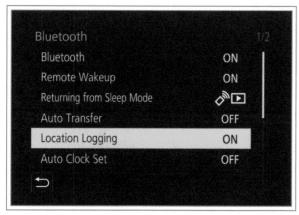

Figure 9-20. Location Logging Selected on Bluetooth Menu

Figure 9-21. GPS Label on Recording Screen of Camera

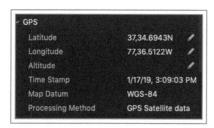

Figure 9-22. Location Data for Image Viewed in Adobe Bridge

PHOTO COLLAGE

On the home screen of the Image App, when a Wi-Fi connection to the camera is active, you also can select Photo Collage. (Some other options, such as Snap Movie and Home Monitor, will be dimmed, because they are not available with this camera model.)

The Photo Collage function lets you choose several images to be combined on the phone or tablet in a collage within a frame. You can choose the shape of the frame and then select images from the phone's display to be arranged within that frame. Figure 9-23 is an example of the result of this operation.

Figure 9-23. Photo Collage Example

If you select Menu, the final icon at the lower right of the Image App's main screen, you will see the screen shown in Figure 9-24, with options for setting the connection destination, Live Control settings, and other items. With the Playback Settings option, you can set the size for images copied from the camera or uploaded to websites.

Figure 9-24. Options List from Image App Menu Screen

TURNING THE CAMERA ON OR OFF USING BLUETOOTH

With the Bluetooth features of the LX100 II camera and the Image App, you can turn the camera on or power it off using the app, without having to operate the camera's power switch. To do this, follow the steps below.

- Establish a Bluetooth connection between the phone and the camera, using the steps described earlier.
- 2. On screen 1 of the camera's Setup menu, go to Bluetooth, select Remote Wakeup, and turn it on.

- 3. Turn the camera's on/off switch to the Off position.
- 4. Open the Image App on the phone. On the home screen of the app, select Remote Operation. The app and the camera will both display messages reporting the status of the Bluetooth connection. The phone may prompt you to go to the Settings/Wi-Fi screen to connect to the camera's Wi-Fi network. Once that connection is made, you can use the Image App to control the camera or transfer images, as discussed earlier.
- To turn the camera off, tap the Off icon in the upper right corner of the Image App's home screen, as shown in Figure 9-25.

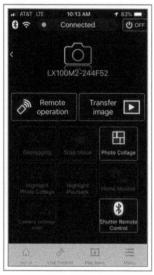

Figure 9-25. Off Icon on Image App's Home Screen

CONTROLLING THE CAMERA'S SHUTTER BUTTON USING A BLUETOOTH CONNECTION ONLY

When the camera is connected to the smartphone with the Bluetooth connection only, you can select the Shutter Remote Control icon in the lower right corner of the Image App screen, as shown in Figure 9-25. In order to initiate that connection once it has been set up previously, all you have to do is open the Image App and tap on the Bluetooth icon, with the camera turned on. The Shutter Remote Control icon should then become active and available for selection.

With this feature, the Image App does not display the live view seen by the camera; it displays only a remote control screen, as seen in Figure 9-26. The camera's on/off switch must be in the On position for this feature to

work. You can use the large button with the camera icon to take still images and the red movie button to start and stop video recordings. You can slide the camera icon button downward to lock it for burst shooting or time exposures.

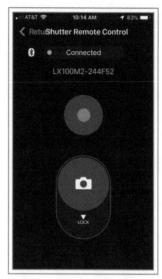

Figure 9-26. Bluetooth Remote Control Screen in Image App

As I discussed in Chapter 3 in connection with Manual exposure mode, using the Bluetooth remote control option is the only way to be able to use a Bulb setting for shutter speed. To do this, in Manual exposure mode, set up this sort of remote control connection and set the shutter speed to T using the shutter speed dial. Then, using the connected smartphone or tablet, press and hold the camera icon on the remote control screen. The shutter will stay open while the icon is pressed; the shutter will close when you release the icon. Or, you can slide the camera icon to the locked position, and the shutter will stay open until you move the icon back to the unlocked position. You can capture exposures lasting up to about 30 minutes with this technique.

UPLOADING IMAGES BY WI-FI TO SOCIAL NETWORKS

As I mentioned briefly in the previous section, when an Android smartphone or tablet is connected to the LX100 II camera over a Wi-Fi network, you can tap on the sharing icon to upload an image directly from the phone or tablet to a social network such as Facebook. You also can upload images in this way directly from the camera. There are some preliminary steps you have to take to make these uploads. Following are the basic steps to get this done.

- On the camera, go to screen 1 of the Setup menu, choose Wi-Fi, then, on the next screen, Wi-Fi Setup, then Lumix Club, then Set/Add Account, then New Account.
- 2. If you have not previously set up an account, the camera will prompt you to connect to a Wi-Fi network using WPS Push or by entering the network ID and password. If you can use WPS push, do so; you just need to select WPS Push on the camera, then press the WPS button on the Wi-Fi router within two minutes, and the connection will be established.
- 3. The camera will ask you to agree to the terms for the Lumix Club account and will display a login ID assigned to your camera, consisting of 12 numerical digits. The camera also will display a screen where you create and enter a password for the account. It must have from 8 to 16 characters and contain both letters and numbers.
- 4. Once the camera has accepted the login ID and password, use a computer or other device to go to the following web address: http://lumixclub.panasonic.net/eng/c/, and log in using the 12-digit user ID and password from Step 3. You will then be prompted to enter your e-mail address and a security question, so you can reset your password later if necessary.
- 5. After you have logged in at the Lumix Club website, you will receive an e-mail message from Panasonic to confirm the registration. After you confirm it, you will be able to log in to the page where you can link your Lumix Club account to any or all of the following social networks (as of this writing): Facebook, Twitter, YouTube, Picasa, Flickr, Ustream, and VKontakte. You also can link your account to Google Drive for storage of images in the cloud.
- 6. Once you have linked your Lumix Club account to one or more social networks, you can upload to those networks at any time. To do that on the camera, from playback mode, press the Down button and the camera will ask if you want to upload the current image by Wi-Fi. If you say yes, the camera will establish a Wi-Fi connection if possible, or prompt you to establish one. It will then display a screen like that in Figure 9-27, where

you can highlight the service to send the image to. (This image is from another Panasonic camera; I could not this function to work with my LX100 II.)

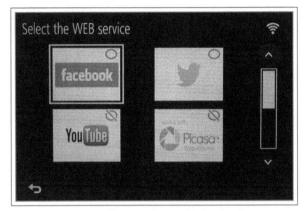

Figure 9-27. Screen Showing Sites to Upload to from Camera

- 7. Select the icon you want and press Menu/Set; the camera will display a screen with the estimated time to upload the image, which may be anywhere from about 20 seconds to two minutes or more, depending on the image. The image will then appear on the appropriate web page for Facebook or another service.
- 8. You also can upload an image from your Android smartphone or tablet when you see the sharing icon, as shown earlier in Figure 9-18.

CONNECTING TO A COMPUTER TO TRANSFER IMAGES WIRELESSLY

The LX100 II camera also comes with the ability to transmit images wirelessly from the camera to a computer on the local network. The preferred approach is to use Panasonic's PHOTOfunSTUDIO software on a Windows-based PC, though Panasonic says there is a way to transfer files to a Macintosh also. Following are the steps that should work, though I have had difficulty trying this with several computers.

- Install and run the PHOTOfunSTUDIO software on a Windows PC, as discussed in Chapter 1. (The program is not compatible with Macintosh.) Make sure the PC is connected to your local network via Wi-Fi.
- 2. The program should prompt you to create a folder for receiving images from the camera. If it does not, go to Tools-Settings-General-Registration Folder and create the folder, using the Auto-create option, or create it manually. When I used Auto-create,

the program created the folder C:\Users\Public\ Pictures\LumixShare.

- 3. On the LX100 II, go to screen 1 of the Setup Menu, choose Wi-Fi, then Wi-Fi Function, then New Connection, then Send Images While Recording.
- 4. Follow the prompts on the camera's display to select the network, then the PC on the network. If prompted for a user name and password, enter the user name and password for logging onto the PC you are sending images to. Then select the folder, such as LumixShare, and follow the prompts.
- When you take pictures with the camera, the new images will soon appear in the LumixShare folder, or other folder you have designated.
- 6. If you want to transfer existing images or videos from the camera to the PC instead of new ones as they are taken, in Step 3 select that option from the menu. Then, when you establish the connection, the camera will give the option of sending a single image or selecting multiple images to send. Make your choice, and the camera will start sending one or more images to the designated folder on the PC.
- 7. Once you have established a connection as described above, you can choose Select a Destination from History, and go immediately to one of the connections listed by the camera. Each previous destination has an icon and a name to indicate whether that connection is for sending images to a PC or for connecting to a phone or other device. Select a destination to a PC, and the camera will be set up for the transfer of new or old images and videos.

SENDING IMAGES TO OTHER DEVICES

You also can send images directly from the camera to other devices using the Wi-Fi menu. To do this, go to screen 1 of the Setup menu, select Wi-Fi, then Wi-Fi Function, then New Connection, then Send Images Stored in the Camera. On the next screen, you can select from Smartphone, PC, Cloud Sync. Service, Web Service, AV Device, or Printer. Follow the prompts in the menu system to connect to the device you select. You also can send images from the camera to other devices while recording, though not to a printer. To do that, choose Send Images While Recording instead of Send Images Stored in the Camera.

VIEWING IMAGES WIRELESSLY ON TV

Another option for using the Wi-Fi features of the LX100 II is to view your still images on a TV set that is compatible with the DLNA standard for sharing media files. (DLNA stands for Digital Living Network Alliance; see dlna.org for more information.) I will describe the setup I used to get my LX100 II to display images wirelessly on a TV set. This sort of setup can be complicated, and you have to use devices that work together with your network. I don't recommend trying this option unless you have some experience using a DLNA server or don't mind digging into technical details with media devices and computers.

In my case, I used a device called WD TV Live, made by Western Digital, and connected it by HDMI cable to an HDTV. On the camera, I went to screen 1 of the Setup menu, to Wi-Fi, then Wi-Fi Function, then New Connection, then Playback on TV, then Via Network. I connected the camera to the network using WPS Push, and the camera found the WD TV Live device.

I pressed the Menu/Set button, and I could then play back images stored on the camera's memory card, and they appeared on the TV screen. This function did not work consistently or reliably for me, but it did work, and possibly would work better with further tweaks.

Other Menu Options for Wi-Fi and Bluetooth

The LX100 II does not have a separate menu for Wi-Fi and Bluetooth options; those menu items are on the Setup menu, which was discussed in Chapter 7. However, in that chapter I did not discuss three menu items that are used only for wireless connections to the camera, so I will discuss them here. These three items are on screen 1 and screen 2 of the Setup menu. The first of those screens is shown in Figure 9-28.

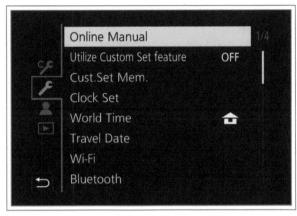

Figure 9-28. Screen 1 of Setup Menu

WI-FI FUNCTION

The Wi-Fi menu option has two sub-options, Wi-Fi Function and Wi-Fi Setup. If you select Wi-Fi Function, you will see the screen shown in Figure 9-29, with choices of New Connection, Select a Destination from History, and Select a Destination from Favorite.

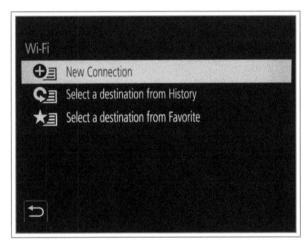

Figure 9-29. Wi-Fi Function Menu Options Screen

If you select New Connection, you will see the screen shown in Figure 9-30, with choices of Remote Shooting & View, Playback on TV, Send Images While Recording, and Send Images Stored in the Camera. I have discussed those options in the earlier parts of this chapter.

WI-FI SETUP

If you return to the Wi-Fi menu item and select Wi-Fi Setup, you will see the screen shown in Figure 9-31, which is the first of two screens of options, discussed below.

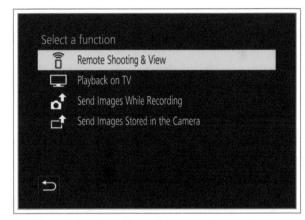

Figure 9-30. New Connection Menu Options Screen

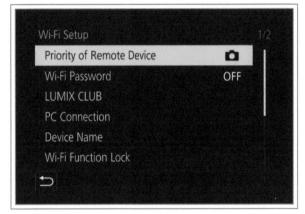

Figure 9-31. Wi-Fi Setup Menu Options Screen

Priority of Remote Device

With this option, you can give priority to either the camera or the remote device (smartphone or tablet) when they are connected wirelessly. If you select Camera, you will be able to control some settings using the camera's controls, such as the aperture ring and shutter speed dial, and you will not be able to control those settings using the smartphone. If you select Smartphone, you will be able to use only the smartphone to change settings; the camera's controls will not function for that purpose.

If you want to retain the ability to change settings using the camera's controls, choose Camera; if you want to make sure the camera's settings are not changed by accident or you will not have easy access to the camera during remote shooting, choose Smartphone.

Wi-Fi Password

This item can be turned either on or off. If it is turned on, you will need to enter a password to establish a Wi-Fi connection between the camera and a smartphone. You also can scan a QR code on the camera's display, instead of entering the password. I generally leave this option turned off in order to make it easier to connect the camera to my phone, but you might want to use a password for added security in some situations.

Lumix Club

I discussed this option earlier in this chapter. You can use it to set up an account with Lumix Club, which is required if you want to upload images to social media sites from the camera or smartphone.

PC Connection

This option is used to set the name of the workgroup for a computer you are sending images to over a Wi-Fi network. The default name is WORKGROUP, but you can change it with this option, using the text-entry screen that is provided.

Device Name

You can use this option to change the SSID (network ID) of the camera, which is used to set up a Wi-Fi connection between the camera and a smartphone or tablet.

Wi-Fi Function Lock

This option lets you enter a four-digit number as a password for access to the camera's Wi-Fi functions. The password can be reset using the Reset Network Settings option on screen 4 of the Setup menu, so it does not provide much protection, and I have not used it.

Network Address

This first item on the second screen of the Wi-Fi Setup options displays the MAC address and IP address of the camera. You may need to see this information in order to diagnose problems connecting the camera to a smart device or computer wirelessly.

Approved Regulations

This option displays data showing the approval of the camera by national regulatory authorities.

BLUETOOTH

The Bluetooth menu option includes two screens of sub-options. The first screen of those items is shown in Figure 9-32.

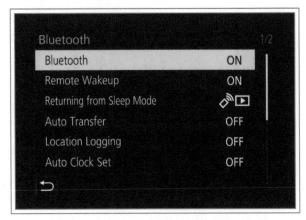

Figure 9-32. First Screen of Bluetooth Menu Options

Bluetooth

The first item on this menu, also called Bluetooth, is used to turn on or off the Bluetooth functions of the camera. When it is turned on, you can choose the Set option to pair the camera with a smartphone or tablet, as discussed earlier in this chapter. If this Bluetooth item is set to Off, then the rest of the items below it on the Bluetooth menu are dimmed and unavailable for selection. When it is turned on and the camera is paired with a smart device, the other items, discussed below, are available for use.

Remote Wakeup

The second item, Remote Wakeup, can be turned either on or off. If it is turned on, the camera can be activated remotely from a paired smartphone, when the camera's power is turned off. I discussed this option earlier in this chapter, under the heading Turning the Camera On or Off Using Bluetooth.

Returning from Sleep Mode

The third item, Returning from Sleep Mode, is available for selection only when the Remote Wakeup item, discussed above, is turned on. In that case, you can select from the two options shown in Figure 9-33.

The top icon represents Remote/Transfer Priority. If you select that option, then, when you use Remote Wakeup to activate the camera, the camera will quickly be ready to use the Remote Operation and Transfer Image options. The bottom icon represents Shutter Remote Priority. If you select that option, then, upon remote wakeup, the camera will quickly be ready to use the Shutter Remote Control option.

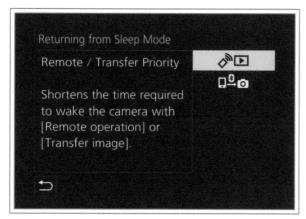

Figure 9-33. Returning from Sleep Mode Menu Options Screen

Auto Transfer

The next item, Auto Transfer, can be turned either on or off. When it is turned on, the camera can be set to automatically send new images to a connected smartphone or tablet by Bluetooth. To use this feature, set the option to On, and the app will display the message shown in Figure 9-34, advising you to go to Wi-Fi settings on the phone and connect to the camera's Wi-Fi network. (If you are using an Android smartphone or tablet, the message will be slightly different; you should select Yes to proceed.)

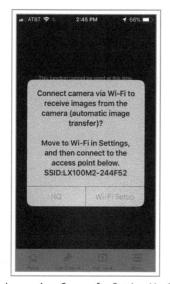

Figure 9-34. Image App Screen for Setting Up Auto Transfer

Once the Auto Transfer system has been set up, any new still pictures you take with the camera will automatically be copied to the normal area for photos on the phone or tablet. (This system will not transfer movies, 4K Photo images, or Post Focus images.)

Once the connection has been established, you can press the Display button to change the settings for the transfer process. You will see a screen like that in Figure 9-35, where you can select the size and file format of transferred images.

When Auto Transfer is turned on, the Wi-Fi Function options are not available, so be sure to turn off Auto Transfer when it is not needed.

Figure 9-35. Auto Transfer Settings Screen in Camera

Location Logging

The next item, Location Logging, lets you set up the Image App to record location data that can be transferred to images taken with the camera. I discussed the procedure for this operation earlier in this chapter.

Auto Clock Set

The Auto Clock Set option lets you synchronize the time that is set for the camera using the Setup menu with the time on a connected smartphone or tablet. Once a Bluetooth connection between the camera and smart device is active, select this menu option and turn it on to synchronize the time settings.

Wi-Fi Network Settings

The final setting for the Bluetooth menu option, Wi-Fi Network Settings, is on the second screen of sub-options. It is available for selection when no Wi-Fi connection is active. You can use this menu option to register additional wireless access points for connecting to the camera. You can register up to 17 such devices. This option accomplishes the same thing as the New Connection option under the Wi-Fi Function item, which is found under Wi-Fi on the Setup menu.

WIRELESS CONNECTION LAMP

This third and final wireless-related item, which appears on screen 2 of the Setup menu, has the simple purpose of controlling whether or not the lamp on the back of the camera, located between the Fn5 and Fn4 buttons, lights up blue when a Wi-Fi or Bluetooth connection is active. If you find that light distracting, turn this menu option off.

Macro (Closeup) Shooting

Macro photography is the practice of taking photographs when the subject is shown at actual size (1:1 ratio between size of subject and size of image) or slightly magnified (greater than 1:1 ratio). So if you photograph a flower using macro techniques, the image of the flower on the camera's sensor will be about the same size as the actual flower. You can get wonderful detail in images using macro photography. For example, I used the LX100 II to take a photograph of a flower. The result, shown in Figure 9-36, provides a detailed view of the subject. The blurred background reduces distractions.

Figure 9-36. Macro Example

The LX100 II, like many modern cameras, has a special capability for shooting in macro mode. To use this mode, you have only one basic setting to change: Move the focus switch on the left side of the lens barrel to its middle position, for Autofocus macro, with the flower icon, indicating macro, as shown in Figure 9-37.

With the focus switch in the AF macro position, the camera can focus as close as 1.2 inch (3 cm) from the subject, when the zoom lever is pushed all the way to the wide-angle setting. With the lens zoomed in for its full optical zoom, the camera can focus as close as about 1 foot (30 cm) in AF macro mode. If the camera is not

set to AF macro mode, then the closest focusing point is about 1.6 foot (50 cm) at either end of the zoom range.

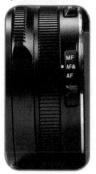

Figure 9-37. Focus Switch at AF Macro Position

You don't have to use the macro setting to take macro shots; if you use manual focus by moving the focus switch to its lowest position (MF), you can also focus on objects very close to the lens. You do, however, lose the benefit of automatic focus, and it can be tricky finding the correct focus manually.

When using the AF macro setting, you should use a tripod, because the depth of field is very shallow at close distances and you need to keep the camera steady to take a usable photograph. It's also a good idea to use the self-timer. If you do so, you will not be touching the camera when the shutter is activated, so the chance of camera shake is minimized. If you want to use flash, you could consider using a special unit designed for close-up photography, such as a ring flash that is designed to provide even lighting surrounding the lens. You also could use the supplied flash unit or another compatible flash, and just use a small piece of translucent plastic or a light-colored cloth to diffuse the flash.

One question you may have is: If the camera can focus down to 3 centimeters and out to infinity in AF macro mode, why not just leave it set in AF macro mode? The answer is that in AF macro mode, the focusing system is set to favor short distances, and it is not as responsive in focusing on farther objects. So in AF macro mode you may notice that it takes more time than usual to focus on subjects at greater distances. If you don't need the fastest possible focusing, you can just leave the camera set to AF macro at all times, if you want the whole range of focusing distances to be available.

Infrared Photography

Infrared photography involves recording images illuminated by infrared light, which is invisible to

the human eye. The resulting photographs can be spectacular, producing scenes in which green foliage appears white and blue skies appear eerily dark.

To take infrared photographs, you need a camera that can "see" infrared light. Many modern cameras include internal filters that block infrared light. However, some cameras do not, or block it only partially. (You can do a quick test of any digital camera by aiming it at the lightemitting end of an infrared remote control and taking a photograph while pressing a button on the remote; if the remote's light shows up as bright white, the camera can "see" infrared light at least to some extent.)

The LX100 II is quite capable of taking infrared photographs. To use this capability, you need to get a filter that blocks most visible light but lets infrared light reach the camera's light sensor. (If you don't, the infrared light will be overwhelmed by the visible light, and you'll get an ordinary picture based on visible light.)

The infrared filter I use is the Hoya R72. You need to find one with a 43mm diameter, because that is the diameter of the area threaded for filters on the lens of the LX100 II. When you attach the very dark red R72 filter to the LX100 II, a great deal of visible light from the scene is blocked. I have found that this reduction in light causes some problems for the camera's ability to set automatic exposure and white balance. With experimentation, though, you can get an interesting result.

Figure 9-38. Infrared Example

For the image in Figure 9-38, I aimed the camera at green trees in bright sunlight to set a custom white balance that would yield the characteristic white appearance of green grass and leaves.

For exposure, I used Manual exposure mode and adjusted the shutter speed and aperture until I could see the image clearly in the viewfinder. I ended up with an exposure for eight seconds at f/4.5, with ISO set to 200.

This sort of infrared photography often is most successful in the spring or summer when there is a rich variety of green subjects available outdoors.

Digiscoping and Astrophotography

Astrophotography involves photographing sky objects with a camera connected to (or aiming through) a telescope. Digiscoping is the practice of using a digital camera with a spotting scope to get shots of distant subjects such as birds and other wildlife.

There are many types of scope and several ways to align a scope with the LX100 II's lens. I will not describe all of the methods; I will discuss the approach I have used and hope it gives you enough information to explore the area further.

I used a Meade ETX-90/AT telescope with the LX100 II connected to its eyepiece. To make that connection, you need adapter rings that let you connect the camera's lens to the telescope's eyepiece. You can get the proper adapter rings for the LX100 II by purchasing the 43mm Digi-Kit, part number DKSR43T, from the online site telescopeadapters.com. I used that setup to take the picture of the moon shown in Figure 9-39.

Figure 9-39. Moon Example

For this image, I set the camera to Manual exposure mode with settings of f/5.6 at 1/500 second, with ISO set to 200. I used a fast shutter speed because the magnification from the telescope made the image very jiggly. I used manual focus, and adjusted the telescope's focus control until the image appeared sharp on the camera's LCD. I used the MF Assist option, so I could fine-tune the focus with an enlarged view of the moon's craters, with Peaking turned on also. When focus was sharp, I saw bright blue pixels around the edges of craters, which made focusing easier than relying on the normal manual focus mechanism, even with MF Assist activated. I also turned on focus bracketing so I could have a variety of focus results to choose from.

I set the self-timer to two seconds to minimize camera shake. I set Quality to Raw & JPEG so I would have a Raw image to give extra latitude in case the exposure seemed incorrect. As you can see in Figure 9-39, the LX100 II did a good job of capturing the nearly-full moon. Because of the large sensor and relatively high resolution of the LX100 II, this image can be enlarged to a fair degree without deteriorating.

You can use a similar setup for digiscoping. I attached the LX100 II to a Celestron Regal 80F-ED spotting scope, using the same eyepiece I used with the telescope.

Figure 9-40. Digiscoping Example

Figure 9-40 is a shot of a bird at a backyard feeder, taken with the LX100 II through this scope. I used Program mode with an exposure of 1/250 second at f/2.8, with ISO set to 5000. I turned on continuous shooting to catch various views of the bird.

Street Photography

One of the reasons many users prize the LX100 II is because it is well suited for street photography—that is, for shooting candid pictures in public settings, often surreptitiously. The camera has several features that make it well-suited for this type of work-it is lightweight and unobtrusive in appearance, so it can easily be held casually or hidden in the photographer's hands. Its 24mm equivalent wide-angle lens is excellent for taking in a broad field of view, for times when you shoot from the hip without framing the image carefully on the screen. Its f/1.7 lens lets in plenty of light, and it performs well at high ISO settings, so you can use a relatively fast shutter speed to avoid motion blur. You can make the camera completely silent by turning off the beeps and shutter sounds, and by using the electronic shutter.

Here are some suggested settings you can start with and modify as you see fit. To get the gritty "street" look, set Photo Style to Monochrome, but dial in -2 Noise Reduction and -1 Sharpening. Use Raw plus Fine JPEG to give you a good image straight out of the camera, but preserving your post-processing options. Set aspect ratio to 4:3. Set ISO to 800 for good image quality while boosting sensitivity enough to stop action with a fast shutter speed. Turn on burst mode at the High setting so you'll get several images to choose from for each shutter press.

When you're ready to start shooting, go into manual focus mode and set the focus to approximately the distance you expect to shoot at, such as 6 feet (2 meters) on the MF scale. On screen 1 of the Custom menu, go to the AF/AE Lock item and set it to AF-On. Then, when you're ready to snap a picture, use the AF/AE Lock button to make a quick fine-tuning of the focus. For exposure, set the camera to Aperture Priority mode, with the aperture set to about f/4.5. When shooting at night, you may want to open the aperture a bit wider, and possibly boost the ISO to 1600. You will probably want to leave the lens zoomed back to its full wide-angle position, both to increase the depth of field and to take in a wide angle of view.

In Figure 9-41, I took a different approach, using Intelligent Auto mode with burst shooting turned on, to grab a variety of quick shots of people walking across a pedestrian bridge over the river.

Figure 9-41. Street Photography Example

Portraits

The LX100 II does not have a dedicated mode for shooting portraits, or a set of "scene" modes that includes a setting for portraits. However, the camera is well suited for taking portraits, because of its wide-aperture lens and relatively large sensor. One approach to taking portraits with the LX100 II is to put the camera into Intelligent Auto (or Intelligent Auto Plus) mode, in which the camera will use its scene-detection programming to recognize a face, and set itself to optimum settings for portraits. However, you do not have much control over how the camera captures the portrait in that situation, so you might want to use your own settings.

Here is a recommended set of options to use for capturing portraits, as a starting point that you can modify according to your needs and preferences.

- Set the camera to Aperture Priority mode with the aperture ring at its widest setting, f/1.7.
- ^o Zoom the lens in to its full optical reach of 75mm.
- [°] Set Photo Style on the Recording menu to Portrait.
- Set AF mode to Face Detection.
- Set the aspect ratio switch to 4:3.
- Set Picture Size to L 17M

- Set Quality to Raw and Fine
- Set AFS/AFF/AFC to AFS
- Set Metering Mode to Center-weighted
- Set ISO to a low value, 400 or lower, if possible in the lighting conditions
- Use burst mode if you want to capture a series of images to give you more options
- Place the subject in front of a plain, uncluttered background, such as dark trees, the wall of a building, or something similar, rather than in front of a group of unsightly objects, furniture, etc.
- Have the subject stand as far in front of the background as possible, to keep him or her separated from the background.

Figure 9-42 is an example taken indoors with flash, with the lens extended to its full optical zoom amount.

Figure 9-42. Portrait Example

Appendix A: Accessories

Then people buy a new camera, especially a fairly sophisticated model like the LX100 II, they often ask what accessories they should buy to go with it. I will discuss a few options, sticking mostly with items I have used.

Cases

As far as I can tell, at the time of this writing in early 2019, Panasonic has not released a case designed specifically for the LX100 II. It is my understanding that the leather Panasonic case designed for the LX100 does not fit the LX100 II. I did find one case that is listed as being made for the LX100 II.

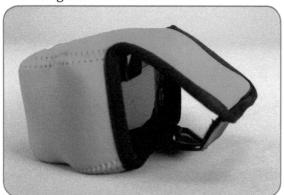

Figure A-1. MegaGear Case, Open

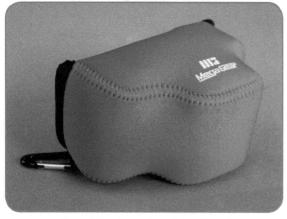

Figure A-2. MegaGear Case, Closed

That case, by MegaGear, is shown in its red version in Figures A-1 and A-2. It is available also in black and

several other colors. It is made of neoprene and is very light. It comes with a clip that lets you attach the case to your belt or other connection.

This case does not have room for anything besides the camera, though it appears to do a good job of protecting the LX100 II against scratches, bumps, and dust. If you want a minimalistic case, this one could serve quite well.

However, I usually like to keep my camera in a case or bag that has room for extra batteries, battery charger, flash, filters, and other items, which the MegaGear case lacks.

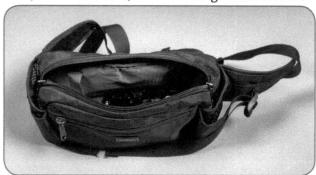

Figure A-3. Eagle Creek Waist Pack

With the LX100 II, I have been using the Eagle Creek Waist Pack, shown in Figure A-3. It has plenty of room for the camera and small accessories, has two mesh pouches to hold small water bottles, and has room for other items for a day trip.

I also occasionally use the Lowepro Rezo 110 AW, shown in Figure A-4. It is compact, but has plenty of room for the camera with an extra battery and charger. It has a loop to fit over a belt.

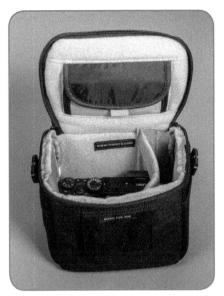

Figure A-4. Lowepro Rezo 110 AW Case

Batteries and Chargers

I use the camera pretty heavily, and I run through batteries quickly. The Panasonic battery, model number DMW-BLG10PP (in the United States), costs about \$40.00 in the U.S. as I write this. You can find third-party replacement batteries from brands such as Wasabi, as shown in Figure A-5, for considerably less.

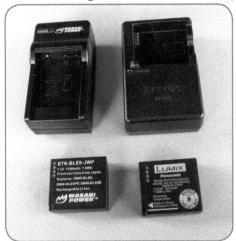

Figure A-5. External Chargers and Batteries for LX100 II

I have used Wasabi batteries extensively in my LX100 II with no problems. You may note that the battery shown in Figure A-5 has a different model number than the Panasonic battery, but that is not a problem; this Wasabi battery works fine as a replacement for the Panasonic battery.

If you use a spare battery, it's useful to be able to charge it outside of the camera. To do that, you need an external charger, such as the Panasonic model no. DMW-BTC9, shown in Figure A-5. You also can use a generic model, such as the Wasabi charger shown in Figure A-5.

For everyday use, I often find it convenient to charge the battery inside the camera, especially if I am not using the camera too intensively. I can take a few shots, and then plug in a power source to recharge the battery before I take another group of shots. If you are working near an electrical outlet, you can just plug the camera's own USB cable and charger into the outlet and charge the battery that way. If you want a more versatile charger that can also charge your smartphone and tablet at the same time, you might try a device like the Anker 40-watt desktop USB charger, shown in Figure A-6. I often use this charger to charge my LX100 II, my iPhone, and my iPad at the same time, and it has no problems with that setup.

Figure A-6. Anker 40-Watt Desktop USB Charger

For more portability, you might try a device like the Mophie PowerStation XL portable USB power supply, shown in Figure A-7, which will charge the camera's battery efficiently when the battery is in the camera.

Figure A-7. Mophie PowerStation XL Portable USB Power Supply

AC Adapter

Another alternative for powering the LX100 II is the AC adapter. This accessory works well in terms of providing a constant source of power to the camera. However, it is somewhat inconvenient to use. With the LX100 II, you need to obtain not only the AC adapter, model no. DMW-AC10, but also another device called the "DC Coupler," model number DMW-DCC11. That device looks like a battery, but it has a connecting port in its side. The adapter and the coupler are shown together ready to be connected to the camera in Figure A-8.

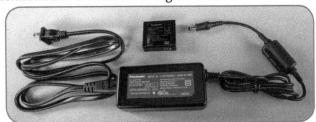

Figure A-8. AC Adapter and DC Coupler

You have to insert the DC Coupler into the battery compartment of the camera, then close the battery door, open up a small flap in that door, and connect the cord from the AC adapter to the port in the DC Coupler, as shown in Figure A-9.

This is not a very efficient (or economical) system, at least from the standpoint of the user. It is a clunky arrangement, and you can't get access to the memory card while the AC adapter is plugged in. But, if you need constant power for a long period of time, this is the only way to get it.

I should emphasize that providing power to the camera is all this adapter does. It does not act as a battery charger, either for batteries outside of the camera or for batteries while they are installed in the camera. It is strictly a power source for the camera. It may be useful if you are doing extensive indoor work in a studio or laboratory setting, to eliminate the trouble of constantly charging batteries. It also could be useful for a lengthy series of time-lapse or stop-motion shots. For everyday applications and still shooting, though, the AC adapter should not be considered a high-priority purchase.

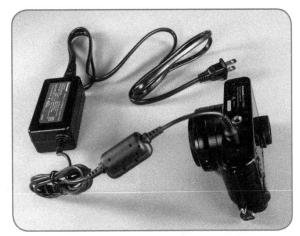

Figure A-9. AC Adapter Cord Going into Camera

Viewfinders

The LX100 II is equipped with an excellent built-in electronic viewfinder, so you are not likely to need to purchase an external one. However, if you prefer on occasion to use a traditional optical viewfinder, you can purchase one made by Panasonic, model number DMW-VF1, that fits into the hot shoe of the LX100 II, as shown in Figure A-10.

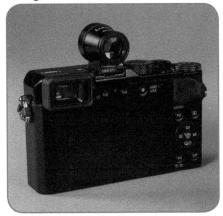

Figure A-10. Panasonic Viewfinder, DMW-VF1

You also can find third-party optical viewfinders that work well with the LX100 II. For example, Figure A-11 shows a Voigtlander 28mm viewfinder on the camera.

Appendix A: Accessories | 177

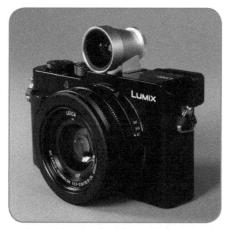

Figure A-11. Voigtlander 28mm Optical Viewfinder

When you use a viewfinder like this, you will probably want to use the step zoom feature of the LX100 II, discussed in Chapters 5 and 7, so you can zoom the lens precisely to the 28mm focal length. In that way, the viewfinder will be using the same angle of view as the camera's lens.

If you use an optical viewfinder rather than the LCD screen, you can turn off the LX100 II's screen, thereby saving battery power and extending the number of images you can record before changing batteries. Or, you can use the Monitor Information Display option on screen 6 of the Custom menu to include the information-only screen in the cycle of screens displayed on the LCD by pressing the Display button.

Add-on Filters and Lenses

One excellent feature of the LX100 II camera is that the front of its lens is threaded to accept standard 43mm filters. You can attach any one of numerous filters or other accessories. You might want to use a neutral density filter to enable the use of slow shutter speeds to blur moving water in streams, or to allow the use of wide apertures to blur backgrounds. You can use polarizing filters to enhance the appearance of the sky, and you can use an infrared filter, as discussed in Chapter 9, to capture infrared images. You can attach an adapter that lets you connect the LX100 II to a telescope or spotting scope, or you can use close-up lenses to enhance the macro capability of the lens.

Figure A-12 shows the LX100 II with an infrared filter attached to the lens.

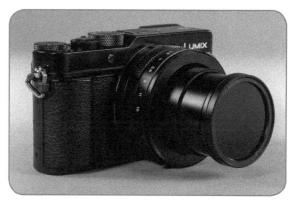

Figure A-12. Infrared Filter on Lens of LX100 II

External Flash Units

Whether to buy an external flash unit depends on how you will use the LX100 II. For everyday snapshots not taken at long distances, the supplied flash unit should suffice. It works automatically with the camera's exposure controls to expose images well. It is limited by its low power, though. Also, if you use only that unit, you will not be able to take advantage of the camera's ability to trigger remote flash units wirelessly.

If you need to use the wireless flash feature or just need more flash power to take photos of groups of people in large spaces, there are several options. One unit that works quite well with the LX100 II is the Panasonic DMW-FL220L, shown in Figure A-13, a small unit that fits well with the camera in terms of looks and function.

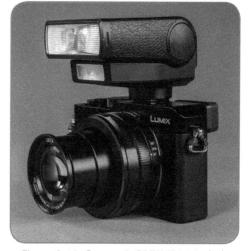

Figure A-13. Panasonic DMW-FL200L Flash

The FL220L fits into the camera's hot shoe and is not terribly tall or bulky. It communicates automatically with the camera in the same ways that the built-in flash does. It is compatible with Panasonic's wireless flash

protocol, and it can act as the controller or a remote unit using that system.

An even larger Panasonic unit that works well with the LX100 II is the DMW-FL360L, shown in Figure A-14.

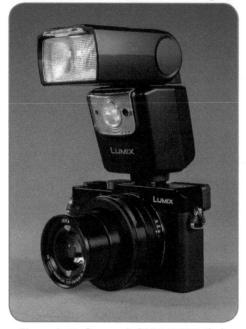

Figure A-14. Panasonic DMW-FL360L Flash

The FL360L functions like the flash that comes with the camera, but it is considerably more powerful and has a flash head that rotates and swivels. If you use it as a remote unit away from the camera, it receives signals sent by the supplied flash (or another compatible flash) and fires wirelessly, as discussed in Chapter 4.

If you want a more powerful unit with similar features, you can use the Panasonic FL580L, not pictured here.

Another flash that is compatible with the camera for automatic exposure is the Metz 36 AF-4 O, shown in Figure A-15. (This flash is sold in several different versions; you need to get the O version, which is compatible with Olympus and Panasonic cameras.) There is a newer model of this flash, the AF-5 O, which I have not tested myself, but which should work very well with the LX100 II camera.

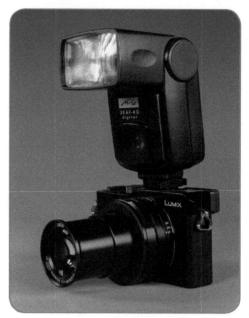

Figure A-15. Metz 36 AF-4 O Flash

Finally, another way to use powerful external flash units with the LX100 II is to use optical slaves, which detect the light from the camera's small flash and fire their own flash when the camera's flash is fired. One excellent unit with optical slave capability is the LumoPro LP180, shown in Figure A-16.

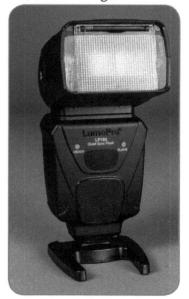

Figure A-16. LumoPro LP180 Flash

With this unit, you need to set the camera to Manual exposure mode. There are other flash units with similar capability, such as the Yongnuo YN-560 IV. There also are separate optical slave units, to which you can attach any compatible flash unit.

Appendix A: Accessories | 179

Automatic Lens Cap

The Lumix LX100 II camera ships with a standard lens cap that clips on to the end of the lens and is designed to be attached to the camera using a supplied piece of elastic string. This system works well enough, but it is somewhat inconvenient because you have to remember to remove the lens cap before you start shooting, and the cap dangles beside the camera in a way that can be distracting. Fortunately, Panasonic provides a solution in the form of a replacement—an "automatic" lens cap, model number DMW-LFAC1. You also can find a generic version of this item, such as the JJC ALC-LK100, which is what I obtained for my LX100 II.

Figure A-17. Automatic Lens Cap Closed

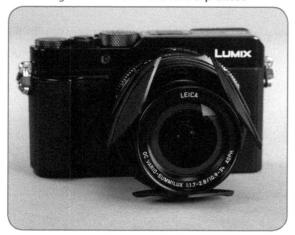

Figure A-18. Automatic Lens Cap Opened

As shown in Figures A-17 and A-18, the JJC lens cap replaces the existing one, and has leaves that open automatically when the lens extends to push through them. The leaves close when the camera is turned off or the lens retracts, as it does after a while in playback mode.

To install this cap, you have to remove the front lens ring, which twists off easily. Then you twist the automatic lens cap on in place of the front ring.

I originally tried this accessory just so I could write about it in this book, but I soon found that it made a considerable difference in my enjoyment of the camera. It is quite a relief to be able to turn the camera on or off without having to worry about attaching or removing the lens cap. At the time of this writing, the official Panasonic automatic lens cap sells for about \$36.00, and the JJC version sells for about half of that price.

External Microphones

As I discussed in Chapter 8, the LX100 II camera has excellent video features, but it has no provision for connecting an external microphone for high-quality audio. Although the built-in microphone records good-quality audio, you can get better results if you use an external audio recorder and synchronize the audio track from that recorder with the sound recorded by the camera.

Figure A-19. Tascam DR-100MkII Audio Recorder

One excellent piece of equipment for this purpose is the Tascam DR-100MkII recorder, shown in Figure A-19.

This recorder includes two sets of high-quality microphones, one set that is omnidirectional for recording lectures or classes, and another that is directional for recording concerts or other performances. The recorder also has two XLR inputs where you can connect high-quality microphones of your choice. There are many other options that will work for this purpose, depending on your budget and needs, including the Shure VP83F, the Tascam DR-40, the Zoom H1, and the Zoom H6.

Appendix B: Quick Tips

his section includes some tips and hints for using the LX100 II that might be useful as reminders. My goal is to give you small chunks of information that might help you in certain situations, or that might not be obvious to everyone.

Always check the aspect ratio and focus switches. It's great to use the Custom Set Memory capability to store your favorite groups of settings in the three available slots. But remember that you can't store the setting of the aspect ratio switch or the focus switch, because they are physical controls. Whenever I use the Utilize Custom Set Feature option to activate a group of settings, I also quickly check to be sure the aspect ratio switch is where I want it and that the focus switch is set properly. It's a good idea to check those two controls before any shooting session, actually.

Use the movable autofocus area in conjunction with Spot metering. When you do this, using an AF mode setting such as 1-Area or Pinpoint, you can move the focus and metering area together around the screen with the direction buttons, so you can focus and meter a small, specific area of your scene. This procedure can add precision to your metering and focusing, and give you more control over your results.

Use Manual exposure mode with Auto ISO. Not all cameras let you use Auto ISO with Manual mode. This feature lets you keep aperture and shutter speed at fixed values, while the camera adjusts ISO to obtain a normal exposure. This is useful, for example, when you need to stop action with a fast shutter speed and also control depth of field with a narrow aperture.

Diffuse your flash. If you find the supplied flash produces light that's too harsh for macro or other shots, try using a piece of translucent plastic as a flash diffuser. Hold the plastic up between the flash and the subject. An approach you can try when using fill-flash outdoors is to use the Flash Adjustment menu setting to reduce the intensity of the flash by -2/3 EV.

Use the self-timer to avoid camera shake. The LX100 II has a self-timer capability that is very easy to use; just press the Down button, scroll to the self-timer item, and choose your setting. This feature is not just for group portraits; you can use it whenever you'll be using a slow shutter speed and you need to avoid camera shake. It can be useful when you're doing macro photography, digiscoping, or astrophotography, also.

Use the 4K Photo option as a type of burst shooting. With this option, reached by pressing the Down button, you can set the camera to capture 4K-quality video that can generate a high-quality still image from each frame. In effect, this means you have a burst shooting mode, with Large-sized images and continuous focusing, at a rate of 30 frames per second (in the United States and other areas that use the NTSC video standard; 25 fps elsewhere). You have to use an SD card rated in UHS speed class 3, but this is an excellent capability for getting great action shots, shots of wildlife, and other opportunities.

Create a custom autofocus zone that uses the entire focusing area. Although the LX100 II has an AF mode setting called 49-Area, that setting actually uses only no more than 9 of the 49 possible focus zones. If you want to have a setting that uses the full extent of the display area, you have to create it yourself. To do that, press the Left button and use the Custom Multi option to create a focus setting with all 49 zones. Chapter 5 explains how to do this.

Use the zoom lever to speed through menu screens. This is a small item, but it can save you a lot of time when you need to scroll through menus with as many as 26 screens. When a menu screen is displayed, press the zoom lever in either direction to move forward or backward a full screen at a time.

Be careful of using Raw for Quality when shooting with Filter Effect settings. The LX100 II will let you have Quality set to Raw when shooting with Filter Appendix B: Quick Tips | 181

Effects, such as Silky Monochrome, Impressive Art, Miniature, and others. The recorded images will appear to have the effects added when viewed in the camera, but that is only because a small JPEG file is embedded in the Raw file. When you open the Raw file on a computer, the picture effect will not be there. You can try to recreate it using software settings, but I have not found any way to recover the full effect as recorded by the camera. (You can view a small, preview version of the image using the Irfanview program, available at Irfanview.com.) So, you might think you have taken some great shots using creative effects, but when you view them on your computer the effects will have disappeared. To avoid this problem, shoot using JPEG (Fine), or, probably the best option, use Raw & JPEG for Quality.

Use the in-camera processing features before uploading images. The LX100 II has a good set of options for transferring images using Wi-Fi and Bluetooth to a smartphone, tablet, or computer, and for uploading directly to social networks. Before you do that, you may want to use options on the Playback menu such as Raw Processing, Cropping, and Resize in order to send images at the optimal size and with the appearance you want.

Use the remote control capability of the Panasonic Image App. With this app, you can take self-portraits and capture images and videos of birds and other subjects while controlling the camera from a distance through a wireless network. Set the camera on a good tripod near a bird feeder to catch great shots of birds, or set the camera in a good location to record video of a school play while you sit nearby and control the camera from your smartphone. You can change settings on the camera while it is under remote control, and use functions such as burst shooting and stop motion animation.

Be aware of how exposure compensation works with this camera. Ordinarily, you can adjust exposure

compensation using the exposure compensation dial on the right side of the camera's top. However, if you assign exposure compensation to a function button using the Function Button Set option on screen 3 of the Custom menu, the exposure compensation dial is disabled. You then need to press the assigned function button to adjust the exposure compensation. You gain the benefit of being able to adjust it up to 5 EV negative or positive, as opposed to only 3 EV using the dial. (You also can assign exposure compensation to the control ring using the Control Ring option on screen 3 of the Custom menu.)

Change function button assignments quickly. You can always assign a new option to a function button using the Function Button Set item on screen 3 of the Custom menu. For a quicker way to make an assignment, though, you can press and hold a physical function button until a list of possible assignments appears, and scroll to the assignment you want for that button. This works for both recording mode and playback mode assignments. It does not work when a function button is assigned to one of a few options that require the button to be held down, such as AFL/AEL.

Use the Monitor Information Display screen to adjust settings. If you turn on the Monitor Information Display option on screen 6 of the Custom menu, the camera displays a black screen with several camera settings and other information in the cycle of screens that are produced by repeated presses of the Display button. When that screen is displayed, if the touch screen is activated through the Touch Settings option on screen 4 of the Custom menu, you can touch the Monitor Information Display screen to adjust several settings, including exposure compensation, ISO, white balance, and others. You can even assign a function to a function button. This feature works while recording movies also, although fewer settings are available for adjustment in that case.

Appendix C: Resources for Further Information

Photography Books

visit to any large general bookstore or library, or a search on Amazon.com or other sites, will reveal the vast assortment of currently available books about digital photography. Rather than trying to compile a long bibliography, I will list a few books that I have found especially helpful.

C. George, Mastering Digital Flash Photography (Lark Books, 2008)

C. Harnischmacher, *Closeup Shooting* (Rocky Nook, 2007)

H. Horenstein, *Digital Photography: A Basic Manual* (Little, Brown, 2011)

D. Sandidge, Digital Infrared Photography Photo Workshop (Wiley, 2009)

S. Seip, Digital Astrophotography (Rocky Nook, 2008)

Websites

Following are several sites that are useful for finding further information about the LX100 II or about digital photography in general

DIGITAL PHOTOGRAPHY REVIEW

http://forums.dpreview.com/forums/forum.asp?forum=1033

This is the current web address for the "Panasonic Compact Camera Talk" forum within the dpreview. com site. Dpreview.com is one of the most established and authoritative sites for reviews, discussion forums, technical information, and other resources concerning digital cameras. If you have a question about a feature

of the LX100 II, there is a good chance you can find an answer through this forum.

OFFICIAL PANASONIC AND RELATED SITES

https://shop.panasonic.com/cameras-and-camcorders/cameras/DC-LX100M2.html

The Panasonic company provides resources for the LX100 II at the above web address, including the downloadable version of the user's manual for the LX100 II and other technical information.

http://panasonic.jp/support/global/cs/dsc/

This is another address where Panasonic provides support information for the LX100 II, the Panasonic Image App, and other devices and software.

http://lumixclub.panasonic.net/eng/c/

At this address, you can get information about the Lumix Club, which you need to join in order to upload images from the LX100 II to social network sites.

http://panasonic.net/avc/sdcard/information/sdxc. html

This site provides information about the compatibility of SDXC cards with the LX100 II.

http://www.isl.co.jp/SILKYPIX/english/p/support/

At this site, you can download the manual for the Silkypix software included with the LX100 II.

http://loilo.tv/product/20

This site is where you can download the manual for the LoiLoScope software for editing videos, a trial version of which is provided with the LX100 II camera.

http://www.wrotniak.net/photo/infrared/

This site provides helpful information about infrared photography with digital cameras.

http://www.cambridgeincolour.com

This site is an excellent resource for general information about a wide range of photographic topics.

Reviews of the LX100 II

Following are links to written reviews of the LX100 $\scriptstyle\rm II$:

https://www.dpreview.com/reviews/panasonic-dc-lx100-ii

https://www.digitalcameraworld.com/reviews/

panasonic-lumix-lx100-ii-review

https://www.cameralabs.com/panasonic-lumix-lx100-ii-review/

https://www.techradar.com/reviews/panasonic-lumix-lx100-ii-review

https://www.photographyblog.com/reviews/panasonic_lumix_lx100_ii_review

https://www.imaging-resource.com/PRODS/panasonic-lx100-ii/panasonic-lx100-iiA.HTM

https://www.trustedreviews.com/reviews/panasonic-lx100-ii

https://camerajabber.com/panasonic-lumix-lx100-ii-review/

Index

Symbols

1-Area setting for AF Mode 76-77 4K Burst setting for 4K Photo option 81 4K Burst S/S setting for 4K Photo option 81 recording of audio with 81 4K Photo Bulk Saving menu option 105 4K Photo menu option 51 4K Photo options 80-83, 180 combining 4K Photo bursts into a light composition 105-106 combining 4K Photo bursts into a sequence composition 106-107 extracting a still image from 4K burst 81-83 requirement of high-speed memory card 80 4K Pre-burst setting for 4K Photo option 81 4K video recording 148-149 requirement of high-speed memory card for 149 24 fps video formats 148 30 fps video formats 148-149 49-Area setting for AF Mode 74-75 60 fps video formats 148

A

AC adapter 6 Panasonic model no. DMW-AC10 176 Adobe Premiere Pro software 152, 156 AF/AE Lock button 5, 89 AF/AE Lock Hold menu option 89, 115 unavailable with AF-On setting 115 AF/AE Lock menu option 89, 114-115 inability to lock exposure in Manual exposure mode 89 AF Area Display menu option 118 AF Assist Lamp menu option 98, 117 AF assist/self-timer lamp 6, 98 disabling operation of 98, 117 AF Macro option for focus mode 170 AF+MF menu option 119 AF Mode/MF option for function button 95 AF mode option 73-78 listing of settings available 73 moving focus frame on display 78 AF-On option for AF/AE Lock button 114–115 AFS/AFF/AFC menu option 29 AFS/AFF/AFC option on Motion Picture menu 149 AF Tracking setting for AF mode 74 Anker 40-watt desktop USB charger 175

Aperture range of available settings 19, 64 dependent on zoom level of lens 20 relationship to depth of field 19 Aperture bracket 56 Aperture Priority mode 19-20 Aperture ring 5, 20, 64 Approved Regulations menu option 168 Aspect bracket 58 Aspect ratio 63-64 relationship to image size 26 Aspect ratio switch 5, 63-64 checking before shooting 180 Astrophotography 171-172 Auto Clock Set menu option 169 Auto Exposure Compensation menu option 46 Autofocus option for focus mode 9, 65 Auto ISO using with Manual exposure mode 23, 180 using with Manual exposure mode with video recording Auto LVF/Monitor Off menu option 138 Automatic lens cap 179 Auto Review menu option 99, 125 Auto Transfer menu option 168 Auto White Balance setting 71 **AVCHD** files locating on memory card 156 AVCHD video format 147-148 \mathbf{B} Back button focus 89, 114 Backlight compensation 14 **Battery** Panasonic model no. DMW-BLG10PP 3, 175 charging 3

inserting into camera 3 Wasabi Power replacement battery 175 Battery charger, external Panasonic model no. DMW-BTC9 175 Wasabi Power model no. LCH-BLE9 175 Beep menu option 137 Bit rate for video recording 148 Bleach Bypass setting for Filter Settings option 37 Bluetooth features of camera using to turn camera on or off 163-164 Bluetooth menu option 137, 162, 168-169 Blurred background achieving with aperture setting 19 using wide aperture to achieve 19 Bracket menu option 54-58 Bulb setting for shutter speed 23, 164 Burst Rate menu option 51 Burst shooting 79–80 autofocus with 79 incompatibility with other settings 80

selecting speed of 79 C	Daylight Saving Time setting for 136
C	DC Coupler Panasonic model no. DMW-DCC11 176
Calendar screen in playback mode 10, 99	
Camera sounds	Defocus control option
silencing 54, 137	using in Intelligent Auto Plus mode 16
Cancel/Delete button 6, 91	Delete Confirmation menu option 111
Cases	Deleting images 91
Eagle Creek waist pack 174	Demo Mode menu option 142
Lowepro Rezo 110 AW 174	Depth of field
MetaGear case for LX100 II 174	relationship to aperture setting 19 Device Name menu option 168
Center Marker menu option 129	-
Charging/wireless connection lamp 5, 90	Dial Guide menu option 124–125 Diffraction Compensation menu option 49–50
disabling operation of 137	Diffraction Compensation intend option 45–56 Diffraction Compensation option on Motion Picture menu
Clear Retouch menu option 107–108	150
Clock Set menu option 7, 136	Digiscoping 171–172
Color Space menu option 40	Digital Zoom menu option 51
Color temperature	Digital Zoom option on Motion Picture menu 150
in general 71	Dimmed items on menu screens 26
Color temperature ratings of various light sources 71	Diopter adjustment dial 5, 68
Color tone	Direct Focus Area menu option 75, 78, 117
adjusting in Intelligent Auto Plus mode 16–17	Direction buttons 5–6, 69–88
Color tone adjustment for Monochrome Photo Style settings	Display button 6, 89–90
31	miscellaneous functions of 90
Communication Light menu option for flash 47	using to display date and time 90
Compression of JPEG images 29	using to display help screens 25–26, 90
Constant Preview menu option 126	using to switch among display screens 89–90
Continuous AF option on Motion Picture menu 147, 149	DLNA streaming media server 166
Contrast	Down button
adjusting 30	functions of 78–88
Control dial 5, 69	Drive Mode options 78–88
Controlling camera from smartphone or tablet 159–160	turning off burst shooting and other settings 78
Control ring 5, 64–65	Dynamic Monochrome setting for Filter Settings option 35
assigning a function to 122	<i>b</i> 1
default functions of 64, 122	E
possible assignments for 122	F 107
using to adjust manual focus 64, 122	Economy menu option 137
Control Ring menu option 122	Enlarging image in playback mode 10–11, 100
Controls on back of camera 5	returning image to normal size 10
Controls on front of camera 6	Exposure bracket 55–56
Controls on top of camera 5	selecting individual or burst shots 56
Create a New Folder menu option 140	setting from exposure compensation screen 56
Cropping menu option 109	setting order of exposures 56
Cross Process setting for Filter Settings option 36	using to create HDR images 55
Custom menu 113–134	Exposure compensation 181
navigating in 113	adjusting in Intelligent Auto Plus mode 16 and video recording 146
Custom Multi setting of AF Mode 75–76	
using to create focus area with all focus zones 76, 180	limited adjustment range for movies 146 Exposure compensation dial 5, 67–68
Custom Set Memory menu option 134–135	disabled when exposure compensation assigned to other
Custom white balance	control 67
procedure for setting 71–72	Exposure Compensation Reset menu option 114
D	Exposure Meter menu option 20, 130
	Expressive setting for Filter Settings option 34
Date and time	Extended ISO menu option 114
displaying on screen 90	Extended Optical Zoom 27, 51
setting 7, 136	

Flash Mode menu option 44-45

incompatibility with other settings 27 Flash Synchro setting for Flash Mode 45–46 relationship to Picture Size setting 27 incompatibility with other settings 46 External audio recorders Fn1 button 5, 68, 90-91 Shure VP83 179 Fn2 button 5, 91 Tascam DR-40 179 Fn3 button 6, 91 Tascam DR-100MkII 179 Fn4 button 5, 91-92 using for video recording 151, 179 Fn5 button 5, 92 Zoom H1 179 Focus Zoom H6 179 general techniques 65-66 External flash units Focus Area Set option for function button 78, 94 LumoPro LP180 178 Focus bracket 57 Metz 36 AF-4 O 178 compared to Post Focus feature 57 Panasonic DMW-FL220 43 playback of images 57 Panasonic DMW-FL360L 43, 48, 178 Focus frame Panasonic FL200L 177 moving around on display 78 Panasonic FL580L 178 Focus mode options 65-66 Yongnuo YN-560 IV 178 Focus/Release Priority menu option 117-118 Eye sensor 5 effect on burst shooting 79, 118 setting sensitivity of 139 Focus Stacking option 85-86 Eye Sensor AF menu option 68, 116 incompatibility with other settings 86 Eye Sensor menu option 68, 139 Focus switch 6, 65-66 checking before shooting 180 F Focus Switching for Vertical/Horizontal menu option 118 Folder/File Settings menu option 140 Face/Eye Detection setting for AF Mode 73–74 Forced On setting for Flash Mode 44 changing eye camera focuses on 73-74 Forced On with Red Eye setting for Flash Mode 44 changing face camera focuses on 74 Format menu option 142 Face Recognition Edit menu option 103 Function buttons 90-96 Face Recognition menu option 133-134 assigning functions to for playback mode 95-96 Fade-in and fade-out effects for video recording 146 assigning functions to for recording mode 92-95 Fantasy setting for Filter Settings option 38 changing assignment by pressing and holding 120 File Name Setting menu option 141 Function Button Set menu option 90, 120-121 Fill-flash setting for Flash Mode. See Forced On setting for Flash Mode G Filter effect adjustment for Monochrome Photo Style settings GPS data. See Location data **Filters** Grain effect adjustment for Monochrome Photo Style settings using with LX100 II camera 177 Filter Settings menu option 32-40 Guide Line menu option 128-129 incompatibility with other settings 34 H making adjustments to settings 33 using with Quality set to Raw 34, 180 Half Press Release menu option 115 Filter Settings option on Motion Picture menu HDMI Mode (Play) menu option 139 list of settings not available for video recording 149 HDMI port 6 Final Cut Pro software 152 HDR (high dynamic range) photography 14, 58-60 Firing Mode menu option 43 using Manual exposure mode for 22 Firmware HDR menu option 58-60 displaying current version 140 incompatibility with other settings 60 updating 140 Flash Adjustment menu option 46 connecting camera to with HDMI cable 139 Flash, built-in unit 43 Help screens in camera 90 diffusing 180 High Dynamic setting for Filter Settings option 36 using in Intelligent Auto mode 9 High Key setting for Filter Settings option 35 Flashing highlights in playback mode 129 Highlight menu option 129 Flash menu option 43-48 Highlight Shadow menu option 41-42 incompatibility with other settings 43 Highlight Shadow option on Motion Picture menu 149

Histogram

moving on display 128	L
playback mode 128 shooting mode 128	Language menu option 7, 140
Histogram menu option 127–128	LCD monitor 96-98
Hot shoe 5	adjusting brightness of 138
	adjusting display settings for 138
I	switching between viewfinder and 139
'A P C '4 1	Left button
iA Button Switch menu option 122	functions of 73-78
iA (Intelligent Auto) button 5, 68	using to activate MF Assist focus frame 78
i.Dynamic menu option 42	Leica D-Lux 7 camera
i.Dynamic option on Motion Picture menu 150	similarity to LX100 II camera 1
i.Handheld Night Shot menu option 14 iHDR menu option 14	Lens
Image sensor plane marker 5	minimum focus distance 65, 170
Impressive Art setting for Filter Settings option 36	retraction in playback mode 89
Index screens in playback mode 10, 99–100	specifications of 6
Infrared photography 170–171	Lens cap
Intelligent Auto mode 13–15	attaching to camera with lens cap string 3
general procedure for using 13	automatic 3, 179
incompatibility with other settings 13	Lens Position Resume menu option 132
Intelligent Auto Mode menu option 14	Lens Retraction menu option 89, 132
Intelligent Auto Plus mode 15–17	Level Gauge Adjustment menu option 142
features of 16	Level Gauge display screens 89
selecting 15	Light Composition menu option 105–106
settings unavailable with 17	Live View Boost menu option 126 Location data
using exposure compensation in 16	
using flash with 17	adding to images using smartphone 162 Location Logging option on Setup menu 162, 169
Intelligent Dynamic. See i.Dynamic	Locking exposure 89
Intelligent ISO setting 70	Locking focus 89
Intelligent Resolution. See i.Resolution	Locking operation of cursor buttons and touch screen 95
Intelligent Zoom. See i.Zoom	LoiLoScope software
Interlaced video formats 148	where to download 3
i.Resolution menu option 42	Long Shutter Noise Reduction menu option 49
i.Resolution option on Motion Picture menu 150	Loop Movement Focus Frame menu option 118
Irfanview software program 34, 181	Low Key setting for Filter Settings option 35
ISO 69-70	Lumix Club menu option 165, 168
native values 114	LVF. See Viewfinder (LVF)
range of values available 69, 70	LVF button 5, 68, 92, 139
ISO Auto Upper Limit (Photo) menu option 49, 70	LVF Display Setting menu option 131
ISO Auto Upper Limit (Video) option on Motion Picture	LVF Display Speed menu option 138
menu 150	conflict between Eco30fps setting and Digital Zoom option
ISO Increments menu option 113–114	138
Items on bottom of camera 6	LVF/Monitor Display Settings menu option 131
Items on front of camera 6	LVF/Monitor Switch menu option 68, 92, 139
i.Zoom 50	M
i.Zoom option on Motion Picture menu 150	M
J	Macro photography 170
JPEG files 29	Manual exposure mode 22–23
Jump Snap feature 160	displaying effects of settings 23
*	icons on screen 22
K	reasons for using 22
Valuin units of salantan material 74	using Auto ISO with 23, 180
Kelvin units of color temperature 71	using exposure compensation in 23
Key icon in playback mode for protected image or video 102	using for HDR images 22
	Manual Exposure mode (movies) range of available shutter speeds 146
	range of available strutter speeds 140

Manual Flash Adjustment menu option 43, 47 Manual focus aids to focusing 65, 78 general procedure for using 65–66 using in conjunction with autofocus 119 Mechanical shutter advantages of 54 Memory card formatting 142 inserting into camera 4 operating camera without 4 requirement of UHS speed class 3 for some types of recording 4	using Aperture Priority mode 145 using automatic modes 145 using exposure compensation 146 using Manual exposure mode 146 using manual focus 146 using physical controls of camera during 152–154 using Shutter Priority mode 146 using the touch screen 154–155 Motion pictures editing in camera 110, 155 editing with computer 11, 156–157 saving still frames from 11, 156 Movie button 89, 123
types of 4	disabling operation of 123
Menu/Set button 6, 88	Movie recording. See Motion picture recording
functions of 88	Movies and TV app for Windows 10 156 MP4 video format 147–148
Menu systems listing of 24	locating MP4 files on memory card 156
navigating among 24–26	MTS files for AVCHD video 156–157
Metering Mode menu option 40–41	Multiple Exposure menu option 60-61
incompatibility with other settings 41	using Overlay option with existing Raw image 61
Metering Mode option on Motion Picture menu 149	My Menu custom menu system 142–143
MF Assist Display menu option 119–120	N
MF Assist frame	
activating 78 MF Assist menu option 78, 119	Network Address menu option 168
incompatibility with other settings 119	Noise reduction
not available for movie recording 146	adjusting 30
MF Guide menu option 130	NTSC video system 144, 149
M/FT menu option 139	Number Reset menu option 141
Microphone	0
built-in 5	
	Old Days setting for Filter Settings option 34
Miniature setting for Filter Settings option 37-38	Old Days setting for Filter Settings option 34 One Point Color setting for Filter Settings option 39
Miniature setting for Filter Settings option 37–38 Minimum shutter speed menu option 49	One Point Color setting for Filter Settings option 39
Miniature setting for Filter Settings option 37–38 Minimum shutter speed menu option 49 Monitor Display menu option 138	One Point Color setting for Filter Settings option 39 Online Manual menu option 3, 134
Miniature setting for Filter Settings option 37–38 Minimum shutter speed menu option 49 Monitor Display menu option 138 Monitor Display Setting menu option 131	One Point Color setting for Filter Settings option 39 Online Manual menu option 3, 134 On/off switch 5, 66–67
Miniature setting for Filter Settings option 37–38 Minimum shutter speed menu option 49 Monitor Display menu option 138 Monitor Display Setting menu option 131 Monitor Display Speed menu option 138	One Point Color setting for Filter Settings option 39 Online Manual menu option 3, 134 On/off switch 5, 66–67 Operation Lock option for function button 94
Miniature setting for Filter Settings option 37–38 Minimum shutter speed menu option 49 Monitor Display menu option 138 Monitor Display Setting menu option 131	One Point Color setting for Filter Settings option 39 Online Manual menu option 3, 134 On/off switch 5, 66–67 Operation Lock option for function button 94 Operation Lock Setting menu option 95, 122–123
Miniature setting for Filter Settings option 37–38 Minimum shutter speed menu option 49 Monitor Display menu option 138 Monitor Display Setting menu option 131 Monitor Display Speed menu option 138 conflict between Eco30fps setting and Digital Zoom option	One Point Color setting for Filter Settings option 39 Online Manual menu option 3, 134 On/off switch 5, 66–67 Operation Lock option for function button 94
Miniature setting for Filter Settings option 37–38 Minimum shutter speed menu option 49 Monitor Display menu option 138 Monitor Display Setting menu option 131 Monitor Display Speed menu option 138 conflict between Eco30fps setting and Digital Zoom option 138	One Point Color setting for Filter Settings option 39 Online Manual menu option 3, 134 On/off switch 5, 66–67 Operation Lock option for function button 94 Operation Lock Setting menu option 95, 122–123 P
Miniature setting for Filter Settings option 37–38 Minimum shutter speed menu option 49 Monitor Display menu option 138 Monitor Display Setting menu option 131 Monitor Display Speed menu option 138 conflict between Eco30fps setting and Digital Zoom option 138 Monitor Information Display menu option 98, 131, 181 Monitor Information Display screen 89, 98, 120 using to adjust settings during video recording 154	One Point Color setting for Filter Settings option 39 Online Manual menu option 3, 134 On/off switch 5, 66–67 Operation Lock option for function button 94 Operation Lock Setting menu option 95, 122–123
Miniature setting for Filter Settings option 37–38 Minimum shutter speed menu option 49 Monitor Display menu option 138 Monitor Display Setting menu option 131 Monitor Display Speed menu option 138 conflict between Eco30fps setting and Digital Zoom option 138 Monitor Information Display menu option 98, 131, 181 Monitor Information Display screen 89, 98, 120 using to adjust settings during video recording 154 Monitor Luminance menu option 138	One Point Color setting for Filter Settings option 39 Online Manual menu option 3, 134 On/off switch 5, 66–67 Operation Lock option for function button 94 Operation Lock Setting menu option 95, 122–123 P PAL video system
Miniature setting for Filter Settings option 37–38 Minimum shutter speed menu option 49 Monitor Display menu option 138 Monitor Display Setting menu option 131 Monitor Display Speed menu option 138 conflict between Eco30fps setting and Digital Zoom option 138 Monitor Information Display menu option 98, 131, 181 Monitor Information Display screen 89, 98, 120 using to adjust settings during video recording 154 Monitor Luminance menu option 138 Monochrome Live View menu option 126	One Point Color setting for Filter Settings option 39 Online Manual menu option 3, 134 On/off switch 5, 66–67 Operation Lock option for function button 94 Operation Lock Setting menu option 95, 122–123 P PAL video system difference from NTSC system 149
Miniature setting for Filter Settings option 37–38 Minimum shutter speed menu option 49 Monitor Display menu option 138 Monitor Display Setting menu option 131 Monitor Display Speed menu option 138 conflict between Eco30fps setting and Digital Zoom option 138 Monitor Information Display menu option 98, 131, 181 Monitor Information Display screen 89, 98, 120 using to adjust settings during video recording 154 Monitor Luminance menu option 138 Monochrome Live View menu option 126 Monochrome setting for Filter Settings option 35	One Point Color setting for Filter Settings option 39 Online Manual menu option 3, 134 On/off switch 5, 66–67 Operation Lock option for function button 94 Operation Lock Setting menu option 95, 122–123 P PAL video system difference from NTSC system 149 Panasonic Image App 157–165 Panasonic Lumix DC-LX100 II camera features lacking 1
Miniature setting for Filter Settings option 37–38 Minimum shutter speed menu option 49 Monitor Display menu option 138 Monitor Display Setting menu option 131 Monitor Display Speed menu option 138 conflict between Eco30fps setting and Digital Zoom option 138 Monitor Information Display menu option 98, 131, 181 Monitor Information Display screen 89, 98, 120 using to adjust settings during video recording 154 Monitor Luminance menu option 138 Monochrome Live View menu option 126 Monochrome setting for Filter Settings option 35 Mophie PowerStation XL portable USB power supply 175	One Point Color setting for Filter Settings option 39 Online Manual menu option 3, 134 On/off switch 5, 66–67 Operation Lock option for function button 94 Operation Lock Setting menu option 95, 122–123 P PAL video system difference from NTSC system 149 Panasonic Image App 157–165 Panasonic Lumix DC-LX100 II camera features lacking 1 features of 1
Miniature setting for Filter Settings option 37–38 Minimum shutter speed menu option 49 Monitor Display menu option 138 Monitor Display Setting menu option 131 Monitor Display Speed menu option 138 conflict between Eco30fps setting and Digital Zoom option 138 Monitor Information Display menu option 98, 131, 181 Monitor Information Display screen 89, 98, 120 using to adjust settings during video recording 154 Monitor Luminance menu option 138 Monochrome Live View menu option 126 Monochrome setting for Filter Settings option 35 Mophie PowerStation XL portable USB power supply 175 Motion Picture menu 147–151	One Point Color setting for Filter Settings option 39 Online Manual menu option 3, 134 On/off switch 5, 66–67 Operation Lock option for function button 94 Operation Lock Setting menu option 95, 122–123 P PAL video system difference from NTSC system 149 Panasonic Image App 157–165 Panasonic Lumix DC-LX100 II camera features lacking 1 features of 1 Panasonic users manual
Miniature setting for Filter Settings option 37–38 Minimum shutter speed menu option 49 Monitor Display menu option 138 Monitor Display Setting menu option 131 Monitor Display Speed menu option 138 conflict between Eco30fps setting and Digital Zoom option 138 Monitor Information Display menu option 98, 131, 181 Monitor Information Display screen 89, 98, 120 using to adjust settings during video recording 154 Monitor Luminance menu option 138 Monochrome Live View menu option 126 Monochrome setting for Filter Settings option 35 Mophie PowerStation XL portable USB power supply 175 Motion Picture menu 147–151 list of items in common with Recording menu 147	One Point Color setting for Filter Settings option 39 Online Manual menu option 3, 134 On/off switch 5, 66–67 Operation Lock option for function button 94 Operation Lock Setting menu option 95, 122–123 P PAL video system difference from NTSC system 149 Panasonic Image App 157–165 Panasonic Lumix DC-LX100 II camera features lacking 1 features of 1 Panasonic users manual where to download 3, 134
Miniature setting for Filter Settings option 37–38 Minimum shutter speed menu option 49 Monitor Display menu option 138 Monitor Display Setting menu option 131 Monitor Display Speed menu option 138 conflict between Eco30fps setting and Digital Zoom option 138 Monitor Information Display menu option 98, 131, 181 Monitor Information Display screen 89, 98, 120 using to adjust settings during video recording 154 Monitor Luminance menu option 138 Monochrome Live View menu option 126 Monochrome setting for Filter Settings option 35 Mophie PowerStation XL portable USB power supply 175 Motion Picture menu 147–151 list of items in common with Recording menu 147 Motion picture recording	One Point Color setting for Filter Settings option 39 Online Manual menu option 3, 134 On/off switch 5, 66–67 Operation Lock option for function button 94 Operation Lock Setting menu option 95, 122–123 P PAL video system difference from NTSC system 149 Panasonic Image App 157–165 Panasonic Lumix DC-LX100 II camera features lacking 1 features of 1 Panasonic users manual where to download 3, 134 Panoramas 87
Miniature setting for Filter Settings option 37–38 Minimum shutter speed menu option 49 Monitor Display menu option 138 Monitor Display Setting menu option 131 Monitor Display Speed menu option 138 conflict between Eco30fps setting and Digital Zoom option 138 Monitor Information Display menu option 98, 131, 181 Monitor Information Display screen 89, 98, 120 using to adjust settings during video recording 154 Monitor Luminance menu option 138 Monochrome Live View menu option 126 Monochrome setting for Filter Settings option 35 Mophie PowerStation XL portable USB power supply 175 Motion Picture menu 147–151 list of items in common with Recording menu 147 Motion picture recording adjusting exposure compensation 146	One Point Color setting for Filter Settings option 39 Online Manual menu option 3, 134 On/off switch 5, 66–67 Operation Lock option for function button 94 Operation Lock Setting menu option 95, 122–123 P PAL video system difference from NTSC system 149 Panasonic Image App 157–165 Panasonic Lumix DC-LX100 II camera features lacking 1 features of 1 Panasonic users manual where to download 3, 134 Panoramas 87 creating 87–88
Miniature setting for Filter Settings option 37–38 Minimum shutter speed menu option 49 Monitor Display menu option 138 Monitor Display Setting menu option 131 Monitor Display Speed menu option 138 conflict between Eco30fps setting and Digital Zoom option 138 Monitor Information Display menu option 98, 131, 181 Monitor Information Display screen 89, 98, 120 using to adjust settings during video recording 154 Monitor Luminance menu option 138 Monochrome Live View menu option 126 Monochrome setting for Filter Settings option 35 Mophie PowerStation XL portable USB power supply 175 Motion Picture menu 147–151 list of items in common with Recording menu 147 Motion picture recording adjusting exposure compensation 146 adjusting ISO 154	One Point Color setting for Filter Settings option 39 Online Manual menu option 3, 134 On/off switch 5, 66–67 Operation Lock option for function button 94 Operation Lock Setting menu option 95, 122–123 P PAL video system difference from NTSC system 149 Panasonic Image App 157–165 Panasonic Lumix DC-LX100 II camera features lacking 1 features of 1 Panasonic users manual where to download 3, 134 Panoramas 87 creating 87–88 playback in camera 88
Miniature setting for Filter Settings option 37–38 Minimum shutter speed menu option 49 Monitor Display menu option 138 Monitor Display Setting menu option 131 Monitor Display Speed menu option 138 conflict between Eco30fps setting and Digital Zoom option 138 Monitor Information Display menu option 98, 131, 181 Monitor Information Display screen 89, 98, 120 using to adjust settings during video recording 154 Monitor Luminance menu option 138 Monochrome Live View menu option 126 Monochrome setting for Filter Settings option 35 Mophie PowerStation XL portable USB power supply 175 Motion Picture menu 147–151 list of items in common with Recording menu 147 Motion picture recording adjusting exposure compensation 146	One Point Color setting for Filter Settings option 39 Online Manual menu option 3, 134 On/off switch 5, 66–67 Operation Lock option for function button 94 Operation Lock Setting menu option 95, 122–123 P PAL video system difference from NTSC system 149 Panasonic Image App 157–165 Panasonic Lumix DC-LX100 II camera features lacking 1 features of 1 Panasonic users manual where to download 3, 134 Panoramas 87 creating 87–88 playback in camera 88 setting direction and size of 53
Miniature setting for Filter Settings option 37–38 Minimum shutter speed menu option 49 Monitor Display menu option 138 Monitor Display Setting menu option 131 Monitor Display Speed menu option 138 conflict between Eco30fps setting and Digital Zoom option 138 Monitor Information Display menu option 98, 131, 181 Monitor Information Display screen 89, 98, 120 using to adjust settings during video recording 154 Monitor Luminance menu option 138 Monochrome Live View menu option 126 Monochrome setting for Filter Settings option 35 Mophie PowerStation XL portable USB power supply 175 Motion Picture menu 147–151 list of items in common with Recording menu 147 Motion picture recording adjusting exposure compensation 146 adjusting ISO 154 autofocus options 147 duration limits for 144 general procedure for 9–10, 144–145	One Point Color setting for Filter Settings option 39 Online Manual menu option 3, 134 On/off switch 5, 66–67 Operation Lock option for function button 94 Operation Lock Setting menu option 95, 122–123 P PAL video system difference from NTSC system 149 Panasonic Image App 157–165 Panasonic Lumix DC-LX100 II camera features lacking 1 features of 1 Panasonic users manual where to download 3, 134 Panoramas 87 creating 87–88 playback in camera 88 setting direction and size of 53 shooting with filter effects 34, 87
Miniature setting for Filter Settings option 37–38 Minimum shutter speed menu option 49 Monitor Display menu option 138 Monitor Display Setting menu option 131 Monitor Display Speed menu option 138 conflict between Eco30fps setting and Digital Zoom option 138 Monitor Information Display menu option 98, 131, 181 Monitor Information Display screen 89, 98, 120 using to adjust settings during video recording 154 Monitor Luminance menu option 138 Monochrome Live View menu option 126 Monochrome setting for Filter Settings option 35 Mophie PowerStation XL portable USB power supply 175 Motion Picture menu 147–151 list of items in common with Recording menu 147 Motion picture recording adjusting exposure compensation 146 adjusting ISO 154 autofocus options 147 duration limits for 144 general procedure for 9–10, 144–145 general recommendations for 155	One Point Color setting for Filter Settings option 39 Online Manual menu option 3, 134 On/off switch 5, 66–67 Operation Lock option for function button 94 Operation Lock Setting menu option 95, 122–123 P PAL video system difference from NTSC system 149 Panasonic Image App 157–165 Panasonic Lumix DC-LX100 II camera features lacking 1 features of 1 Panasonic users manual where to download 3, 134 Panoramas 87 creating 87–88 playback in camera 88 setting direction and size of 53
Miniature setting for Filter Settings option 37–38 Minimum shutter speed menu option 49 Monitor Display menu option 138 Monitor Display Setting menu option 131 Monitor Display Speed menu option 138 conflict between Eco30fps setting and Digital Zoom option 138 Monitor Information Display menu option 98, 131, 181 Monitor Information Display screen 89, 98, 120 using to adjust settings during video recording 154 Monitor Luminance menu option 138 Monochrome Live View menu option 126 Monochrome setting for Filter Settings option 35 Mophie PowerStation XL portable USB power supply 175 Motion Picture menu 147–151 list of items in common with Recording menu 147 Motion picture recording adjusting exposure compensation 146 adjusting ISO 154 autofocus options 147 duration limits for 144 general procedure for 9–10, 144–145	One Point Color setting for Filter Settings option 39 Online Manual menu option 3, 134 On/off switch 5, 66–67 Operation Lock option for function button 94 Operation Lock Setting menu option 95, 122–123 P PAL video system difference from NTSC system 149 Panasonic Image App 157–165 Panasonic Lumix DC-LX100 II camera features lacking 1 features of 1 Panasonic users manual where to download 3, 134 Panoramas 87 creating 87–88 playback in camera 88 setting direction and size of 53 shooting with filter effects 34, 87 Panorama Settings menu option 53, 87

Peaking menu option 126–127	Quick Menu 5, 61–62
Photo Collage feature 163 PHOTOfunSTUDIO software 103, 134, 165	R
where to download 3	•
Photo Style menu option 30–32	Rating menu option 102
adjusting parameters for 30–31	Rating option for function button 96
comparison chart 31	Raw & Fine or Raw & Standard setting for Quality 29
incompatibility with other settings 31	Raw format 28–29
saving a custom setting 32	ability to alter settings after images captured 28
using with Raw setting for Quality 31	compressed and uncompressed files 29
Photo Style option on Motion Picture menu 149	incompatibility with other settings 28
PictBridge protocol 6, 112, 139	using with Filter Settings options 28
Picture Mode in Recording option on Motion Picture menu	Raw images
150	processing in camera 103–105
Picture Size menu option 26–27	Raw Processing menu option 103–105, 181
incompatibility with other settings 27	Recording Area menu option 132
relationship to aspect ratio 26	Recording Format option on Motion Picture menu 147–148
Picture Sort menu option 111	Recording menu in general 24–26
Pinpoint AF Display menu option 116–117	Recording modes
Pinpoint AF Setting menu option 116–117	list of 12
Pinpoint AF Time menu option 116	Recording modes of the Panasonic Lumix LX100 II camera
Pinpoint setting for AF Mode 77	12
Playback	Recording Quality option on Motion Picture menu 148–149
movies	Record/Playback Switch option for function button 95, 96
adjusting volume 11	Red-eye Removal menu option 49
general procedure 11, 155	Remaining Display menu option 132
still images	Remote Wakeup menu option 163, 168
general procedures 10, 99	Reset menu option 141
sorting chronologically 111	Reset Network Settings menu option 142
Playback button 5, 89	Resetting camera settings 141
using to turn on camera in playback mode 89	Resize menu option 108–109
Playback menu 100–112	Restore to Default option for function button 95
Playback Mode menu option 101	Retro setting for Filter Settings option 34
Playback on TV menu option 166	Returning from Sleep Mode menu option 168
Plural Eyes software 152	Right button
Portraits	functions of 71–73
settings for taking 173 Post Focus option 83–85	Rotate Display menu option 109, 111
incompatibility with other settings 86	Rotate menu option 109
Preview option for function button 93–94	Rough Monochrome setting for Filter Settings option 36
incompatibility with other settings 94	S
Printing images directly from camera 6, 112	3
Priority of Remote Device menu option 159–160, 167	Saturation
Profile Setup menu option 134	adjusting 30
Program mode 17–19	Saving custom settings for menu options 134–135
Program Shift 18	Scene detection 13
incompatibility with other settings 18	Second-curtain flash 45-46
Progressive video formats 148	Select Folder menu option 140
Protect menu option 101–102	Self-timer 86–87
	general procedure for using 180
Q	incompatibility with other settings 87
O Many bytton F 01	taking multiple shots with 86
Q.Menu button 5, 91	Self Timer Auto Off menu option 86, 132
Q.Menu menu option 121–122 Quality menu option 27–29	Self-timer menu option 51
distinguished from Picture Size option 27	Sensitivity (ISO)
Quick AF menu option 115–116	settings available for video recording 146
Anex 11 mena obtion 110-110	Sepia setting for Filter Settings option 35

Sequence Composition menu option 106–107 Setup menu 134-143 Sharpness adjusting 30 Shooting modes. See Recording modes Shutter AF menu option 115 Shutter button 66 using to start and stop video recording 146 Shutter Priority mode 20–22 incompatibility with other settings 22 Shutter Remote Control feature of Image App 164 Shutter speed procedure for setting speeds not on dial 67 range of available settings 19, 20, 23, 54 for movies 146 using setting to freeze or blur motion 21 Shutter speed dial 5, 67 Shutter Type menu option 21, 54-55 Silent Mode menu option 54 Silent Operation option for video recording 154-155 Silky Monochrome setting for Filter Settings option 36 Silkypix software where to download 3 Simultaneous Record Without Filter menu option 32 Sleep Mode menu option 137 Sleep Mode (Wi-Fi) menu option 137 Slide Show menu option 100-101 Slow-motion video creating using 60p video format 148 Slow Sync setting for Flash Mode 44-45 Soft Focus setting for Filter Settings option 38 Software for use with LX100 II camera where to download 3 Sound Recording Display option on Motion Picture menu Sound Recording Level Adjustment option on Motion Picture menu 151 Speaker 6 Spot setting for Metering Mode menu option moving spot metering area on display 41, 180 Stabilizer menu option 50 Stabilizer option on Motion Picture menu 150 Star Filter setting for Filter Settings option 38 Step-by-step guides adding location data to images 162 connecting camera to smartphone or tablet 157 preliminary steps before taking pictures 12 quick start for motion picture recording 144 saving still frame from motion picture 156 sending images to a computer 165-166 sending images to computer by Wi-Fi 165-166 taking pictures in Intelligent Auto mode 8 turning camera on or off using Bluetooth connection 163-164 uploading images to social networks 165 using external audio recorder when recording video 152 using the Video Divide option 155

Step zoom function for control ring 65, 125 Step zoom function for zoom lever 125 Stop Motion Animation menu option 52–53 Stop Motion Video menu option 111 Street photography 172 Sunshine setting for Filter Settings option 39–40

T

Tables function button assignments for recording mode 92 shutter speed equivalents 22 use of camera controls for video recording 152 Text Stamp menu option 108 using with Profile Setup option 134 using with Title Edit option 102-103, 108 Time exposure setting for shutter speed 23, 67 Time Lapse Shot menu option 51-52 Time Lapse Video menu option 110 Time zone setting 136 Title Edit menu option 102–103 Touch AE icon 97 Touch AE option for function button 94 Touch AF menu option 117, 124 Touch AF/Touch Shutter icon 97 Touch Pad AF menu option 124 Touch screen features 96-98, 123-124 in general 96 using during video recording 154-155 using with viewfinder 124 Touch screen icons 96-98 Touch Screen menu option 123 Touch Settings menu option 123-124, 181 Touch Shutter option 97, 124 using during video recording 154 Touch tab icons 97 Touch Tab menu option 124 Touch Zoom icon 97, 155 Toy Effect setting for Filter Settings option 37 Toy Pop setting for Filter Settings option 37 Tracking focus 74 selecting in Intelligent Auto mode 74 Travel Date menu option 136 Tripod socket 6 TV Connection menu option 139

U

Ultra-HD video format. See 4K video format Up button functions of 69–71 USB Mode menu option 139 USB port 6 Utilize Custom Set Feature menu option 134–135

V

Version Display menu option 140

Video button. See Movie button Video button menu option 89, 123 Video Divide menu option 110, 155 Video files locations on memory cards 156 Video recording. See Motion picture recording Viera Link menu option 139 Viewfinder (LVF) 5, 68 adjusting display settings for 138 adjusting for vision 69 automatic switching to LCD screen 68 switching between LCD monitor and 5, 68, 139 using touch screen with 124 Viewfinder menu option 138 Viewfinder, optical Panasonic model no. DMW-VF1 176 Voigtlander 28mm 176 Virtual function buttons 92, 97-98 functions that cannot be assigned to 93

W

WD TV Live media device 166
White balance 71–73
adjusting for Raw files 73
adjusting using color axes 72
list of preset options 71
setting by color temperature 72
setting custom value manually 71
White balance bracket 57–58
activating from white balance adjustment screen 58, 72–73
incompatibility with other settings 58
Wi-Fi and Bluetooth features of camera 157–170
adding location data to images 162
assigning ratings to images and videos within Image App

162 connecting to smartphone or tablet 157-158 controlling camera's shutter button with Bluetooth 164 controlling camera with smartphone or tablet 159-160, 181 Jump Snap feature 160 sending images and videos to smartphone or tablet 160-162 sending images to a computer 165-166 sending images to printers and other devices 165 turning camera on or off with Bluetooth 163-164 uploading images to social media sites 162, 164-165 viewing images on TV 166 Wi-Fi Function Lock menu option 168 Wi-Fi Function menu option 167 Wi-Fi menu option 137, 167-168 Wi-Fi Network Settings menu option 169 Wi-Fi Password menu option 157, 167-168 Wi-Fi Setup menu option 167-168 Wind Noise Canceller option on Motion Picture menu 151 Wireless Channel menu option for flash 47 Wireless Connection Lamp menu option 90, 137, 169–170 Wireless flash options 47-48 Wireless menu option for flash 47 Wireless Setup menu option for flash 47-48 World Time menu option 136

Z

Zebra Pattern menu option 129–130 Zoom lever 5, 66 using to navigate quickly through menus 66, 180 Zoom Lever menu option 125